HELLENISTIC ART

SECOND EDITION

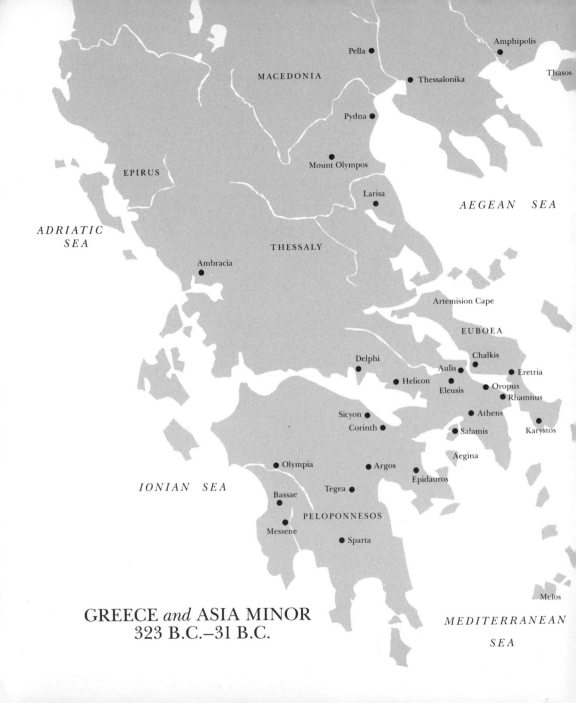

GREECE *and* ASIA MINOR
323 B.C.–31 B.C.

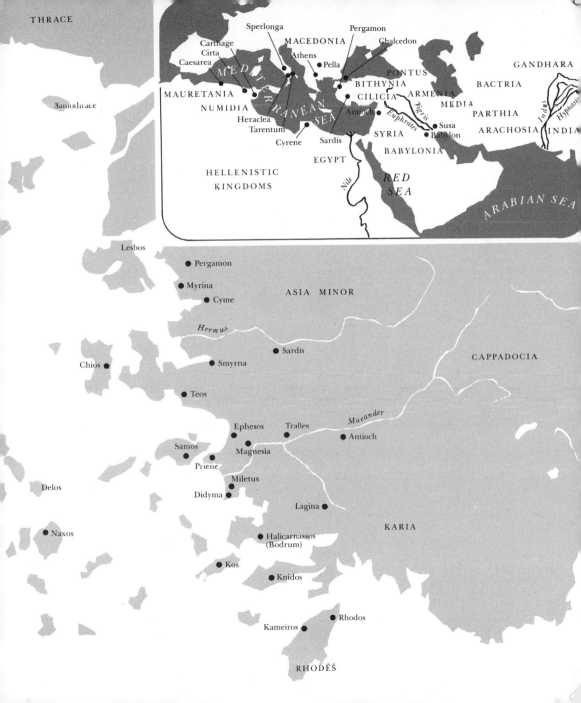

THRACE

Samothrace

MAURETANIA

Carthage
Cirta
Caesarea

NUMIDIA

MEDITERRANEAN SEA

Heraclea
Tarentum

Cyrene

Sperlonga

MACEDONIA

Athens

Pella

Sardis

Pergamon

Chalcedon

PONTUS

BITHYNIA

CILICIA

Antioch

SYRIA

EGYPT

Nile

HELLENISTIC
KINGDOMS

RED
SEA

GANDHARA

BACTRIA

ARMENIA

MEDIA

PARTHIA

Tigris

Euphrates

Susa

Babylon

BABYLONIA

ARACHOSIA

Indus

Hyphasis

INDIA

ARABIAN SEA

Lesbos

Pergamon

Myrina

Cyme

ASIA MINOR

Hermus

Sardis

Smyrna

Chios

Teos

Ephesos

Tralles

Maeander

Antioch

Samos

Magnesia

Priene

Miletus

Didyma

Lagina

KARIA

CAPPADOCIA

Delos

Naxos

Halicarnassos
(Bodrum)

Kos

Knidos

Rhodos

Kameiros

RHODES

HELLENISTIC ART
The Art of the Classical World from the Death of Alexander the Great to the Battle of Actium

SECOND EDITION

by Christine Mitchell Havelock

VASSAR COLLEGE

W · W · NORTON & COMPANY

NEW YORK LONDON

**Published simultaneously in Canada by
Penguin Books Canada Ltd,
2801 John Street, Markham, Ontario L3R 1B4.**

W. W. Norton & Company Inc. 500 Fifth Avenue New York N.Y. 10110

W. W. Norton & Company Ltd. 25 New Street Square London EC4A 3NT

ISBN 0 393 95133 2

3 4 5 6 7 8 9 0

Acknowledgments

For help in the preparation of this book my thanks are due to several professional colleagues : G. Bass, C. Beck, P. H. von Blanckenhagen, J. Boardman, A. P. Burnett, K. Erim, W. Fuchs, D. Glass, A. Greifenhagen, D. K. Hill, J. Kroll, P. W. Lehmann, H. Lloyd-Jones, J. McCredie, V. Poulsen, E. Rohde, E. Segal, C. L. Striker, E. Vanderpool, and C. Vermeule. I am also grateful to Claire Barrett and Pamela Cottam for assisting me in the course of my research, and to Vassar College for fellowship aid. Last but not least I owe thanks to my husband for his constant encouragement and helpful criticism.

Table of Contents

List of Illustrations Identified by Arabic Numerals

9

27. Bronze Statuette of a Philosopher,
 Roman copy

 Original second half of third century B.C. London,
 British Museum

28. Bronze Statuette of
 a Philosopher, Roman copy

 Original 250—200 B.C. New York, The Metro-
 politan Museum of Art, Rogers Fund, 1910

29. Chrysippos, Roman copy

 Original c. 200 B.C. Body: Paris, Louvre. Head:
 London, British Museum

30. Bronze Head of a Philosopher

 200—150 B.C. Athens, National Museum
 (Alison Frantz)

31. Epicurus, Roman copy

 Original later second century B.C. New York,
 The Metropolitan Museum of Art, Rogers
 Fund, 1911

32. Poseidonios

 70—60 B.C. Naples, Museo Nazionale

33. Menander, Roman copy

 Original early third century B.C. (?). Washing-
 ton, D.C., Dumbarton Oaks Collection

34. Homer, Roman copy

 Original 150—100 B.C. Boston, Museum of Fine
 Arts

35. Archilochos (?), Roman copy

 Original 200—150 B.C. Copenhagen, Ny Carls-
 berg Glyptotek

36. Hesiod (?), Roman copy

 Original late second century B.C. Naples,
 Museo Nazionale

ARCHITECTURE

37. Athens, View of the Agora
38. Athens, Agora, Stoa of Attalos II

 Attalos reigned 159—138 B.C.

39. Athens, Agora, Stoa of Attalos II
 (detail)

40. Athens, Plan of the Agora
 after Hellenistic remodeling

41. Miletus, Plan of the
 Hellenistic Agora

42. Priene, Acropolis and ruins

43. Priene, Plan of Hellenistic city

44. Priene, Model of Hellenistic city

45. Priene, Council-house today

46. Priene, Council-house c. 200 B.C.

47. Priene, Theater

 Late second century B.C.

48. Priene, Theater today

49. Priene, Ground plan of
 lower gymnasium

 c. 130 B.C.

50. Priene, Lower gymnasium, interior

51. Priene, View of
 "Athena Street"

52. Priene, House 33 on
 "Theater Street"

 Third century B.C.

53. Delos, House of the Masks,
 ground plan

 200—150 B.C.

54. Delos, House of the Masks,
 peristyle court

55. Alexandria, Pharos

 c. 279 B.C.

56. Athens, Tower of the Winds

 c. 40 B.C.

57. Athens, Tower of the Winds
 (detail)

58. Samothrace, Arsinoeion

 289—281 B.C.

SCULPTURE IN THE ROUND

91. Apollo Belvedere, Roman copy

Original 200—150 B.C.(?) Vatican Museum (German Archaeological Institute)

92. Dancing Satyr, Roman copy

Original c. 200 B.C. Naples, Museo Nazionale (Alinari)

93. Dancing Satyr, Roman copy (another view)

94. Flying Eros

c. 175 B.C. Boston, Museum of Fine Arts

95. Satyr Falling Asleep, Roman copy

Original c. 200—150 B.C. Naples, Museo Nazionale (Anderson)

96. Aphrodite from Melos

c. 150—100 B.C. Paris, Louvre (Hirmer)

97. "Heyl" Aphrodite

c. 150 B.C. Berlin, Staatliche Museen

98. "Borghese" Warrior

Early first century B.C. Paris, Louvre (Alinari)

99. Singing Negro

100—50 B.C. Paris, Bibliothèque Nationale (Giraudon)

100. Sandalbinder, Roman copy

Original c. 100 B.C. Paris, Louvre

101. Seated Boxer

70—50 B.C. Rome, Museo Nazionale delle Terme (Hirmer)

102. "Beautiful Head" from Pergamon

c. 160 B.C. Berlin, Staatliche Museen

103. Head of Athena by Euboulides

Second half of second century B.C. Athens, National Museum (Alinari)

104. Head of a Boy

c. 200 B.C. Alexandria, Greco-Roman Museum

105. Head of an Old Woman

100—50 B.C. Dresden, Staatliche Skulpturensammlung

106. Palladion from Sperlonga by Hagesandros, Athanadoros, and Polydoros

First century A.D. Sperlonga, Museum (German Archaeological Institute)

107. Head of Sarapis, Roman copy

Cambridge, Fitzwilliam Museum

108. Head of Anytos by Damophon

First half of second century B.C. Athens, National Museum

109. Sleeping Woman, Roman copy

Original 180—160 B.C. Rome, Museo Nazionale delle Terme (Alinari)

110. Male Head from Samos

100—50 B.C. Paris, Louvre

111. Themis from Rhamnus by Chairestratos

c. 300 B.C. Athens, National Museum (Alinari)

112. Nikeso from Priene

First half of third century B.C. Berlin, Staatliche Museen

113. Terra-cotta Draped Woman

First half of third century B.C. New York, Pomerance Collection (Nelson)

114. Sacrificing Girl, Roman copy

Original second half of third century B.C. Rome, Museo Nazionale delle Terme (Hirmer)

115. Standing Draped Female from Pergamon

c. 170 B.C. Berlin, Staatliche Museen

116. Cleopatra from Delos

138—137 B.C. Delos (Hirmer)

117. Tyche of Antioch, Roman copy

Original 300—290 B.C. Vatican Museum (Alinari)

118. Statuette of a Maiden

First half of third century B.C. Budapest, Museum of Fine Arts

13

171. Votive Relief to Cybele and Attis

c. 100 B.C. Venice, Museo Archeologico del Palazzo Reale

172. Relief of the Dance of the Nymphs

c. 100 B.C. Athens, National Museum

173. Grave Relief

Early first century B.C. Athens, National Museum

174. Dionysos Visits a Dramatic Poet, Roman copy

Original early first century B.C. London, British Museum

175. Funerary Relief

50—30 B.C. Berlin, Staatliche Museen

DECORATIVE ARTS

176. Mule Ornament

Second to first century B.C. New York, Metropolitan Museum of Art, Rogers Fund, 1913

177. Nereid Riding a Sea Monster

Late second century B.C. Taranto, Museo Archeologico

List of Plates Identified by Roman Numerals

DECORATIVE ARTS

I. Hellenistic jewelry

Late fourth to second century B.C. London, British Museum (Derrick E. Witty)

II. Medallion with bust of Artemis

Third century B.C. Athens, National Museum, Collection of Mrs. Hélène Stathatos (Emile)

III. Crater from Dherveni

Late fourth century B.C. Salonika, Archaeological Museum

IV. Tazza Farnese

Late second century B.C.(?) Naples, Museo Nazionale (M. Carrieri)

PAINTING AND MOSAICS

V. Vase from Centuripe

Third century B.C. Catania, University, Institute of Classical Archaeology (Hirmer)

VI. Lion-Hunt Mosaic.

c. 300 B.C. Pella (Il Parnaso Editore)

VII. Detail of Plate VI

(Il Parnaso Editore)

VIII. Mosaic, Head of a Tiger (detail)

Late second century B.C. Delos (Il Parnaso Editore)

IX. Achilles in Skyros. Copy

Original third century B.C. Naples, Museo Nazionale (M. Carrieri)

X. Thetis in the Workshop of Hephaistos. Copy

Original third century B.C. Naples, Museo Nazionale (M. Carrieri)

XI. Alexander Mosaic. Copy

Original c. 300 B.C. Naples, Museo Nazionale (M. Carrieri)

XII. Herakles and Omphale. Copy

Original early second century B.C. Naples, Museo Nazionale

Foreword

THIS BOOK introduces the arts of Greece as they were executed between the death of Alexander (323 B.C.) and the Battle of Actium (31 B.C.), when Greece finally lost her independence and Augustus assumed control of the Mediterranean. Surveys of Greek art are prone to treat the Hellenistic period in summary fashion, devoting longer and more enthusiastic chapters to the classical ages of the fifth and fourth centuries B.C. Surely it is time to recognize that Hellenistic art constitutes an enrichment and enlargement, not a degeneration, of earlier styles. It is not, as is often said, simply dedicated to realism. Principles of design inherent in Archaic and Classical art are continued in the Hellenistic age. The art is therefore still essentially Greek and constitutes more than a mere transition between the classical Greek and the Roman. Moreover, the period under consideration produced works of art of supreme beauty, rivaling in every sense those by Phidias or Praxiteles. The Nike of Samothrace or the Temple of Apollo at Didyma attests to the creative vigor of the age. Variety and diversity are the keynotes of Hellenistic art. Novel subjects, daring experiments in form, a profound identification with nature spring forth, and yet, underlying them, the essential Greek spirit prevails.

In many ways, the Hellenistic period was dominated by Alexander the Great. As king, conqueror, demigod, his personality and achievements sparked the imagination, the ambitions, and the longings of the entire epoch. He had roamed the world, he had conquered and enlarged it, bending both his immediate followers and his newly-won subjects to his own will and ideas. The sense of wonder with respect to the human personality, the power one man could exert, the heroic feats he could perform was thus, because of Alexander, placed in the foreground of

men's minds. It is hardly surprising, then, that portraiture, in the true sense of the term, is one of the of the new art forms of the period.

The small democratic city-state of the Classical period had provided the special character of its own contemporary art. Now there were empires and kingdoms ruled by autocratic princes. Thus in his acts an Attalos or a Ptolemy sums up the whole Hellenistic age to a far greater extent than Pericles can be said to epitomize the Classical. Furthermore, whereas the story of Classical art may be written in terms of one city — Athens — it is quite the opposite for the period after Alexander's death. Pella, Pergamon, Alexandria, Antioch, Didyma, and Rhodes, as well as Athens, are important centers of artistic creativity. It is true that as a result of Alexander's conquests Greek culture spread well beyond these centers, but the major developments of Hellenistic art occurred within the relatively small area of the eastern Mediterranean in which they were concentrated. This book therefore focuses upon them rather than upon the peripheral regions of the Hellenistic world.

In spite of the newly enlarged world, it is precisely during the Hellenistic period that we ourselves for the first time draw close to the Greeks. The Classical period, for all its grandeur and nobility, remains remote. The Hellenistic age, on the other hand, is the first modern one in its self-awareness, in its desire to understand the nature of man, in its reverence for the past and yet its ability to turn away from it and see the past for what it is. All these facets of Hellenistic civilization are, of course, expressed in its art — an art that is sometimes nostalgic, sometimes revolutionary, at one time austere, at another intimate, comprehending the human tragedy and also the human comedy.

Compared to the Classical, Hellenistic art is more

broadly based and its character more secular. In architecture it is the marketplace, the theater, the assembly hall, the schoolroom, as well as the temple, on which creative thought is expended. If in a historical and ideological sense Alexander represents the Hellenistic age, in the visual arts the foremost place is occupied by Aphrodite, the Goddess of Love. It was under her aegis that the female nude came into its own, a subject that ever since has challenged both painters and sculptors. Hellenistic paintings and mosaics reveal an unprecedented richness, a new colorism and sensuality. Alexander's conquests, by making gold and precious stones available as never before, had also made it possible for the women of the time to emulate the Goddess of Love and clothe themselves with jewels and trinkets. Even a small earring unearthed at a Hellenistic site exemplifies the splendor and richness of an era dominated by Alexander and also by Aphrodite.

The vastness of the subject and the opaqueness of our present knowledge have furnished discouraging obstacles to the completion of this work. It is one thing to study a single monument or a single class of monuments within the Hellenistic period but quite another to offer within some kind of logical framework a survey of all the fields of artistic endeavor over three centuries. The most difficult task proved to be portraiture, chiefly because so many examples are Roman copies rather than Greek originals.

Among the many debts I owe to others who have helped me in this task, I wish to single out for special acknowledgment my obligation to my former teacher George Hanfmann of Harvard University. His encouragement and advice have never failed me when I needed them, and as a reader of this manuscript he has contributed a sympathetic but also exacting criticism which has proved invaluable. If I have another special debt to acknowledge it is to the writings of Rhys Carpenter, whose approach to the subject has profoundly influenced me and who convinced me years ago that my first obligation to a work of Greek art was to look at it intensely.

April 1968 *Vassar College*
 Poughkeepsie, New York

PREFACE TO SECOND EDITION

In the decade since the first edition of this book appeared scholarly contributions toward our understanding of Hellenistic art have proceeded apace. I have attempted to acknowledge or incorporate the most significant of these and to bring the general bibliography up to date. In addition further excavations have shed new light on heretofore familiar material; this is the case for instance with the temple at Sardis (59–60) and the sculptures from Lycosoura (108). However, in the interim few, if any, controversial issues have been solved; Hellenistic art, whether architecture, sculpture, or painting, remains a fascinating but always problematic field of inquiry.

The revisions have been greatly assisted by suggestions from George M. A. Hanfmann and Brunilde S. Ridgway, and I would like to take this opportunity to express my appreciation to them.

1979 *Vassar College*

I Portraits

No one had more altered the course of history, no king had expanded his domains to a greater extent, no man was more personable or unique than Alexander the Great. Every battle he fought was a military marvel; each river he crossed a major triumph; the cities he besieged and those he founded stretched from sea to sea. Yet not one of these events did he commemorate on his coins. Julius Caesar, Charlemagne, or Napoleon would not have missed such an opportunity. But more than that, it never occurred to Alexander to put his own portrait on his coins. If, therefore, it can be asserted that the royal coinages of Alexander the Great and the Hellenistic kings are one of our best sources of insight into the nature and purpose of portraiture in ancient Greece, it must be understood that the history of portraiture is complex and that the very term portraiture needs definition.

In classical Greek times the erection of a portrait statue was the exception, not the rule. Only a man of outstanding public achievement was deemed worthy of such an honor. Moreover, in sculptures of Pericles, the features are indistinguishable from those of any bearded god of the same period. We do not possess a single original portrait from the fourth century, but judging from the Roman copies that represent Plato, for example, the general type prevailed during that century too. Furthermore, no Greek of the Classical period was ever portrayed on coins. Initially, then, the early Hellenistic princes had good reason to hesitate to employ their portraits and, even when they did so, the likeness was sure to appear with some symbol or sign stating that the prince was extraordinary, unlike the common run of men, akin to the heroes of the past or to gods. Tradition here worked to their advantage. Heads of deities had appeared in many classical coinages. It was not a startling breach of custom, then, if Seleu-

kos introduced himself wearing the horns of Ammon, if Ptolemy wore the aegis of Zeus like a necklace, or if Philip V dressed up as Perseus. Similarly significant is the transformation of Herakles' profile into that of Alexander (4) and then Alexander's into that of Mithridates VI (14). Philip, Alexander's father, had used the head of Herakles as his chief coin type; Alexander continued it, without change, throughout his reign. The seated figure of Zeus most often occupies the reverse of his coins. Athena and Nike appear from time to time.

The conclusion would seem to be that even as late as Alexander's reign the time was not yet ripe for a developed portraiture. To be sure, Alexander commissioned Lysippos to sculpture his portrait, Apelles to paint it, and Pyrgoteles to cut it in a gem, but despite their efforts we still do not know what Alexander really looked like.

Yet it is true that Greek portraiture proper first emerges in the early Hellenistic age. It will not surprise the reader to learn that it arose simultaneously with the companion art of biography, a literary genre that owed much to the influence of the Lyceum, the school founded by Alexander's tutor Aristotle (26). The history of coinage reveals the story. At first the generals who governed the various parts of Alexander's empire immediately after his death conspicuously avoided stamping their own likenesses on their coins. Eventually they went so far as to add, in one small corner, their personal badges or their names. It was not until some years later, when they had put on the diadem of kingship, that they dared take the revolutionary step of issuing coins bearing their own portraits. But not all of them felt it necessary to circulate these likenesses. The Seleucid kings maintained the most continuous series of portrait coins; among the kings of Macedon and Egypt such series were only sporadic. In Pergamon, with one excep-

tion, no living monarch employed his own image. And it is astonishing that none was issued by Pyrrhus (8), the headstrong monarch of Epirus who dreamed of conquering the world.

Lysimachos of Thrace was one of the successors who declined to use his own portrait; we find him using Alexander's instead (4). Ptolemy III issued magnificent gold coins (6) that featured the combined portraits of his parents and grandparents. With rare exceptions individual achievements or triumphs receive no notice on coin reverses. An assortment of deities or animals appears instead.

Many more examples could be accumulated, but from those already cited it is possible to see that in Hellenistic royal coinages there is a distinct preference for Panhellenic and dynastic, as opposed to personal, symbols. Herakles may have been the mythical ancestor of the Macedonian ruling house, but, like Zeus, he was not the private property of any one state. As the most popular Greek hero, he belonged to all. This was the banner the conquering Alexander carried through Asia. Lysimachos put Alexander's profile on his coins because he considered himself, and in fact was, one of his successors. What caused Ptolemy to put his whole genealogical table on a coin except a desire for dynastic rather than personal prestige? The effect was to extol the ruling group rather than the individual members, and indeed this may also be why family resemblance in these portraits is so strong. Battles usually went unrecorded on coin reverses because otherwise attention would be focused on the reigning monarch instead of on the dynasty as a whole. One of the notable aspects of Hellenistic coinages is the constancy of the types. This was no doubt economically expedient, but, in view of Roman and later coinages, not essential. In Greece, the ultimate reason for the choice of types is that group identity, whether in Panhellenic or dynastic terms if we consider coins, took precedence over individual identity. In his own mind Alexander was Greek first, Macedonian second, and Alexander last. This may be hard for us to understand, but understand we must if we are to grasp the particular character of Greek portraiture.

When we turn from men of action to men of thought, coinages are no longer helpful. It is clear, however, that sculptured portraits of philosophers, orators, and poets also reveal typological or group thinking. All are rendered according to a preconceived type based either on the beardless Apollo or the bearded Zeus, both Greek gods renowned for their intelligence and wisdom. How strongly type controls the individual representation will be observed by anyone who has tried to carry in his memory a portrait of Metrodoros as opposed to Hermarchos as they are illustrated, for example, in the second volume of G. M. A. Richter's *The Portraits of the Greeks* (figs. 1230, 1292). There are many instances, furthermore, in which the portraits were made several years or even centuries after the man's death, and the features must have been invented. We can imagine how the sculptor of Homer (34) went about his job: "What should a poet look like?" he asked himself. "Well, like other poets." "But what should *this* poet look like?" He has heard it said that Homer was blind. That is all he has to go on. Under the circumstances the artist is bound to produce a type. What then are we to expect but twenty-five possible identifications offered for the head shown in 36? Need we be surprised that the one reproduced in 33 has provoked unending controversy between the claims of Menander and Vergil?

We have been saying, essentially, that all Greek portraits are generalized or idealized, and that the Greeks did not value realism as highly as we do. Yet not all Greek portraits are generalized to the same degree. Portraiture proper begins at the point when individual features depart significantly from the canonical or typological form. These circumstances, we have said, did not prevail in the fifth or in the fourth century. In Alexander's lifetime we are on the threshold. With his successors, particularly the Ptolemies and the Seleucids, the first original likenesses appear on royal coins. Even these are portraits in a qualified sense – the dynastic type tends to predominate and may become so standardized that it is difficult to distinguish father from son, or one monarch from his successor. But these coin series do show beyond question that portraiture, as we usually understand the term, first emerges in the early Hellenistic age.

THE DEVELOPMENT
OF HELLENISTIC PORTRAITURE

Although material evidence may be abundant, the study of the development of Hellenistic portraiture is baffling and difficult. We walk on a tightrope of conflicting theories, surmises, even guesses, a shred of new evidence can alter the balance overnight. The primary reason for this is that the bulk of the material consists of Roman copies rather than Greek originals. To base any stylistic development upon them is treacherous in the extreme since we still do not understand fully enough the methods of the copyists. In the instances where there are many copies, we really cannot know which one is closest to the original. How then can we possibly arrive at a date for the original? The biographical approach has been attempted, but it is even more hazardous. In the past it has led to chaos, taking us down tortuous paths marked by incredible stylistic transformations. Few identifications are beyond question, and furthermore, although Demosthenes (25) lived before Attalos I of Pergamon (9), we cannot therefore assume that a portrait of the great orator is in every respect earlier in its origin than one of the monarch.

Since portraiture is an art form, we are entitled to look beyond the subject in a search for a development of style. We should rely as far as possible on original material. In the absence of numerous sculptured originals, let us first see how much we can learn by turning again to numismatics. Coin portraits are, of course, datable. They are indispensable in determining identity and, as we have seen, in illuminating the nature of portraiture in ancient Greece. The Seleucid series, the most continuous, would seem to offer just what we need: a chance to trace the development of style step by step. But we are met with disappointment. The series deteriorates rapidly in the second century, and the portraits become increasingly stereotyped. As for the Ptolemaic issues, they exhibit great gaps after 200 B.C. At the same date the issues of other dynasties only begin. A precautionary word is also required: coin designs of all periods in Greek art show, as the natural consequence of the medium, a formal freedom and pliancy, almost a caricature quality, which contemporary sculpture in stone could not match. Nevertheless if we thread our way through all the coinages of the Hellenistic age we can draw certain important conclusions. Third-century portraits prove to be more generalized on the whole than those of the second century. Compare, for instance, heads of two Ptolemaic rulers (6) with that of Perseus, King of Macedon (11). A physiognomy as unprepossessing, as full of angles and slopes as that of Euthydemos, King of Bactria (12), will not be found in the first half of the third century. It can also be seen that the heads on many coins dating well into the second century are more three-dimensional and plastic than those of the early Hellenistic age. The surface that comprises Alexander's forehead (3), although delicately modeled, is unmistakably flatter than the brusquely protruding forehead of Perseus. The eyes too are different: in the first case they lie in a plane flush with the temple; in the second they are embedded deeply in a skull that is conceived in the round rather than in relief. The broad, rather simple areas that compose the Ptolemaic heads have been replaced by smaller and more numerous forms in that of Perseus. On the whole, too, there is a certain reserve in the facial expressions of third-century heads. Unless they are reincarnations of Alexander, as the Mithridates VI (14), second-century profiles are more aggressive and intense.

The coins, then, can provide an overall stylistic framework for the study of monumental portraiture of the period. Keeping them in mind, we tentatively propose for portraits sculptured in the round the following sequence:

Third Century:

A classical language still prevails in portraits of the third century. Our finest examples are Alexander (1) and Arsinoe (7). In this period the head as a whole and the face itself are marked by an abstract beauty, an underlying clarity and simplicity of shape, regularity of contour, and relatively uninterrupted surfaces. These qualities, in addition to the symmetry that can be observed in the whole and in the separate features, make the frontal view the most satisfactory. All forms are well defined, firmly shaped, and fairly static. The eye area is treated in a manner simi-

lar to that found in heads from the Parthenon of the fifth century or in gravestones of the fourth century; eyebrows follow closely the curvature of the upper eyelid. We appreciate this repetition because of the full undisturbed plane between the eyes. The eyes are not very deeply inset, and the eyeballs are quite flat.

In expression, harmony with the self and with the world are indicated. There is a definite internal quality, an inner absorption, but it is effortless and only latent. These people are aloof, reserved, self-confident, a little bland perhaps, but composed.

Late Third Century and First Half of Second:

There are some fine examples to work with in this period. We mention in particular the heads of Alexander in Istanbul (3), Ptolemy I (5), Pyrrhus (8), and the impressive one of Attalos I (9). Sculpture from Pergamon offers excellent corroborating material. We have not yet reached a style that can be called realistic, for abstract classical conceptions – that is, a certain formality – are still prevalent. The head, for instance, continues to be viewed as a single unit with symmetry and geometric clarity. The contours of the face, however, are not as regular. Jaw, jowl, temple, and cheekbone may break beyond the pure ovoid shapes seen in the earlier period. As noted in the discussion of coin portraits, there is now more movement and more plasticity. We seek a three-quarter view in order to realize the full implications of contour or plane. The planes of the face are not as broad, but neither are they unrestricted in number or perpetually and imperceptibly running into one another. The skin is a little looser; eyelids can droop and the flesh weigh heavily on the forehead or at the corners of the eyes, which are more deeply recessed. The eyebrows take a broader curve away from the eye or dip toward it; in either case they arch more independently.

The heads of this period show a stronger internal activity, and the expression is at the same time more outgoing. Warm and human, these portraits are throbbing with life and energy; they are more romantic and heroic. In that sense they are "baroque," and they begin to challenge the spectator.

Second Half of the Second Century:

The original work in bronze from Delos (20) and the Roman copy of Homer (34) are later than the Pergamon Altar (180-160 B.C.), in which outbursts of movement and feeling are still subject to the restraints of classical stylization and decorum. The thesis advanced by R. Carpenter in his *Greek Sculpture* that the style we now observe is "plastic" rather than "glyptic" is very valid indeed. The artist seems to mold rather than to carve, to think in terms of soft clay or wax rather than hard stone. Almost no broad planes remain; instead there are an infinite number of fluctuations and mobile surfaces. Contour is quite insignificant amid the shifting lights and shades, shimmering flesh and dissolving forms. We almost feel the perspiration or the oil on the skin. Bone and flesh are a great deal more differentiated. Eyes and eyebrows oppose each other, sometimes quite dramatically. The eyebrows ascend and descend in high sweeps and audacious dives. The eyes themselves burn in their deep sockets.

The expressive content accordingly alters. Inner control has almost gone. These people are intensely caught up in their own thoughts; there is an extraordinary fervor and passion about them. But as in portraits of the preceding style, their thoughts and feelings are larger than life, though now they are even more grandiose, almost frightening.

First Half of the First Century B.C.:

During the first half of the first century one may discern in general a basic subdivision between a classicistic style and a realistic one. The chief example of the first is the male head from a grave relief (22). The realistic style is illustrated by the priest in the Agora museum (24). These stylistic trends, however, as we shall see, are not mutually exclusive.

The so-called classicistic style is characterized by a return to conceptions and forms prevalent in the High Hellenistic period and also to those of the classical ages of the fifth and fourth centuries. The rumpled surfaces of the later second century become smoother, and attention is again thrown on shape and contour and on the unity of the head as a whole.

The surface in these portraits tends to harden, and line usually takes on a corresponding emphasis and decorative function. The eyebrows again follow the upper eyelids, for instance, and we observe a new neatness, perhaps overneatness, in such details as the short beard and thin hair of Poseidonios (32), the hair an imitation of the coiffures in Polykleitan heads of the fifth century. A serenity and mildness of mood overtakes the expression. There is, in short, a weakening and dilution of emotional content.

The term "realistic" is justified for the first time in referring to the second group of first-century portraits (21, 24). It is but a short step from these to the portraiture of late Republican Rome. There is nothing fancy, so to speak, about the style. These men look you straight in the eye; their physiognomies and personalities are drawn with a new concreteness and lack of pretension. The fleshiness of the second-century style remains to a certain degree, but as in the first group, the linear hardness is new. Whereas the line of the classicistic group is largely ornamental, in the realistic portraits it is expressive. Engraved and deep, it is unprecedented in Greek portraiture. The classicizing heads may look a little vacuous; not so the realistic ones. They are down-to-earth, fully human. At last we seem confronted by specific individuals with whom we could speak, in contrast to the earlier portraits in which the sitter seems more or less preoccupied and unaware of the observer. Perhaps the most important element, and certainly the most expressive, is the treatment of the eyes. The head of Demosthenes (25), which in some ways is classicizing, nevertheless has a powerful glance and should be mentioned here. The eyebrows seem to want to knit together over the bridge of the nose and to press down over the eyes themselves. They are unusually strongly horizontal. The total effect is one of a piercing glance, a new and almost painful self-awareness and spirituality.

1, 2 Alexander III (The Great) of Macedon (ruled 336-323)

The name Alexander the Great is pure magic. Few figures in history more excite the imagination and wonder of the Western world. Few have held its interest for so long. The many and varied portraits that survive of him in no way dispel the magic. In stone, in bronze, in mosaic, on gems and coins, his face, always beautiful, perpetually enthralls us.

The portrait shown here is a fragment of a statuette, one-third life-size, which includes the head, most of the chest, and the upper right arm. Still visible on the left shoulder is the edge of a cloak which left exposed the right arm and chest. In the profile view we can see a fairly regular groove running through the hair; he must have worn a diadem. His left hand, which was found separately, held a sword, and it has been conjectured that the right hand held a lance. He was probably standing or striding. An Alexander in the Louvre and another in Istanbul have been cited as possible parallels. The similarity of the profile to that on coins issued by Lysimachos of Thrace at Magnesia (4) is the basis for the identification, although it has been pointed out that the noses do not correspond.

Alexander's extremely handsome appearance, which is mentioned over and over again in literary sources, is fully apparent here. The hair is sketchily rendered but abundant, and though the curls are almost obliterated at the back, they climb to a kind of summit and then fall again over his brow. His forehead swells above the bridge of his straight, narrow nose. His mouth is unusually sensitive and aristocratic, especially in the profile view.

The turn of the head, the partially raised arm, the athletic build, the lively hair and countenance all contribute to an impression of controlled energy and alertness. Yet there is nothing tormented, demonic, or overstated in this portrait.

The admiration, or rather the adoration, Alexander has long inspired arises mainly from the almost incredible extent and swiftness of his conquests. His domains, wrested largely from the Persians, included most of the Balkan peninsula, Asia Minor, Syria, Egypt, the Tigris-Euphrates Valley, the Iranian plateau, and a section of northwestern India. All this he gained between 336, when at twenty he succeeded to the throne of Macedon, and July 13, 323, when malaria overtook him in Babylon.

But admiration is also aroused by his character: his complexity and range, his quite awesome abilities, his hopes and dreams, his many virtues which

23

seem all the more remarkable combined as they were with his well-known faults. Capable of every human emotion, sometimes given to extremes, Alexander could be at the same time cautious, restrained, and self-controlled. A great general, indeed a military genius, he could outwit any enemy on the battlefield. Then he would retire and read Homer or Aristotle or converse with his companions on deep philosophical problems. His curiosity was boundless; he wanted to understand the world as well as to conquer it. To his contemporaries, to his immediate successors, to many a Roman emperor, to Charlemagne, to Louis XIV, to Napoleon, and to us, he is the ideal warrior and prince. He appeals to all our romantic instincts and is endlessly fascinating.

Portraits, or what are thought to be portraits of Alexander, abound. Yet whether visual or verbal, the records of his appearance are tantalizingly brief and generalized. Ancient writers are never very specific in their descriptions of facial features. Here, for instance, is what Plutarch says in his *Life of Alexander:* "The outward appearance of Alexander is best represented by the statues of him which Lysippos made, and it was by this artist alone that Alexander himself thought it fit that he should be modeled. For those peculiarities which many of his successors and friends afterwards tried to imitate, namely, the poise of the neck, which was bent slightly to the left, and the melting glance of his eyes, this artist has accurately observed." The Priene portrait fills the bill very well, and some scholars have thought that it does resemble Lysippos' work (compare the Apoxyomenos, 80). But we must remember that Plutarch is describing Lysippos' statues, not Alexander himself, and though we may marvel at how closely literary description and portrait statue agree, neither reduces the distance between us and the still-elusive Alexander. For no matter what the date of the portrait, we behold an ideal, not a person; a legend, not a fact. Physical beauty and youth: only these are consistently present in the innumerable works of art believed to represent him.

The statuette was found in a house in the western section of the city of Priene. On the doorpost an inscription (probably cut in the third century) indicates that the house was used as a place of worship. That the house was dedicated exclusively to the ven-

eration of Alexander seems unlikely, for fragments of statues of Greek gods were found in the same location. Nearly all scholars believe the Priene statuette was created sometime late in the fourth century B.C., that is, shortly after Alexander's death. The very generalized rendering of both the physiognomy and the personality accord with that date.

Berlin, Staatliche Museen, inv. 1500. Marble. H. 0.28 m. Found in 1895. Made in three separate pieces: head, torso, and arm. Back of head and body cut away, right side of hair very rough, surface color varied. T. Wiegand and H. Schrader, *Priene*, Berlin, 1904, 180-82. For Alexander in the Louvre and in Istanbul, see M. Bieber, *Alexander the Great in Greek and Roman Art*, figs. 78 and 94 respectively. For Alexander's biography: Arrian, *Anabasis*; J. R. Hamilton, *Alexander the Great*, London, 1973; T. Hölscher, *Ideal und Wirklichkeit in den Bildnissen Alexanders des Grossen, Heidelberg*, 1971; Plutarch, *Life of Alexander*; U. Wilcken, *Alexander the Great*.

3 Alexander the Great

Compared to the portrait of Alexander from Priene (1, 2), which exhibits the repose and serenity associated with a classical style, this head, found at Pergamon, is much more outgoing, expressive, and emotional. The Alexander in the Priene statuette turns his head solemnly to one side, whereas here the turn becomes a wrench. The tense and massive neck pulls against the head and in a kind of tug-of-war underlines the strained relationship that exists between the two. While the wrinkled brow of the first portrait expresses concern and intelligence, the deeper, jagged corrugations of the second depict anxiety, if not real distress. While the eyes of the first gaze unflinchingly ahead, in the second they seem to roll heavenward. Clearly detached from the eyelids, the eyeballs are capable of movement and, one can easily imagine, of filling with tears. There is a world of difference also in the rendering of the mouth. In this example the lips are asymmetrically drawn down at the corners and parted; one can even see the lower edges of the teeth. Breath thus seems to be drawn in and speech is very possible. The animation and nervousness betrayed by the countenance as a whole and by the individual features are restated in the modeling and arrangement of the hair. It climbs again from the center of the forehead and then, in

long shaggy streams, descends rapidly and almost pathetically to either side. Less luxuriant perhaps than in the Priene head, it displays decidedly more intense expressive qualities.

How are we to explain the great difference between these two portraits of the same person? Do they represent different periods of Alexander's life – one perhaps as Lysippos knew him, the youthful king, unperturbed, self-confident, eager, and yet untried; the other, the older disillusioned Alexander, exhausted from war and mutiny, and ill with excessive drinking? Perhaps each portrait commemorated a distinct aspect of Alexander's personality: his moral uprightness, his nobility, his Olympian calm on the one hand, and the transfigured, demonic, and inspired hero on the other. Or is the difference simply formal? Whereas the statuette from Priene was created in a period that still clung to classical ideals, the Pergamon head was probably executed at least a century later, between 200 and 150 B.C. when emotional or "baroque" values were preferred.

When we survey the many sculptured portraits identified as Alexander, they seem to fall into the two general types represented by the Priene and Pergamon examples discussed here. They have been distinguished as "ethical" as opposed to "emotional" by Bernouilli; and, essentially, as the "young" rather than the "mature" Alexander by Bieber. It would be more to the point to designate them as "Classical" versus "Hellenistic." No example of the so-called emotional or mature type can be dated with any real foundation before the second century B.C. It therefore seems evident that for the fourth and third centuries the classical style permeated, indeed determined, all renderings of Alexander. During the High Hellenistic epoch (240-150) new versions of Alexander were created in which, corresponding to other sculpture of the period, dynamic and baroque elements are determinative. Expressive qualities, which are tentative and implicit in the earlier portraits, were further developed and became explicit in the later ones. There is thus continuity between the two general types, but it is not the result of any commitment to the special characteristics of Alexander's physiognomy for these are, after all, not very similar in any of the examples. Nor does it have anything to do with his biography.

The continuity is based rather on an evolutionary principle, fundamental to Greek art, by which one style grows out of an earlier one. After 150 B.C. or so, both types were made concurrently. Late Hellenistic, and Roman artists, too, were free to choose one or the other or, very frequently, to combine them.

Istanbul, Archaeological Museum, no. 1138. Marble. H. 0.42 m. Found 1899 in the ruins of the market building. No restoration. Tip of nose missing. F. Winter, *Altertümer von Pergamon*, VII, 1, 147-149. J.J. Bernouilli, *Die erhaltenen Darstellungen Alexanders des Grossen*. M. Bieber, *Alexander*, 63-64. A new tomb discovered at Vergina in Macedonia has perhaps yielded portraits of both Alexander and his father; see M. Andronikos, *Archaeology* 31, 4, 1978, 33–41.

4 Alexander the Great, Coin Portrait

After taking Asia Minor and Syria from Darius, the king of Persia, Alexander, in 332, proceeded into Egypt. The land offered no resistance; the Persian satrap was powerless, and the native population welcomed a liberator. At the capital, Memphis, Alexander was proclaimed Pharaoh, and journeying north he founded a new city on the delta, Alexandria. Then he undertook a mysterious pilgrimage: with a few followers, he set out west along the coast of Libya and then turned south into the dry, hot desert, where he lost his way. Snakes or birds came miraculously to his assistance and guided him to his destination, the oracular shrine of the god Ammon. Alexander was greeted by the priests and then listened, all alone, to the utterances of the oracle. Emerging from the inner shrine he refused to divulge what had been said, but later he let it be known that he had been told he was the son of Ammon and that he would be given dominion over all the world. He was, in short, a god, and it is in this exalted role, as well as in that of a Great King, that Alexander is shown in the coin here. A diadem similar to the one worn by the kings of Persia surrounds his head; the ram's horns, symbolic of the divinity of Ammon, spring from his temples. The eyes, enlarged and shining, look upward. His features are beautiful, elegant, and sensitive; his hair, with the prominent *anastole,* is electric and alive. Some uncanny breeze sets it, along with the tails of the diadem, in violent motion. This

is no ordinary mortal, even though we are aware that the person represented is profoundly human.

Alexander had long exploited his divine origins. His family claimed mythical descent from Herakles and Zeus, and kinship with Dionysos. At his conception his mother Olympias had portentous dreams, and at his birth one of the largest temples then known burned to the ground. One scholar has said Alexander was the victim of a "religious fever." During his farflung campaigns, he was untiring and diligent in paying his respects to local deities, no matter whose they were. Little by little the holiness accrued to himself. It is not surprising, then, when we learn that in 324 he requested that the Greek cities of the mainland treat him as a god, as did all his other dominions. How much Alexander believed in his own divinity and how much he regarded it as a political necessity can probably never be known. In either case it was his own idea, and it worked a decisive change in the political history of the Greek world. Henceforth the ruler cult became an established institution; all Hellenistic kings profited from it, and the cult was continued and accentuated under the emperors of Rome.

The coin portrait of Alexander, a silver tetradrachm minted by Lysimachos of Thrace, one of his successors, was struck between 286 and 281 at Magnesia. Although highly expressive and calligraphic, the portrait is nevertheless a restrained and classical work of art when contrasted with portraits on coins issued in the second century B.C. In these, pathos and turbulence are coupled with a strongly plastic handling of form, in the manner of the head of Alexander from Pergamon (3).

Boston, Museum of Fine Arts, 36.147. Dia. 32 mm. For coins of Herakles issued by Alexander, and for second-century coins with his portrait, see M. Bieber, *Alexander*, figs. 30, 31-33, 61, 63, 64. H. P. L'Orange *Apotheosis in Ancient Portraiture*, 28-38. P. Jouguet, *Macedonian Imperialism in the Hellenization of the East*, New York, 1928. E. Badian, *Studies in Greek and Roman History*, 197-205. H.W. Parke, *The Oracles of Zeus*, 1967, 223 f. E.T. Newell, *Alexander Hoards*, I-IV, American Numismatic Society, Notes and Monographs, 1921-29, and *The Alexander Coinage of Sicyon* (arr. by S.P. Noe), New York, 1950.

5 Ptolemy I Soter of Egypt (ruled 323-285)

Ptolemy, who was a boyhood friend of Alexander, remained his intimate and faithful companion and trusted general throughout Alexander's entire eastern campaign.

After Alexander's death in Babylon, Ptolemy, along with the other senior officers, sat in council to decide what should be done with the vast empire. Without hesitation, Ptolemy declared his desire to become the satrap (governor) of Egypt. His choice was perspicacious. Because of its stable history, the homogeneity of its population, and its natural borders, Egypt was the easiest part of the empire to govern and control; it also possessed great wealth.

Ptolemy chose Alexandria as his capital. Determined to make it one of the cultural centers of the world, he began to build a great library, the first in the Western world, and a museum, a kind of academy or institute where scholars, scientists, poets, and philosophers could live, work, and discourse. He invited men of learning from all over the world to visit or, he hoped, to settle in Alexandria. He already had one prized possession there which aroused universal interest and envy: the embalmed body of Alexander in a magnificent mausoleum.

But Ptolemy was equally eager to turn his attention and energies in other, more practical directions. To protect his western borders he took possession of Cyrene and neighboring towns, and, with occasional setbacks, secured Palestine and Cyprus. In 304 the island of Rhodes conferred the title of "Soter" (Savior) upon him when he assisted its people against Demetrius of Macedonia. In the same year Ptolemy took his most crucial step and declared himself king of Egypt. With this act he founded the dynasty that held out longer that any other against Rome.

The ideal beauty of Alexander's portraits seemed appropriate to his youth as well as to the comprehensive and idealistic nature of his conceptions. Ptolemy did not have Alexander's dream of world empire, nor did he have his illusions. He was about forty when he went to Egypt, and his objectives were limited; he calculated almost exactly what he could and could not do there. His maturity and his realism, caution, and enormous vitality are all apparent in

this portrait. They inspire confidence rather than devotion. This is a man, not a superman.

Round full forms, suggestive of heavy flesh, are noticeable. The bony structure seems to be buried far below the surface, as if the king were obese, which indeed seems to have been the case. The eyes, which are deeply set and rather small, protrude within the thick rims of the eyelids. The nose, again fleshy but pugnacious, arches vigorously before it tapers down into surprisingly delicate nostrils. The chin, which projects well in front of the mouth, is characteristic of his coin portraits. In its present state, the head is incomplete, and what we have is essentially a mask. The rest of the head was probably filled in with stucco, a practice in Egypt that is attested by other portraits found there (7). In the head as it survives, there is no trace of a diadem. Was it also added in clay?

The date of the head is extremely problematic. The poet Theocritus informs us that Ptolemy II (ruled 285-246) set up statues of his mother and father in a shrine at Alexandria. The statues were of gold and ivory, precious materials formerly reserved for cult images of gods. In our head, the stucco additions and their possible gilding point to a relationship with these chryselephantine figures. In short, the Copenhagen head could be a copy of a mid third-century original. Yet it cannot be, for stylistic reasons, a contemporary copy; the surfaces are too mobile and plastic for the third century. It is more likely a free rendering, executed in the first half of the second century, of the chryselephantine statue.

Copenhagen, Ny Carlsberg Glyptotek, I.N. 2300. Marble. H. 0.25 m. Said to have been found in Fayoum in Egypt. No restorations; holes periodically in surface; chin chipped. Theocritus, *Idylls* XVII 121-125. L'Orange, *Apotheosis*, 39-47. V. Poulsen, *Les portraits grecs*, 57, no. 30. P. M. Fraser, *Ptolemaic Alexandria*, Oxford, 1972. H. Kyrieleis (*Bildnisse der Ptolemäer*, A13, 13–15) places it in the third century but after Ptolemy's death.

6 Ptolemy I Soter and Berenice I, Coin Portrait

As long as Ptolemy remained satrap of Egypt he dutifully put the head of Alexander on his coins. After 304, when he pronounced himself king, he ordered that his own rather belligerent profile, adorned with a diadem, should appear instead. This was a bold step: it was a declaration of independence and a clear assertion of Ptolemy's intention to exploit all the powers of his new title.

His grandson, Ptolemy III (ruled 246-221), had a still bolder idea. As the third Ptolemy to reign in succession, he was justifiably proud of his family background. Thus he imprinted his genealogy on a series of coins – gold octodrachms. On one side were the profiles of his parents (Ptolemy II and Arsinoe II) and, on the other, as illustrated, his grandparents Ptolemy I and Berenice I.

As a work of art, the coin is superb. While the surface of the coin is never ignored, the two busts nevertheless have remarkable volume and monumentality. The diameter of the coin is only 27 mm., yet we seem to behold enormous busts of great corporeality. The modeling, especially in the profile of Ptolemy, is vigorous, with depressions and strong swellings for the eye area, nostrils, cheeks, and jaw. The busts are corpulent, as well as corporeal; the heads rest heavily on the necks. But though the forms are bulky, they are so well adjusted to the size of the field that any sense of crowding or compression is absent.

On the other hand, there are rhythms and repetitions which prevent the two heads from escaping the limits of either frame or surface. Each wavy strand of Ptolemy's hair, his ear, and the delightful and demonstrative curves of the various features, including the popping eyes, repeatedly echo one another. In their lively rhythms they freely confirm the fact that this is an essentially two-dimensional design. Although one head overlaps the other, no distinction is made between them in size or clarity; space and perspective have been disregarded. Together the heads form a circle, reiterated in the border of dots and in the contour of the coin proper.

Ptolemy wears a royal diadem with trailing streamers and a cloak; Berenice also wears a diadem, and a veil. The king's beady eyes, beaked nose, and prominent chin we have seen before, in 5. Berenice, who was first his mistress, then his wife, looks very much like him, especially if we follow the contour of the long nose, pursed mouth, jutting, yet sloping, chin.

So much is made of family resemblance that the portraits on the reverse representing Ptolemy II and Arsinoe are almost replicas of those of Ptolemy I and his wife. Family solidarity and dynastic pride have never been more strongly declared.

But there are, in addition, elements of idealization and heroization in these heads. When either Ptolemy or Berenice appears alone on coins, the portraits are usually more incisive and individual. In this coin the two monarchs are Ptolemies, but they are also gods. While it has been suggested that the popping eyes may indicate some family thyroid condition, they more likely refer to the exceptional wisdom and superhuman vision of the king and queen. The lustrous gold from which the coin is made further enhances their divinity.

Boston, Museum of Fine Arts, 03.979. Frances Bartlett Collection. Obverse illustrated. Dia. 27 mm. Minted in Alexandria. A.B. Brett, *Catalogue of Greek Coins*, 301, no. 2273, pl. 168. On reverse with portraits of Ptolemy II and Arsinoe is engraving: "Theon Adelphon" (brother and sister gods), a very characteristic reference to their close relationship. For coins showing Ptolemy I and Berenice alone, see Richter, *Portraits*, III, figs. 1775 and 1776. Jacobsthal suggested a thyroid condition (see *JHS, 48*, 1928, 242, n. 21). J. L. Tondriau, "Rois lagides comparés ou identifiés à des divinités," *Chronique d'Egypte, 23*, 1948, 127-146. N. Davis and C. M. Kraay, *The Hellenistic Kingdoms, Portrait Coins and History*, Ch. 2.

7 Arsinoe II of Egypt (ruled 275-270)

Soft flesh, impressionistically modeled hair, a rather dreamy gaze, a small mouth, curved and mobile: these are the characteristics that have often been associated with the Hellenistic art of Alexandria. All of them, ultimately derived from the style of Praxiteles, are present in this magnificent portrait of Queen Arsinoe, wife of Ptolemy II Philadelphos. They do not, however, completely conceal her will of iron; the regal poise of the head and the strong chin indicate that this is indeed a formidable woman. Traces of a furrow remain on her hair, suggesting that a diadem of stucco was originally attached to the head. Her queenly status is thus assured.

Arsinoe's marital career casts a clarifying light on the often crucial role played by women in the power politics of the Hellenistic period. The daughter of one of Alexander's successors, Ptolemy I (5), she was married in 299, at the age of fifteen or sixteen, to King Lysimachos of Thrace, in order to restrain the conquests of a third king, Seleukos of Syria. When Lysimachos died in battle in 281, Arsinoe escaped, disguised as a beggar, and soon married Ptolemy Keraunos who promised her the throne of Macedonia and of the whole Seleucid empire. When this scheme failed, she returned to Egypt and persuaded her full brother Ptolemy II, now king, to dispose of his wife and marry her instead. Matrimonial alliances for political purposes were common throughout the Hellenistic period, but for a Greek king to marry his sister was unheard of. It has been explained as an imitation of Egyptian practice, but this has been disputed. Theocritus however, justified it as being comparable to the "sacred marriage" of Zeus to his sister Hera. In fact, this consanguineous marriage worked to secure the succession and to consolidate dynastic power and wealth within Egypt, and it became the pattern frequently followed by later kings and queens in both Egypt and other countries. But Arsinoe was not the pawn of any king. Her brother Ptolemy II admired her profoundly, and with good reason, for because of her Egypt enjoyed its most prosperous and glorious period. Arsinoe seems to have dictated policy, both foreign and domestic. With her prodding and guidance Ptolemy built up his sea power and extended his domains to include nearly all of Syria and the south coast of Asia Minor. But Arsinoe did not stay at home in Alexandria; records show that she traveled about inspecting the defenses of her country. She was also a lover of the arts; because of her, patronage festivals held in Alexandria and elsewhere were lavish and unforgettable spectacles; poets flourished at her court and sang her praises.

Arsinoe died in 270 B.C. Her husband immediately deified her, and very soon she was honored as a goddess, with the title Philadelphos ("brother-loving"), in the whole Aegean area. Her statue was erected at Athens and Olympia, and in every votive temple in Egypt her image stood beside those of the traditional gods. Coins bearing her portrait were issued; streets and cities were named after her; tem-

ples were erected solely to her cult in Alexandria, Memphis, and Samothrace.

Her personal beauty, which is so apparent in this portrait, was one of the many reasons for her renown and certainly contributed to the belief that she was a goddess. Her hair is combed to either side in gentle waves, and it was probably gathered in a chignon (added in stucco) at the back. Even though the head is held high and imperiously, it is tilted slightly to the right, thus increasing our awareness of the charm and femininity of this remarkable woman. For beauty, brains, and power, she almost excelled Cleopatra (15-17). The portrait is an original of about 280-270.

Alexandria, Greco-Roman Museum, inv. 3262. Parian marble. H. 0.24 m. From Alexandria. Gift of Sir J. Antoniades. No restorations; end of nose chipped off. Two holes at top of head suggest that a metal *stephane*, or uraeus, was attached. A. Adriani, *Bull. Soc. Arch. Alex., 32*, 1938, 90 ff., pls. VII-IX. D.B. Thompson, *AJA, 59*, 1955, 199-206. Theocritus, *Idylls* XVII 129-134 (Arsinoe's marriage to her brother) and XV (festival of Arsinoe). G. Macurdy, *Hellenistic Queens*, 111-130. H. Kyrieleis, *Bildnisse der Ptolemäer*, J3, 82–94. D. B. Thompson, *Ptolemaic Oinochoai and Portraits in Faience*, Oxford, 1973, 117–24.

8 Pyrrhus of Epirus (ruled 295-272)

A wreath of oak leaves, interwoven with the writhing strands of hair, suggests that this head is a portrait of a king. The slight turn of the head to the right, the leaping waves of the *anastole*, the parted lips and passionate glance all testify to the fact that the king is envisaged as the reincarnation of Alexander the Great. Unfortunately, no coin portraits come to our aid, but the person most likely to have been represented thus is Pyrrhus, the king of Epirus whose personality and career are movingly described by Plutarch.

Pyrrhus was, in actuality, related by marriage to Alexander, and he claimed descent from Achilles. He modeled himself on both these heroes, but he was no match for either of them. Hungry for power, impulsive, he was in every sense a military man and an extremely skillful one. Even Hannibal rated him highly in this respect, and Plutarch asserts that Pyrrhus was happy only on the battlefield. Music to him was so much nonsense; he studied only military strategy.

It was at Heraclea in Italy in 280 B.C. that the king won his famous "Pyrrhic victory." The Greek city of Tarentum sought his assistance against the Romans, who were pressing ever further south in their irresistible conquest of the whole peninsula. The appeal suited Pyrrhus perfectly. He had nothing better to do at the moment, and his expansionist policies in Greece had been frustrated. Relieving the Tarentines would serve as a convenient excuse for entering Italy with a large army, and then he could swiftly master it. With about twenty-five thousand men and twenty elephants, he sailed for Italy and eventually confronted the Romans at Heraclea. This was the first time the Roman legions had encountered the phalanx battle formation invented by the Macedonians. But, according to Plutarch, "the elephants in the end were indeed what won the battle and did most distress the Romans." (North trans.) Pyrrhus carried the spectacular and confused day, at the heavy cost of four thousand men. Although he soon made his way to within forty miles of the city of Rome, he was unable to follow up his victory or resolve the issue. Preferring action to negotiation, he grasped at an invitation from the Sicilians to defend them against the Carthaginians. This project, too, ended in failure just when success seemed imminent. The king, after being defeated by the Romans at Beneventum, at last returned home in 275. But incurably ambitious and foolhardy as he was, he next invaded Macedonia, then assaulted Sparta. He was finally decapitated in 272 in a street fight in Argos. Pyrrhus' death was accompanied by sighs of relief throughout Greece; he had interfered everywhere and threatened many thrones. Yet his failure in Italy had astounded and dismayed his fellow countrymen. Like him they had not taken the full measure of Roman power and determination. By 265 all the Greek cities in Italy had succumbed.

In Plutarch's account of him, Pyrrhus exhibits a tempestuous character. The same impression seems to be conveyed in the disorded bushy hair of this portrait. Even the wisps of beard brush his cheeks impatiently. We are also told that Pyrrhus was a person of deep feeling and warmth, and that he was adored by his soldiers. These qualities, too, can be detected in his countenance, which is more appre-

hensive and moody than fierce. In Naples there is another portrait identified as Pyrrhus which, like this one, has a thick lower lip. The crown of oak leaves he wears in the Naples portrait was the special emblem of Epirus and refers directly to the crown worn by Zeus, who had a major forest sanctuary at Dodona. Such were Pyrrhus' divine longings.

Copenhagen, Ny Carlsberg Glyptotek, I.N. 578. Marble. H. 0.34 m. Supposed to have been found near Naples or Alban Mountains. Restorations: tip of nose, right eyebrow and surrounding area, middle of upper lip. A Roman copy of the second century A.D. V. Poulsen, *Portraits*, 59, no. 32. H. W. Parke, *The Oracles of Zeus*, Cambridge, Mass., 1967, 144 f. First identified by W. Helbig, *Mélanges d'Archéologie et d'Histoire de Rome*, XIII, 1893, 377 ff. and pl. I. L. Laurenzi (*Ritratti greci*, 125, no. 83) denied it is Pyrrhus. For the Naples head of Pyrrhus see Richter, *Portraits*, III, 258, figs. 1762-63.

9 Attalos I of Pergamon (ruled 241-197)

It is generally believed that this head portrays Attalos, the first ruler of Pergamon to proclaim himself king. Everything about it suggests that Attalos was an energetic and ambitious person, but one, nevertheless, not given to excess. His expression combines toughness with humanity, hardheadedness with understanding. The features are characterized by a certain heaviness and breadth which are particularly apparent in the wide brow and full chin, yet there is nothing formless or flabby here. The swelling flesh and muscle which protrude at the corners of the eyes and on the forehead indicate the thinking and feeling capacities of the man. Yet he is no dreamer.

This series of expressive antitheses arises from the concrete configuration of the head, which holds in balance qualities of repose and movement at one and the same time. Stillness and calm are conveyed by the steadiness of the gaze, the symmetry and firmness of the mouth, and the clean regularity of the facial contour. On the other hand, there is mobility in the surfaces of cheeks, brows, and forehead, and there is a touch of the transient in the shadows accumulating around the eyes and eyelids, and in the slight turn of the head to the left. But activity is most pronounced in the hair, in which thick strands are heaped and tossed one above the other, each one seeming to be a dynamic force in itself.

Indeed the hair is one of the most fascinating aspects of this portrait. It was executed in two separate stages. Rather plain and limp curls lying close to the head originally made up the entire coiffure. Those framing the forehead were scraped down, and a wig, no less, was substituted. In front of the ears, as well as at the edges of the temples, the low-lying strands of the original hair can still be seen. Above and around these we can easily differentiate the tumbling plastic locks of the wig, which form a wreath framing the face. They are anchored to a kingly diadem not visible in our frontal view.

The addition of the wreath of curls transformed the whole head. What must originally have been a relatively sober and restrained portrait became one very much more dramatic and one imbued with reminiscences of the heroic, the divine, and the awe-inspiring qualities of Alexander the Great.

Why and when did the transfiguration take place? Attalos achieved two major triumphs during his reign: he subdued the barbarian Galatians who had been molesting his kingdom as well as many of the neighboring Greek cities, and he expanded the territory of Pergamon well beyond its original modest limits, in spite of protestations and armed resistance from the Seleucid rulers. Because of the first he was regarded as the savior (soter) and champion of the Greeks, and because of the second Pergamon became one of the strongest kingdoms of the Hellenistic period. Only now did Attalos dare to pronounce himself king. He did not, however, go so far as to call himself a god. But his son Eumenes II (reigned 197-159) had no such qualms. The wreath of locks was probably added at his order. The portrait is thought to belong to the period between 210 and 160 B.C.

Berlin, Staatliche Museen, P130. Marble. H. 0.395 m. Found in Pergamon. Greek original. No restorations. Identified as Attalos by F. Winter (*Altertümer von Pergamon*, VII, I, 144 ff., no. 130, figs. 130 a-c, Pls. XXXI-XXXII) though there is no coin type of this ruler. An alternative theory has been proposed that the head represents Seleukos I Nikator of Syria, that it originally had horns, indicating divinity, which were probably removed shortly after or before 262 when Pergamon freed itself

from Seleucid rule. See A. Rumpf, *AM, 78*, 1963, 189-90. R. B. McShane, *Foreign Policy of the Attalids of Pergamon*, Urbana, Illinois, 1964.

10 Antiochos III of Syria (?) ("The Great," ruled 223-187)

This is one of the most striking portraits we shall encounter. It is a keen and penetrating study in which the sitter is revealed as a mixture of strength and weakness. The strength seems to be concentrated in the upper part of the head: in the hard dome of the skull, the muscular ridges of the forehead, the forbidding horizontality of the brows, the high cheekbones, and the prominent bridge of the nose. But then something soft sets in. The flesh around the mouth loosens and the chin recedes. The lips take gentle but sensual undulations. The expression of the whole head suggests that this is a man who is tremendously well-bred, thin-skinned, intelligent, and very self-aware. The diadem is not flat but rolled, and it projects well above the thin, dried fringes and sideburns. The portrait is without pretensions; it merely states the truth, especially the psychological truth, about this one individual. Because of the flat and rather receding hair, the gaunt, grim face, the knitted brows, and the long mouth, this head was once thought to represent Julius Caesar. Now, primarily because of its similarity to coin portraits, it is generally accepted as a portrait of the Seleucid monarch Antiochos III. Nevertheless, it seems to contain some of the grimness and realism of first-century portraits. We must then view with circumspection the opinion that the head was executed between 200 and 150 B.C.

Of the three kingdoms into which Alexander's empire was divided, the Seleucid was by far the largest. It stretched from the Mediterranean to India. Vast, unwieldy, with an extremely heterogeneous population, it was doomed to be the most unstable. Within a short time after its founding by Seleukos I, the empire began to shrink and disintegrate as one part after another fell away. By the time Antiochos III came to the throne, Seleucid territories were not much more than half what they had originally been.

This Antiochos would not tolerate. He was determined to reconquer the lost provinces, and even to expand. Advancing eastward, he reclaimed Parthia and Bactria as vassal kingdoms, and he even rattled his sword in India and Arabia. His military success startled the world. Here was a new conquering Alexander, and he too became known as "the Great."

His attention then turned westward, and there the trouble began. He allied himself with Philip V of Macedon, and together they set out to swallow up Greece, the Ptolemaic kingdom, Asia Minor, and many of the Aegean islands. Everyone became alarmed, especially Pergamon, which was situated, so to speak, on Antiochos' doorstep. Attalos I (9) then made a momentous decision: to ask Rome for help. Pyrrhus (8) had confronted the Romans earlier, but on Italian soil. Now for the first time the mighty Romans sailed east, and on Greek soil in 197 Philip, and then in 190 Antiochos, were overwhelmingly defeated. Both were left with far less than their original territories. The direct influence of Rome on the Hellenistic world had thus begun.

Paris, Louvre, Ma 1204. Marble. H. 0.35 m. Found in Italy; acquired by Napoleon. The end of the nose is restored as are parts of the ears and the left end of the diadem. The base of the neck is rounded for insertion into a statue. Copy or original? Perhaps copy of equestrian statue by Meidias set up at Delphi as we know from inscription. On this question and for portrait coins of Antiochos see Richter, *Portraits*, III, 270-71, figs. 1875-77. E. Badian, *Studies in Greek and Roman History*, 112-40. G. Dickins identified head as Agathocles of Bactria (*JHS, 34*, 1914, 308, fig. 11). To be noted also is the direct influence of Hellenistic art on Roman art during Rome's hegemony in Greece and Asia Minor. See C. C. Vermeule, *Roman Imperial Art in Greece and Asia Minor*, Cambridge, Mass., 1968.

11 Perseus of Macedon (ruled 178-168), Coin Portrait

There is no known sculptured portrait of Perseus, the last King of Macedon. But splendid renditions of this dauntless monarch appear on his coins, where he sometimes resembles Alexander the Great and sometimes his father, Philip V.

Roman armies had first entered Greece at the invitation of the Greeks themselves. Only Rome, it was argued, could secure the balance of power, curtail the ambitious strivings of Hellenistic monarchs,

and protect the small, independent city-states. But after the defeat of Philip V and Antiochos III, the Greeks realized that the tables had turned. The real threat was no longer from their immediate neighbors. It was from Rome. They now watched with apprehension any move from the west. They could be roused to passionate fits of anti-Roman feeling, and they were always ready to rally behind any leader who could defend their liberty and independence against this new menace. Perseus seemed to be such a man. The Romans had also been watching him as he built up his army and sought allies, and they feared him. In the beginning they were lenient: they tried to sign a mutual nonaggression pact; then they tried to talk him into submission. At last, and with apparent reluctance, the Roman consul, Aemilius Paullus, landed his troops in Greece and inflicted total defeat on Perseus in 168 at Pydna (157). The Greek army was completely routed, its commander was taken captive to Rome, and Macedon was occupied. The battle of Pydna was the deathblow to the kingdom that had numbered among its kings the greatest of them all, Alexander.

Perhaps Perseus was foolhardy. Perhaps he believed too strongly that the mythical hero after whom he was named would save him. Obviously he underestimated Rome's power and determination. Yet we admire the pride and courage that are revealed in his actions as well as in this coin portrait. The head stands out from the background: the hair is almost as wild and squirming as Alexander's; and also like Alexander's, curls radiate from the crown. Perseus' father, whom he respected and whose policies he continued, had also worn a beard. In an unusual manner one streamer of the diadem flutters over to lie at the side of the neck. The ferocity of the expression, perhaps even its desperation, bring us close to the man who tried honorably to preserve the freedom of his country, which, despite his efforts, became a Roman province in 148.

London, British Museum, B/1841/929. Tetradrachm, Dia. 33 mm. Minted in Pella 178-168 B.C. On Perseus, C. F. Edson, *HSCP* 46 (1935), 191-202. F. W. Walbank, *Philip V of Macedon*, Cambridge, England, 1940. For a possible sculptured portrait: *JdI*, 82, 1967, 157–166.

12 Euthydemos I of Bactria (ruled 230-200), Coin Portrait

13 Mithridates III of Parthia (ruled 57-54), Coin Portrait

For a little over half a century after Alexander's death, the eastern territories of his empire adhered to the Seleucid kingdom and remained loyal, though halfheartedly. Around 250 B.C., however, Bactria and Parthia broke loose and declared their virtual autonomy. It was then that Alexander's initial policies and those of the succeeding Seleucid kings bore fruit. The cities they had founded and the Greeks they had brought in to populate them had thrived and multiplied. In spite of their remoteness from the homeland and the preponderance of Orientals who surrounded them and mingled with them, they had kept a good deal of their racial identity and vitality. Although insisting on their independence, neither the kings of Bactria nor those of Parthia desired to cut themselves off from the West and their Hellenic roots. At the same time they looked east, and through their kingdoms passed Indian, Mongolian, and even Chinese goods. Alexander's dream of establishing Greek cultural supremacy throughout the East seemed to have come true.

Euthydemos and his son Demetrius brought Parthia to the height of its power and prosperity. The competence and toughness of this dynasty are epitomized in the features of Euthydemos in this coin portrait. Thick-set, pugnacious, he is represented toward the end of his reign, an elderly man with sagging jowls and toothless mouth. The frankness and objectivity of the portrait are extraordinary. The type of coin and portrait are thoroughly Greek, and, as propaganda, they declare Euthydemos' intention to be regarded as a legitimate Hellenistic monarch. In addition, the high artistic quality of the coin demonstrates that Euthydemos attracted Greek artists, and first-rate artists at that, to his capital. A sculptured bust in Rome has been recognized as representing the same king because of its close resemblance to this coin series.

Euthydemos was a Greek from Asia Minor. Mith-

ridates III of Parthia was not fully Greek, but he and other members of his dynasty were staunch Philhellenes and mimicked the manners and culture of their neighbors to the west. Occasionally, however, Parthian coins assume an Oriental aspect, such as in this coin of Mithridates. Thus, while the portrait of Euthydemos, like those of Alexander, includes only the head to the base of the neck, the image of Mithridates includes the upper chest and shoulders. The Parthian coin also shows a new ornamental enrichment – the dot-studded tunic, the star on the chest, and the parallel series of small strokes for the hair – that is not found in other Greek coins of this period. The diadem, which lies horizontally below the hairline like a metallic crown, is again a new element. But the border of pearled dots and the plastic modeling of the features make it perfectly clear that a Greek artist must have cut the design.

For a long time our knowledge of Parthia and Bactria during the Hellenistic period was hazy and meagre because literary and archaeological evidence was incomplete or nonexistent. In 1967, however, a Bactarian city discovered at Aï Khanoum (Afghanistan) yielded important new information, notably about the area's archicture, sculpture, and pottery, which were modeled directly after Greek prototypes. But the coin series remain particularly valuable because they show to what extent and for how long Hellenistic culture penetrated the East. Bactria was conquered by Scythian tribes about 130 B.C., and Greek coins ceased to be issued. Parthia, with great difficulty, remained an independent state long after Rome had established her hegemony in the Near East. But her coins gradually lost all their Hellenic character.

12. Euthydemos coin: Boston, Museum of Fine Arts, 35.156, anonymous gift in memory of Zoë Wilbur. Dia. 30 mm. Tetradrachm minted in Bactria.
13. Mithridates coin: Boston, Museum of Fine Arts, 30.449, anonymous gift in memory of Zoë Wilbur. Dia. 29 mm. Tetradrachm minted in Seleukei-on-the-Tigris, Babylonia. W. W. Tarn, *The Greeks in Bactria and India*. E. T. Newell, *Royal Greek Portrait Coins*, 66 ff., figs. 3-4. For sculptured head of Euthydemos, M. Bieber, *The Sculpture of the Hellenistic Age*, 86, fig. 310. Aï Khanoum: D. Schlumberger, *L'Orient Hellénisé, L'Art Grec et ses Heritiers Dans L'Asie Non Mediterraneénne*, Paris, 1970, 26–32; M. A. Colledge, *Parthian Art*, London, 1977, *passim*.

14 Mithridates VI of Pontus ("Eupator," ruled 120-63 B.C.), Coin Portrait

The beauty of this face is remarkable, the nobility and the openness of the expression beguiling, the hair, nearly concealing the diadem, floats halo-like around the face as if under water. The portrait and the person appear exceedingly romantic, even Pre-Raphaelite. But this is a disguise. Earlier coin portraits of Mithridates show a nervous, older face, with sensual lips and worried, cruel eyes.

As early as 301 B.C. Pontus became an independent state when the Persian satrap there made his declaration of independence. For eighty years it remained a small but strong kingdom ruled by a family proud of its Persian descent, but maintaining nonetheless a veneer of Greek culture. In 120 a new young king, Mithridates VI, inherited the throne, and the civilized world soon realized that the kingdom of Pontus was bent on an expansionist policy of no ordinary kind. To the Greeks of Asia Minor and the Continent, Mithridates was another hero and savior, much needed after the overthrow of Perseus (11) and Antiochos (10) to rid them of the oppressive domination of Rome. By treaties, bribes alliances, battles, and murders, Mithridates was soon in possession of almost all of Asia and Greece. City after city, kingdom after kingdom, joined his cause. Alexander's empire seemed about to be revived. The Romans had never been so angry or so fearful. Neither Perseus nor Antiochos had been as formidable, nor had they succeeded in recruiting so many Greeks against the Romans. It took three of Rome's ablest generals several years to triumph over Mithridates. In 86, Sulla expelled him from Greece. Lucullus, and finally Pompey in 63, deprived him of all his Asian territories. With all hope gone, Mithridates committed suicide.

The coin shown here was minted in Pontus in 75-74 B.C. when Mithridates was fifty-seven years old and on the eve of one more campaign to rid Asia of the Romans. But this representation of him removes all trace of age or strain. No hint that he could be bloodthirsty is betrayed by that sweet smile. He

appears as another Alexander: young, beautiful, and a demigod.

One or two sculptured portraits of Mithridates have been tentatively identified.

Boston, Museum of Fine Arts, 01.5517. C. P. Perkins Fund. Tetradrachm, Dia. 33 mm. For earlier coins see A. B. Brett, *Catalogue*, pl. 69; nos. 1355, 1356. For sculptured portraits see Richter, *Portraits*, III, p. 275, figs. 1930-33. *CAH*, IX, chs. V, VIII.

15-17 Cleopatra VII of Egypt (ruled 51-30 B.C.)

This beautiful head (16, 17) may represent Cleopatra, the last queen of Egypt, for several features correspond to coins from Alexandria that carry her portrait (15). The melon coiffure, the prominence and curve of her nose, the rapid recession of her cheeks, and the mouth which retreats into the cheeks like an archaic smile are visible in both. Even the hint of the Oriental which we see in the features of the British Museum portrait is not surprising, for although Cleopatra was mainly Greek she did have a touch of Iranian blood. But whereas in the coin the hair is bound by a flat royal diadem, no diadem appears in the sculptured portrait. For this reason the identification as Cleopatra has been seriously questioned and even discarded. The absence of the diadem is indeed a stumbling-block, but it is not absolutely conclusive.

For all its individuality, the head has a classical simplicity and an emphasis on design for its own sake that is characteristic of many works of this period of the first century B.C. (see above, page 22). Flaring eyebrows, eyelids, and nostrils repeat one another's linear rhythm, and the size and shape of the mouth are echoed in the treatment of the eyes. Every feature is in harmony with the oval contour of the whole head. The elaborate arrangement of the coiffure is another instance of the artist's preoccupation with ornament. The hair moves back from the forehead in melon segments within which individual strands are impressed. Then an enormous braided plait is laid in a loop against the back of the head, seeming to crown it like a diadem after all. Yet the coiffure is not completely formal and artificial; corkscrew locks stray to the sides of the neck and cheeks, and very fine wisps depart from the melon segments to caress the temples. The *pièce de résistance* must have been the earrings, which surely were exquisite and delicate. For a possible example of these, see Color Plate I.

The elegance of the face and the intelligence of the countenance make us reluctant to reject this as the portrait of the Egyptian queen. Beautiful in a special way, highly educated and cultured, she was charming, volatile, proud, cunning, and fearless. She thought of herself as monarch first and as woman second, though she would not hesitate to use feminine wiles to attain her ends. While her love affairs with Caesar and with Antony, two of the most powerful Romans of the period, have stirred the poetic imagination ever since, they were not mere romances; the fate of Egypt and the stability of the whole Mediterranean world were involved. Her own people adored her; the Roman people hated her. She did not commit suicide because her heart was broken by the death of Antony, but because her dynastic ambitions had been thwarted, and all hope for the independent survival of her country had vanished. Egypt was the last of the Hellenistic kingdoms to be conquered by Rome.

Spectacle and pageantry delighted Cleopatra; she loved to adorn herself. When she was twenty-nine years old, Antony ordered her to sail to Cilicia and appear before him to answer the charge of aiding his enemies Cassius and Brutus. The breathtaking scene which he beheld on her arrival disarmed him completely:

The barge she sat in, like a burnish'd throne,
Burn'd on the water; the poop was beaten gold;
Purple the sails, and so perfumed, that
The winds were love-sick with them; the oars were silver,
Which to the tune of flutes kept stroke, and made
The water which they beat to follow faster,
As amorous of their strokes. For her own person,
It beggar'd all description: she did lie
In her pavilion, cloth-of-gold of tissue,
O'er-picturing that Venus where we see
The fancy outward nature; on each side her
Stood pretty dimpled boys, like smiling Cupids...

SHAKESPEARE, *Ant. and Cleop.* Act 2, Sc. 2

On that occasion, Cleopatra appeared as Aphrodite attended by her Erotes, or cupids. At other times she donned the robes of the goddess Isis, or of Hathor, or Selene. These were not simply pranks or costume parties; they were the visual manifestation of her own and her people's belief in her divinity.

15. Coin: Boston, Museum of Fine Arts, no. 34.1400, anonymous gift in memory of Zoë Wilbur. Bronze. Dia. 26 mm. Undated issue.

16-17. London, British Museum, No. 1873. Fine limestone. H. 0.27 m. Greek original. About 40 B.C. Findplace unknown. Another possible sculptured portrait of Cleopatra: M. Bieber, *Sculpture*, fig. 366. H. P. L'Orange, *RM, 44,* 1929, 171. G. Macurdy, *Hellenistic Queens,* 183-223.

18 So-called Mausolos and Artemisia

During the British archaeological campaigns of 1856–57 at Halicarnassos, C. T. Newton found these large-scale statues of a male and a female. They were discovered along with other sculptured fragments outside the north wall of a tomb that was famous in antiquity, that of Mausolos, satrap of the Persian province of Caria in the years 377 to 353. According to Pliny, the tomb was erected shortly after his death in 353 by his wife Artemisia, who died in 351. It was of tremendous size and was one of the Seven Wonders of the World. The tomb consisted of a pyramid supported by columns; surmounting the pyramid was a chariot drawn by four horses. British scholars immediately concluded that the male and female statues had fallen from the chariot and that they represented the occupants of the tomb. Doubt soon arose, however, about the original location of the figures. Pliny did not mention them, and some scholars considered the stance of the figures unsuitable for holding reins. Perhaps, they argued, the statues were situated in the cella or within the colonnade. However, no one questioned either their identity or that they were made early in the second half of the fourth century or perhaps a little later (Buschor). Then, in 1960, Rhys Carpenter, having decided "there is no compelling reason to identify them as Mausolos and Artemisia," dated them both in the second

century B.C. on the grounds of sculptural style. He placed the male figure near the middle of the century and the Artemisia, he declared, "also belongs to the Hellenistic period but is stylistically of somewhat later date."

In several respects, Carpenter's views remain persuasive: the generally "plastic" quality of both the head and body of "Mausolos," which, he pointed out, does not seem to be prevalent in the fourth century. The pose, in which the right shoulder advances ahead of the other and then, in opposition, the left thigh pushes forward while the other retires, is again too complex and too full of tension for the fourth century. The sheer accumulation of drapery, its weight and mass, and the way in which it tends to act as an impediment to free movement is perhaps the most outstanding characteristic of the entire statue, and one doubts that a convincing analogy from the fourth century in either vase painting or sculpture, whether from Asia Minor or Greece proper, can be cited. For the pose, drapery, and indeed the whole feeling of this draped figure we might compare the sculptured example in our 124. As for the head, the individuality of the features and the specificity of the expression leave little doubt that the representation of a particular person was intended. "Artemisia" can profitably be compared and contrasted with Themis from Rhamus (111), a figure which can be dated to about 300 B.C. In "Artemisia" all surfaces are in greater flux, and the total concept is less linear. The arrangement of the hair, in an aureole of tiny, shell-like ringlets, is an archaistic element more characteristic of the late Hellenistic period than of the fourth century.

In very recent years the round sculptures of the Mausoleum have been restudied by B. Ashmole and G. Waywell. Waywell has been particularly astute and energetic in seeking detailed stylistic parallels. For instance the type of sandal worn by "Mausolos" is not, he argues, of Hellenistic but of fourth-century date. Ashmole insists that the drapery of "Mausolos" reflects contemporary fourth-century fashions and that the arrangement can be seen on grave reliefs and votive reliefs of that period. If it is more voluminous, he asserts, this is because of the scale and monumental character of the statue. Waywell believes that the realism of the head, rarely if at all to be found in sculpture of Greece proper during the fourth cen-

tury, simply illustrates an Ionian-Persian propensity toward portraiture which was already evident in satrap coinages of the early fourth century. He would view "Mausolos" as heralding a new development in monumental Greek art, and as initiating what will become a strong interest in the art of portraiture in the Greek world as a whole during the Hellenistic age.

In the long run the debate could be said to revolve primarily around matters of sculptural style, and these can be very controversial. If the male figure was not made in the fourth century, and if it does not represent Mausolos who else could it be? Waywell suggests that while it may not depict Mausolos it nevertheless portrays a member of his distinguished fourth-century family. Carpenter proposed that it represented some ruler of Caria, which had been restored to independence by Rome in 165. This remains a possibility. A date after 129 is unlikely for either statue because Caria at that time was made part of the Roman province of Asia. Do the two figures belong together at all? The male strides, the female stands; there seems to be no rhythmical connection between them. Excavations of the tomb and its temenos have been continuing under K. Jeppesen but decisive archaeological support for the dating of the round sculptures appears as yet to be lacking. Thus we should be wary of drawing final conclusions.

London, British Museum, Mausolos, 1000, Artemisia 1001. Both of marble. Height of Mausolos: 2.99m; Artemisia 2.91m. Much of the hair on the left of Mausolos' head is restored and has been removed. C. T. Newton, *A History of Discoveries at Halicarnassus, Cnidos and Branchidae*, London 1862,II, 214. Pliny, *Natural History* XXXVI. iv. 30-32. E. Buschor, *Maussolos und Alexander*, Munich, 1950. Richter, *Portraits*, II, 161f. R. Carpenter, *Greek Sculpture*, 214–16. C. M. Havelock, *Studies Presented to George M. A. Hanfmann*, Cambridge, Mass. 1971, 55–64. B. Ashmole, *Festschrift für Frank Brommer*, Mainz, 1977, 13–20. G. Waywell, *The Free-Standing Sculptures of the Mausoleum of Halicarnassos in the British Museum*, London, 1978. K. Jeppesen and J. Zahle, *AJA*, 79, 1975, 67–79. K Jeppesen. *IstMitt.* 27–28, 1977–78, 169–211.

19 "Hellenistic Ruler," Demetrius I Soter of Syria (?) (reigned 162-150)

Few works of Greek art assault the spectator. The reticence that pervades all sculpture of the classical period still permeates much of the art of the Hellenistic age. This bronze portrait statue is an outstanding exception. Towering and glowering, the figure refuses to leave us alone; it aggressively declares its overpowering supremacy.

The head is small; the body, in contrast, seems almost gigantic; and yet there is no real disproportion. The pose has some of the logic of a classical statue: the leg that bears the weight is counterbalanced by the arm that is raised to hold the lance; the relaxed leg is opposed to the arm at rest. But the figure is not internally balanced, or still. Though he leans in part on the lance he is restless, and there is no limb or muscle without tension. Although the torso itself does not twist away from the spectator, foreshortened contours and movement into depth are introduced in the arms. The anatomy is neat and precise, even patterned; we know the relationship of each part. But the structure shouts at us, und maybe it is too clearly stated. The face and hair have the same energy – we imagine a ruddy complexion, leathery skin, and high blood pressure. Forehead, cheeks, and the tendons of the neck swell and are close to bursting. The beard and moustache are rendered by vigorous, curving scratches. He is speaking, but what he is saying is not likely to be pleasant.

The statue was found in Rome in 1884. The difficulty has been to decide if it represented a Greek or a Roman, and then which Greek or which Roman. In 1914 it was suggested that it might represent Demetrius I of Syria, whose coin portraits show the same thick neck, short, fleshy face, and hawk's nose.

Although this identification has found general acceptance, it has not discouraged alternative proposals. Phyllis Williams expressed the intriguing view that the prince had a twin and that the two stood on either side of the famous bronze Seated Boxer (101) of the first century B.C., the group of three representing the mythical Kastor, Amytos, and Pollux. Carpenter went one step further and argued that the group was allegorical and that its true meaning involved the Roman victory over Mithridates VI of Pontus (14). The prince was then not a Greek but the Roman Sulla, and his twin was Lucullus.

No diadem ornaments the hair of the prince, and this is one reason for skepticism in regard to identifying him as the king of Syria. The stylized musculature and his heroic and outgoing energy suggest that the figure originated while the baroque style was still vigorous. Regardless of who is represented, the characterization has a completeness that is typically Greek. The portrait involves the whole man, and the body as much as the head conveys the traits of his personality. Perhaps about 150 B.C.

Rome, Museo Nazionale delle Terme, No. 1049. Bronze. Dark green with brown patches. H. 2.33 m. Found in Baths of Constantine. Restored: plinth, lance, and a few details. Pupils of colored glass or paste must have been inset originally. P. Williams, *AJA, 49*, 1945, 330-47. R. Carpenter, *AJA, 49*, 1945, 353-57. B. M. Felletti Maj, *I ritratti*, no. 35. O. Vessberg, *Studien zur Kunstgeschichte der Römischen Republik*, 171. Perhaps early third century according to M. Robertson, *History of Greek Art*, 520.

20 Bronze Head from Delos

Mithridates VI of Pontus (14) sacked Delos in 88 and again in 69 B.C. for siding with Rome. The island, which through the second century had been a busy and prosperous free port, now went into a decline from which it never fully recovered. This portrait, which was found in the old palaestra, was surely made before these disasters. Since Delos had large settlements of Italians and Orientals as well as Greeks, the ethnic origin of the person represented has been debated. Current opinion is in favor of identifying him as a Greek, but whether he was athlete, general, or prince has not been determined.

As a result of these catastrophes, extraordinarily few bronzes have been unearthed at Delos. We are therefore fortunate to have this life-size head from a site where bronze workers enjoyed a high reputation in antiquity – and with good reason, judging from this supreme masterpiece, which by some miracle has hardly been damaged. Technically it is extremely fine. The walls are very thin and smooth, and after the casting the artist has used a burin to engrave details: to divide the locks more emphatically and to indicate the short bristles of the eyebrows. This delicate work is indeed crucial for the total effect; the eyes, which had

been left empty, were inlaid with ivory-colored paste holding irises of black marble which in turn contain a cavity for the now-missing pupils. The humanity of this head was complete.

There is something pathetic and melancholy but intensely alive about this portrait. The poise of the head, which is tilted up and to the side, owes a great deal to the portraits of Alexander the Great (3). However, we notice the bull-like power of this neck. Head and neck are not decisively separated as volumes, yet they strain against each other. All the surfaces seem as soft as the clay from which they were originally modeled, and each reacts, with innumerable variations, to light. As a consequence, there is little to be learned by following contour. Indeed, the surface is all-important here; it continuously undulates in response to the protuberance of bone, drooping of flesh, or tensing of muscle. The wobbly bars of the forehead, the jowls which both hang and bulge, the minute fluctuations in the lower areas of the cheeks illustrate not only the superb craftsmanship but also the powers of observation of this artist working near the end of the second century B.C.

Athens, National Museum, no. 14.612. Bronze. Very dark green patina. H. 0.325 m. Found in 1912 by French archaeologists. Has been attributed to Agasias of Ephesos (see 98). G. Kleiner, *MJb, 1*, 1950, 9 ff. G. Krahmer, *GöttNachr*, I, 1934, 217 ff. C. Picard, *MonPiot, 24*, 1950, 83-100.

21 Male Head with Diadem

The creamy-smooth surface of the flesh, the frank presentation of the features, and in contrast, the sketchy and seemingly artificial luxuriance of the hair have led some scholars to call this head Roman and to date it as late as the second century A.D. The majority, however, see the head as Greek, but the dating has ranged all the way from the early third to the first century B.C. The rather grim expression and the lean and bony face have been related to the portrait of Antiochos III (10). At one time the subject was thought to be King Cotys of Thrace, of Augustan date. On the whole, the portrait is grouped most readily with some Athenian portraits of the first half of the first century B.C.

in which the realism of late Republican sculpture of Rome can be felt to some degree.

The head is not posed frontally but is turned very slightly to the left. The lips are almost imperceptibly parted. The hair, which is deeply undercut around the forehead, drops in disorderly ringlets from under the diadem; light and shadow form lively and strong contrasts as the strands pile up and turn. All these elements call to mind the "baroque" aspects of the Hellenistic style. They seem, especially the rendering of the hair, somewhat incongruous with the emaciated older man who is portrayed. His face is long, with pronounced jaws, small eyes, distended nostrils, and long narrow lips. The chin is supported, as it were, in a hammock of creases which is suspended from the two cheekbones. The thin flesh wrinkles and folds on both face and neck, and it lies directly over the bony structure, which is felt everywhere. To a few authorities, the distinction made between skin and bone is certain evidence of the Greek rather than Roman origin of the portrait.

The leaves of the diadem have been tentatively identified as olive. The diadem, unfortunately, does not help us determine whether the subject was king, priest, or poet.

Athens, National Museum, no 351. Pentelic marble. H. 0.30 m. Found in Athens in 1837. No restorations. Tip of nose and some ringlets of hair missing. Drill marks visible in hair. G. Häfner, *Späthellenistische Bildnisplastik*, 104 f. J. W. Crowfoot, *JHS*, *17*, 1897, 321-26. H. Riemann, *Kerameikos*, II, Berlin, 1940, 56.

22 Unknown Man from Smyrna

The head was originally inserted into a full-length body; the "collar" at the base of the neck makes it clear that the figure was draped. The head is not carved in the round; it has been broken off from a relief. A veiled female head, similar in style, scale, and mood, was found with it. They came from the same monument, probably a grave monument, where they stood side by side within an aedicula, as man and wife.

The male portrait shown here is an interesting mixture of earlier styles. The strong divergence between the axes of head and neck, which is charac-

teristic of the High Hellenistic period (3) and which still retained some dramatic force in the late second century (20), has now become a formula from which the dynamics have been drained. The head does not vigorously strain against the neck, nor does one lean on the other, but the two are set into a mannered, self-conscious pose in which the long oval volume of the face is nicely tilted on an elongated, shapely neck. Organically and expressively the results tend to be weak. The facial expression is passive rather than passionate, spiritless rather than sad; we are reminded of the art of Praxiteles rather than that of Pergamon. The modeling as well as the mood is reminiscent of Praxiteles and stops short of clear definition. The eyebrows, lower lids, and mouth are without edges and merge with the surrounding areas. The clear delineation of the upper eyelids and the crow's feet nevertheless betray the linear preoccupations of the period. The lips have pronounced curves and they form a faint smile of almost excessive sweetness. The hair, which is sketchily rendered and which shows traces of the drill, seems wet and lifeless. Three pointed strands cunningly distribute themselves in inconspicuous symmetry over the forehead.

The sentiment and the indistinctness that appear to have been imposed upon the portrait prevent any strong revelation of character. Yet the charm and appeal of the head are undeniable. It was probably sculptured during the first half of the first century B.C.

Athens, National Museum, no. 362. Parian marble. H. 0.415 m. No restoration. Tips of nose and chin missing. There are five holes on right side to hold metal pins; the head must have been wreathed. For head of wife see L. Laurenzi, *Ritratti*, 127, no. 90. G. Häfner, *Späthellenistische Bildnisplastik*, pl. 12.

23, 24 Head of a Priest

The expression on this face may be depressing, but it is unforgettable. The head's long shape, the thick strips of the eyelids, the deep folds descending from the nose and mouth, the drawn, pouting lips, and the diagonal creases at the ear make us acutely aware of how mass and flesh react to both age and gravity. Line, whether it is engraved or whether it results from the sudden convergence

of two planes, is the primary formal element in this portrait. It betrays the age of the sitter and depicts his character; it both establishes and relieves the symmetry, and by moving away from the spectator it allows him to apprehend the depth of the whole head. The three engraved lines in the forehead, for example, function in both frontal and profile views to carry our eye from the surface into depth. The sculptor has observed his model carefully, and he has not taken many pains to disguise his subject's lack of beauty. Yet he has made a work of art. The forehead creases stray from their course, yet they are too willing to return to it and too neatly spaced to be considered merely realistic. The diadem plays its artistic role by restating, more strongly, the direction of the forehead lines.

It would be difficult to say what thoughts are running through this head. The expressiveness is achieved by the hardness and power of the delineation rather than by an overt portrayal of emotion. He looks straight out; he refuses, though he could, to speak; he will not sigh. This is the most matter-of-fact portrait we have so far seen and the only one where the external physiognomy of the individual, rather than his status or social role, has been of overriding importance. The diadem, which is rolled, is believed to indicate that the man is a priest. His shaven head, which is only roughly finished with a rasp, could mean that he was a priest of Isis. But we hardly concern ourselves with his social function, so fascinated are we by that intricate array of lines, bones, veins, and fat that denote his humanity and nothing more.

E. Harrison has shown how the agora priest resembles certain Roman Republican portraits of around 70 B.C. that were carved in a "wood-cut" style. But although our head is Romanizing, it is nevertheless one of the last portraits to come from Greece that we can still call Greek in style and conception. It was made about the middle of the first century B.C.

Athens, Agora Museum, Inv. 5333. Pentelic marble. H. 0.29 m. Found in the agora in 1933 by American excavators. No restoration. Nose broken off, ears chipped, and other minor abrasions. E. Harrison, *The Athenian Agora*, I, *Portrait Sculpture*, Princeton, 1953, 12 f., pl. 3.

25 Demosthenes (lived c. 384-322)

There are about fifty extant portraits of Demosthenes, all presumably going back to one lost Greek original. A bronze bust found in Herculaneum in 1753 and now in Naples is inscribed with Demosthenes' name and has led to the identification of the other replicas. Two are full-length statues: the one shown here, now in Copenhagen, the other in the Vatican Museum.

Demosthenes is portrayed as a man of fifty or sixty years of age, pausing momentarily, no doubt for effect, in the middle of an oration. Wearing sandals, standing with his right leg advanced and his fingers interlaced, his body is wrapped in a mantle which is rolled above the waist, crosses his back, and comes over his left shoulder to conclude in a bundle of long, hanging folds. His chest is rather sunken, his shoulders and arms thin and bony. Hair, moustache, and beard tend to be short and closely cropped. His features express intense mental activity and inner concentration. Between the horizontal eyebrows, which impinge upon the upper eyelids, there are deep creases.

In Krahmer's pioneering study of Hellenistic composition this statue was cited as illustrating the "centripetal" form characteristic of the early third century. Closed and compact, the figure withdraws physically but by no means psychologically. His arms are pressed to his sides, the drapery weighs down and against him, and it is almost too heavy for his frail body. Lines move slowly; harshness, angularity, and strain permeate the whole.

Demosthenes was no mere speechmaker. Born in Attica, he lived in Athens all his life except for one brief period of exile. He played a crucial role in the events that occupied the Greeks around the middle of the fourth century: the rise of Macedon and the conquests of Alexander the Great. Demosthenes dreaded the possibility that Athens might lose its independence and used his oratorical gifts to rouse the city against Macedon. Any rapprochement with Alexander's father or Alexander himself therefore seemed to him threatening and dishonorable. He is one of the great patriots of all time — with the zeal, conviction, and limitations that go

along with this role. Athens revered him as a statesman and sent him on important ambassadorial missions. He was not, however, without enemies, and on more than one occasion his trenchant prose was required in self-defense. His speeches, delivered in the Athenian law courts or the Assembly, were hard-hitting, sometimes abusive, but always models of style and organization. We can realize how critical his speeches must have been when we remember that he spoke at a time when there were no newspapers and when the entire population of a city could assemble and listen to a speaker. Whether he quelled or aroused the citizens' passions, the results were bound to be serious. In the end, however, his appeal was always to reason, and he achieved his effects by persuasion, not by histrionics or wild gesticulations; it is probably significant, therefore, that in the statue his arms are held close to his body. The well-known story that Demosthenes overcame a speech impediment by practicing with pebbles in his mouth is probably spurious. On the other hand, the evidence seems clear that with determination and training he did overcome voice difficulties.

Plutarch mentions that a statue of Demosthenes was erected in the agora at Athens forty-two years after his death (280 B.C.). The sculptor Polyeuktos, he continues, made the statue of bronze showing Demosthenes with his fingers interlaced. In all likelihood, then, our statue bears some relationship to this original.

But the problem remains how much. The stance of the figure and the arrangement of the drapery may have been taken from the early third-century original. However, the intensity and directness of the facial expression and the realistic rendering of the bony chest and arms are not in keeping with third-century sculpture as we presently know it from originals. There is therefore a strong possibility that although in general the statue may reflect Polyeuktos' style, the copyist, working in the first century B.C., "modernized" head, chest, and arms to the extent that they betray the major hallmarks of the period in which he worked. There is another possibility: the head could be an entirely new creation, having nothing to do with Polyeuktos, of the first half of the first century.

The portrait of Poseidonios (32) provides, in style and expression, an appropriate parallel. The Romans, who held the art of rhetoric in high esteem, considered Demosthenes the supreme orator. We should not be surprised, then, that the number of copies of Demosthenes' portrait is so great and that they have nearly all been found in Italy. The subject, not the maker of a portrait, interested the Romans. What reason would they have to require specifically an exact reproduction of Polyeuktos' original? Surely they would prefer something more to their contemporary taste, in a modern style which represented Demosthenes as they, not the Greeks of the third century, imagined him to be.

Copenhagen, Ny Carlsberg Glyptotek, I. N. 2782. Marble. H. including plinth, 2.02 m. Said to have been found in Campania. Restored: nose, several toes; the hands, which are made of plaster, were taken from a pair of marble hands found in Rome. For relevant information and bibliography about the portraits of Demosthenes: Richter, *Portraits*, II, 219, no. 32. G. Krahmer, *RM, 39*, 1924, 138-89. On how Roman copies were made: Richter, *RM, 69*, 1962, 52 f. The early classical features of the composition observed by M. Robertson, *History of Greek Art*, 512, tend to suggest that the body also was a late (Hellenistic?) invention.

26 Aristotle (lived 384-322)

"He was the most eminent of all the pupils of Plato; he had a lisping voice... He had also very thin legs, they say, and small eyes; but he used to indulge in very conspicuous dress, and rings, and used to dress his hair carefully." This description of Aristotle's appearance comes from the *Lives of Eminent Philosophers* by Diogenes Laërtius. Other ancient writers speak of his short hair and beard, his boldness, and the mocking expression in his face. Still another mentions, in direct contradiction, his strong bones and his thick beard.

In spite of the formidable amount of scholarship devoted to the problem, we are still not certain that the portrait of Aristotle – several were recorded in antiquity – has been correctly identified. We possess no inscribed bust, and a sixteenth-century drawing, now in the Vatican library, of a lost portrait (illustrated in Richter's second volume on portraits,

page 171) only increases the confusion already present in literary sources. The most likely candidate as the best copy of Aristotle's portrait is this head now in Vienna; some fourteen replicas exist. Since the number of copies is impressive, we can be reasonably sure that the person it represents was famous, and there is enough agreement between the copies and the Vatican drawing to make the identification plausible. Although the hair is not particularly short, the baldness, the length of the beard, the small eyes, and the mobile, perhaps lisping, mouth of the Vienna head accord in general with literary evidence. The nose is restored. However, the great expanding vault of the upper part of the head is the most individual trait, and what does it not imply in regard to the encyclopedic mind of the philosopher! In comparison, the cheeks seem flat, but the chin and jaws project and expand and thus balance the dome above. The head may have belonged to a seated statue, and an attempt has been made to reconstruct the whole.

Whereas Alexander the Great was the political father of the Hellenistic age, Aristotle was its spiritual father. For twenty years he was a member of Plato's Academy, and then in 341 he founded his own school, the Lyceum, where every conceivable branch of intellectual endeavor was studied and classified. Aristotle was the first Greek to realize the full value of the written word. His desire to collect and arrange manuscripts from every field of learning was revolutionary in concept. It was also the stimulus behind the later great libraries that were established at Alexandria and Pergamon. Education was one of his primary interests; he thought it was the key to most human problems. He himself had been a prize pupil: in 343 he was invited to Pella, the capital of Macedon, to tutor the crown prince Alexander. It is delightful to think of these two men – one middle-aged, the other youth of thirteen – reading and conversing together as they strolled up and down the colonnaded court of the palace. To Aristotle Alexander owed much of his interest in geography, zoology, and botany, and his enduring respect and love for the classics. From Aristotle the Hellenistic age as a whole ultimately derived its love of learning. The original statute is generally believed to have been executed between 325 and 300 B.C. However, there are some features – the extreme softness of the fleshy parts, and the lack of clear definition around the temples – which lead us to surmise that the copyist altered the original to some extent and increased its expressive qualities.

Vienna, Kunsthistorisches Museum, n. 179. Gift of the Archbishop V. E. Milde, 1846. Marble. H. 0.29 m. F. Studniczka (*Das Bildnis des Aristoteles*, Leipzig, 1908) collected eleven of the copies. G. Gullini (*ArchCl, 1*, 1949, 130 f.) reconstructs the whole figure. Richter, *Portraits*, II, 170-75. J. H. Jongkees, *Portraits of Aristotle and Menander*, Leiden, 1965. On Aristotle's philosophy, see W. Jaeger, *Aristotle*, Oxford, 1934. J. P. Lynch, *Aristotle's School*, Berkeley, Los Angeles, London, 1972.

27 Bronze Statuette of a Philosopher

The evolution of Greek art is frequently described in terms of an increasing realism, of a growing ability to observe and record natural phenomena. According to this theory, as the artist became more and more skillful, his figures become more and more lifelike. In the Archaic period (c. 615-480), for example, the sculptors, it is often said, were capable of only elementary and often erroneous depictions of the anatomy of the human body. Step by step the crude and rigid figures of the first stage were endowed with the capacity to move. By the Transitional, or Early Classical, period (480-450) the weight of the body was unevenly distributed between the legs, and joints and muscles which had never been seen before were now detected. Lysippos, at the close of the Late Classical period (400-323), finally liberated the figure completely. The full effects of his art are seen in the Hellenistic age. Anatomy was no longer a mystery; as the form rotated in space, every detail of torsional action was reflected in the handling of weight, bone, muscle, and tendon. The process, it is now claimed, was at an end; the sculptor had at last achieved what he had sought for centuries: realism, or fidelity to nature.

Although we cannot escape the validity of this conception, we should be aware of its limitations. It is only a partly satisfactory account of the development of Greek sculpture. It is concerned only with externals and visual observation. Of equal if not greater importance are the changes that occur in content and meaning. An archaic Kouros smiles with joie de vivre and bursting good health. But he neither thinks nor feels. The revolution that occurred in the Transitional period lay not so much in the

statue's new power to move as in its capacity to meditate. Artists were not merely more technologically advanced but showed a deeper concern with and understanding of the nature of man. Subsequently the emotional and intellectual – the internal aspects – of the human being were gradually explored and represented. As a consequence the content of the statue became increasingly rich and complex.

By the third century B.C. Greek artists had accumulated a complete vocabulary of poses and gestures expressive of essential and universal states of mind. The raising of hand to face is one of these. We do it instinctively when in sorrow or in thought, as if the head were the physical source of suffering or contemplation and therefore needed to be supported or touched. The gesture does not appear in early Greek art, in which men and women had flung out their arms or struck their heads in mourning or sorrow. But at the close of the Archaic period the more restrained and thoughtful gesture was introduced and became, for obvious reasons, one of the attributes of the philosopher-type. Its significance strikes one immediately, and as we see in this statuette derived from an original of about 230 B.C., it is always moving.

The philosopher, who may be Cleanthes, a Stoic, is seated with his right hand barely touching his lowered head. He wears sandals with long tongues, and a large cloak is thrown over his left shoulder and around the lower part of his body. His left arm and hand are completely covered by the drapery; his legs are crossed at the ankles. The man is solid and well-proportioned; except for the left arm, which seems to hug his waist, he appears relaxed and comfortable. The bench is modern.

London, British Museum, no. 848. Bronze. H. 0.508 m Said to have been found in Brindisi. There are three or four other replicas. K. Esdaile (*JHS*, *34*, 1914, 47-59) identified the figure as Aristippus, G. Lippold (*RM*, *33*, 1918, 19 ff., fig. 7) as Zeno, and K. Schefold (*Bildnisse*, 146) suggested Cleanthes. G. Neumann, *Gesten und Gebärden in der Griechischen Kunst*, Berlin, 1965.

28 Bronze Statuette of a Philosopher

The generalization that underlies all Greek art can make the search for identities hazardous, frustrating,

and inconclusive. When this beautiful statuette was acquired by the Metropolitan Museum of Art it was thought to represent Hermarchos, a pupil of Epicurus and the second director of the Epicurean School. More recently other identifications have been made: perhaps it is Epicurus himself, or Metrodoros, another of his pupils. Perhaps the subject is not an Epicurean at all, but a Cynic or Stoic philosopher. Although the features are rendered with precision and fineness, and even though the beard and hair are arranged in a distinctive manner, it is impossible to identify the person with any certainty. The various schools of philosophy in third-century Athens looked upon one another with sectarian distrust; we can easily discover from their writings where their theoretical differences lay, but when it comes to portraiture there is no final way of distinguishing a Stoic from a Cynic or an Epicurean. Sometimes it is even difficult to distinguish between two members of one school, in spite of identifying inscriptions.

The age of the man, his intelligent face, his beard, and the dumpy body suggest, nevertheless, that his occupation was sedentary and that his concern was wisdom. His head leans on a thick, rather flabby torso in which the chest droops and flows into a protruding belly. The right arm bounces off the body at the elbow; the right hand may have held a scroll. The cloak, with a few diagonal and vertical folds, is all he wears. It encircles him, leaving his chest bare, overlaps at front and back, and winds around his left arm. The legs are thin and distorted; his sandaled feet are placed far apart. He looks a little wobbly and unbalanced. The composition is freer than that of the statue of Demosthenes (25); the drapery hangs more generously; this figure can move, however slowly, wherever he likes.

The statuette is mounted on a lampstand in the form of an Ionic column of which only the capital remains. Between the volutes is a stylized flower, and dipping down on either side are loops which were probably intended to hold garlands or fillets. The abacus that forms the base on which he actually stands has three moldings, each one decorated with a different design. Statues mounted on columns are not infrequent in either Greek or Roman art. A reduced Roman copy of a late third-century B.C. original.

New York, Metropolitan Museum of Art, Acc. no. 10.231.1. Rogers Fund, 1910. Bronze, hollow cast. Crusty green patina. H. of statuette alone, 0.263 m. (total height of column as restored, 0.317 m). Figure and column made separately. Shaft of column restored in wood. Said to be from Ostia. E. Robinson, *BMMA*, June 1911, 130-34. Richter, *Portraits*, II, 199. There is an inscribed bronze bust of Hermarchos (*ibid.*, 204, fig. 1292) with features resembling those on the inscribed portrait of Epicurus (*ibid.*, 196, fig. 1176); see also Richter's earlier publication, *Greek Portraits*, II: To what extent were they faithful likenesses? *Coll. Latomus, 36*, 1959.

29 Chrysippos (lived 280-206)

Pericles, the Parthenon, and the Propylaea belonged to the past. Athens in the Hellenistic age no longer erected great monuments proudly hailing her patron goddess; the city had lost an empire and all her military power. Yet she was still the most illustrious city in the ancient world, and the envy of all others. The capital of no kingdom, yet respected by kings and princes, Athens remained free and rather removed from the turmoils and bloody battles that surrounded her. It was a good place to live, to think, and to write. Small wonder that Athens was a university town and the seat of philosophy. During the early Hellenistic period Plato's Academy and Aristotle's Lyceum continued to attract students of philosophy. Epicurus opened his Garden in 306. About 300 B.C. Zeno established his rival school, known as the Stoic because it met at the Painted Stoa in the agora. Stoicism dominated philosophical thinking throughout our period and throughout the Roman empire. It influenced Christianity and is still alive even today though not, of course, in its original form.

Zeno was the founder of the Stoic school, but Chrysippos, who became its director in 232, was its most verbal exponent. If we are to believe Diogenes Laërtius, he wrote over seven hundred books, in which the main tenets of Stoicism were recorded. Like the Epicureans, the Stoics taught not so much a philosophy as a way of life or religion. They both asked the question: how can a man find peace of mind? Chrysippos replied: by accepting the will of the supreme god and by living in harmony with nature. All things work together for good; even evil is an indispensable part of god's grand design.

The body of the statue is in the Louvre, and the head there placed on it is a cast of a head identified as Chrysippos, now in the British Museum. Seated, hunched forward and leaning on his elbows, the philosopher raises his head and extends his right hand. The fingers move nervously. Chrysippos appears here as the wise teacher rather than the thinker; he seeks earnestly yet quietly to explain his point of view. He is shown as an old man, one in whom we might see a divine spark. He is bald to the very crown of his head, and even his beard has lost its luxuriance. There are at least four ancient sources that refer to statues of Chrysippos. Cicero mentions one in Athens showing the philosopher seated "with hand extended." Perhaps our statue is a copy, not unaltered, of this original, which may have been made about 200 B.C.

Paris, Louvre, Ma 80. London, British Museum, no 1846. Marble. H. about 1.20 m. Several details of the body are restored, as are the nose, upper lip, and other details of the head. J. Charbonneaux reconstructed the statue. Richter, *Portraits*, II, pp. 190 ff. L. Edelstein, *The Meaning of Stoicism*, Cambridge, Mass., 1966.

30 Bronze Head of a Philosopher

In 1900 this head was recovered from the sea off Anticythera. Other masterpieces in bronze and marble were found with it — sure proof that together they had formed the cargo of a ship that was wrecked en route, quite possibly, to Italy. In the second and early first centuries B.C., after their victories in Greece and Asia Minor, Roman generals sent home thousands of statues, which were very much in demand. The port of departure of this ship may have been on the central coast of Asia Minor, and the time was probably between 80 and 50 B.C.

Scarcely recognizable when first found, the head required a thorough cleaning before its true qualities became visible. The surface is highly corroded in places, and the expression is therefore somewhat misleading. The inlaid eyes, for instance, which are original, would not have seemed so hypnotic if the smooth surfaces of the flesh had been preserved. A right arm, a left hand, some pieces of drapery, and two sandaled feet were rescued at the same time and indicate that the head belonged to a large standing draped statue. That it was the portrait of a philoso-

pher seems certain. Not only did statues of philosophers come into vogue only in the Hellenistic period, but the head belongs to a well-established type. The philosopher is always bearded and of mature, if not old, age. Statues of Zeus, the father of the gods and the wisest of them, undoubtedly inspired the type. In spite of the rough surface of the flesh and the untidy, matted hair, the head has a tremendous dignity, nobility, and pride. The moustache and beard are quite neatly arranged: tiers and divisions, as well as a certain amount of symmetry, impart a definite sense of order. The upper lip is covered by the moustache and the lower lip is thin yet firm; the ridge along the bottom edge helped to hold a layer of silver. No one has succeeded in identifying the philosopher. Stylistically the head could be compared to some of the bearded giants from the Pergamon Altar. First half of the second century B.C.

Athens, National Museum, no. 13.400. Bronze, hollow cast. H. 0.29 m. J. N. Svoronos, *Das Athener Nationalmuseum*, Athens, 1908, I, 29 f., II, pl. 3-4. R. Carpenter, *Greek Sculpture*, 242. G. Weinberg et al., *The Antikythera Shipwreck Reconsidered*, Philadelphia, 1965. P. C. Bol, *Die Skulpturen von Antikythera*, Berlin, 1972, 27.

31 Epicurus (lived 342-270)

Two portraits, one of bronze, one of marble, are inscribed with the name of the founder of the Epicurean school of philosophy. In addition there are something like thirty other replicas, of which this portrait now in New York is among the finest. Epicurus is shown at an advanced age, with a long, distinguished, and sensitive face which may suggest the poor health from which he suffered in his last years.

The teachings of Epicurus fulfilled a profound need in the hearts and minds of many men during the Hellenistic age. Alexander's conquests changed everything. The world had grown so large the political function of the individual had dwindled or ceased altogether and with it the authority and support of the Olympian gods and the civic deities. For the common man a new identity could be sought in any number of mystery religions. The educated intellectual might choose a philosophical creed – Cynicism, Skepticism, or Stoicism. But many, both intellectuals and ordinary people, were drawn to embrace a philosophy that was also a way of life by adopting the teachings of the kind and learned Epicurus. In Athens, they could resort to a certain garden sheltered from the hustle and bustle of city life, listen to the teacher, and enjoy the companionship of sympathetic men and women. Their aim was pleasure. But sustained pleasure could be gained only by living modestly and by avoiding excessive emotional commitments to marriage, children, or political action. Excess, passion and power – all inflicted pain. The Epicurean would also learn that the only avenue to knowledge was sense-perception and the only subject worth investigating was science. Indeed it is the scientific foundation Epicurus gave to his teachings that is of unusual interest to us today. He adopted the atomic theory of matter, which was first propounded by Democritus (c. 460–370 B.C.), as the ultimate reality. He could accordingly claim that since the soul of man is composed of atoms, it scattered completely and felt nothing at death. What then was there to fear in dying?

During his lifetime Epicurus was surrounded by adoring pupils; they considered him divine, and they probably expressed their devotion by erecting a portrait of him in the school garden. Throughout the Hellenistic period and during Late Republican and early Imperial times his likeness was in great demand. An inscribed bust and a large number of papyri expounding his philosophy were found in the Villa dei Pisoni in Herculaneum.

The kindness of his personality seems evident in the portrait shown here. His hair is brushed forward to form casual curls along his forehead. Spiral locks descend from the temples to a beard, which is divided into long symmetrical strands. His moustache, also long, plunges over the edges of his mouth. The eyes are deeply inset and modeled rather than engraved; crow's feet radiate from them. The surface of the forehead and cheeks is anything but flat; the flesh sometimes sags and hangs. For both historical and stylistic reasons, then, R. Carpenter's dating of the original to the late second century B.C. may be adopted. G. Lippold has shown that this head type belongs to a draped, seated statue.

New York, Metropolitan Museum of Art, 11.90. Rogers Fund, 1911. Marble. H. 0.404 m. Purchased in Rome. No restorations. G. M. A. Richter, *Catalogue of Greek Sculpture*, 96, no. 186; same author, *Portraits*, II, 194-200, figs. 1149-1225. G. Lippold, *Griechische Porträtstatuen*, 77 ff., fig. 17. R. Carpenter, *Greek Sculpture*, 247. D. Comparetti and G. de Petra, *La Villa ercolanese dei Pisoni*, 1883. H. Bloch, *AJA*, 44, 1940, 485-93. On Epicurus, *CAH*, VII, 231-34 and A. M. Festugière, *Epicurus and His Gods* (trans. C. W. Chilton), Oxford, 1955. His garden: M. L. Clarke, *Phoenix*, 1973, 386.

32 Poseidonios (lived c. 135-45 B.C.)

This is the only portrait we possess of the Stoic philosopher, Poseidonios, whose name is inscribed on the drapery. It is a Roman copy, perhaps of the first century A.D., of an original that was made between 70 to 60 B.C. while Poseidonios was still alive. The crisp handling of the hair and beard suggest that the original was of bronze. Hair and beard are clipped close; their strands are fastidiously arranged, and have both a linear and a decorative effect reminiscent of Polykleitan heads of the later fifth century. The eyes are small and perfect shapes — with narrow lids above and below forming uninterrupted arcs. The crow's feet, dainty and repetitious, seem artificial, as if they were stamped into unyielding flesh. The features are isolated from each other. These qualities, in addition to the emphasis placed upon the head as a single whole, reveal the rather academic classicizing style of the first half of the first century B.C. The head of Cleopatra (16) is a product of the same current, whereas the Agora priest (23, 24), though roughly contemporary, exhibits the more outspoken naturalism that may also be found in this period. Yet the head of Poseidonios shows a certain hardness and realism that relate it to some Late Republican portraits of the time. His skin seems dry and stretched over the bony cheeks and forehead. The breadth of the face, and the long distance between the nose and mouth, make it amply clear that while the artist may have had a classical canon in the back of his mind, he was equally interested in the individual aspects of his sitter's physiognomy. The philosopher appears supersensitive, highstrung, and rather withdrawn.

Poseidonios, who was born in Apamea in Syria, spent most of his life in Rhodes. He was a frequent visitor to Rome and counted Pompey and Cicero among his close friends. Often called the last great Greek intellectual, he was a man of enormous learning. He was not only a philosopher but a historian, orator, and scientist. His belief in supernatural demons, and his acceptance of Plato's antithesis between body and soul, marked a departure from the more severe rationalism and unitarianism of the early Hellenistic philosophers and greatly affected the Roman stoicism of Seneca and Cicero.

Naples, Museo Nazionale, inv. 6142. Marble. H. 0.44 m. Dark gray discolorations. Restored: end of nose and much of the ears. From the Farnese collection. Perhaps the work of a Rhodian artist. B. Schweitzer, *Die Bildniskunst der Römischen Republik*, 69. L. Edelstein, *The Meaning of Stoicism*, Cambridge, Mass., 1966.

33 Menander (?) (341-292)

Controversy raged around this portrait, of which there are more than forty replicas. Does it represent one of Greece's greatest dramatists, Menander, or is it Rome's greatest poet, Vergil? The weight of the argument seems to fall on the former proposal. But if V. Poulsen is correct in identifying Vergil in another series of portraits, the problem is eradicated. The ancient descriptions of Menander as "anointed with perfume, effeminate in dress, walking with deliberate and languid steps," the fact that he came from a wealthy Athenian family, and even that he was cross-eyed are in no way contradicted by his appearance in this head now at Dumbarton Oaks in Washington. The man seems elegant, wordly, witty, and a bit sour. He must surely be Menander, the New Comedy poet, who was held in very high esteem particularly during the early centuries of Imperial Rome. His portrait was widely distributed in libraries, houses, and gardens. One in a mosaic from Mytilene may finally clinch the indentification.

Characteristic of many replicas are the round head, the wavy locks combed from right to left above the forehead, the two vertical furrows between the eyebrows, the high cheekbones, the full mouth, and the prominent Adam's apple. Menander's age here would be between forty and fifty years, and his somewhat disillusioned mood is indicated by the creases in his

forehead, and swift descent of the eyebrows as they join the nose, and the marked curves of his upper lip. Yet how handsome he is! Unlike the portrait of Poseidonios (32) the head has a marvelous organic unity and a rhythmic interplay among the various shapes, contours, and surface lines, and this despite the fact that our example is a hard and quite mechanical copy.

Pausanias states that he saw a statue of Menander in the theater at Athens which was executed by the sons of Praxiteles, who worked in the early third century. Many scholars believe that all the copies go back to this original. May not the style of this head and of other good copies (such as the one in the Museum of Fine Arts in Boston) tempt one to propose a date nearer the end of the third century? Is there a possible analogy in the head of Attalos (9)?

Contrasted with Aristophanes, the fifth-century poet of Old Comedy who dealt broadly with themes of political satire, Menander depicted episodes from everyday life. Love stories and broken hearts were his forte, and in this sense he is a true Hellenistic, rather than a Classic, poet. Yet his characters, like contemporary sculptured portraits, are still types more than they are individuals. They feel and act predictably and conventionally, and this is why they have been and remain universally appealing.

Washington, D.C., Dumbarton Oaks, inv. 46.2. Marble. H. 0.34 m. Said to have been found in Tarquinia. No restorations. Base of neck finished for insertion into statue. End of nose broken, back edges of ears chipped off, cheeks scratched and pitted, and deep cuts on chin and right cheek. Right side of face discolored. V. Poulsen, *Vergil*, Opus nobile 12, 1959. For full discussion of identification controversy and bibliography: Richter, *Portraits*, II, 224 f. For the mosaic portrait: S. Charitonides, L. Kahlil et al., *Les Mosaiques de la Maison du Ménandre à Mytilène*, Berlin, 1970.

34 Homer (lived c. 700 B.C.)

The genius and inventive power of the Hellenistic age, which is all too often denigrated, is nowhere better illustrated than in this purely imaginary portrait of the early Greek bard Homer. There existed, of course, no record whatever of his appearance. Several ancient sources state that he was blind, but there was no single tradition on this matter. At least one author denies it, and by no means all of the surviving portraits of the poet show him as sightless.

R. and E. Boehringer have classified the four types of Homer portraits made, presumably in different periods, in Greece. This bust is an exceptionally fine example of their "Blind Hellenistic" type. Here is the inspired poet par excellence, a balding old man wearing the fillet that signifies his calling. The lips are slightly parted, and the bearded face looks benign. The hair is thin at the top and then springs from beneath the fillet down the sides of the head in thick ringlets. The moustache is rather sparse, too, but the beard then develops from the cheeks and chin in rich, wavy tufts. The head leans forward, ahead of the neck, as if he were stooped; the neck is almost scrawny and is scored by two creases. But it is the eyes and their handling that are truly fascinating. All around them are folds of flesh and irregular accumulations that hint of tumors and cysts. The eyes are unusually small and are made to seem blind because the flaccid upper lids cover so much of the eyeballs. The eyebrows are equally expressive. They are thick and arch highly, denoting, it seems, the sheer effort and concentration that ultimately permit him to see and know everything. Here we are reminded of the seer Tiresias whose inability to see lent his prophecies all the more authority. It is not vision we speak of, needless to say, but insight. Homer's cheeks are drawn and pinched, and there are a few wandering furrows on his forehead. The head is strongly plastic and pictorial, particularly because of the long trenches above the eyes and the ringlets. If it were not for the stabilizing effect of the symmetrical hair and beard, the soft and decrepit skin and bone structure would verge on dissolution. No portrait of the Hellenistic period is more moving, and of the four types of Homer portraits, this one most completely embodies our conception of the ideal poet. The stylistic relationship between it and the head of Laocoon (146) has often been noted. No bearded figure from the friezes of the Pergamon Altar offers such a close analogy. A date in the late second century B.C. seems the most plausible for the invention of the type.

While it is true that the *Iliad* and the *Odyssey* were familiar to all Greeks during the Archaic and Classic periods, Homer nevertheless enjoyed a kind of renaissance during the Hellenistic age. It arose from a new and unprecedented appreciation of the past and from the scholarly pursuits of the time. The literary scholars and historians who gathered at the Museum in Alexandria pronounced Homer to be a "classic." A cult arose in his honor; he was considered divine, and a temple was erected to him. His "Zeuslike" aspect, which was cited by Christodoros and which informs this portrait, is therefore no coincidence.

Boston, Museum of Fine Arts, 04. 13. H. L. Pierce Fund. Marble. H. 0.41 m. No restorations. Chipped here and there on diadem, top of right forehead; scratches on cheek; nose gone. Brown stains on left side head. R. and E. Boehringer, *Homer, Bildnisse und Nachweise*. Breslau, 1939. Richter, *Portraits*, I, 45 ff., with reference to Christodoros. Carpenter believed original of bronze (*Greek Sculpture*, 246-47). For the way in which Hellenistic poets modeled their art on Homer, see T.B.L. Webster, *Hellenistic Poetry and Art*, chs. III, V.

35 Archilochos (?) (lived early seventh century)

Hellenistic savants ranked the poet Archilochos as highly as Homer. In their textbooks on the history of Greek literature, the first to be written, Homer was extolled as the "inventor" or founder of the art of epic poetry, and Archilochos of iambic and lyric poetry. A few things are known of Archilochos' life, and some fragments of his poems have come down to us. He was born in Paros; he fell deeply in love with a young maiden only to be rejected when he asked her to marry him; and he died in battle. His rejection left him bitter and scornful. His lyrics consequently were, as Quintilian says, marked by "powerful and terse, throbbing phrases, full of blood and nerves."

Unfortunately, there is no final proof that the seated figure in the Copenhagen statue represents Archilochos. However, the fillet and wreath which appear on other copies of the head, and the lyre which should be restored to his hands, leave no doubt that the sitter was at least a poet. Furthermore, the stormy countenance and the impassioned manner in which he turns his head and shoulders are consistent with what is known of Archilochos' life and temperament. In the only known representation of Archilochos, on a silver cup from Boscoreale, he is shown holding a lyre. The identification therefore seems possible. Another candidate is Alkaios. Pindar has been eliminated since the relatively recent discovery of his portrait statue in Egypt.

The poet is seated on a throne with a curved back which is joined to a lion's legs by a double volute design. He is nude to the waist; a thick woolen mantle envelops the lower part of his body and his crossed legs. On his feet are leather sandals. Archilochos plays his lyre without looking at it; he angrily recollects his feelings and experiences. The composition is quite open and full of strong diagonals. The movement of the body, the poet's seeming fury, and the stylized organization of his features relate the work to Pergamene sculpture of the first half of the second century. The eyes were inlaid with another material and the top of the head, including the fillet, was completed by another piece.

Copenhagen, Ny Carlsberg Glyptotek, I.N. 1563. Formerly in Borghese Collection. Marble. H. 1.63 m. Found at foot of Monte Calvo in 1835. Nose, ears, and fingers of right hand missing, upper forehead and beard badly damaged. On right hand there are traces of the plectra. Richter, *Portraits*, I, 66 ff., C. M. Bowra, *Greek Lyric Poetry* 2nd ed., Oxford, 1961, passim. *Entretiens, Fondation Hardt pour l'étude de l'Antiquité classique*, t. 10, 1963 (Geneva, 1964).

36 Hesiod (?) (lived early seventh century)

Nearly forty copies of this haunting head have been found. Who is this man, who was obviously very popular in both Hellenistic and Roman times? Is he a poet or a philosopher? Is it an imaginary or a real portrait? At least twenty-five identifications have been put forward, but there is no clinching evidence for any one of them. The most intriguing puzzle in all Greek portraiture remains unsolved.

G. M. A. Richter, who has made the most recent survey of the problem, comes out in favor of Hesiod

as the likeliest possibility. The chief grounds for her identification are that the person represented is probably a poet (for in one copy he wears an ivy wreath), who (judging by his aging face) lived to an advanced age, and who was renowned (why else forty copies?). He was not of aristocratic background but (because of the hint of uncouthness) of peasant stock. Hesiod, the early epic and didactic poet, corresponds best to these requirements. The portrait would therefore be imaginary, and it may be coupled, both stylistically and iconographically, with the head of Homer (34). A stele commemorating Hesiod erected in a sanctuary of the Muses on Mount Helikon in Hellenistic times may indicate a contemporary interest amounting almost to a cult, which would explain the popularity of the subject.

The head in Naples, which is life-size and the only replica in bronze, is certainly the finest copy and probably the closest to the original. It is, above all, the expression that impresses itself on the memory. The subject seems caught up, as Homer was, in a moment of inspiration. Yet he is not as inwardly oriented or as dignified. His mouth, which is almost wide open, has a lower lip of uncommon thickness and weight. The insignificant chin soon gives way to the hanging flesh underneath and the innumerable moldings formed by the wrinkles on the neck. The hair is quite untidy; the separately conceived strands sometimes take different upward curves; more often they subside in a ragged fashion over the ears, neck, and forehead. The poet is a victim of creeping baldness, for in spite of the activity and plasticity of the locks the skull is just beneath. The beard grows unevenly, first thinly, then thickly. The ruggedness of the features and the lack of careful grooming of hair and beard are responsible for his peasantlike mien. This is an excellent example of the expressive portraiture of the late second century B.C.

Naples, Museo Nazionale, Inv. 5616. Bronze, hollow cast. H. 0.33 m. Usually called "Pseudo-Seneca." No restorations, inlaid eyes ancient. Found at Herculaneum, Villa dei Pisoni in 1754. Richter, *Portraits*, I, 56 ff. For Mount Helikon stele: *BCH, 14,* 1890, 546 ff. How this portrait and no. 31, as well as other sculptures, were displayed in the villa, is discussed by D. Pandermalis, *AM*, 86, 1971, 173–209.

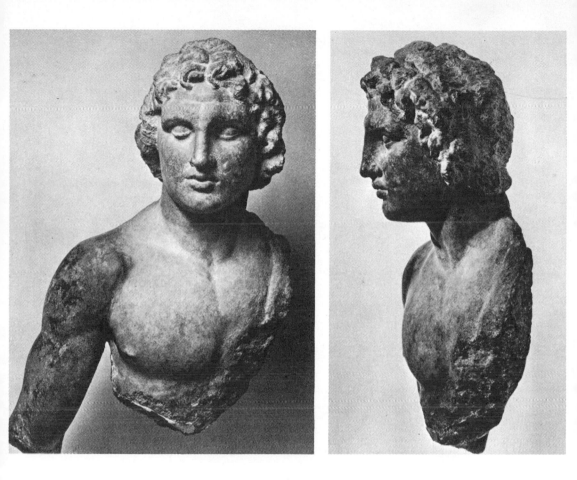

1. and 2. Alexander. 320-300 B.C.
Berlin, Staatliche Museen

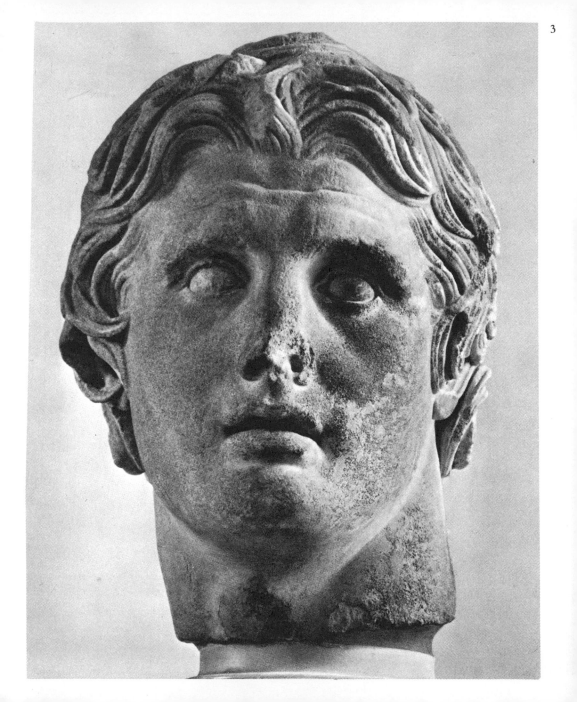

3. Alexander. c. 160 B.C.
 Istanbul, Archaeological Museum

4. Alexander.
 Coin struck by Lysimachos, 286-281 B.C.
 Boston, Museum of Fine Arts

5. Ptolemy I Soter. 200-150 B.C.
 Copenhagen, Ny Carlsberg Glyptotek

6. Ptolemy I Soter and Berenice I.
 Coin struck by Ptolemy III, 246-221 B.C.
 Boston, Museum of Fine Arts

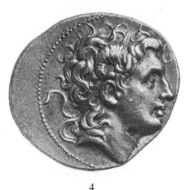

4

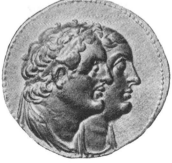

6

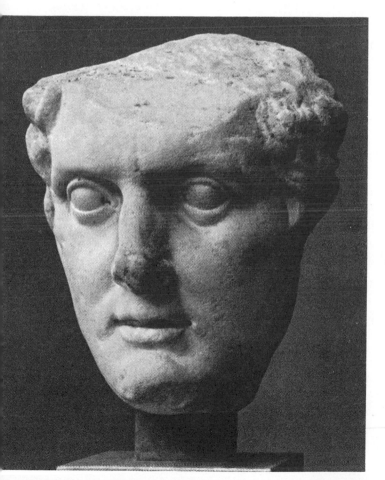

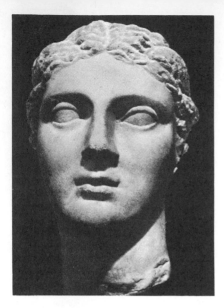

7. Arsinoe II. c. 280-270 B.C.
Alexandria, Greco-Roman Museum

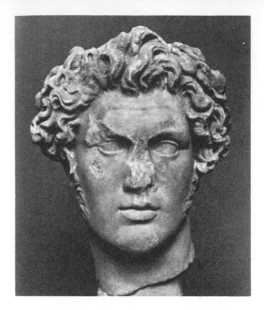

8. Pyrrhus. 200-150 B.C.
Copenhagen, Ny Carlsberg Glyptotek

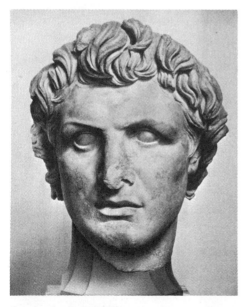

9. Attalos I. 210-160 B.C.
Berlin, Staatliche Museen

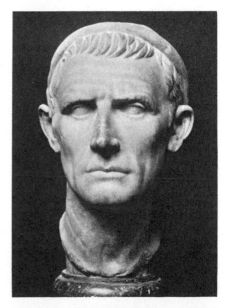

10. Antiochos III (?). 200-150 B.C.(?)
Paris, Louvre

11. Perseus of Macedon.
 Coin struck between 178-168 B.C.
 London, British Museum

12. Euthydemos I of Bactria.
 Coin struck between 230-200 B.C.
 Boston, Museum of Fine Arts

13. Mithridates III of Parthia.
 Coin struck c. 55 B.C.
 Boston, Museum of Fine Arts

14. Mithridates VI of Pontus.
 Coin struck 74 B.C.
 Boston, Museum of Fine Arts

15. Cleopatra VII.
 Coin struck between 51-30 B.C.
 Boston, Museum of Fine Arts

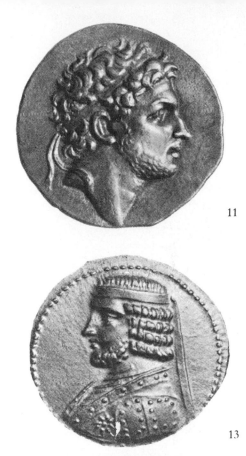

11

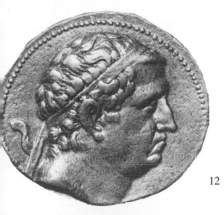

12

13

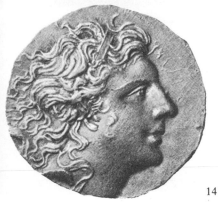

14

15

16. and 17. Cleopatra VII (?). 50-30 B.C.
London, British Museum

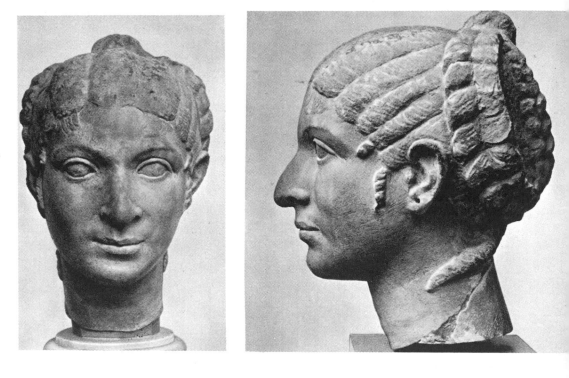

18. So-called Mausolos and Artemisia. 160-130 B.C.(?)
London, British Museum

19. "Hellenistic Ruler," Demetrius I
 Soter of Syria (?) c. 150 B.C.
 Rome, Museo Nazionale delle Terme

20. Bronze Head from Delos.
 Late second century B.C.
 Athens, National Museum

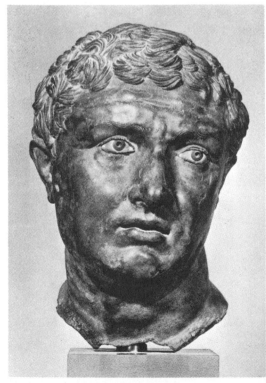

21. Male Head with Diadem.
100-50 B.C.
Athens, National Museum

22. Unknown Man from Smyrna.
100-50 B.C.
Athens, National Museum

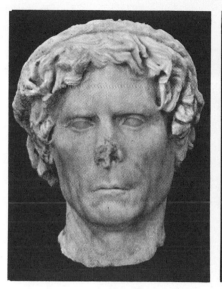

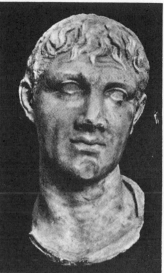

21

22

23. and 24. Head of a Priest. c. 50 B.C.
Athens, Agora Museum

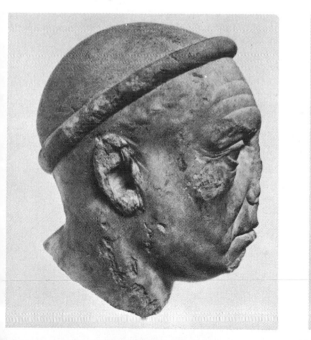

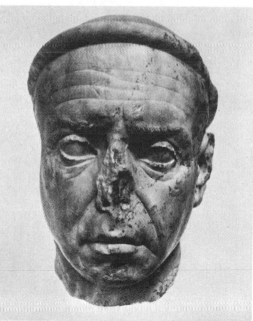

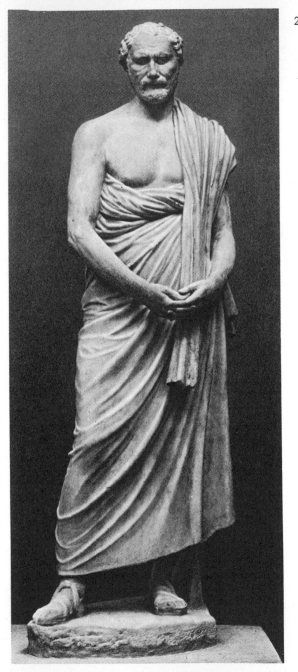

25. Demosthenes, Roman copy.
Original c. 280 B.C. (?)
Copenhagen, Ny Carlsberg Glyptotek

26. Aristotle, Roman copy.
Original c. 325-300 B.C.
Vienna, Kunsthistorisches Museum

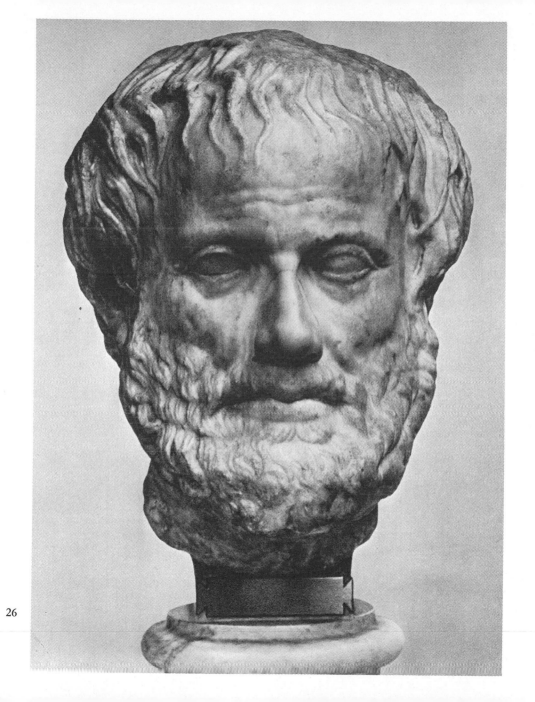

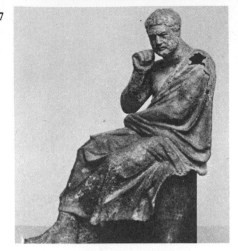

27. Bronze Statuette of a Philosopher, Roman copy. Original second half of third century B.C.
London, British Museum

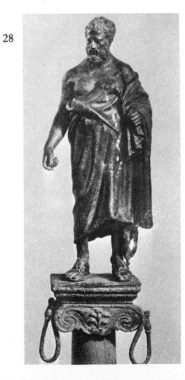

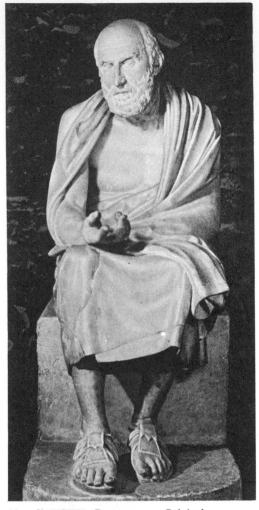

29. Chrysippos, Roman copy. Original c. 200 B.C.
Body: Paris, Louvre. Head: London, British Museum

28. Bronze Statuette of a Philosopher, Roman copy. Original 250-200 B.C.
New York, The Metropolitan Museum of Art

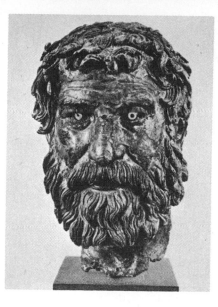

30

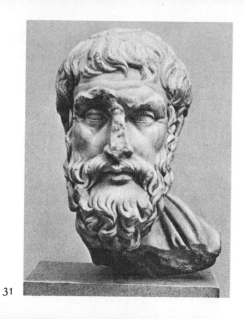

31

30. Bronze Head of a Philosopher. 200-150 B.C.
Athens, National Museum

31. Epicurus, Roman copy.
Original, later second century B.C.
New York, The Metropolitan Museum of Art

32. Poseidonios. 70-60 B.C.
Naples, Museo Nazionale

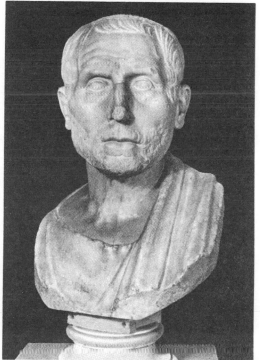

32

33. Menander, Roman copy.
Original early third century B.C.(?)
Washington, D.C., Dumbarton Oaks Collectio

34. Homer, Roman copy. Original
150-100 B.C.
Boston, Museum of Fine Arts

35. Archilochos (?), Roman copy.
Original 200-150 B.C.
Copenhagen, Ny Carlsberg Glyptotek

36. Hesiod (?), Roman copy.
Original late second century B.C.
Naples, Museo Nazionale

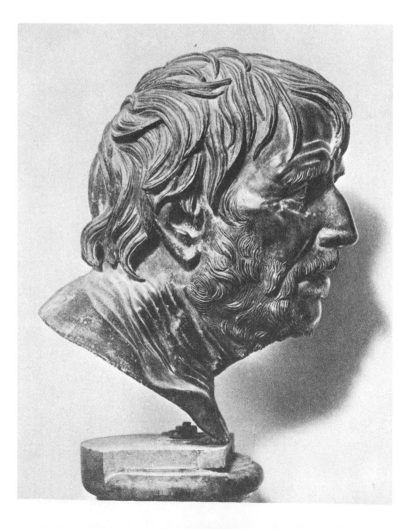

II Architecture

The architecture of ancient Greece has never lacked admirers. Eulogy, however, tends to be focused on the architecture of the Classical period and, above all, on the buildings on the Acropolis in Athens erected under Pericles. The Parthenon, in particular, is selected as the embodiment of the Greek spirit at its most sublime. It is held up as the culmination of a historical development in which everything preceding it is somehow imperfect, groping, and experimental, and everything afterward degenerate and insignificant. Never before and never again was the Hellenic ideal so well expressed.

The Parthenon is indeed a perfect building (66). It is just the right size and shape; with its eight marble columns on the front and seventeen on each side, it is neither too long nor too wide. It is a sculptural unity, a living body, and although rectangular, it puts no undue stress on the ends. The three steps of the platform raise it from the ground but do not elevate it pompously. The brilliant columns tightly and tensely surround the interior, which harbored the statue of Athena, yet between them are the shadowed pauses or open spaces that permit penetration. The angle columns are slightly enlarged in order to guarantee necessary stability and compactness to the corners. The stresses and strains of post and lintel construction are stated with great sensitivity and subtlety. Support and weight, embodied in the upright columns and horizontal entablature, are in equilibrium. The curved profiles of the shafts and capitals indicate that they are performing their function with strength and ease. One triglyph over each column and one over each space between columns maintain the structural logic implicit in the Doric Order. Internal balance is achieved because a porch concludes each end of the cella. There are no soaring arches or vaults; the design is composed of horizontals and verticals only, yet inertia is utterly absent. Inclinations of walls and columns, upward curvature in the platform, and discreet swellings of shaft and capital contours fill the temple with life and movement. A system of rational proportions governs the whole.

Although charming in their own way, archaic temples were failures if Parthenon standards are applied to them. They are too long; the front is accentuated; the angles are unsolid and the interior unbalanced. The columns act alone rather than in unison; their swellings are often overpronounced, their capitals soggy. Some temples anticipate the Parthenon: here and there we may find a refinement, such as curvature of the platform or some mathematical proportioning, but these tend to be incidental and not carried through the whole design.

Similarly, the Hellenistic temple fails when looked upon in the light of the classical Attic temple. In a sense the failure seems less forgivable, for Hellenistic architects, it is said, turned away from perfection, whereas archaic architects at least sought it. License, unorthodoxy, disharmony, and disunity prevail instead of rational order, balance, and oneness. Now the temples are too short; the back porch is again left out; one end predominates. The platform elevates the temple to immodest heights. The peristyle no longer forms a sculptured body, but is a hollow veranda exposing a weak interior. Gone is the deep understanding of the inherent meaning of post and lintel construction. Curvatures are forgotten; the capital is abused by flattening; verticality is stressed at the expense of horizontality; the columns are excessively slender and the entablature unsuitably low. Two or even three triglyphs are fitted in between the columns, and flutes are stopped too soon or begun too late.

But the story is not really so sad, nor is this by any means all of it. The Parthenon is essentially a Doric temple. The tale we have told in brief principally concerns the fate of the Doric Order in those regions of the Mediterranean where it prevailed: mainland Greece, Sicily, and South Italy.

The Ionic Order, on the other hand, evolved and prevailed in the eastern Mediterranean, in the islands and along the coast of Asia Minor which had been originally settled by the Ionian Greeks.

Ionic temples of the Archaic period have some of the same "faults" as archaic Doric: a decided one-sidedness, or frontality, one porch rather than two, and erratic column spacing. They do not pretend to have the compactness or unity that in comparison reside even in some archaic Doric. They are very often colossal. Their exteriors are crowded with columns, giving an impression that has frequently been called a "forest" or "grove," sprawling, bound to the earth, seemingly endless and shapeless, and completely hiding the interior.

But where, we may ask, is the Ionic equivalent of the Parthenon? When did the Ionic Order enter its "classic" phase? We reply: in Asia Minor, in the Hellenistic age. In short, after the fifth century, after the decline of Athens as a major power, the creative and exciting developments of temple architecture occur not in the Doric but in the Ionic Order, and not primarily on the mainland of Greece but in those cities of the east newly founded or conquered by Alexander and his successors.

Nevertheless, if we are to understand the Ionic Hellenistic temple we must not forget the Parthenon and its neighbors on the Athenian Acropolis. A further look at them is therefore required. While the overall design and the surrounding colonnade are Doric, the Parthenon incorporates certain elements of the Ionic : the interior columns of the west room were of that order, and around the external wall of the cella there was a continuous sculptured frieze of the type found on the Ionian treasury built by the Siphnians at Delphi, in the Archaic period. The two styles were thus combined in one temple. Although the soft and rich Ionic may be said to temper the stiff and formal Doric, the latter, in all essentials of appearance and design, reigned supreme. The contemporary Propylaea and other Doric buildings either in Attica or under Attic influence also accepted, with the same degree of reserve, Ionic volutes or friezes into their midst.

Two of the Parthenon's immediate neighbors, the temple of Athena Nike and the Erechtheum, are, on the other hand, more outspokenly Ionic. The

Doric column was discarded : the coiling curves of the Ionic capital replaced the vibrant cylinder of the Doric, and a base was added to the much more slender shaft as in many archaic Ionic temples. Yet the organization of the elements remained fundamentally Doric. The three trim steps of the Doric platform were carried over. The fabric of the structure was revealed rather than concealed by columns, and the contours, such as those of the column bases and capitals, have the vigor and tension usually associated with the Doric. Furthermore, neither the columns' bases nor their capitals were directly copied from Asiatic Ionic prototypes. Instead, both are novel adaptations bearing a strong Attic imprint. As many scholars have realized, the right name for this style of Periclean architecture shown in the temple of Athena Nike and the Erechtheum is not "Ionic" but "Attic-Ionic."

Historical causes, needless to say, lay behind this fusion of the two Orders. Athens in 477 had become head of a league of Greek cities, including those in Ionia, which paid tribute to her in return for protection against any new aggression on the part of Persia. Under Pericles, however, the league was converted to an empire, and Athens at once became the leading city of the Hellenic world. Wealth poured in from all quarters, and men and ideas naturally followed. Those from the Ionian cities were particularly welcomed, for the Athenians considered themselves as belonging to the Ionian branch of the Greek race. For Pericles, moreover, promotion of Ionian culture had a political motive: it allowed Athens, a city on the predominantly Doric mainland, to hold up the imperialist banner of Panhellenism. The Acropolis buildings, in short, symbolize the supremacy of Greek culture and Greek power in the widest sense.

But then, at the end of the fifth century, Athens was defeated in war by Sparta and lost her empire. Morally and economically depleted, she felt the threat of political upheaval and internal instability, and only just held her own against stronger rivals — until the awesome figure of Alexander the Great appeared. Sweeping down over Greece, he subdued all its cities by force of arms or persuasion. For Athens, with which he dealt leniently, he had always a deep reverence. One can easily imagine

his blond head lifted in admiration to the columns and sculptures of the Parthenon or Erechtheum. Two years later he had crossed the Hellespont into Asia with military conquest his intention, but also with the aim of spreading Greek culture. To Alexander and all his successors, as the discussion of portraiture has already shown, Greek culture meant primarily Athenian culture with all its desired Panhellenic overtones.

In this way the conquests of Alexander marked the turning of the tide. Attic men and ideas were disseminated eastward into the old Ionian regions of Asia Minor and indeed far beyond them to Egypt and Syria as well. Attic drama and poetry, it is well to remember, inspired almost all the literature of the Hellenistic age whether it was produced in Alexandria, Kos, Rhodes, or Pergamon. The Attic style in fifth-century sculpture likewise deeply affected the form and content of Hellenistic sculpture. It is therefore to be expected that many of the dramatic changes that occurred in the design of the Ionic temple in the period after Alexander have their source in Attica. The buildings on the Acropolis showing that the two orders could be combined successfully provided the most stimulating models.

Just as it was impossible for the mainland architects of the fifth century to abandon their Doric heritage when they adopted Ionic elements, so it was impossible for architects working in Asia Minor during the Hellenistic age to forego entirely their own traditions. The new temples therefore resemble in some respects the archaic ones: they tend to be large, and the Ionic Order is unhesitatingly preferred. It is therefore all the more interesting to note how Doric principles invaded the design: the forest was thinned out and a single dignified row of columns promenaded around the cella; curvature of the platform and wall inclinations imparted a new springiness and masculinity; balance was achieved by the addition of a back porch; column spacing became denser and more regular; the angle column was enlarged; and the resilient Attic-Ionic column base was substituted for the stacked-saucer type native to Ionia. The long sculptured frieze, heretofore never used on Ionic temples of Asia Minor proper, began to decorate the entablature in unquestionable imitation of the Athena Nike temple

and the Erechtheum. An underlying order, based upon numerical proportions, instilled rationality into the arrangement of elements. No one temple exhibits all these features, but each of them — the temples at Sardis, Magnesia, Didyma, and still others we have not space enough to mention — included more than one. The clear structure of the parts and the overall unity and coherence compel us to see these temples as "classical" examples of the Ionic Order. This architectural style we may justifiably call "Ionian-Attic," although we admit it was never definitively summed up in any one temple. But the term is a guide to an understanding of the Hellenistic temples of Asia Minor and points up the difference between them and their archaic predecessors. The style was first manifested in Pythios' temple of Athena Polias at Priene, which was dedicated by Alexander the Great in 334, and its final and most outstanding formulation appeared in the temples designed by Hermogenes in the latter part of the second century. Two of the temples we discuss — that of Athena Polias at Pergamon (77) and Asklepios in Kos (72) — are not, however, in the Ionic Order but in the Doric. They, and the numerous Doric stoas that surround many a sanctuary or agora, merely underline the extent to which mainland forms and ideas established themselves in Asia Minor and adjacent islands during this period.

The most important innovation of the Hellenistic period, affecting not only temple design but all architectural forms, is the interest shown in space as a positive element, and in the organization and interrelationship of volumes. Perhaps the ultimate stimulus for the first also came from Attica — from the architect of the Parthenon, Ictinus, who built an unusually wide cella and so equipped it with columns that an expansive but palpable interior space was created for the first time in Greece. In the temple of Apollo at Didyma, the fluctuation in the size, shape, and level of the various parts, the emptying out or filling up of given areas, and the undulating pilaster-lining of the court walls are dramatic extensions of the same desire to stress the interaction between mass and space. The work of Hermogenes, the most influential architect of the Hellenistic period, is highly relevant to this discussion. At Didyma the multiplicity of columns

had continued archaic practice: there are two rows all the way around (62). In the temple of Artemis at Magnesia (70) Hermogenes omitted the inner row, thereby inventing, as Vitruvius said, the "pseudo-dipteral" system. This has frequently been denied, the argument being that a very few earlier temples, especially in western Greece, had already shown the same scheme. But these were Doric temples and except perhaps for Sardis (59) Ionic pseudodipterals do not predate Hermogenes. In respect to Ionic design then he remains important. But more to the point is that by eliminating the inner row of columns he consciously created a vast space where it did not normally exist in the Ionic temple. This space was, in its proportions and shape, thematically meaningful and calculated, and was directly related to the surrounding volumes. The wide corridors between the peristyles and cellas of western Greek temples of the Archaic period do not seem to have been the outcome of as much deliberation, or, if they were, one learns that they were structurally but not aesthetically determined. In short, Hermogenes' "invention" is another indication of the vital role played by space-concepts during the Hellenistic age.

In the Classical period, the Greek temple was an independent entity, austere and dignified in its complete isolation. Here again we may turn to the Parthenon. Like a work of sculpture in the round, it can be viewed with equal enjoyment from all sides. Calm and detached, no neighboring building touches it or really affects our experience of it. In the Hellenistic period, on the other hand, the temple tended to lose its autonomy and become part of a complex of buildings. Concurrently the space between the various structures gained an identity for the first time. The stoa was of extreme importance in this new and more comprehensive form of architectural planning. In the sanctuary of Asklepios at Kos (72) or of Athena at Pergamon (77), for example, horseshoe or L-shaped stoas provided colonnaded backgrounds for the temples. The temples were still, like the Parthenon, "carved in the round," but they were now partially framed, and if the observer was to appreciate the framing he had only a restricted number of viewpoints. Small wonder, then, that quite often the temple's inherent balance was destroyed by frontal emphasis and short proportions. But while it may have relinquished its former autonomy, the temple was no less impressive. Indeed, care was taken to guarantee its dominance. It was frequently raised high on a lofty platform and its deep volume subordinated surrounding stoas.

The stoa was also the prime organizer of the marketplace. When one was erected near or next to another, as was usually the case in the Hellenistic period, they could not only enframe single buildings, they could also enclose an unoccupied space. Steps and sometimes terraces projected beyond their abundantly colonnaded facades and, in a limited way, both penetrated and absorbed exterior space. In a sense then, one stoa may call to the other across the void which we thus become aware of. Long stoas were added in liberal quantity to the agora at Athens during the third and second centuries. They gave it a definitive character it never had in the Classical age.

However, because the Athenian agora as a whole had grown organically over many centuries, its shape never conformed to a pure rectangle. On the other hand, the Hippodamian city plan, the checkerboard system, which proved so practical for the quick laying out of new cities, especially in Asia Minor, automatically imposed a regular outline on the areas reserved for the marketplace. Thus at Miletus (41) and Priene (43) the stoas, stretching out along several blocks, joined one another at right angles, delineating a huge but calm rectilinear space. The majority of stoas seem to have been built in the second century, and we may therefore conclude that this period, to which Hermogenes also belonged, was the one that felt more strongly the need to create a spatial environment.

Theater design furnished a related phenomenon. Here a crucial development occurred at a time when these new ideas were having their most enthusiastic reception. In the classical period the scene building consisted of a narrow one-storied structure which housed props and costumes and, at the same time, constituted a backdrop for the performances which took place in front of it in the circular orchestra. In the Hellenistic period, the dramatic action was finally transferred to a permanent stone podium which was added, apparently never before 200 B.C.,

to the facade of the now two-storied scene building (47). The actors could also perform in nichelike spaces which opened above and into the podium. At intermission, the orchestra was kept alive with singing and dancing. In sum, then, the action now occurred in more architecturally-defined areas, and the total space available for the players and the possibilities for movement had decidedly increased.

An open space in which to practice athletics had been set aside from earliest Greek times. Covered arenas for political or religious assemblies were also built before the Hellenistic period. But the gymnasium as an architectural form and as a defined spatial unit is a postclassical phenomenon, and closed halls with roofs spanning impressive spaces now appeared in greater number and quantity. We are fortunate indeed that Priene has such excellent examples of both (50, 45). No less pertinent to our theme is the development that can be followed in the design of the domestic house. The classical house was a rather mean dwelling with a small undecorated courtyard placed almost anywhere and with rooms unsymmetrically distributed about it. The house had no real focus or tectonic character. In the third-century houses at Priene one room was selected for monumental emphasis, and while the court had a new regularity, on the whole it remained unprepossessing (52). In the second-century houses at Delos, on the other hand, the court was a most imposing affair; it was large and centrally located and decorated on all four sides by columns. The open space they surround was thus seriously thought about and fully described. As a logical consequence, the adjacent rooms began to be related to it by a more symmetrical disposition (53).

Although little is known about the lighthouse on Pharos Island, the literary sources suggest that several fascinating engineering and optical devices went into the construction, maintenance, and projection of its bright beacon. Erected in the third century in Alexandria, the age and city of the mathematician Euclid and the geographer Eratosthenes, it was a monument to the truly outstanding scientific achievements of the Hellenistic period (55). So too was the Tower of Winds in Athens, built in the first century, which included the most up-to-date methods for telling the time of day and the direction

of the wind (56). The lighthouse was the tallest tower that had ever been built ; both day and night it guided voyagers into and away from the most cosmopolitan city in the world. In Athens, too, merchants and mariners consulted the Tower on wind and weather and reckoned their arrivals and departures accordingly. It is no accident that these singular Hellenistic buildings were erected to aid and comfort those who journeyed into space.

The manipulation of interior and exterior space and the composition of building complexes were the preoccupations of late Republican and Imperial Roman, as well as of later Greek, architects. A concluding word, therefore, as to the differences in approach and conception between Greek and Roman may enlighten us further as to the special nature of Hellenistic architecture. Roman buildings, whether temple, forum, or theater, enclosed and defined space completely; they created their own self-contained environment. Hellenistic architecture throughout resisted absolute containment. Over and over again—at Pergamon, Kos, Miletus, Priene, and Athens—we shall see how one boundary of a sanctuary or marketplace was left open, even vulnerable, to the external world. Roman space was shaped and molded, largely by the vaulting system of construction, and it was therefore active and palpable to a degree not sought in Greece. Hellenistic architects were well aware of the principle of the arch, but with a few minor exceptions which will be duly noted, they never employed it to obtain spatial or monumental effects. Roman space has qualities of grandeur and mystery; Greek space is clear, concrete, calm, and never overwhelming. In Roman group design, a comprehensive scheme controls all the elements, and the single building dwindles to insignificance. In Greek design, no matter how many colonnades were adjoined, and in spite of a substantial amount of framing, the temple, altar, or stoa never entirely lost its individuality. Axes, cross-axes, and symmetry pervade Roman group design. In Greek building complexes there are right angles and echoing volumes, but it is remarkable how little rigidity there is and how stoa or room remains independent, avoiding symmetrical ordering. Roman architecture coerces the observer and compels him to follow a path laid out by every detail of the de-

sign. Greek architecture entices the observer, offers him choices, and finally allows him to remain spiritually free. This is true not only for the Classical but also ultimately for the Hellenistic period.

37 Athens, View of the Agora

In the heart of modern Athens, approached by wide, paved avenues crowded with cars and buses and by narrow streets lined with shops and houses, the visitor suddenly comes upon an unexpected quiet. Before him is a low-lying area, of no particular shape, verdant with shade trees and bushes growing ever larger, and dotted with flowers, benches, heaped stones, and old foundations. A silent, pretty, but empty park to some, to others an awesome sanctuary, overflowing with memories and noisy with voices from the past. This is the marketplace, or agora, of ancient Athens, the hub of the civilized world in Hellenistic times (in the photograph it is the open stretch in the middle ground). Here political schemes were hatched, stirring orations delivered, new philosophies—as well as meat, fish, and vegetables—offered for sale. Here Socrates once questioned the young; Demosthenes (25) defended himself; Chrysippos (29) taught; and well after the Hellenistic period, the Apostle Paul argued with anyone he met. The agora was not only the commercial but also the political and civic center of the city, the principal town square. Surrounding it on crooked, narrow lanes were the citizens' houses, which did not, however, sprawl on forever as they seem to do today. The population of Athens in the Hellenistic period was about 200,000.

Although Athens was the most exciting place for a student of philosophy, it must have seemed a rather quiet spot for princes, artists, poets, and sailors. Athens was cherished as a moral ally, but she really had little military power; there were not a great many buildings and sculptures being commissioned; there was no local king to praise in poems, and no lavish court to provide room, board, and entertainment. With no navy to speak of, Piraeus, the port of Athens, was only moderately interesting. Except in philosophy, the great innovations and experiments of the age were taking place elsewhere, in newer and wealthier cities.

In spite of this, nearly all the famous men of the period, whatever their occupation, came to Athens at one time or another. Often they came to look, for Athens set out to be a showpiece and to exploit what no other Hellenistic city had to such a degree: a glorious past. Visible signs of it were everywhere. On the Acropolis (upper right in the photograph) stood the Propylaea, the temple of Athena Nike, the Parthenon, and the Erechtheum, gleaming in their tawny whiteness, each one a vivid reminder of the golden age of Pericles. The Parthenon, as architects from abroad must instantly have recognized, was unsurpassed in its beauty. They seem to have been moved to record its measurements for future reference and to have taken notes on its sculptures (125). In the agora itself there were monuments and statues honoring the city's founders and heroes, and also buildings that went far back into their civic history. On the south rose one of most revered sites of all, the hill of Ares, or Areopagus, (middle right, just below the Acropolis) where the oldest Athenian council met and which furnished the principal setting for Aeschylus' *Eumenides*. On the west side, overlooking the agora, there was another Periclean temple dedicated to Hephaistos (middle left). There was so much to see, the tourist needed a guidebook. Accordingly, one was written in the late third century and another in the second, both of which survive, in part, in the compilation put together by Pausanias in the second century A.D.

The old was preserved, but renovations and additions were welcomed. The king of Pergamon, Attalos II, must have been handsomely cheered when he presented the long colonnaded stoa (center) to frame the east side of the agora. Other kings made similar large-scale gifts (66) to the city.

In the right distance are the unwooded but lovely slopes of Mount Hymettos, mauve at twilight and famous for their honey. In the left distance is the Pentelikon range of mountains, source of marble for buildings on the Acropolis and in the agora.

Hellenistic Athens suffered a major blow. In 86 B.C. she sided with Mithridates VI of Pontus (14) against Rome. Sulla, the Roman dictator, took revenge and

laid siege to the city. The outraged Athenians pointed to their services to Rome and their historic past. Sulla replied he had come to punish rebels, not to learn ancient history. Thereupon he broke into the city, slaughtered her inhabitants, and destroyed or pillaged many of her buildings and monuments.

The pyramidal mountain in the distance is Mount Lykabettus. This photograph was taken in 1959; the trees and shrubbery in the agora are by now much more luxuriant. Pausanias 1.2.4-1.17.1 H. A. Thompson and R. E. Wycherley, *The Agora of Athens*: H. A. Thompson, *The Athenian Agora, A Short Guide*, Princeton, N.J. 1976.

38, 39 Athens, Agora, Stoa of Attalos II (restored)

When a young man, Attalos II, king of Pergamon (ruled 159-138) had come to Athens to study, and out of deep veneration for the city he later donated this impressive long stoa (a shed with an open front) to close off the east side of the agora. The stoa as an architectural form was of great antiquity, but its monumental and spatial possibilities were not fully realized until the Hellenistic age. A stoa can be extended indefinitely; it is both open and closed; and it can serve a wide variety of functions not just in agoras, but in religious sanctuaries, theaters, and gymnasiums.

The Stoa of Attalos is two-aisled and two-storied. On the facade the lower colonnade is Doric, and the upper Ionic. The ridged roof is carried internally by a colonnade with Ionic capitals below and by columns with bell-shaped Egyptian palm capitals on the second floor. Lining the back of each story were twenty-one rooms which functioned in antiquity as shops. Today they have been rearranged below to serve as the Agora Museum and above as work space for the excavation staff of the American School. Outside staircases at either end of the building gave access to the upper floor, and in the spaces beneath the stairs were arched alcoves, the first known instance of the revealed arch in Athens. Extending in front of the entire facade is a broad terrace where spectators could get a good view of the colorful Panathenaic procession which followed the diagonal path (lined with stones at right) leading to the Acropolis beyond. The view must have been still better from the parapet above.

The regular rhythm of the colonnades, the repeated horizontals of the terrace, cornices, and moldings and the boxlike effect of the whole might seem monotonous to the modern eye. Yet the stoa when experienced and observed in detail is rich in effect and always changing. While walking along and in and out of the building, the columns close up into a wall one moment and open out the next. Flutes and triglyphs animate the surfaces, and lions' heads and palmettes enliven the roof line. The interior is cool, spacious, and airy, alive with contrasts of light and shadow. Color, too, is present. Against a white background of Pentelic marble there is the pale blue of the parapet, the pale red of the terra-cotta roof tiles, and the deep green of the vines and shrubbery that adorn the terrace. The stoa was rebuilt between 1953 and 1956 by the American School, using the preserved fragments wherever possible.

L. 116.5 m. W. 20.05 m. Pentelic marble for the facade and all columns and limestone for the walls. 45 columns on each story. Roof beams, originally of wood, are now of concrete encased in wood. T. D. Boyd, *Arch and Vault*, 72; J. J. Coulton, *The Architectural Development of the Greek Stoa*.

40 Athens, Plan of the Agora after Hellenistic Remodeling

Early in the sixth century B.C. the Athenians developed the sloping area northwest of the Acropolis as the site of their marketplace. Buildings soon began to rise, each one facing the open plaza and adjusting itself to the terrain and existing thoroughfares. By the fifth century a row of small buildings had closed off most of the west side; by 450 the Stoa Poikile, or Painted Stoa (A), had been built on the north; and by 400 B.C. another stoa had gone up on the south. Except along the west border, however, the agora often merged unceremoniously with the ordinary streets.

Shortly after 200 B.C. the agora was given a face-lifting with the addition of several new buildings, changing the character of the whole area. A space once so open and undefined became almost

completely enclosed; buildings which had been small and self-contained were enlarged and made to pay attention to their neighbors; what had been an assemblage of independent structures became a coherent design. In other words, the agora had ceased to be Classical and had become Hellenistic.

On the west the small temple of Apollo Patroos (B) and the Stoa of Zeus (C), both of classical date, were left undisturbed, but during the building program of the second century a very important addition was made on this side: a long porch was attached to the new Metroon (D). The spectator in the agora now saw on the west a succession of columns—in front of the Metroon, the temple of Apollo and the Stoa of Zeus—forming together a continuous monumental facade interrupted only briefly to allow a view of the sacred temple of Hephaistos (E), also columned. If he looked south the enormous new Middle Stoa (F), erected perhaps by Ptolemy VI and begun in 175, presented a similar colonnaded facade, and so did Attalos' stoa on the east (G). The agora thus became more regular and definitively shaped, more formal and imposing. Because the modern city and the subway overlie it, the north side of the ancient agora remains imperfectly known, but parts of it, including the Stoa Poikile, were no doubt colonnaded.

Every major street in Athens led to the agora, the heart and soul of the city. Secular and religious, political and social, athletic and educational activities were jumbled together in one dynamic environment. Few buildings were reserved exclusively for one purpose: the Metroon was a shrine to the Mother of the Gods, but it also housed the state archives; a law court, a palaestra, and a sanctuary to Theseus all seem to have been located in the Heliaia (H); and of course almost anything could happen in a stoa. Government officials dined and slept in the Tholos (I); the city council debated in the Bouleuterion (J); a schoolroom (K), a gymnasium (L), a fountain and perhaps a swimming pool (M) were located in the south. In short, the agora had everything, even to drainage and drinking water.

The agora has been excavated from 1931 to the present by the American School of Classical Studies. R. Martin *Re-*

cherches sur l'agora grecque. R. E. Wycherley, *The Stones of Athens,* Ch. II.

41 Miletus, Plan of the Hellenistic Agora

The Athenians had spruced up their agora (40) during the Hellenistic period. But their architectural practice was conservative compared with that of Miletus. How erratic and haphazard was the effect in Athens compared to the cool right angles and smug perfection of the plan of the Ionian city.

Despite the Hellenistic remodeling, the agora at Athens quite naturally retained some of its old irregularities. The Milesians, on the other hand, began to build an entirely new marketplace late in the fourth century. A low-lying area at the center of the city was chosen for the site. The work was prolonged over two centuries, and in the end two dignified agoras had been erected, one at the north and one at the south. The stoa was the major architectural unit in both. Though the stoa was a simple building, imposing spatial and framing effects could be achieved when stoas, tastefully spaced and varied in length, were combined.

Miletus was a busy seaport, so the first agora was built facing the harbor (top of plan). To a long Doric stoa with shops at the back (A) was added a short spur (B) at right angles at the west. Adjoining it on the rear was a square colonnaded court (C). In the third and second centuries the south agora gradually took shape. An immense stoa with three layers of rooms behind was built on the east (E), and facing it on the west were two L-shaped stoas with double colonnades (F). Between the two agoras a rectangular Council House, or Bouleuterion, (G) was constructed in the years 175 to 164. A little later the north agora was further expanded to include an L-shaped stoa (D) behind the earliest one.

Although right angles abound and stoas face each other and join, access from one agora to the other was easy, and the space they contained still remained quite free and open. There would be no claustrophobia here. A horseshoe combination of stoas (top center) enclosed and defined one side only, and one could wander down to the Council House with little restriction. The arms of a horseshoe, moreover, may differ in length, or the opening

may not be on axis. There is no strict symmetry anywhere. Nor were there hard and fast rules in respect to the function of each area. Buying and selling may have been heaviest in the north agora, but trade was also conducted in the east stoa of the south agora (E). Political meetings were held in the Council House but no doubt spilled over into both agoras. Perambulation was probably more pleasant away from the docks in the quieter and cleaner south agora, but as in Athens there was an intermingling of activities.

T. Wiegand, ed., et al., *Milet: Ergebnisse der Ausgrabungen und Untersuchungen seit dem Jahre 1899*, Berlin, 1906-1936. R. Wycherley, *JHS, 62*, 1942, 21-24. R. Scranton, *AB, 31*, 1949, 247-68. On Hippodamus and Miletus: A. Burns, *Historia*, 25, 1976, 414–28.

42 Priene, Acropolis and Ruins

Priene was a very old Greek city, one of the first to be founded, about 1000 B.C., by the Ionians, who had left the Greek mainland and began settling along the west coast of Asia Minor. It is not, however, that first settlement (whose location is unknown) that is of interest to us. Because of the silting up of the river Maeander, the Prienians decided about 350 B.C. to abandon their old city and found a new one not far away. A site that could be defended was desirable. This they found a few miles inland from the sea, just north of the Maeander on the southern flank of Mount Mycale. One enormous, sharp protrusion formed a redoubtable back wall as well as an acropolis. From the other three sides the site was vulnerable, and ramparts and towers (which can be seen in the distance) were begun at once. Simultaneously the Prienians traced out as speedily and practically as possible a new city plan.

The city opened its arms to Alexander the Great when he arrived in 334 after defeating the Persians on the river Granicus. It was perhaps in memory of his visit and his financial contribution to the building of their temple of Athena that they set up his portrait (1, 2) in a shrine. Priene, whose population was around four thousand, was a small city compared to its neighbor Miletus. During the Hellenistic period it played no leading role in

historical events; yet it was affected by and forced to submit to the aggressive maneuverings of Ptolemaic, Seleucid, and Pergamene monarchies. When Pergamon bequeathed herself and her territories to Rome in 133, Priene was included and became part of the province of Asia. The Romans exacted what taxes they could from her, yet she was still rich enough to build a gymnasium (49).

Excavated by Germans between 1895-98. Ruins of city are visible at right half of photograph in middle ground. T. Wiegand and H. Schrader, *Priene, Ergebnisse der Ausgrabungen und Untersuchungen in den Jahren 1895-1898*. M. Schede, *Die Ruinen von Priene, kurze Beschreibung*, Berlin, 1964. The foundation for the new city in 334 B.C.: D. von Berchem, *Mus. Helv.* 1970, 198–205.

43, 44 Priene, Plan and Model of Hellenistic City

The new Priene was built on the irregular, rapidly rising slope under the Acropolis. In some respects the nature of the terrain was ignored, in other it was exploited to great advantage. A grid design, more suitable to a flat landscape, was chosen for the city plan. As a consequence, terraces had to be built throughout, and while the streets running east to west were manageable, those running north and south often became arduous staircases. In their compulsive geometric march, some streets came to a dead-end against the city wall. On the other hand, the wall (A) itself, which circumscribed the lower part of the city and took in most of the Acropolis, zigzagged back and forth in response to the difficult terrain. The theatre (B) and the assembly hall (C) were located high up so that their seats could rest against the steep hillside. The main sanctuary (D), devoted to the city goddess, Athena, was situated on a promontory above the agora (E), towering over it symbolically in the same way that the Acropolis towers over the marketplace at Athens (37). Even in the arrangement of the streets the checkerboard system was not allowed to become an absolute straitjacket. One east-west street departed from its course in order to go behind the stoa at the south border of the agora. The lower gymnasium (F) and the stadium (G), which were not provided for in the original grid

plan, avoided its geometry altogether and were fitted in to suit the convenience of the ramparts and the terrain in the late Hellenistic period.

All the streets were narrow by our standards, purely functional and without monumental character. Six ran east to west, two of them slightly wider than the others because they led from an outer gate to the heart and center of the city, the agora. Of the fifteen north-south arteries, only one (H), coming down past the sanctuary of Athena to the agora, was emphasized. The model shows particularly well the private quality and modesty of the houses in contrast to the open expanses and columned grandeur of the public areas, which occupy so much of the city. The two zones are blended by the grid system, yet neither one impinges upon the other.

The Greeks associated town planning and the grid system with the name of Hippodamos of Miletus, an architect who lived around the middle of the fifth century. He is known to have designed two or three towns himself, and he probably inspired the scheme of his native city, Miletus (41), that of Priene, and those of many other new cities which were being built in Asia Minor during the Hellenistic period.

Average width of E-W streets: 3.8 m. to 4.4 m.; wider E-W avenues measure from 5.6 m. to 7.4 m. Width of ordinary N-S streets: 3.2 m. to 3.9 m.; wider N-S street measures 5.6 m. R. E. Wycherley, *How the Greeks Built Cities*, 2nd ed., 69-74. A. von Gerkan, *AM, 43*, 1918, 165-176, That Hippodamus did not invent the grid plan is clear, as a result of recent excavations at Old Smyrna. Cf. J. M. Cook et al, *BSA*, 53-54, 1959, 1-181. J. B. Ward-Perkins, *Cities of Ancient Greece and Italy*, 14–17; J. R. McCredie, *Studies Presented to G. M. A. Hanfmann*, 96–100.

45, 46 Priene, Council House

No Greek city-state was without its political meeting place. In a matter of a minute or two, the citizen of Priene could make his way through the shady stoas of the agora to the Council House. Conveniently located, cool because it was roofed, it was a building well made, commodious and dignified.

The building, which was almost square, borrowed as a facade some of the columns of the stoa to the south but otherwise it presented a severe unadorned exterior (see 44). The interior, which resembled a theater, was what really mattered to the architect.

The unpaved rectangular "orchestra" was the focal point. Here the speaker addressed his audience; in the center stood the elaborate square altar where sacrifices were held before the meetings began. The marble seats rose in three sections defined by diagonal aisles at four points. (Two are visible in the photograph and drawing.) A level passage paved with marble ran along behind the seats but turned into steps to reach the higher level at the back of the auditorium. The wooden roof covered an unusually wide span and was supported on the interior by fourteen stone pillars whose lower courses still remain.

The seating capacity of this meeting hall was between six and seven hundred. It was just large enough to accommodate an assembly, or *ecclesia*, of all the voting male citizens of Priene, the ultimate governing body of the city. The council, or *boule*, a smaller executive body, probably met here too. A rectangular niche open to the sky and fronted by a beautiful semicircular arch faced the whole auditorium and provided choice seats for the presiding officers. The hall was erected around 200 B.C.

Auditorium measures 18.5 m. wide by 20.3 m. long. On the altar, which is of the third century, are bulls' heads, garlands, and busts of Asklepios, Apollo, and perhaps Hermes and Herakles. W. A. McDonald, *The Political Meeting Places of the Greeks*, 84-91, 264-66. F. Krischen, *Antike Rathäuser*, Berlin, 1941.

47, 48 Priene, Theater

The theater at Priene was compelled to obey the rules laid down by the city plan. Two blocks, or insulae, of the checkerboard were reserved for it, one and a half actually being used. The horseshoe auditorium faced south to conform with the longitudinal axes of the blocks. The stage was built exactly parallel to one of the east-west streets (see 43, B). Geometric logic was thus maintained. Yet the theater at Priene, like nearly all Greek theaters, looks as if it had been there forever, like a natural feature of the landscape. To a certain extent this is true, for the auditorium was hollowed out of the hillside, not built on top of it as Roman theaters were. The theater is small; it seated about five thousand.

An orchestra, or flat circular area at the center, a one-storied scene building, and an auditorium of

seats were the standard components of all classical Greek theaters. To these, Hellenistic architects added a new and exceedingly important element – the raised stage – of which the theater at Priene contains the best-preserved example.

The stage building consisted of two parts; the scene building, which now becomes a two-storied structure with dressing and storage rooms, and a narrow, one-storied podium projecting in front – the proscenium. The facade of the proscenium was formed by twelve pillars, ten having engaged Doric columns and all carrying an architrave and frieze of triglyphs and metopes. Stone crossbeams then ran back to the main building, and wooden boards were laid between to form a platform. Of the spaces between the pillars, two were closed by grilles, three by double doors, and the remaining ones by interchangeable wooden panels with painted scenery. Three gigantic doors (*thyromata*) opened in the upper story of the scene building. They could be used to extend the stage space provided by the roof of the proscenium, or they could be closed by a curtain or painted like a backdrop. When the entire stage building is thus analyzed it becomes clear that performances could be conducted in two separate places: the orchestra, for which the proscenium would form an architectural backdrop, or the roof of the proscenium *logeion* for which the upper story of the scene building could supply a similar setting. But why two stages? Could they not make up their minds?

Like so much of Hellenistic art, the theater design at Priene and other sites adopted the new without abandoning the old. In the classical tragedies of Aeschylus, Sophocles, and Euripides, the chorus was an organic part of the dramatic action, which took place entirely in the orchestra. By 300 B.C., due chiefly to Menander (33) and other New Comedy poets, dialogue rather than dancing dominated the performance, the role of the chorus had declined, and the individual actors had, so to speak, stolen the show. They did not need the large stage space provided by a circular orchestra; for dramatic concentration and visibility they were better situated on a narrow, raised stage. But classical tragedies were frequently revived during the Hellenistic period and so, in spite of New Comedy fashions, the orchestra had to be retained. On the other hand, the presence of the orchestra was not lost on the writers of New Comedy, and they did not regard it as waste space. Although the dramatic action of their plays was confined to the raised stage, they wrote choral interludes which were performed in the orchestra. The interludes were not necessary to the plot, but would they not have reminded the audience, perhaps intentionally, of the classical past?

The double function of a Hellenistic theater such as the one at Priene resulted in a rather loose organization of the parts. The stage building, intercepted by a deep orchestra, seems remote from the auditorium. With the orchestra as the stage at one time, and the proscenium at another, where was the best seat? It was left to the Romans, with different traditions and needs, to solve some of these problems.

There is much dispute about the date of the stage building at Priene. The theater as a whole was laid out about 300, but the stone proscenium was probably added a century later. The drawing shows what the theater was like in the late second century after numerous and problematic alterations.

Seats of marble. The Romans extended the scene building. A. von Gerkan, *Das Theater von Priene*. M. Bieber (*History of the Greek and Roman Theater*, 108-15, 126-28) and W. B. Dinsmoor (*Architecture of Ancient Greece*, 302-08, 312-14) have good discussions of all the problems involved.
According to A. von Gerkan (and W. Müller-Wiener, *Das Theater von Epidauros*, 1961), a stone proscenium was erected in the theater at Epidauros early in the third century, but was rarely used.

49, 50 Priene, Lower Gymnasium

A seemingly endless staircase which formed the lower end of "Main Street" (running north and south) took one down to the gymnasium, another building characteristic of a Hellenistic city. It was entered by a handsome columned gateway (A) facing both out and in. This gateway and one small door at the east were the only breaks in the solid exterior wall. Inside, open to the sky and filled with sun and air, was a spacious square court (F) defined by fifteen Doric columns on each side. Here on the soft earth, naked wrestlers, boxers, jumpers, kept themselves in shape by exercise and contest. Should the weather prove inclement they could move inside to the cor-

ridor (B) at the north which was protected from a stiff wind or rain by the walls behind it and yet remained open toward the south for invigorating air and necessary light. If a running track was needed, the door at the east (C) led to a long colonnaded portico above the stadium which conveniently adjoined the gymnasium. A series of rooms along the north and west of the gymnasium was also at their disposal; the rooms were used when applying oil to the body, for rubdowns, or for workouts with the punching bag. Equipment remaining in two of these rooms allows us to determine their uses with certainty. In the northwest corner was the washroom (D). Five raised basins with a water channel above were found against the back wall, and two long basins for washing the feet were found in the floor at either side of the entrance. There were no bathtubs, and there was only cold water. To a Roman, and of course to us, the bathing facilities would seem meagre, but oil, not water, was the chief cleansing agent in ancient Greece.

Down the corridor was the most interesting room (E) of all. A wide entrance was punctuated by two Ionic columns between antae. Within, a wooden bench ran along all three sides. To the height of ten feet the walls were faced with marble, and Corinthian half-columns adorned the upper part. A room of this type has been found in many Hellenistic gymnasiums; it is a lecture or school room, sometimes called an *exedra* or *ephebeum*. The benches indicate its function, and the hundreds of names scratched on the walls by those who sat there furnish endearing confirmation.

In classical times a Greek gymnasium was the school for physical education and training. By the Hellenistic period intellectual instruction had been included and had become very nearly the most important part of the curriculum. Professors of philosophy, rhetoric, and grammar were appointed to the faculty along with gymnastic teachers. Visiting lecturers, such as the one we see in our drawing (50), came and tried out their ideas on the young men of eighteen years (*ephebes*) who attended the gymnasium for one year at the city's expense. They received both physical and spiritual edification; in typical Greek fashion the Prienians believed that the whole man, body as well as mind, profited from training

and discipline. Gymnasiums sprang up everywhere in the Hellenistic world, in newly founded cities as well as in the old.

An inscription conveys the information that a rich citizen of Priene by the name of Moschion built the gymnasium there about 130 B.C.

The gymnasium is all on one level. Court is 35 m. 55 by 35 m. 11. F. Krischen, *JdI, 38-39* (1923-24), 133-50. J. Delorme, *Gymnasion: étude sur les monuments consacrés à l'éducation en Grèce, des origines à l'empire romain*, Paris, 1960.

51 Priene, View of "Athena Street"

"Athena Street" (see 43, I) was one of the arteries running east to west above the Council House and the agora at Priene. It was so named by the excavators because it led directly to the chief sanctuary of the city, that of Athena Polias. Yet it formed a narrow and undistinguished approach, for ordinary houses (whose stone walls are still visible at the lower left of the illustration) crowded along its edges blocking the view and making the street itself a utilitarian passage rather than an avenue with calculated architectural effects. The streets of Priene, like those of other Hellenistic cities, were unpaved except in the stretches where the ground was steeply sloping. The public fountains and a few private houses received water by means of simple gutters, mostly open but occasionally covered, still preserved in other parts of the town. The enormous supporting wall required for the south terrace of the sanctuary of Athena projects mightily in the left middle ground. As in every inch of the city wall, the masonry here is beautifully rusticated; it avoids monotony and is of extremely high quality.

The photograph looks toward the west. The half-ruined pillar is what remains of the gateway, of Augustan date, to the sanctuary of Athena.

52 Priene, House 33 on "Theater Street"

All the city blocks in Priene were the same size. Each one normally contained four houses, packed tight one against the other, sharing walls and sometimes roofs. Every house was, however, a self-contained

entity, ignoring its neighbors and the street, and putting on no outward show.

House 33 was one of the more fashionable houses that stood on the north side of "Theater Street." The wall facing the street was composed of attractive bossed masonry, and it was pierced by an unimposing doorway – the only entrance. A small vestibule then sheltered the visitor while he waited at the door just beyond. He next passed through a long pillared passage to the open area of the court, the heart of the house and one of the constant elements of Prienian houses. Several rooms were grouped around it, but the one on the north was more striking than any other. It had a very broad entrance containing two stately Doric columns; a porch (*prostas*) and finally a door led to a rectangular room, the largest and tallest in the house. This was the main living area (*oecus*). One smaller room led from the *oecus* and another from the *prostas*, the latter probably being an *andron*, or dining room. The kitchen cannot be identified, and there was no bathroom. Bedrooms cannot be identified either, but they were probably on a second floor. The small rooms at the southeast could have been offices or servants' quarters. Personal comfort was not entirely overlooked. A portable brazier was available to be moved to any room. The court and *prostas*, which were oriented north and south, received the maximum amount of sun and warmth. Only the court was paved, other floors being of hard-packed earth. There were a few windows in the presumed second story.

House 33 was built in the third century. It has, compared to Greek houses of the fifth century, a new monumentality and formality. Instead of a lax accretion of irregularly shaped rooms, one is selected for special emphasis by size and by the addition of columns. But as we shall see in the next example, the desire for a rational design was not dependent on the Hippodamian system. Rather, the more luxurious and monumental dwellings which now appear in the Hellenistic age can be considered an expression of the new individualism and the new emphasis on the private as opposed to the public sphere. It is interesting to observe in the same connection that the citizens of Priene would not have tolerated the worst aspects of present-day housing developments. No two residences are the same. In spite of the uniform-

of the blocks, there was marvelous individuality in the internal arrangement of rooms.

Size of blocks, 47.20 m. × 35.40 m. The exterior house walls and even several on the interior were of stone. Upper walls perhaps of sun-dried brick. Wiegand and Schrader, *Priene*, 285-87; D. M. Robinson, *The Hellenic House*, VIII.

53, 54 Delos, House of the Masks

The streets of Delos were narrow and sometimes tortuous because of an uneven terrain. The blocks between were consequently highly irregular and were so arbitrarily divided and subdivided that the houses were virtually shapeless. The House of the Masks (called that because it contained a mosaic decorated with masks), which occupied about one-half of a block, was sandwiched in like all the others, yet it had a certain palatial air. In common with House 33 at Priene, privacy and inwardness were the keys to the plan. One unobtrusive doorway (A) opened from the street on the east into a long vestibule at the end of which was a second door. After this came a vast square room (B). In the center of it was an open, rectangular court surrounded by twelve Doric columns. By comparison the courtyard at Priene now seems an afterthought. At Delos the courtyard is spacious and elegant, and because of the columns, definitely shaped and articulated. To the north was the next largest room of the house, the *oecus* (C), and on either side two more rooms (D, E) of nearly the same size faced each other across the portico. These three rooms, which were reception and banquet halls, were very special not only because of their size but because of their floors, which were covered with rich mosaics, both abstract and figurative in design (Pl. XVIII). The courtyard acts, then, as the focal point for a good part of the house, both geometrically and functionally. The plan is not exactly symmetrical and there is not much concern for axial alignment, but a definite attempt has been made to organize the major spaces to anticipate one another.

The southern part of the house was one-storied, and therefore lower than the two-storied north, in order to give the winter sun as much access as possible. For the same reason the columns on the north

side of the peristyle were higher than the others. The brackets on the angle columns held the architrave of the other two sides. Roofs were probably flat throughout. The walls of every room were plastered and painted with architectural designs that closely resemble the "Incrustation Style" familiar to us from Pompeii. An altar, a regular feature of every Greek house, was found at the east doorway.

In many houses excavated at Delos, a cistern was found beneath the *impluvium*, the sunken basin of the peristyle court. In the House of the Masks a roughly shaped cistern was located in the large area south of the court (F). It is immense and could easily supply the neighbors as well. Since the water from neighboring roofs was conducted to this cistern, they had, in any case, every right to draw from its contents. They reached it without disturbing the inhabitants of the House of the Masks by way of a long passage (G) leading from the street on the southeast. The plan also shows the drainage system (H) whereby the waste was carried along the floor in terra-cotta channels to the *impluvium* or across the court to be discharged into the street at the west.

Within the same block there are three other dwellings, two (I, J) (on the northeast and southeast) containing similar but more modest elements. In these houses we notice that the rooms adjacent to the street are trapezoidal whereas the walls of the interior have been marshaled into rectangles. House C, on the southeast (J), which had a peristyle court, may have constituted a separate apartment set aside for the women of the House of the Masks. The single rooms to the northeast with one door on the street were probably shops. Unlike Priene, business could be conducted in the residential areas at Delos. The house was built during the first half of the second century when Delos was a booming port.

Except for the mosaic pavements, flooring was of packed earth. All walls were of loose stone, mainly granite. Dimensions of the nearly square court: N: 13.78 m., S: 13.28 m., E: 13.60 m., W: 13.77 m. J. Chamonard, *BCH*, *57*, 1933, 98-169. In *JdI*, *50*, 1935, 1-8, A. Rumpf analyzes the correspondence between the House of the Masks and Vitruvius' description of the Greek house. C. Krause, "Grundformen des griechischen Pastahauses," *AA*, 1977, 164–69.

55 Alexandria, Pharos

Ancient poets and writers sang the praises of the city of Alexandria. It was the most cosmopolitan, the most colorful, and judging by Idyll XV of Theocritus, one of the most exasperatingly crowded of the new large Hellenistic cities. We hear from the various sources of its broad streets and magnificent buildings: the royal palace of the Ptolemies, the Museum, the Library, the Sarapeion, the Tomb of Alexander, the gymnasium, and on the outskirts the lovely gardens. But no building excited more enthusiasm and admiration than the great lighthouse which stood on the tiny island of Pharos. Its flaming beacon guided ships past reefs and shallows into the two harbors on the north side of Alexandria.

The appearance of the lighthouse is roughly known through coin representations of the Roman period and through vague descriptions, chiefly written by awestruck Arab writers of the Middle Ages. Occasional representations on reliefs, mosaics, and glass are perhaps more confusing than helpful. Taking all the evidence into account H. Thiersch in 1909 proposed a reconstruction (shown in the drawing) which in the main has been accepted ever since. He was not aware, however, of the findings of an industrious Andalusian Moor who measured the remains in 1165-66.

The lighthouse, which took the name Pharos from its location, reached the astounding height of 440 feet. The foundation was formed by a platform whose sides sloped inward. The tower itself then ascended in three sections: one square, one octagonal, and one round, each with tapering sides and each set back from the one below. Inside the square section, which measured about 100 feet in width, a spiral staircase and many rooms. On its exterior, tritons blowing through conches were probably seated atop its four corners. The octagonal and circular sections are extremely problematic. Did they contain an elevator for hoisting the fuel to the flame? Where exactly was the flame? Was wood, oil or naphtha burned? The sources mention reflectors to intensify the beam, but where were they? And one wonders how many other gadgets, reflecting the scientific thinking of Alexandrian scholars, went into the

lighthouse. A statue stood at the summit, and here too there are questions. Did it represent Poseidon, the lord of the sea, holding his trident (shown in the drawing), or was it Isis, Zeus, or the figure of a Ptolemaic king in nude heroic guise? If the Moor's measurements are indeed those of the ancient building, the sections seem to have been mathematically proportioned.

Strabo mentions the dedication inscribed on the south facade. It read: "Sostratus of Knidos, to the savior gods, on behalf of the mariners." Sostratus was, we know, the architect, and Ptolemy Soter and his wife Berenice (6) were the savior gods. The lighthouse was probably built by their son Ptolemy II and dedicated in 279 B.C., the same year in which he held a great procession in honor of his parents. Traces of it have been found recently.

H. Thiersch, *Pharos, Antike Islam und Occident*, Leipzig and Berlin, 1909. M. Asin and M. L. Otero, *ProcBritAc, 19*, 1933, 277–92. C. Picard, *BCH*, 76, 1952, 61–95. S. Stucchi *Aquileia Nostra* 30, 1959, 17–31; R. G. Goodchild, *The Antiquarian Journal* 41, 1961, 218–23. H. Frost, "The Pharos Site, Alexandria, Egypt," *J Naut.Arch.* 4, 1975, 126–30.

56, 57 Athens, Tower of the Winds

Vitruvius tells us that the astronomer Andronikos from Kyrrhos in Syria designed this fascinating building which provided the ancient Athenians with a fund of information about time and weather. It was erected about 40 B.C. near the entrance to the Marketplace of Caesar and Augustus, which was not distant from the Greek agora (37). Thus the tower was in the "downtown" area where it was most needed by merchants and the general public.

The building is octagonal in shape, each of the faces corresponding exactly to one of the eight wind directions systematized by Aristotle (26). The winds, winged and in human form, are represented in the frieze just below the cornice. Inscribed above them are their names. The full figure shown at the left of the detail (57) is Boreas, the north wind. His warm clothing and buskins, his fierce expression, and the shell trumpet he is preparing to blow indicate very clearly what the Greeks thought about his stormy and noisy nature. At the right stern Skiron, the

northwest wind, dumps his unpleasant contribution out of his overturned jar. In contrast, the side facing the warm west wind depicts Zephyrus almost nude with flowers filling his cloak. Disappeared long ago, a weather vane in the form of a bronze triton pivoted in the middle of the roof, holding out his rod above the side from which the wind was blowing. Another ancient writer, Varro, says that there was also a device in the interior to show wind-direction. The compass had not yet been invented, but the tower must in fact have functioned in some such way. Beneath each wind (and visible in 57) are the incised lines of a sundial. Inside the tower there was another time machine, a water clock whose mechanics are only now being reconstructed. The water was apparently supplied from a circular reservoir which is attached to the exterior of the south wall.

The building had two large doorways, each reached through an airy porch with an entablature supported by two Corinthian columns. The figures of the winds in the frieze are in high relief and bear marked traces of the "baroque" style which we associate with Pergamon.

Pentelic marble. H. 12.80 m. Dia. 7 m. Doors are on NW and NE. Roof was octagonal on exterior, conical on interior, and made of twenty-four marble slabs. The "window" is not ancient. Vitruvius I. 6.4. Aristotle, *Meteorologica* 2.6. H. Robinson, *AJA, 47*, 1943, 291-305. D. J. de Solla Price, *National Geographic, 131*: 4, April 1967, 586 ff. A thorough discussion of the intricate mechanisms of the clock has just been published by J. V. Noble and D. J. Solla Price in *AJA* 72, 1969, 345-55, pls. 111-18. J. Travlos, *Pictorial Dictionary*, 281, Figs. 362–78.

58 Samothrace, Arsinoeion

Circular buildings were quite rare in Greece. This one, on the island of Samothrace, is the largest closed one known, having a diameter of over 20 meters. The dedicatory inscription, part of which has been found, states that it was the gift of Queen Arsinoe (7) when she was the wife of Lysimachos.

The rotunda, now only ruins, was the most spectacular of the several buildings erected in the Sanctuary of the Gods, for which the island was famous particularly during the Hellenistic and Roman periods. Samothrace, surrounded by dangerous seas and dominated by rugged mountains, has

a primeval beauty and provides a most dramatic setting. Cults to the "Great Mother," the supreme fertility goddess, and to the twin youths, the Kabeiroi, as well as to several other pre-Greek and Greek divinities, were celebrated from day to day and at great annual festivals. Included in the ceremonies were the "mysteries," whose rites, only vaguely known, were solemnly performed by the initiates who hoped for good things both in this world and the next. The sanctuary also served as a place of refuge. Arsinoe escaped to Samothrace before going to Egypt to marry her brother. Perseus, King of Macedon (11), after his overwhelming defeat by Aemilius Paullus, fled to the sanctuary before giving himself up.

The lower part of the rotunda was a solid wall of masonry pierced on the south by a doorway. Above a decorative molding there was a gallery of forty-four Doric pilasters carrying a triglyph entablature. Between the pilasters were windows and parapets which were ornamented with libation bowls and bulls' heads. On the inside Corinthian half-columns were attached to the pilasters. The conical roof was made of scale-shaped tiles and was crowned by a marble finial decorated with laurel leaves. Round buildings in Greece were often used for sacrificial rites. This seems to have been the case here, for excavations in the interior and periphery revealed the existence of altars, and the finial contained a device for the escape of smoke. But the building may also have served as an assembly hall 'for the dignitaries who visited the sanctuary during the annual festivals.

Built between 289-281. Dia. 20.4 m. Foundations of limestone, superstructure of Thracian marble. K. Lehmann, *Samothrace: A Guide to the Excavations and the Museum,* 3rd ed. New York, 1966. K. Lehmann, *AJA, 44,* 1940, 326-58. The statue as the crowning feature of the finial is hypothetical.

59, 60 Sardis, Temple of Artemis

The craggy and crumbling peaks and cliffs of the Acropolis of Sardis overlook the ruins of the huge temple of Artemis. Deep within a peristyle of eight by twenty Ionic columns is the cella (A), which consisted of two large colonnaded shrines

devoted to two separate deities whose cult images stood back to back. In front of each porch of the cella were six additional columns, arranged in a row of four, with two on the returns. The central pair were of smaller diameter and were consequently raised on high square pedestals intended to receive sculpture in relief. One of these unfinished pedestals and the fluted columns that stand on them are visible in the center of our photograph. A great rectangular hall (B) was thus formed at each end of the temple, and two more wide and lofty spaces were provided by the deep corridors on the flanks. Although it is a Hellenistic idea to bury the cella within open areas in this way, the temple at Sardis nevertheless retained, no doubt deliberately, one feature that can be found in the archaic temple of Artemis at Ephesos: the graduated rather than uniform spacing of the columns. The central intercolumniation on the ends is distinctly the widest; toward the corners the interaxials become progressively smaller. The columns on the flanks, on the other hand, are crowded together. The soaring height of the whole temple was quite unlike the relatively low edifices of the archaic period. The Ionic capitals were incredibly beautiful and unusually ornate; the column bases were of the normal Asiatic type. A certain amount of movement was furnished by the change in level: the cella was five feet higher than the level of the peristyle and was reached by a series of steps inside the porches. A red sandstone structure situated at the west of the temple is probably an altar (C).

The fame of Sardis, the capital of Lydia, arose mainly in connection with the fabulous wealth and power of its last king, Croesus. In 547 he was defeated by the Persian king Darius who stormed the walled Acropolis. The city, which became the terminus of the Royal Road, remained in Persian hands until the arrival of Alexander the Great in 334 B.C. It then became an important Greek city in the Seleucid empire. About 180 B.C. the Attalid kings of Pergamon gained control of Sardis and, with all their other possessions, bequeathed it to Rome in 133 B.C.

There are numerous unsolved problems connected with the temple. Most of these arise from the fact that the first plans for the temple were apparently

altered and it is difficult to clearly distinguish the separate building phases. At least two major stages occurring during the Hellenistic period can, however, be hypothesized. An early Hellenistic temple was begun following a pattern similar to the archaic temple of Artemis at Ephesos in which the interior rooms were surrounded by two rows of Ionic columns. At this time there was only one cella, housing an image of Artemis, which opened on the west. Then either under Achaeus (220–215 B.C.) or Antiochos III (213–190 B.C.) major revisions were made in which the east end was opened up and the cella was divided into two parts. G. M. A. Hanfmann proposed that a colossal image of Zeus, fragments of which have been found, was set up in the east section at this time. The same revision converted the dipteral plan into a pseudotipteral scheme. Thus the spacious corridors we observe in the plan may anticipate the ideas of Hermogenes, the renowned architect of the late Hellenistic period who, according to Vitruvius, invented the pseudodipteral plan.

A devastating earthquake destroyed much of the temple in 17 A.D. The better-preserved columns at the east end are largely replacements made after that date. But the temple was never actually finished for most of the columns are still unfluted. The last major revision occurred when the Emperor Antoninus Pius (A.D. 138–161) erected a colossal statue of himself next to Zeus and one of his wife Faustina beside the image of Artemis.

Marble. Measurements of stylobate: 41.87 m. × 94.94 m. Height of columns: 17.73 m. Some of the architectural details are in the Metropolitan Museum of Art in New York. The photograph is taken from the west. G. M. A. Hanfmann, *A Short Guide to the Excavations at Sardis*, and same author, *BASOR*, April 1962, 1 ff. H. C. Butler, *Sardis*, Leiden and Princeton, 1922; G. M. A. Hanfmann and J. C. Waldbaum, *A Survey of Sardis and the Major Monuments Outside the City Walls*, Cambridge, Mass. 1975, Ch. V.

61, 62 Didyma, Temple of Apollo

By 335 B.C. the Ionian Greeks had become thoroughly dispirited; their freedom had been curtailed for a long time. A Persian garrison occupied the major city, Miletus. At Didyma, which stood in Milesian territory and was under the protection of the city, the renowned oracle of Apollo had been mute for a century and a half, his temple lay in ruins, his archaic bronze image had been carried off to Ecbatana by Xerxes in 494 B.C.

Alexander the Great, appearing like the god Apollo himself, suddenly brought deliverance. Advancing down the coast of Asia Minor, he liberated one Ionian city after the other. Miletus was besieged but not destroyed. At Didyma, only eleven miles away, the oracle was heard to speak again – uttering first the name of Alexander. A few years later, about 300 B.C., under Alexander's successor Seleukos I of Syria, a new temple to the god, more resplendent than ever, was begun, and the bronze image brought back. However the archaic design was in some respect preserved.

The design unites classical principles of proportion and order with Hellenistic concepts of space and grandeur. The whole temple rose proudly on seven high steps. The columns are quite close together, and the intervals and all the diameters are equal. Like the Parthenon the platform as well as the entablature has a slight upward curvature. Some of the moldings on the column bases and capitals have profiles conspicuous in their firmness and tension. In its attention to formal logic, in its mathematical organization, in its liveliness and density, the temple is definitely reminiscent of Attic architecture of the fifth century. On the other hand, the sheer height of the columns, the vast spaciousness of the interior as opposed to the corporeality of the peristyle, the dynamic contrasts between closed and open, light and dark areas, the movement and change arising from shifts in level, and the dramatic treatment of walls are in an entirely new spirit.

A double row of Ionic columns surrounded the cella, and twelve more filled the very deep porch, or pronaos. A colossal doorway then opened in front of the spectator. But he could not pass through it, for the threshold is nearly five feet above the floor level of the pronaos. Perhaps it was from this "manifestation" door that the oracle was delivered. From the antechamber behind, which contains two Corinthian columns, two staircases led to the upper storey. Also from the antechamber three doors led to a truly monumental staircase which took one down, a total of eighteen feet, to the great unroofed cella. At the back of this unpaved court

amid green laurel groves sacred to Apollo, stood a tiny Ionic temple, complete and independent. Here one saw the statue of the god and his oracular spring.

The architects were Paeonios of Ephesos and Daphnis of Miletus. It was one of the largest temples ever built in Asia Minor, and the work on it continued until the second century A. D. Even then it was never completed, as the unfluted columns and the bosses on the cella wall show.

Marble. Stylobate measures 51.14 m. × 109.38 m. Column height, 19.70 m. Axial spacing, 5.30 m. Total number of columns, 120. H. Knackfuss, *Didyma I, Die Baubeschreibung*, 3 vols., Berlin, 1942. W. B. Dinsmoor, *Architecture*, 229-33. J. C. Montegu, *AJA* 80, 1976, 340-45.

63, 64 Didyma, Temple of Apollo,
Interior Court and Cross Section

The court may be reached by the staircase at the west end of the antechamber or, from the pronaos, through long descending barrel-vaulted ramps. The grandeur upon entering must have been overwhelming, and the brilliance of the sun blinding after dark porches and tunnels. The soaring height of the walls seen from court level exceeded even that of the exterior columns, for the court level was well below the platform. The vastness of the open area was underlined by the handling of the walls. A high podium supported a series of immense pilasters. They projected very boldly and enlivened the surface with strong lights and shadows. Their capitals were varied in design, with long, narrow volutes framing either griffins or plant forms arranged in a symmetrical fashion. Between the capitals were further bands of relief with griffins saluting Apollo's lyre. Thus a continuous decorative border bound wall and pilaster together.

Placed toward the rear of the court, the Ionic shrine with its four slender columns might have appeared fragile in front of the giant pilasters. Yet the court as a whole and the pilasters which articulate its walls were, in fact, protective in effect and made the tiny jewel in their midst all the more precious. Only the foundations remain; the statue was lost long ago.

At the top of the great flight of twenty-four steps, the central of three doors was framed by two semidetached columns with Corinthian capitals.

H. of podium: 5.36 m. F. Krauss, "Die Höhe der Säulen des Naiskos in Tempel von Didyma," *Istanbuler Mitteilungen*, 2, 1961, 123-33, pls. 25-31. T. D. Boyd, *Arch and Vault*, 63-65; R. A. Tomlinson, *Greek Sanctuaries*, 132-36.

65 Didyma, Temple of Apollo, North Wall
of Pronaos

The colossal scale of the temple and the massiveness of its walls and columns can be vividly appreciated in this detail. The thick north wall of the pronaos projects at the center of the photograph, and the foreground columns to left and right are two of the ten that constituted the second row along the east front. Nothing was spared in this costly temple by way of ornamentation. Around the entire base of the cella wall ran two decorative moldings with convex profiles. Above a plinth, a guilloche weaves its way around the dots of its interstices. Above this ran a plain concave zone. In the second convex molding the design of horizontally bundled laurel leaves, terminated at the corners by upright palmettes furnishes reference to Apollo.

The outer row of Ionic columns of the east facade, probably of Roman date, rested on bases that are sometimes fantastically ornate. Those in the second row, shown here, are of the Hellenistic period and stand on bases of the usual Asiatic type: three thin roundels with flutes are separated by two deep concavities, and on them rests a convex disc which is also fluted. A square plinth forms a firm foundation, and the shaft with its flutes separated by fillets sits majestically on top. What seems almost miraculous is the way in which structural monumentality and massiveness have been combined with intricate and graceful detail.

66 Athens, Temple of Zeus and Acropolis

The temple of Olympian Zeus, situated on a broad flat plain and bordered with pines and cypresses, lies to the southeast of the Acropolis and constitutes, with the Acropolis, the most spectacular sight in Athens. Thirteen of the surviving columns stand in a cluster at the east end; two more toward the west guard the one broken colleague that lies between them. The periphery of the foundations and parts of the platform also remain. The area

was sacred even in remote antiquity. According to an ancient myth, Deucalion, the Greek Noah, worshiped the supreme god at this place before any temple was built.

The sons of the tyrant Peisistratos were the first to plan and to begin building the temple, late in the sixth century B.C. In size it was to exceed all others on the Greek mainland, comparable only to those colossal edifices erected in the Archaic age at Samos, Ephesos, Selinus, and Acragas. After Hippias' exile in 510 B.C. the work stopped, and the temple, whose dimensions but little more had been established, lay unfinished for more than three centuries.

Antiochos IV of Syria, like Attalos II, had spent part of his youth in Athens. He too wished to pay homage to this noble city by presenting it with a costly gift: he would finish the temple of Zeus. It was hardly a selfless project, however. As his title "Epiphanes" makes clear, Zeus was thought to manifest himself in the person of the king; the temple, therefore, would be available for the worship of both. Moreover, it was Antiochos' great ambition to unite all the Greeks in Asia under the aegis of the supreme god of the Hellenes.

As architect, Antiochos employed Cossutius, a Roman. While his ground plan adhered to that already laid down by the Peisistratids, Cossutius substituted the ornate Corinthian Order for the Doric of the original design. He probably did so at the request of the king, for the Seleucid monarchs favored this order. The columns, for instance, of the propylon in front of the Bouleuterion at Miletus (41), also built by Antiochos IV, were Corinthian, and among the architectural finds from the recently excavated city at Aï Khanoum in ancient Bactria (originally Seleucid territory) was the fragment of a Corinthian capital.

The work on the temple began in 174 and was carried up to the roof. But then in 164, Antiochos died, and once more the temple failed to reach completion. In 86, Sulla transported some of the columns to Rome to decorate the temple of Jupiter on the Capitoline. No doubt this is one of the reasons why later Roman architects took such a liking to the Corinthian Order. Some work was done under Augustus, but completion and dedi-cation had to await the emperor Hadrian in about A.D. 130. Near the chryselephantine statue of the god, Hadrian erected one of himself.

Pentelic marble. Arch of Hadrian visible in right middle ground. The agora (37) is on the other side of the Acropolis. Berve and Gruben, *Greek Temples*, 394-97. For Miletus, H. Knackfuss, *Das Rathaus von Milet*, Berlin, 1908, pls. IX-X. For Aï Khanoum, see 12. On Cossutius: H. Rawson, *BSR*, 43, 1975, 36-37; C. Williams, *AJA*, 78, 1974, 414.

67, 68 Athens, Temple of Zeus

The Corinthian Order had appeared in earlier Greek buildings, but never in such profusion. The columns proliferate around the cella: three rows of eight stood at the front and back and two rows of twenty along each side. There may have been more in the porches. The bases were similar to those of the Erechtheum, with a convex molding above and a concave one below. The capitals, however, are the main delight. Acanthus leaves unfurl in layers, volutes pop up at the corners, and a lilylike flower clings to the inward-curving abacus. The freedom and exuberance of these plant forms, their unwillingness to remain meekly bound to their background, are characteristic of all the art of the second century.

The emphasis on the length of the temple, in which the flanks measure well over twice the ends, is an archaic rather than classical or Hellenistic feature. The columns' interaxials are almost exactly equal throughout, however, revealing the rather pedantic interest in mathematical uniformity that permeates other temples of the period. The dense grove of columns, standing on the usual Doric platform of three steps, would pretty well have obliterated the walls of the cella, whose interior arrangement is still not known. Was it open to the sky? This is not likely, at least in Hadrian's time, for the gold and ivory cult statue of Zeus, copied after Phidias' work at Olympia, needed protection from the weather.

Measurements of stylobate: 41.12 m. by 108.0 m. Statue of Zeus is illustrated on Hadrianic coins. A.W. Byvanck, "Quelques observations sur l'architecture hellénistique", *BAntBeschav., 24*, 1949, 36-41. See P. Graindor, *Athènes sous Hadrien*, Cairo, 1934. H. Abramson, *California Studies in Classical Antiquity*, 7, 1974, 1-25.

69, 70 Magnesia, Temple of Artemis Leucophryene

Hermogenes was the most important architect of the Hellenistic period. Something of an intellectual, he wrote commentaries on two of his temples – that of Dionysos at Teos and of Artemis Leucophryene ("white–browed") at Magnesia. Vitruvius, who drew from these commentaries, held Hermogenes in such high esteem that he urged all budding architects to adhere to the principles of good design enumerated by the master.

The plan of the temple of Artemis is in itself quite fascinating. It is like an abstract painting, relying for both its visual beauty and meaning on strong contrasts, repetitions, and geometric harmonies. A rectangular central motif (cella) is enframed with Mondrian-like care and calculation by large dots and straight lines (columns and platform). Contrasts between solid blacks and whites are startling. When translated into three-dimensional architecture, we become aware that there are mathematical relationships that demand our appreciation and interactions between space and volume that are exciting and completely unclassical.

The temple proper, which faces west, was set high off the ground on a platform of seven steps. The top step is deep enough to form a narrow terrace all the way round, and here one could pause and admire the proportions and spacing of the columns. They are Ionic, Hermogenes' favorite order, and there are eight on the ends and fifteen on the sides. Except for the central pair on the facades, they are all evenly spaced, the distance between them being exactly the same as the width of the square plinths on which they stand. As in the Parthenon, the angle columns are enlarged. Between the peristyle and the cella there is a spacious, uninterrupted ambulatory. The cella, whose length is three times the width of the temple, is divided into three parts – the west porch, or pronaos, precisely the same depth as the shrine, and the back porch, or opisthodomos, half the depth. All interior columns are aligned with those on the peristyle. How neat, and how clear! The mathematical ratios throughout are simple, the whole design eminently rational. Attic details are fused with this overall

Ionic style. The columns have bases similar to those on the Olympeion (66), and a continuous sculptured frieze (158) surmounts the architrave just as it does on the fifth-century Erechtheum and temple of Athena Nike in Athens. There was no sculptural decoration in the pediment; to decrease its weight three apertures were introduced at the center and sides. Finally, three enormous floral akroteria were perched at the corners of the pedimental triangle.

Hermogenes, a great theoretician and neo-classicist, may have come from the city of Priene. The temple of Artemis was his last work and should be dated about 130 B.C.

Marble. Measurements of stylobate, c. 31.61 m. by 57.90 m. (Dinsmoor). Vitruvius, 3.26; 3.3.6-9; 4.3.1. Strabo, 14.1.40. C. Humann et. al., *Magnesia am Maeander*, Berlin, 1904. R. A. Tomlinson, *JHS, 83*, 1963, 133-45.

71, 72 Kos, Sanctuary of Asklepios

The sick and the diseased journeyed, full of faith, to the many sanctuaries of Asklepios, the god of healing, whose cult was enormously popular during the Hellenistic and Roman periods. Epidauros in the Peloponnesus was the site of one of Asklepios' major sanctuaries and so was Kos, an island off the coast of Caria. Sacrifices, prayers, and hymns preceded the period of incubation in which the patient fell asleep on a mat and was visited in his dream by the god, who either cured him then and there or prescribed potions, exercises, or diet which would in time allow him to recover his health. If Asklepios himself did not appear, perhaps a holy snake, the constant assistant of the god, would administer the necessary therapy. Miracles sometimes happened; commonsense advice often worked too; but the suffering pilgrim rarely left the shrine without renewed hope.

The extensive buildings erected to Asklepios at Kos during the third and second centuries are clear proof of the importance of his cult and the honor in which he was held. The vast complex, which climbs the hillside and is arranged on three well-supported terraces, calls to mind the temple of Queen Hatshepsut at Deir-el-Bahri in Egypt. The

main planning of the Asklepieion actually occurred when the Ptolemies were in control of the island. The upper terrace (A) was surrounded on three sides by a horseshoe stoa with Doric colonnades. Under these the faithful slumbered hopefully in close proximity to the god. The stoa embraced his large second-century temple (B) for which the Doric Order was deliberately chosen in emulation of his parent temple at Epidauros.

By classical standards, the temple was very short, only six by eleven columns. It was emphatically frontal — that is, it had no back porch but a deep hall and pronaos on its facade which looked north. The upper terrace was joined to the middle one by a long, monumental staircase (C). Below this and on a cross-axis was a huge second-century altar (D) decorated with the Ionic Order, and a small temple without peristyle of the third century, whose sumptuous furnishings were described in a mime by the poet Herodas (E). Another monumental staircase (F) descended to the lowest terrace (G), a courtyard again colonnaded on three sides. Near the center, and opening out of the northernmost stoa, was a proplyon (H) with still more steps in front.

The successive levels of the sanctuary were determined by the mountainous terrain yet their aesthetic effect was far from negligible and must therefore have been calculated. The Asklepios temple (B) in itself is a mediocre building, its moldings and proportions much inferior to the classical Doric temples of the Greek mainland. As the chief element in a formal architectural environment it is, however, extremely interesting. Set on the highest level of the sanctuary, it is the dominant structure, the crowning and climactic feature. Stoas frame it and give it an imposing setting. The visitor making his solemn progress ever higher and higher through propylon, court, and staircase would have seen his objective long before reaching it. The ground plan of the sanctuary, nevertheless, is surprising. Only the upper terrace and the steps leading to it show symmetry and axial alignment. The lower court, in itself regular, is only casually related to the one above it. Thus the observer would thread his way to the temple, always prompted but never compelled, stopping here and there to admire the view from the frequently open-sided terraces.

Hippocrates (c. 460-375), the celebrated physician and the founder of scientific medicine, was born and practiced in Kos. In consequence, a distinguished school of medicine flourished on the island during the Hellenistic period. But the cures at the sanctuary seem never to have been effected by "respectable" doctors, even though medical instruments have been found there. Asklepios ran neither a hospital nor a clinic. On the contrary, he offered a religious experience, conveyed in dreams and ultimately mysterious and irrational.

R. Herzog, Kos, Ergebnisse der deutschen Ausgrabungen und Forschungen. P. Schazmann, Asklepieion, I, Berlin 1932. E. J. and L. Edelstein, Asclepius, Baltimore, 1945. P. W. Lehmann, JSAH, 13: 4, 1954, 15-20. V. Scully, The Earth, The Temple and the Gods. 208-12. C. Kerenyi, Asklepios, New York, 1959.

73 Pergamon, Citadel

The Acropolis at Pergamon, which is visible from afar, inspires awe and seems to heave out of the valley of the Caicus river as the very symbol of absolute power and enduring strength. Unlike Priene (42-52), Pergamon was a royal city. Her kings, the Attalids, were ambitious and crafty. Within fifty years, roughly between 200 and 150 B.C., they erected a city which has been compared to Versailles, and an empire which challenged the three great powers: Seleucids, Ptolemies, and Macedonians. As a result of the enthusiastic patronage of her rulers, Pergamon was second to none in culture and art. She rivaled Athens and Alexandria in attracting poets and scholars; her library was vast and world famous, her sculptors probably more creative than those of any other Hellenistic center.

In the second century Pergamon took on its definitive Hellenistic form when Eumenes II (197-159) extended the fortification walls and completed a major building program within. The city rested on the south slopes and summit of the Acropolis, which fell off precipitously on the northeast. There were three major complexes, including the lower agora at the south, the Sanctuary of Demeter and the gymnasium further up, and, finally, the upper city, seen in the photograph, which contained the royal palace and the chief sanctuaries. Private houses were

scattered between, and a serpentine road led from one part to the other. The terrain was difficult, the slopes often steep, and the plateaus narrow, yet at Pergamon nature was never violated as it was at Priene, and remarkable ingenuity was shown in exploiting this exacting site.

Hitherto only a fortress, the city was founded for all practical purposes in 282 by Philetaerus, who governed the area for Seleukos I of Syria. The power of his successors resulted chiefly from their strong policy toward the neighboring Gallic tribes and, on the other hand, their determination to remain on friendly terms with Rome. Rome repaid the city well, and turned over to her almost all of Asia Minor after the defeat of Antiochos III in 190. The building program of Eumenes II coincided with this period.

The theater and, beyond it, the long retaining wall of the Trajaneum are the most conspicuous ruins revealed in the photograph. The Acropolis rises 274 m. above the plain. The excavation of Pergamon was begun in 1873 by the Germans, and they continue it to the present day. *Altertümer von Pergamon*, I-X, Berlin, 1885-1937, and E. Boehringer, *Neue Deutsche Ausgrabungen*, Berlin, 1959, 121 f.

74, 75 Pergamon, Plan and Model of Upper City

The crescent-shaped Acropolis, which rose in a series of levels from the south and dropped down at the north end into a wedge-shaped plateau, was divided by the road (A) into an eastern and a western section. The religious areas on the west were the most spacious and imposing and enjoyed a wide view over the countryside. The secular buildings on the east were more enclosed and were compelled, it seems, to fit themselves in between the fast descending terrain on one side and the broad domains occupied by the sanctuaries on the other. The contour of the slope on the west formed an arc suitable for a theater (B) but, as we shall see later (76), presented certain problems for both the auditorium and the stage. The terraces on which the individual buildings stand are partly natural and partly artificial. They were generously extended wherever it was thought necessary to make the surrounding space ample enough for a monumental setting.

The checkerboard plan used for the city of Priene (43) is inherently static, and the buildings there submit to the principle of uniformity. The plan of the upper city at Pergamon, on the contrary, stresses movement, and its building complexes, each a separate entity, are shifted about and oriented to emphasize their autonomy and nonconformity. Only the Trajaneum (C), of Roman date, located on the highest point of the Acropolis, exclusively favors parallelism and centrality in its design.

The first building complex one reaches in the upper city is the agora (D), consisting of an open area colonnaded on two sides and on half of another. At the northwest a stairway between a small temple and hall led down to the theater terrace. The long stoa on the southwest was cut in two by the roadway, which then climbed straight through the marketplace to the next terrace (E), the most interesting of all, which supported the Great Altar of Zeus (78, 79). Continuing along the road, which ascended as gently as the terrain allowed, one passed on the right the square court and surrounding rooms of the Heroon (F), which was reserved for the cult of the local rulers. Higher still was the impressive sanctuary of Athena (77), the oldest on the Acropolis. The royal palaces (H), guarded by towers, multiroomed and with occasional courtyards, occupied in elongated but unspectacular fashion much of the east side. Further north the defensive character of the citadel was evident in the barracks (I) and magazines.

The Acropolis was not adorned overnight. The building was begun under Philetaerus, and each successive king, above all Eumenes II, added to it. As R. Martin has pointed out, the architectural planning exhibited at Pergamon is exceptional: no other Hellenistic city displays such an awareness of monumental mass, of group design, and of the imaginative adjustment of buildings to site. It was a truly royal city, and the consciously developed conceptions of dynastic power and luxury manifested there were well suited to and were later adapted by Imperial Rome.

E. V. Hansen, *The Attalids of Pergamon*. R. Martin, *L'Urbanisme dans la Grèce Antique*, ch. III.

76 Pergamon, Theater

The theater occupies the west slope of the Acropolis just below the sanctuary of Athena. The terrain here, though conveniently hollow to contain the auditorium, was very steep, and the hollow itself was shallow. The seats therefore seem to rest lightly on the surface of the landscape rather than nestle into it. The slope continued precipitously below the orchestra. It thus proved difficult to provide a landing wide enough to support a stage building as well as a means of access to the lower ranges of the auditorium. An enormously long and narrow terrace buttressed by high retaining walls was consequently constructed. Its foundations can be traced in the photograph as they recede diagonally from the foreground. Lined along the whole west side and a portion of the east by colonnaded stoas, the terrace also functioned as a street and promenade, leading not only to the theater but also to an altar and small temple to Dionysos, the patron god of drama, at its north end.

The auditorium accommodated ten thousand spectators on seventy-eight rows of seats which were divided horizontally into three unequal sections, each third subdivided vertically by aisles into seven, six, and five wedges proceeding from the bottom to the top. The higher rows could be reached by means of stairs and ramps from the precincts of Athena and the Great Altar as well as from the agora. Because of the narrowness of the theater terrace, the orchestra did not form a full circle, and the only place for the actors to perform was in the middle of the street! This obstacle was surmounted by a portable wooden stage building which could be erected on the terrace for performances and subsequently dismantled. The quadrangular holes set into the terrace pavement to hold the stage are evident in the photograph.

Most Greek theaters, such as the one at Priene (48) are restful and harmoniously proportioned. At Pergamon, the auditorium is top-heavy and the seats plunge down like a landslide upon the thin terrace. Movement of an almost sensational kind is thus characteristic of this building, as it is of most Pergamene art.

The theater was built by Eumenes II but was later modified under the Romans. The late antique tower in the background marks the line of the retaining wall of the sanctuary of Athena. The small temple of Dionysos was rebuilt by Caracalla. The base of the altar in front of it is shown at the bottom right. The two trees in the middle distance rise from the sanctuary of the Great Altar. R. Bohn, *Altertümer von Pergamon*, IV, 1896.

77 Pergamon, Sanctuary of Athena Polias Nikephoros

Athena, the patron goddess of the city and the "Bringer of Victory," had a temple and terrace of her own. The photograph is taken from the northwest and shows the foundations of the long stoas which closed the north and east sides. Thus the temple, whose ruins lie near the late Roman tower in the background, did not stand isolated, but was imposingly framed by two-storied colonnades. Perched at an angle close to the western edge of the terrace and with columns all around it, it nevertheless inevitably retained its independence and dominance. The Doric Order, which adorned the temple of Athena on the Acropolis at Athens, was also chosen for her temple at Pergamon. Constructed in the reign of Philetaerus (282-263) it was short, with six by eleven columns, all widely spaced and extremely slender. There was no opisthodomos. The north stoa, built by Eumenes II, was deep, and was divided down the center by an internal colonnade. The Doric columns of the first story and the Ionic of the second call to mind the stoa donated by Attalos II in the agora at Athens (38, 39). At least five rooms behind the north stoa housed the famous Pergamon library which, it has been estimated, comprised seventeen thousand volumes. In one room there was still another indication of the Attalids' profound respect for Athens: against one wall there stood a copy of the Athena Parthenos (125). Joining the north stoa was another, narrower one enclosing the precinct on the east. This and a handsome propylon were also built by Eumenes II.

The effect was never barren. Sculptured friezes ran along the stoa facades, and statues and monuments were scattered around the court. One of the largest and most important was a high circular base (center

middle ground) which may have supported the heroic figures of Gauls, a dedication of Attalos (141).

R. Bohn, *Altertümer von Pergamon*, II, 1885.

78, 79 Pergamon, Great Altar of Zeus, Foundations and Model

The marble altar dedicated to Zeus and erected during the reign of Eumenes II is the chief glory of Pergamon and the supreme artistic achievement of the Hellenistic age. It was so colossal and aggressive, and so lavishly decorated, that any framing devices such as columned stoas were rightly deemed superfluous and undesirable.

As for the altar itself, four steps on all sides underlay a podium, eighteen feet high, which was decorated with moldings below a continuous sculptured frieze nearly eight feet high. The frieze (153-156) represented the struggle between the gods and the giants. A strongly projecting cornice concluded the podium and overhung the frieze. Externally, three sides of the altar presented the same forbidding mass. The frieze was in very high relief, and standing on the podium were Ionic columns which followed a solid wall ornamented on the inside with the life story of Telephos, the mythical founder of the city of Pergamon (166). On the west, however, a flight of twenty-four steps cut deeply into the podium and created a projecting wing on either side. The Ionic colonnade, crowned by another strong cornice and a roof which carried tritons as akroteria, was carried across the altar at the top of the stairs to enclose the platform where the actual altar of sacrifice was situated. Thus an interior court was formed to frame, in typical Hellenistic fashion, the most sacred area.

In its general form the altar had precedents reaching back to the Archaic age. But there is a new emphasis on movement and a more thoroughgoing attempt to affect the emotions of the worshiper. In 79 we can see how vigorously the four steps, wings, moldings, and various cornices protrude into space, and how, on the other hand, the very broad staircase is sucked in toward the interior. Overwhelming and superhuman from the outside, on the interior the architecture becomes intimate and human, and to walk within the Ionic colonnade, which is just under nine feet high, is a comforting rather than a challenging experience. We shall see how the sculptural decoration enhances these effects.

The excavation of Pergamon began with C. Humann's discovery of the altar in 1873. Two pines and a few foundations, much overgrown, now mark the site.

Altar at base measures 34.0 m. by 36.6 m. It can be seen, partly reassembled and reconstructed, in the Staatliche Museen in Berlin; E. Rohde, *Pergamon, Burgberg und Altar*, Berlin, 1961. J. Schrammen, *Altertümer von Pergamon*, III 1, 1906, and H. Winnefeld, *Altertümer von Pergamon*, III 2, 1910. H. Hoffmann, *JSAH, 11,* 1952, 1-5. M. C. Sahin, *Die Entwicklung der griechischen Monumentalaltäre*, Bonn, 1972.

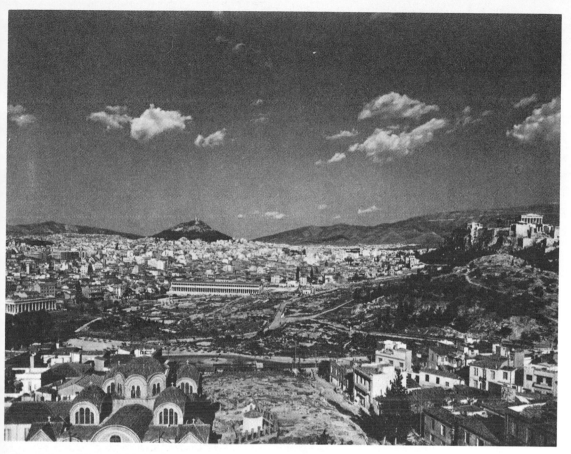

37. Athens, View of the Agora.

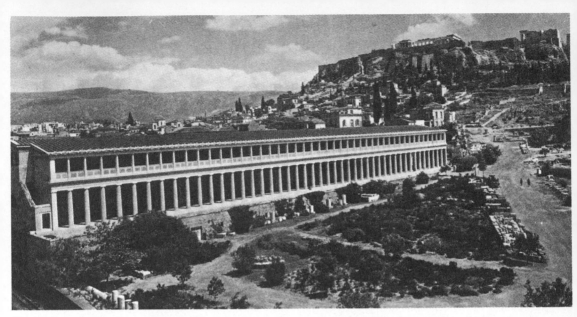

38. Athens, Agora, Stoa of Attalos II.
 (Attalos reigned 159-138 B.C.)

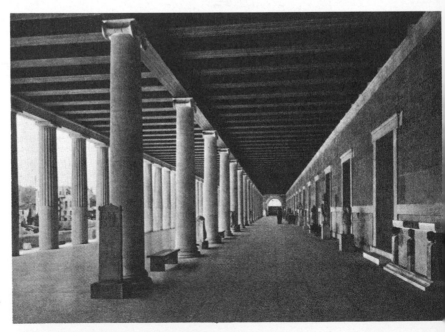

39. Athens, Agora,
 Stoa of Attalos II,
 detail.

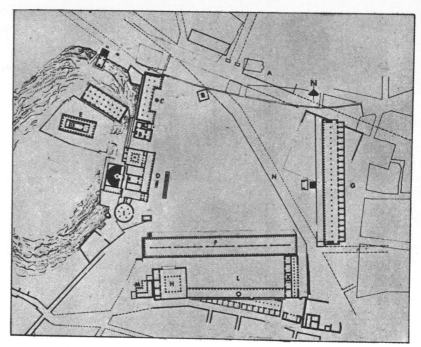

40. Athens, Plan of the Agora
after Hellenistic remodeling.

A Stoa Poikile
B Temple of Apollo Patroos
C Stoa of Zeus
D Metroon
E Temple of Hephaistos
F Middle Stoa
G Stoa of Attalos
H Heliaia and Theseion
I Tholos
J Council House
K School
L Gymnasium
M Fountain and Swimming
 Pool
N Street of the Panathenaia
O South Stoa

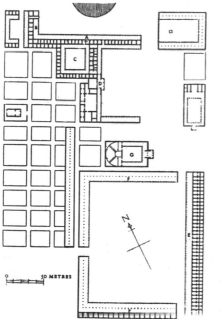

A-D Stoas and Courts of North Agora
E-F Stoas of South Agora
G Council House

41. Miletus, Plan of the Hellenistic Agora.

42. Priene, Acropolis and ruins.

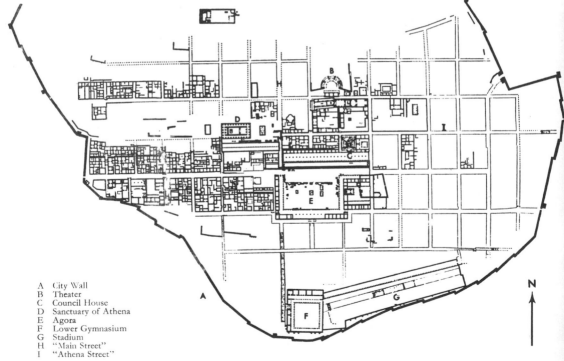

A City Wall
B Theater
C Council House
D Sanctuary of Athena
E Agora
F Lower Gymnasium
G Stadium
H "Main Street"
I "Athena Street"

N

43. Priene, Plan of Hellenistic City.

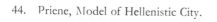

44. Priene, Model of Hellenistic City.

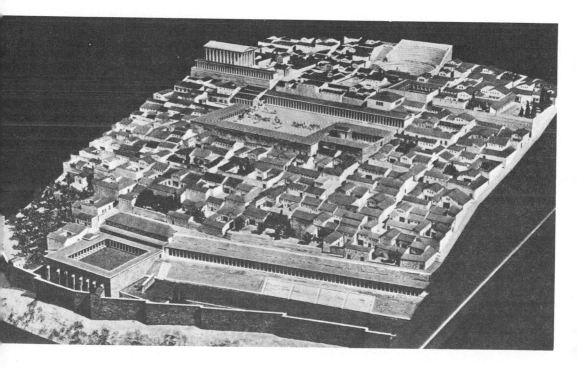

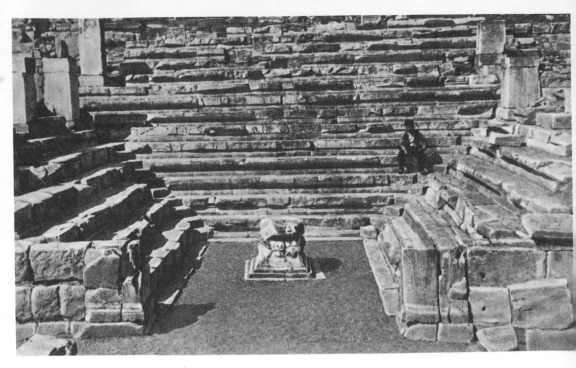

45. Priene, Council House, today.

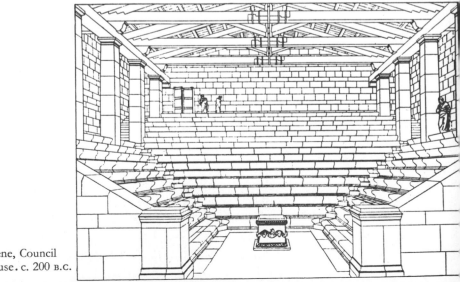

46. Priene, Council
House. c. 200 B.C.

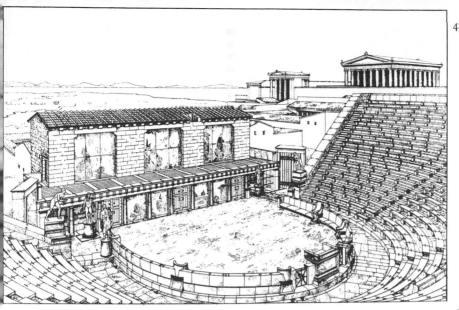

47. Priene,
Theater. Late
second
century B.C.

48. Priene, Thea-
ter, today.

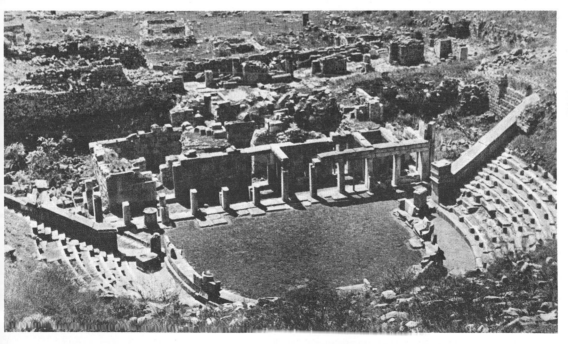

49. Priene, ground plan of lower gymnasium. c. 130 B.C.

A Gateway
B Corridor for indoor exercise
C Door leading to stadium
D Washroom
E Schoolroom
F Court

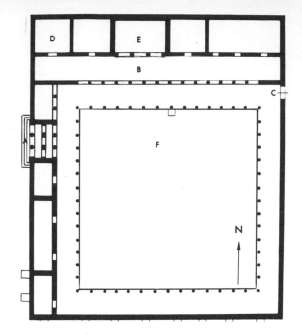

50. Priene, Lower gymnasium, interior.

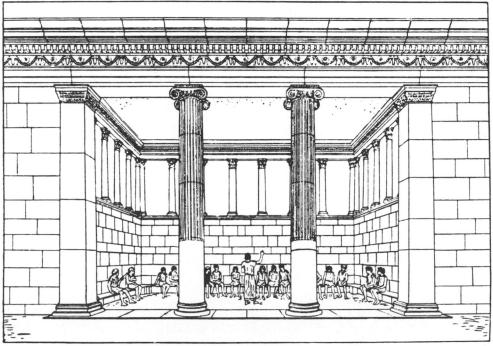

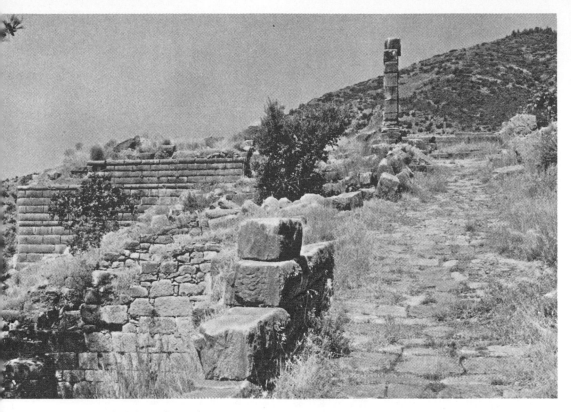

51.　Priene, View of "Athena Street."

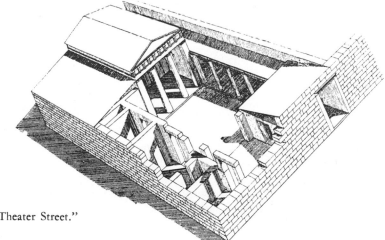

52.　Priene, House 33 on "Theater Street."
　　　Third century B.C.

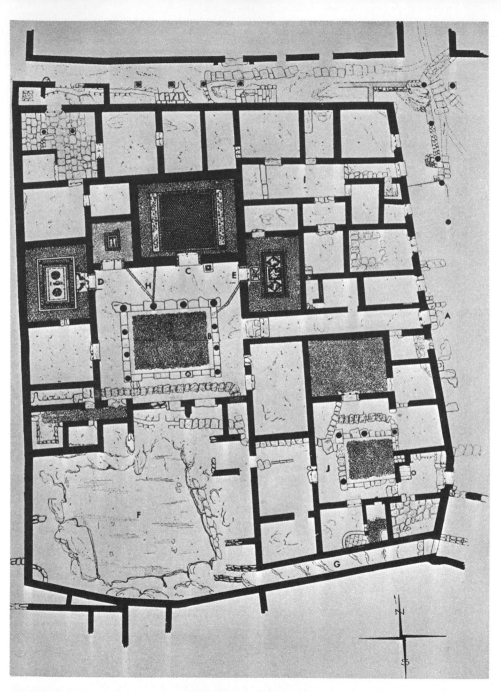

53. Delos, House of the
Masks, ground plan.
200-150 B.C.

A Entrance
B Peristyle Court
C Main Room ("Room
 of the Masks")
D Room with Amphora
 Mosaic
E Room with Mosaic of
 Dionysos riding a Pan-
 ther (Color Plate
 XVIII)
F Cistern
G Passageway to cistern
H Drainage channels
I, J Dwellings adjoining

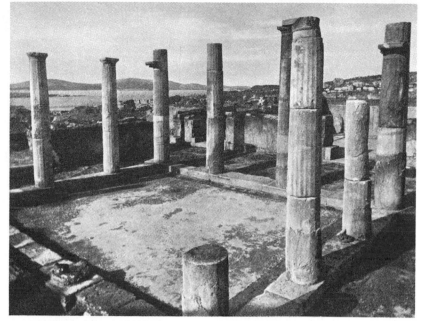

54. Delos, House of the Masks, peristyle
court.

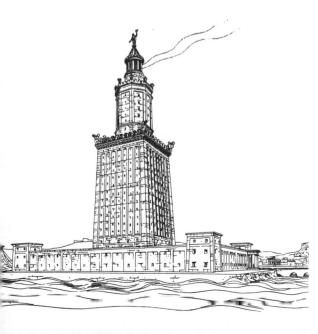

55. Alexandria, Pharos. c. 279 B.C.

56. Athens, Tower of the Winds. c. 40 B.C.

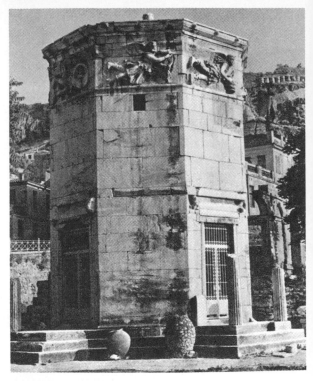

57. Athens, Tower of the Winds, detail.

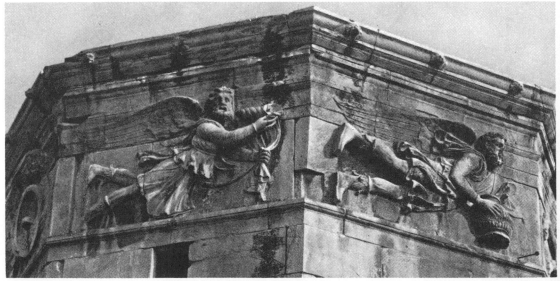

58. Samothrace, Arsinoeion. 289-281 B.C.

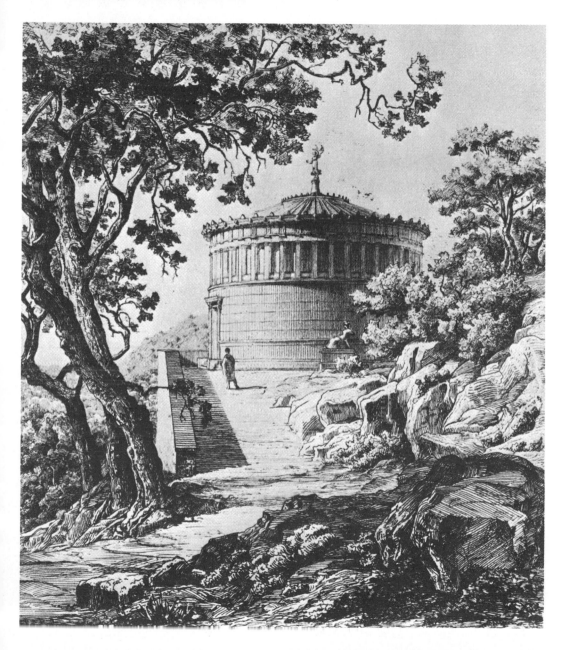

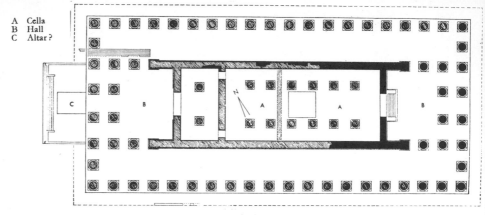

A Cella
B Hall
C Altar?

59. Sardis, Temple of Artemis, ground plan.
 Third century B.C. to second century A.D.

60. Sardis, Temple of Artemis.

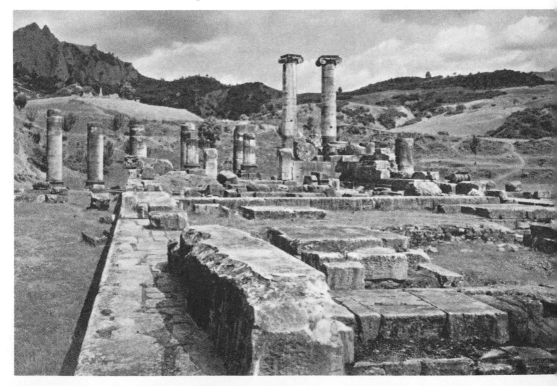

61. Didyma, Temple of Apollo, ground plan. c. 300 B.C. to second century A.D.

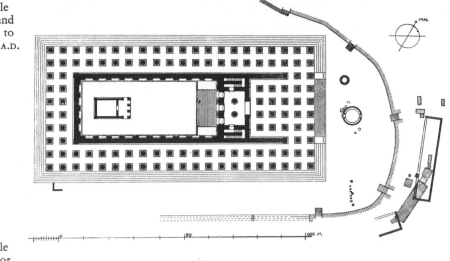

62. Didyma, Temple of Apollo, exterior, east end.

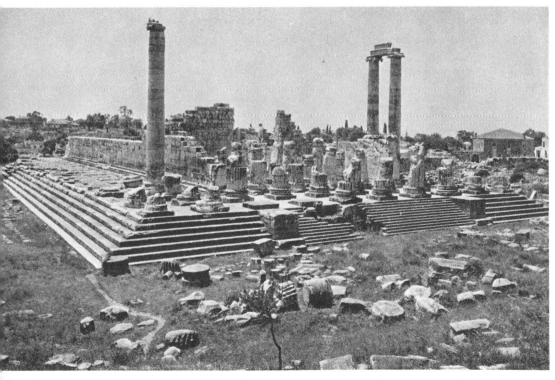

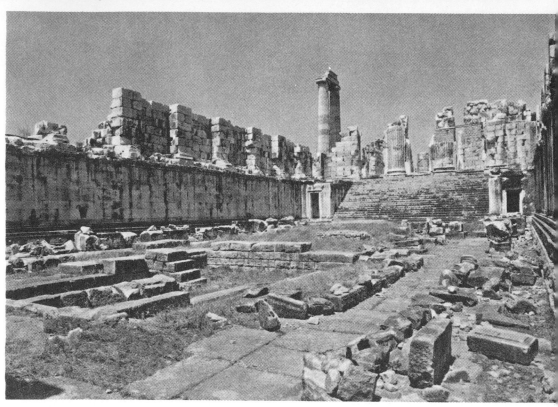

63

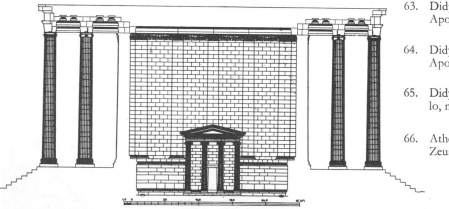

63. Didyma, Temple of
 Apollo, interior court.

64. Didyma, Temple of
 Apollo, cross section.

65. Didyma, Temple of Apo
 lo, north wall of pronao

66. Athens, Temple of
 Zeus and Acropolis.

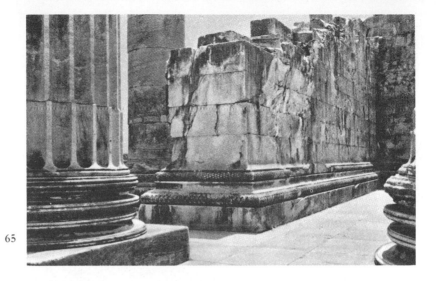

65

66

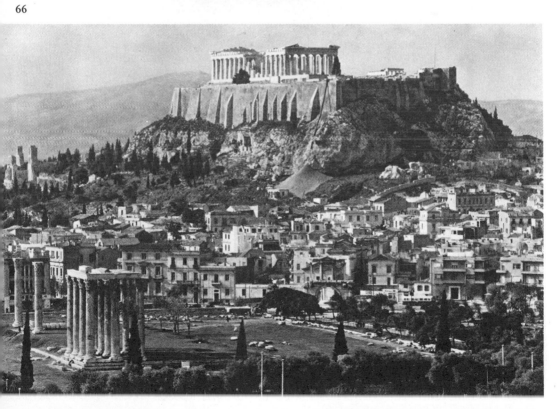

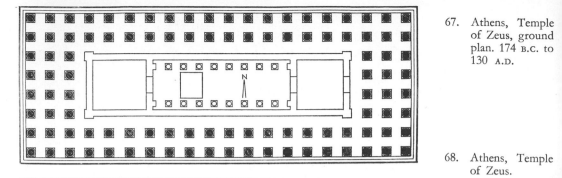

67. Athens, Temple of Zeus, ground plan. 174 B.C. to 130 A.D.

68. Athens, Temple of Zeus.

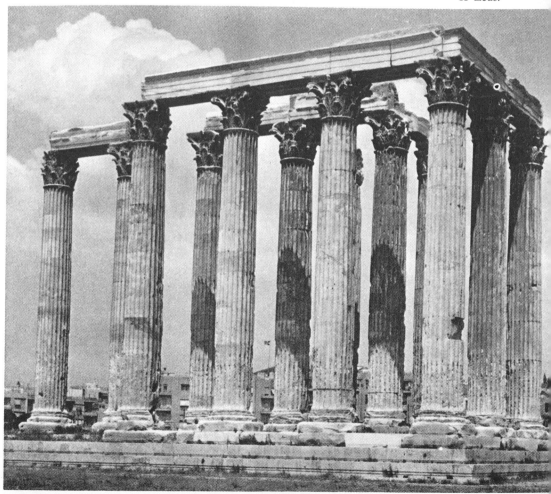

69. Magnesia, Temple of Artemis Leucophryene, ground plan.
c. 130 B.C.

70. Magnesia, Temple of Artemis.

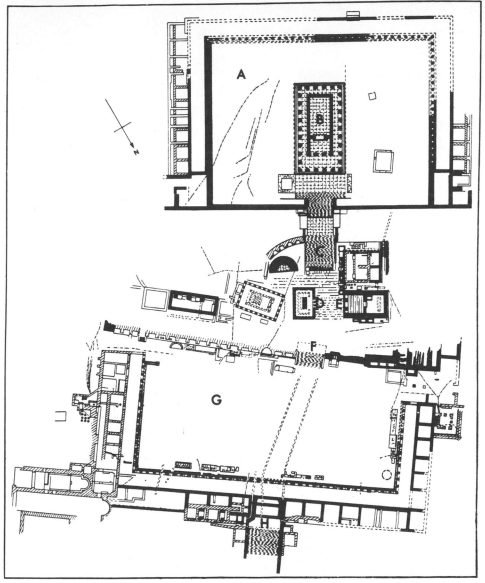

71. Kos, Sanctuary of Asklepios, plan.
Third to second century B.C.

A Upper Terrace
B Temple of Asklepios
C Staircase
D Altar
E Temple
F Staircase
G Lower Terrace
H Gateway

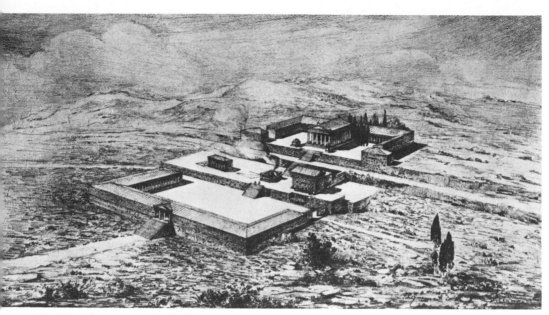

72. Kos, Sanctuary of Asklepios.

73. Pergamon, Citadel.

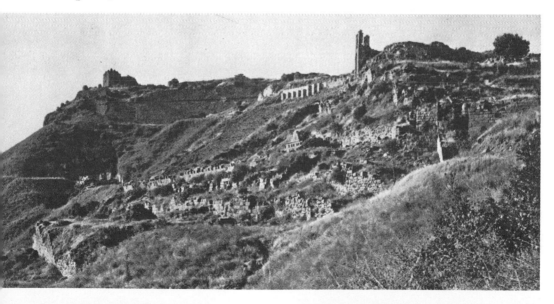

74. Pergamon, Plan of Upper City.

A Road
B Theater
C Trajaneum
D Agora
E Sanctuary of Zeus
F Heroon
G Sanctuary of Athena
H Palaces
I Barracks

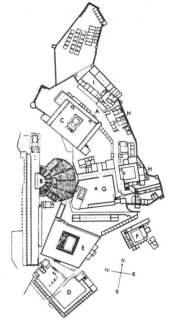

76. Pergamon, Theater.

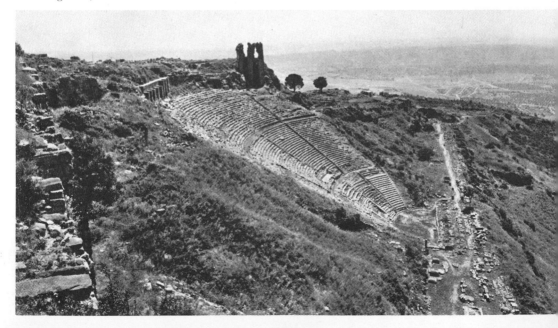

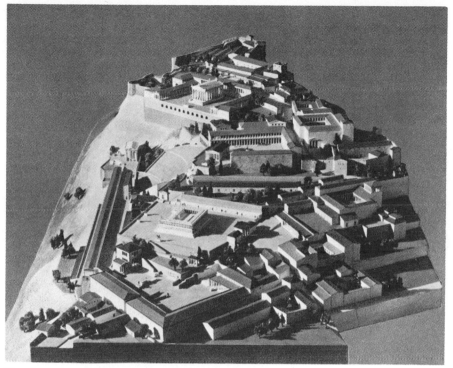

75. Pergamon, Model of Upper City.

77. Pergamon, Sanctuary of Athena Polias Nikephoros.

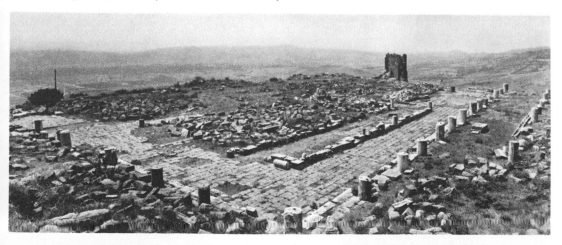

78. Pergamon, Great Altar of Zeus, foundation.

79. Pergamon, Great Altar of Zeus, model. c. 180-160 B.C.

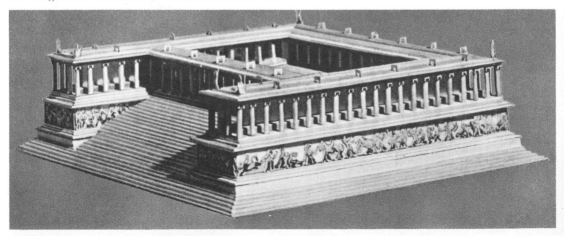

III Sculpture in the Round

Nearly everyone would agree that, on the whole, the formal evolution of pre-Hellenistic sculpture was exceptionally logical and coherent. One major style prevailed at any given time, and the development, a steady and continuous one, was never seriously thrown off or halted by revivals or retrospective thinking.[1] The major criterion for dating a pre-Hellenistic work is "naturalism"– the more naturalistic a figure is, the later it is. Elementary though this may be, and woefully inadequate for a true understanding of archaic and classical art, it is nevertheless an almost unfailing method for establishing the chronology of any individual work.

Unfortunately, the field of Hellenistic sculpture is by no means so well charted. How we wish we could simply say that in this final phase the goals of earlier Greek art were not only pursued but triumphantly attained. But we must admit that our knowledge and understanding of the sculpture of the Hellenistic period are still vague and uncertain. The primary reason for this is the paucity of externally-dated examples. This is particularly true for the third century. In addition, the originating place of many works is unknown, and it is therefore difficult, if not impossible, to interpret them in the light of a given historical or local context. Another reason is that Hellenistic sculptors often looked back to earlier styles, adapting, imitating, and copying them. Conservatism and classicism, then, are often found simultaneously with experimentation and innovation. Measuring the realistic component is of little assistance. The most idealistic work might well be the latest. In short, for Hellenistic sculpture there is no single straight line of development as there is in earlier Greek art.

However, for the last forty years or so, ever since Gerhard Krahmer conducted his pioneering studies,[2] it has been generally acknowledged that the sculpture of the Hellenistic age may be viewed within the framework of three major periods: Early, High (or Middle), and Late. The first period extends from the death of Alexander (323 B.C.) and continues through the third century until about 240; the second from 240 until the middle of the second century; and the last from 150 to the advent of Augustus (31 B.C.).

The phases have been variously labeled. Krahmer spoke of the style of Early Hellenistic sculpture as "severe" or "plain"; V. Müller called it "restrained"; R. Carpenter, "tempered formalism" verging on "realism." To M. Bieber the first period is essentially one of transition in which the Late Classic style is dominant, although there are clear signs of something more revolutionary.[3]

The term "baroque" is usually adopted for the High Hellenistic phase. Works of this period, especially those from Pergamon, are according to Krahmer "dynamic," "pompous," and "pathetic." Carpenter has greatly illuminated this period recently by designating it a "Classic Renascence." A "rococo trend," as Bieber points out, flourished at the same time, but this denotes a type of subject matter – tending toward the light and intimate, as the term "rococo" suggests – rather than a style.

The last period is so complex that it cannot be covered by one label. "Classicistic" probably has the most currency. "Eclectic," meaning of course that the period offers a bit of everything, is also apt. The baroque style and rococo trends continued; Archaic, High and Late Classic, and even earlier Hellenistic styles were revived. Accompanying these there is a strong vein of realism.

This framework has been applied in the first instance to round sculpture, and the examples that follow will illustrate in more detail what occurred during the Hellenistic period.

EARLY HELLENISTIC: 323–C. 240 B.C.

Among the outstanding characteristics of High and Late Classical art are harmony and lucidity. They were achieved primarily by composing the human

figure according to laws of mathematical proportioning and by a clear articulation of the surface, whether draped or undraped. Nature was accordingly never closely imitated; abstract principles governed the size and relationship of the body parts, and details that obscured the basic structure were omitted. Classical sculptors were persistently theoretical and intellectual in their approach and methods.

The early Hellenistic period did not suddenly break with these values and traditions. The art of Lysippos (c. 375-300), the court sculptor of Alexander the Great and the most illustrious artist of the period, is in this respect extremely significant. Ancient writers tell us that Lysippos was careful to preserve, not discard, the "symmetry," that is, the commensurability, of earlier art. Indeed, he introduced a new canon of proportions which furnishes proof that he believed in the intellectual ordering of a work of art. We have, fortunately, a copy of one of his statues, the Apoxyomenos (80), which embodies his theory: the head is one ninth the length of the body and its breadth is a finite fraction of the width. But the statue illustrates another quality of his art to which ancient sources also refer – although this time as an innovation. Pliny states that Lysippos "modified the squareness of the figure of old sculptors." This is assumed to mean that the quadrifaciality and flatness of earlier statues were, through the device of spiral torsion, transformed into multifacial compositions which the spectator can apprehend only by making a full circuit of the figure. This was an exceedingly important innovation, and its consequences were felt for at least the next two centuries in Greek art. But it was only a partial break with the classical past. As R. Carpenter has rightly maintained, the spiral torsion of Lysippan statues is only one more of the "significant formal devices which distinguish classic Greek sculpture." The geometric element of Lysippos' art is thus very strong. So was his debt to earlier masters. We must not be misled therefore by another statement that Pliny, apparently unaware of the contradiction, attributes to Lysippos: "No artist should be imitated but only nature itself."

Several of the third-century statues we illustrate show the new interest in movement in depth and space which was ushered in by Lysippos. The torsion is sometimes slight or extremely subtle, as in the Bronze Maiden from Verroia (86) or the Tyche of Antioch (117); at other times the major parts of the body all seem to face in opposite directions, as in the Seated Hermes (85) or the Maiden (118, 119) now in Budapest. We long to follow, around and around, every drapery fold of the latter, to measure the depth of Aphrodite's turning torso (84), or to swim off freely with Orontes in the Tyche of Antioch (117). The Naples statue of the Seated Hermes (85), furthermore, conforms in general to Lysippos' system of body proportions. Although Pliny praised Lysippos for his "delicacy of execution even in the smallest details" and for his "realism," we fail to find in the Apoxyomenos (80) and in the work of the third century conclusive evidence that classical harmonies and clarity of organic structure have been destroyed in favor of anatomic fidelity. A certain simplicity and idealism, an insistence on sheer physical beauty, are still very much present. Observe, for example, the lovely, soft features of Themis (111) or Aphrodite (90). We might even turn back to the pure oval shapes in the contemporary portraits of Alexander (1, 2) and Arsinoe (7). Many grotesque subjects, on the other hand, are striking and effective for the opposite reason: the deliberate omission of these idealizing qualities (83).

The lucidity and harmony of classic art were to a large extent carried over in the clothed figure, too. Drapery folds may not traverse and explain the underlying pose as thoroughly as before, but the body is not obscured or lost to sight. We continue to be aware that the two are in accord. Themis from Rhamnus (111) and the Draped Woman (113) in the Pomerance Collection show this very clearly. It is true, however, that drapery does begin to take on a more active role than it did heretofore, that instead of acquiescing it applies a pressure here and there, but with restraint, and that it does not feel obliged to hug all the body contours. The statue of the priestess Nikeso (112) or the Budapest Maiden (118) reveal this newly emerging phenomenon. Coupled with it is an increased interest in the texture of the material as such. For example, light, crinkly linens are contrasted with weighty wools (112). Yet large and continuous rhythms predominate as they

114

did before, and a few long folds sweep around the body, holding it together as a single deep but unified volume.

That the rational organization and geometric order characteristic of classical art were not eradicated or even seriously imperiled by early Hellenistic artists may be seen in yet another way: their frequent use of pyramidal design. The Tyche of Antioch (117) and the Crouching Aphrodite (84) are both constructed on this pattern. This is not, however, a retreat to a sort of trifaciality which ignores the innovations of Lysippos. Rather there is movement within the pyramid that exposes it as a three-dimensional form. Something always induces us to move around, perhaps not to the back but at least to the side: Tyche looks in one direction and Orontes, at her feet, looks in another; Aphrodite's arms, which are unfortunately missing in our copy, would simply entice the spectator to view what she modestly attempts to conceal (84).

Enclosure of the figure within a compact geometric outline was, in fact, proposed by Krahmer as a leading characteristic of third-century sculpture. Thus his term "closed form." Statues like Themis or Nikeso were compared with classical figures, and the conclusion was drawn that the outline in the later works was more rigid and severe and that the stance was less rhythmic. This is unquestionably true. We can observe the difference by comparing any one of these figures with the Pomerance statuette (113), certainly the most classical of our examples. On the other hand, it is not a matter of harshly compressing or forcing the body into a rectangular mold; the draped women still move with a good deal of freedom.

In one last respect, the composition of groups, it appears that the early Hellenistic period continued the linear principles of the Classical period. Although the individual statues of the Niobids (137, 138) are now believed to be late Hellenistic, their organization as a group reflects the fashions of the late fourth or early third centuries. The ensemble comprised no less than sixteen statues, and these were simply strung out side by side, perhaps on ascending ground. The focus of the composition, such as it was, was Niobe and her daughter who form, we notice, a roughly pyramidal shape. But all these unhappy creatures must be viewed from one angle, like sculpture in relief.

We are impressed by the amount of restraint and control and by the lack of inner tension and conflict in either content or form of these early Hellenistic works. We think of them as on the whole rather quiet and serene. Emotions are expressed, but they are subdued. "Realistic" they are not; the geometry is too visible, the love of beauty too intense.

HIGH HELLENISTIC: c. 240-150 b.c.

The most signal change that occurs, beginning toward the end of the third century, is that the composition – whether of the single figure or of groups – opens out. "Closed form," or centripetal design, gives way to "open form," or centrifugal composition – but at least fifty years before Krahmer's date. Movement is more pronounced and is "continually in flux." The effects of Lysippos' break with the self-containment of the classic do not seem to be fully felt until we reach this phase.

The first stirrings are felt in the Sleeping Hermaphrodite (89) and in Ariadne (122). The left leg of the former strives to free itself from the binding drapery, and Ariadne's arms begin to loosen. But soon the organization becomes still looser and the figures consequently more space-penetrating. The tempered relaxation of the Seated Hermes (85) becomes the abandoned euphoria of the Satyr (95) dancing or falling asleep. Limbs and arms radiate from a rotating torso, yet always in an orderly, comprehensible manner with flowing movement and rhythmic interrelationships. There is nothing mystical or incredible about the airborne flight of the Victory of Samothrace (123).

The exuberant movement and physical energy expressed in the pose are often enhanced by stepping up, so to speak, surface activity. We mean by this that, at least in the male figure, the muscles ripple, swell, and expand, almost to the point of bursting. This is an artificial device, a from of exaggeration too selective to be interpreted as "realism."

The best illustration is probably the torso of the battling Zeus from the large frieze of the Pergamon

Altar (153); the nude body of the Dancing Satyr is another (92). Unfortunately, the photograph of Poseidon (124) does not quite reveal all the rich play of flesh, bone, and muscle that his figure actually possesses.

When we turn to the draped figure of the High Hellenistic period we may equally speak of surface activity. The women from our first period will seem, in comparison, to have had an easy time of it. The drapery is now so complicated, so forceful, and so heavy that it conducts a veritable tug-of-war with the underlying form. In the later part of the third century it does in fact temporarily triumph. Our attention becomes almost exclusively concentrated on complex folds and rolls of cloth and with the triangular areas they create as they intersect. The drapery divides and subdivides the figure, and the figure's classical unity is thereby destroyed. The material accumulates to such a degree that the body contours are fairly well obliterated (114).

A balance of forces was struck, however, during the first half of the second century. And how beautiful are the results! The bodies seem especially healthy and vigorous, often indeed heroic, and they are always capable of thrusting aside massive layers of material, single folds, or even bundles which seem to have the strength of steel. Observe, for example, the colossal Draped Female from Pergamon (115) or Eos on her fiery steed (156). The results are also very dramatic. But we would not be aware of this if the body contours did not assert themselves in places or even, as in the Victory of Samothrace (123), along the entire outline. The drama is still further heightened by the contrasts and nuances of light and shade that play over the ever-varying folds. Even the perfectly static figure of Dionysos is enlivened by this means, and, as would be expected, facial features and hair are similarly animated (126, 102).

A vigorous interest in and revival of the art of the past also occurred during the first half of the second century. Thus we may adopt Carpenter's term "Classic Renascence," the first of many in the history of ancient art. This renascence occurred chiefly in mainland Greece and in Pergamon, partly as a response to the rising power of Rome. Primarily, however, it resulted from an indigenous desire to strengthen and exploit the purely Hellenic tradition, and to advertise it as a still-vital and continuing phenomenon. A love of Greece, a determination to serve it, and a deep pride in being linked with the glories of the Classical age were what ultimately motivated Eumenes II to decorate his Great Altar with a frieze depicting the battle between the gods and giants (Gigantomachy) and to erect a statue of Athena Parthenos in his library. In a sense the revival was a mild one, and it was completely free of academicism and pedantry. Although they were historically conscious of art, and appreciative of the formal values that distinguished earlier styles, the artists of the period never mechanically copied or closely imitated the older works. The Athena Parthenos of Pergamon (125) is as baroque as it is classical; indeed it is a marvelous mixture of old and new. In Greece, Damophon created his cult statues for the temple at Lycosoura. Executed at a site nearer the fount of the classical style, they are perhaps more fully imbued with fifth-century characteristics (108).

The balanced relationship between body and drapery described above has relevance as well to our understanding of the "Classic Renascence." During the first half of the third century the body was certainly felt but it was not actually seen beneath the drapery. But now, a century later, the underlying form emerges through a transparent chiton or peplos in precisely the way that it did in many late-fifth-century statues. "Modeling" and "motion" lines, which were inventions of the High Classical period,[4] also reappear in the second century, both in the Victory of Samothrace (123) and the "Heyl" Aphrodite (97). Linear motifs and flourishes drawn from a still earlier Greek art, were also employed, mainly for decorative reasons, in the products of the "Archaic Renascence," a contemporary but less important stylistic current. This we may observe in the relief of Dionysos and the Seasons in the Louvre (165), but similar motifs were also included in a few contemporary sculptures in the round.

The pathetic group of Menelaos and the Body of Patroklos (139) stands at the very beginning of this second period. The two figures are masterfully arranged in a pyramidal design, which we remember was frequently adopted by the third-century sculptors.

The pyramid, however, is not quite as confining, and we can predict by the pronounced foreshortening of Menelaos' body and by the swift outward turn of his head that it will soon be opened out. And so it is in the multifacial pair of the Gaul Killing Himself (140). If Schober's reconstruction (141) is correct, this group of the Gaul and his wife occupied the center of the most ambitious and most three-dimensional composition of the Hellenistic age. It has also been argued that the most famous ensemble of all antiquity, the Laocoon (146), likewise belongs to this pompous and dynamic period.

The term "baroque" then, is exceedingly appropriate for the sculpture of the High Hellenistic period. Just as European baroque of the seventeenth century contains many classical ingredients, so also does its ancient counterpart. Perpetual and contrasting movement, rich effects of light and shade, and an outspoken expression of emotion are characteristic of both. Sculpture in the round of the High Hellenistic period takes cognizance of the external environment and reaches out to incorporate surrounding space. We shall see that in this respect it sought the same ends as contemporary nonarchitectural sculpture in relief.

LATE HELLENISTIC: C. 150-31 B.C.

E. R. Dodds once wrote that the late Hellenistic age exhibited a "fear of freedom."[5] He was referring to the intellectual climate. We think, however, that the phrase is not inappropriate if applied in a limited way to sculpture in this period. Figures and groups tend to withdraw and retract, movement in depth is diminished, and energy subsides. Free "open form" closes up again. By the end of the second century, what Krahmer spoke of as "one-sided" composition seems to prevail.

Classicism had only modified the dominant baroque style of the first half of the century. In the second half it began to attain supremacy and to affect nearly all sculptural efforts. Rome's ascendancy in the Mediterranean world was largely responsible. She had already developed a taste for Greek art – in the plunder after the capitulation of Tarentum in 272 and of Syracuse in 212. Aemilius

Paullus had taken a huge number of statues and paintings to display on his triumphal return after defeating Perseus in 168. In 146, after he had sacked Corinth, Mummius collected cartloads of both major and minor works of art and shipped them to Rome. The Romans began to thirst for Greek art with which to decorate their houses and gardens They preferred masterpieces of the fifth and fourth centuries or works in the manner thereof, like that of Damophon (108), but they would happily take just about anything as long as it was Greek. Soon the demand began to exceed the supply. If originals were not available, copies, imitations, or adaptations would serve instead and were just as welcome. No doubt in response to this demand, a mechanical device for making exact reproductions was invented about 100 B.C. Workshops were set up in Greece and Italy, and they turned out vast quantities of copies and imitations. Athens was perhaps the most esteemed source of supply. Beginning in the late second century and continuing through the Augustan period, a group of her sculptors known as "Neo-Attic" specialized in decorative reliefs whose motifs were always based on figure-types of the past. In addition, many Greek sculptors from all the major Hellenistic centers began to seek work in Rome itself. By the end of the Hellenistic age, some of the most able, like Pasiteles (see 147), had left their homes and become Roman citizens.

The more pedantic classicism of this period can be seen in the Head of Athena by Euboulides (103). Its cool Phidian poise should be compared with the spirited expression and the dramatic lights and darks of the Head of Anytos by the earlier classicist Damophon (108). Similarly, attempts to imitate the archaic style were more studied and successful than before. As illustration, the figure of Aigeus on the Neo-Attic base in the agora (162) might be compared to those in the earlier Dance of Dionysos and the Seasons (165). The head inserted in the body of the Demeter of Knidos (127) is almost indistinguishable from a Praxitelean prototype. The styles of both Myron and Polykleitos are mixed in the head of the Boy from Tralles (131), although the body is based on a late-fourth-century type. This kind of eclecticism is characteristic.

The prevailing habit of imitating pre-Hellenistic

styles naturally led sculptors to introduce classical elements into statues that were based on postclassical or earlier Hellenistic models. The "Borghese" Warrior (98) and the Sandalbinder (100) in the Louvre, both of which revive the style of Lysippos, are cases in point. Though every muscle of the Warrior responds individually to the violence of his action, he nevertheless seems frozen in one long, schematic diagonal. The Sandalbinder twists over to reach his raised foot, but not with ease and freedom; he somehow seems cramped and compressed. There is no more lovely or voluptuous maiden than the Artemis in Milan (128). Her nudity and torsion bring to mind the Victory of Samothrace (123). But isn't she forced into an impossible pose? All of these figures have the capacity for free movement; each one is placed in sophisticated torsions; yet they are drained of some of their vitality. They are unnaturally and inorganically constricted between two vertical planes and thereby flattened into the relief-like composition characteristic of the Classical period. The conflict is only resolved, or nearly so, when we see them in profile – certainly for each the best viewing position. Even the active and eager little Jockey (132) in the National Museum in Athens maintains a pose that is striking for its geometric parallelism. The tense, bulging muscles of the Seated Boxer (101), which revive the heroics of the Pergamon altar frieze, cannot conceal the frontal, un-baroque pose. In group composition similar trends are apparent. The Niobids (137, 138), as we said above, probably go back to early Hellenistic originals, yet they are not as individuals conceived in depth to anything like the extent third-century statues are.

On the whole a new quiet descends also on the drapery of the period. It can, for one thing, be of deadening weight and thickness – massed in pulpy layers which almost completely conceal the underlying form. The Cleopatra from Delos (116), Demeter of Knidos (127), and Polyhymnia (130) are submerged in this way. In the first half of the century the folds and gathers could make a rich chiaroscuro pattern, as seen in the Draped Female from Pergamon (115). Now the folds may be toned down to a few rather monotonous lines or channels or, on the other hand, may be meaninglessly complicated. They are never as instructive about the body undeneath.

A favorite motif of the period, though certainly not its invention, is the transparent shawl worn above a heavy garment.

Part of the same overall development is illustrated in the general decrease in plasticity and the corresponding increase in purely surface effects. It is not only the composition of the "Borghese" Warrior (98) that is largely two-dimensional, but also the anatomy, an elaborate map of muscles and tendons which do not seem to flow out of but to be pasted onto the body core. Similarly, the folds of Cleopatra's drapery (116) lack the energy to curve up, as modeling lines do, before they reach the contour. In spite of her massive proportions, therefore, her figure as a deep volume is de-emphasized. Such also is the case with "Polyhymnia" (130) another one-view composition that the drapery fails to make three-dimensional.

It would be wrong to conclude that this last period of Hellenistic round sculpture was merely decadent and uninspired, that it did over, less well, what had already been done, or that it revived old ideas because new ones were not forthcoming. With very few exceptions the technical quality remained extremely high. Granted that these figures and groups ring the changes on earlier styles, the majority of them are nonetheless very beautiful and still rank among the masterpieces of Western art. Even this statement does not give due credit to the continuing creativity of the period. Some of the most eclectic works have an unprecedented psychological realism, a new internal dimension. The Seated Boxer's battered and suffering countenance is unforgettable; the smile on the youth from Tralles is a revelation of his half-innocence and of his narcissism. What could be more ironic and hard-hitting than the clumsy dunce of a Thorn-Remover from Priene (136) who patiently removes the thorn from his foot, or the ugly old Dancer (135) who insists on displaying her supposed charms? The Singing Negro (99) and the Old Woman (105) are intense and sharp analyses of specific types of human beings. These are only a few of the many examples. Until the end, Greek sculptors had something new and significant to say.

1 This opinion is not universally held. An archaistic style flourished, according to some scholars, from the fifth

118

century on. See W. Fuchs, *Die Vorbilder der Neuatti-schen Reliefs, JdI*, Ergänzungsheft, 20, 1959, and E. Harrison, *Athenian Agora, Archaic and Archaistic Sculpture*, 1966. I have argued to the contrary in *AJA, 69*, 1965, 331-40.

2 G. Krahmer, "Stilphasen der hellenistischen Plastik," *RM, 38-39*, 1923-24, 138-89. "Die einansichtige Gruppe und die späthellenistische Kunst," *Nachrichten der Gesellschaft der Wissenschaften zu Göttingen*, Phil.-Hist. Klasse, 1927, 53-91.

3 V. Müller, *Art Bulletin, 20*, 1938, 359-418; R. Carpenter, *Greek Sculpture*, 1960, 180-88. M. Bieber, *Sculpture*, 6.

4 "Modeling" and "motion" lines, formal devices governing the representation of drapery in the High Classical period, were analyzed by R. Carpenter, *Greek Sculpture*, ch. V.

5 E. R. Dodds, *The Greeks and the Irrational*, ch. VIII.

80 Apoxyomenos of Lysippos

This statue of a young man scraping himself with a strigil, the Apoxyomenos, is one of the most familiar masterpieces of antiquity. It has become a tradition to hail its creator, the sculptor Lysippos, as the man who ushered in the Hellenistic age in art. Although it is debatable how far any single master rather than a group of collaborating artists determined the development of Greek sculpture, there is no question that to focus on Lysippos and his work dramatizes the crucial difference between Classical and Hellenistic art.

Pliny records that Lysippos altered the "square" figures of earlier sculptors. We understand this to mean that the sculptor created statues whose pose is neither clear nor satisfactory from the front view alone. Were we to stand where we could look straight into the eyes of the Apoxyomenos, we would discover that his arms are foreshortened and their action therefore obscured. Any other position within a 90-degree arc, such as the one in the photograph, would tell us more, even though some part of the figure would always appear at an angle. In statuary of the fifth and early fourth centuries, on the other hand, frontality reigned supreme. Arms rested or were raised only to the sides of the torso. The arms of the Apoxyomenos project and cross in front of his body, and this inevitably forces the spectator to stand aside. We can also discover, from anywhere within the prescribed arc, that the movement of the torso is

counter to that of the arms. Most of the weight is taken by the left leg, but the right leg carries some too. He is thus not completely at rest in the sense in which a Classical figure is at rest. He seems undecided and unstable, perhaps arrested even in the process of walking.

These innovations may seem elementary and unstartling to the sophisticated modern eye. But seen in relation to all ancient art of the West they represent a remarkable achievement. They created an unprecedented interaction between the figure and space; they increased the statue's implied capacity for movement; and they reduced the psychic distance between the statue and the observer. As the changes became more developed during the course of the Hellenistic age, they led to a vastly enriched formal and expressive language.

Lysippos was born in Sicyon and began working at least as early as 370 and continued probably as late as 306. His Apoxyomenos, made in honor of a victorious athlete, was one of his later works, dating from about 320 B.C. It was famous in antiquity and was ardently admired by the Roman emperor Tiberius. In spite of its fame, there are only two other versions. According to ancient documents, Lysippos faithfully copied nature, yet the Apoxyomenos reveals how abstract and generalized his style actually was. The sources also mention that he introduced a new canon of human proportions in constructing his statues. This, however, is not important in understanding the novel aspects of his art, for ever since the Early Classical period (480-450) Greek sculptors had concerned themselves with mathematical proportioning.

Rome, Vatican Museum, Gabinetto dell'Apoxyomenos inv. 1185. Marble. H. 2.05 m. Found in Rome. Some details restored. W. Helbig, *Führer durch die öffentlichen Sammlungen klassischer Altertümer in Rom*, 4th ed. I, no. 254. Original was bronze. M. Bieber, *Sculpture*, ch. III. J. J. Pollitt, *The Art of Greece, 1400-31* B.C. p. 143 f. (on sources). Other versions: *Antike Plastik* II, Pls. 60-62; Bonner *Jahrbücher*, 167, 1967, 119-28; A. F. Stewart, *AJA*, 82, 1978, 163-71.

81 Herakles, Farnese type

"Lysippos is said to have made 1,500 works, all of them of such artistic quality that any single one

could have given him fame...," wrote Pliny. One of his favorite subjects seems to have been Herakles, the most popular Greek hero. Continuing the tradition of Archaic and Classical art, he made, for one sanctuary in Greece, a whole series representing Herakles undergoing his famous labors. But Lysippos was praised at length in antiquity for two particular statues of Herakles, both of bronze and both of colossal size, which showed the hero not in the midst of his labors but after their conclusion, in a state of leisure and even exhaustion. The first and most famous was a seated figure which was set up on the Acropolis at Tarentum and in 209 was removed to Rome; the other, which is described by Libanios, a rhetorician of the fourth century A.D., represented Herakles leaning on his club draped with the lion skin. Where this second statue was located is not known; Athens as the site is a good possibility, for a similar figure is depicted on Athenian coins. Sicyon and Argos have also been suggested.

Libanios' description is so detailed that there has been no difficulty in recognizing the statue, which exists in about twenty-five Roman copies. The largest of the copies, the Farnese Herakles in Naples, is signed by Glykon, an Athenian sculptor of the second century A.D. A copy in Florence even has an inscription which states that it is "the work of Lysippos." Perhaps the most beautiful and most accurate of all the copies, however, is the bronze statuette we illustrate here, which was discovered at Foligno in the latter part of the nineteenth century.

Lysippos was not the first sculptor to represent Herakles with his duties done. But never before had this robust and virile hero evinced such melancholy and moral weariness, such reflective potential, as it were. He utterly depends on the support of his knotted club, which is braced under his armpit. Some weight is also carried on his right leg, but because the other is advanced and free, a note of restlessness pervades the entire pose. His left arm and hand hang down over the lion skin; his right arm is bent behind his back. Like the Apoxyomenos (80), the head is small in relation to the body. The anatomy is perhaps puffier and more minutely defined than in the original. On the other hand, Lysippos would have approved of the strong divisions between trunk and legs and the clear articulation of the chest and dia-

phragm. He probably made the original statue late in his career. The sculptor of the Telephos Frieze at Pergamon (167) seems to have seen it.

Paris, Louvre, no. 652. H. 0.425 m. On sources: Pollitt, *The Art of Greece*, 145, 148-49. F. P. Johnson, *Lysippos*, 190-212. E. Sjöqvist (*Lysippos*, 31) favors Sicyon as the site for the original statue. Another good and nearly complete bronze copy has been found recently at Pergamon (*AA*, 1966, 440, figs. 22a and b). The inscription on the copy in Florence is modern: *AJA, 76*, 1972, 102. C. Vermeule, *AJA, 79*, 1975, 323-32.

82 Praying Boy

There are no unexercised muscles or knotted ligaments in this body. The pose seems utterly simple and extremely graceful. The boy tilts back ever so slightly; most of his weight is carried on the left leg; the right foot lightly touches the ground. The balance is very delicate indeed. Seen here in pure profile, which betrays no torsion, the contour moves in and out with little inhibition; on the satiny surface light plays gently and not too analytically.

Unfortunately, both arms are restorations, and it is therefore impossible to interpret the original action conclusively. Since the palms of the hands are turned upward as if in prayer, the statue is often thought to be a work, perhaps an original one, of Boedas who, according to Pliny, "made a figure who is worshipping." Since Boedas was a pupil of Lysippos, the statue should date about 300 B.C. But this reasoning is very tentative; perhaps he was not praying, but playing ball. Because of the lack of clear anatomical articulation, R. Carpenter questions such an early date and, accordingly, the association of the work with Boedas.

Berlin, Staatliche Museen, inv. no 2. Bronze. H. 1.28 m. Found in Italy. Plinth restored. Surface repolished. E. Loewy, *RM, 16*, 1901, 391-94. R. Carpenter, *Greek Sculpture*, 182.

83 Hunchback

Figurines in bronze or terra cotta representing slaves, dwarfs, beggars, and deformed people are one of the major categories – the "grotesquerie" – of Hellenistic art. Sometimes they are satiric and amusing; at other times, as in this case, they are pitiful and

heartrending. The body of this little hunchback is fantastically misshapen and twisted; the vertebrae protrude like a bony fin. Realism is overlooked in the grim and exaggerated disproportions: the emaciated limbs are but matchsticks in relation to the enormous, drooping head. A sitting posture is the only one possible. From other examples we can deduce that he sat on a rock, now lost.

The hooked nose and the short pigtail suggest that the hunchback is an African. Possibly, then, the figurine came from Egypt where similar ones have been found. But they were made all over the Hellenistic world. Like this one, they often have an enlarged phallos, a sign, according to Wace, that they were used as talismans. These small works of art are particularly hard to date. This example may be about the middle of the third century because it is most satisfactory when seen in profile or from a three-quarter view, and the limbs are gathered close to the torso.

Hamburg, Museen für Kunst und Gewerbe, inv. 1949-40. Bronze. H. 0.066 m. Lacks right arm and right foot. Eyes and teeth inlaid with silver. A. B. Wace, *BSA, 10*, 1903-04, 105 f.; U. Jantzen, *Jahrbuch der Hamburger Kunstsammlungen, 3*, 1958, 47 f.; H. Hoffmann, *AA*, 1960, 122, no. 35; D. G. Mitten and S. F. Doeringer, *Master Bronzes of the Classical World*, Fogg Art Museum, 1967, *119*: 116.

84 Crouching Aphrodite by Doidalsas

A totally undressed Aphrodite, goddess of love and beauty, was something neither archaic nor classical artists could bring themselves to represent in large scale sculpture. The disrobing began, a little at a time, in the early work of Praxiteles until finally, shortly after 350 B.C. as the Classical period drew to a close, he produced his famous statue for Knidos, which showed the lovely creature completely nude but not unchaste, awaiting her bath. Thereafter, the goddess was more often than not represented nude and usually at some moment in bathing, which for her was a religious act. The beauty of the male body had long been admired in Greek art. We owe to the Hellenistic period the permanent establishment of the female form as an artistic subject.

The type illustrated here occurs in many replicas and variations. The original was probably of bronze and was made by Doidalsas of Bithynia between 250 and 240. Aphrodite crouches to receive a shower of water; her arms, which are missing in this example, were folded across her body. The right one was bent at the elbow and raised toward her head. The figure when viewed in profile is gathered into a clear pyramidal form. The body, though not unbuoyant, takes on impressive mass and weight as the flesh folds accumulate and press down against the waist and buttocks. Her expression is sweetness itself; she seems ready to relish the cool liquid that will fall upon her. Some copies show that Eros was nearby holding a mirror for the goddess to gaze into, but it is not certain that he was present in Doidalsas' original.

Rome, Museo Nazionale delle Terme, inv. 108 597. Marble. H. 1.06 m. From Hadrian's villa at Tivoli. L. Laurenzi, *ASAtene*, 24-26, 1946-1948, 167 f.; R. Lullies, *Die Kauernde Aphrodite*, Munich, 1954. Dated late third century and wrongly attributed to Doidalsas according to A. Linfert, *AM*, 84, 1969, 155-64. A half-draped Aphrodite, usually considered the early work of Praxiteles, has been reassigned to the Greco-Roman period by B. S. Ridgway: *AJA* 80, 1976, 147-54.

85 Seated Hermes

Hermes was perhaps the busiest of the Olympic deities. The most important among his manifold functions were to carry messages to and from the gods, to guide the dead to the underworld, to accompany all travelers, and to bring good fortune to athletes, those young men renowned for speed of action. Equipped with winged sandals, a herald's staff and hat, intelligence and cunning, he was a god in almost perpetual motion. Not until the Hellenistic period, however, were these capacities of Hermes given complete visual expression, for it was not until then that figures, whether in sculpture or in painting, seemed to move unimpeded in space.

In this beautiful bronze statue in Naples, then, we are not allowed to feel that Hermes, even though seated, has lapsed into inactivity. He is not tense but neither is he relaxed. His body turns in expectation "like a revolving compass," as Carpenter has put it. He is ready to spring up on his left foot; in fact he already leans forward as if waiting for a starting

signal. His limbs and torso are so arranged that it is virtually impossible to predict the direction he will take.

The statue, found in Herculaneum in 1758, is usually associated with Lysippos or his school. At least a dozen other versions on a smaller scale exist. In the Naples statue, the major parts of the body are clearly articulated and still quite generalized. The figure is hatless, but formerly carried a staff in the left hand. A good Roman copy of a mid-third-century Greek original.

Naples, Museo Nazionale, no. 5625. Bronze. Almost black. H. 1.05 m. From Villa dei Pisoni. Rock is modern. R. Carpenter, *Greek Sculpture*, 183. F. P. Johnson, *Lysippos*. C. Picard, *Manuel*, IV, 2, 600 ff.

86 Bronze Maiden

We exclaim, What simplicity! Long, uninterrupted contours, broad and firm surfaces, a perfect oval head, a stance that is unstrained, frontal, and entirely intelligible from the viewpoint presented in the photograph. For these reasons, this lovely and very young maiden discovered, it is said, at Verroia in Macedonia, is often thought to be a classical work of about 400 B.C. However, there is a twist to her pose. The shoulders pull back her upper body diagonally to our left, her hips and thighs rotate in the very opposite direction: what at first might appear simple is in truth exceedingly subtle and complicated and shows a profound knowledge of the human body.

Schuchhardt believes the maiden's left hand leaned against a pillar and that her head is inclined toward a mirror originally held in her right hand. She may have been a votive gift to Aphrodite or a delicious ornament for a private home. Probably the first half of the third century.

Munich, Museum für Antike Kleinkunst, inv. 3669. H. 0.25 m. Hollow cast. W.-H. Schuchhardt, *Die Antike, 12,* 1936, 84 f. A. Greifenhagen (*Das Mädchen von Beröa,* Opus nobile 9, 1958) favors a date of c. 400. For the girl's headdress as grounds for dating, see J. Charbonneaux, *Greek Bronzes,* 134. M. Robertson (*A History of Greek Art,* 549) places it in the second century B.C.

87 Aphrodite Untying Her Sandal

This figure has a famous and enchanting predecessor in the parapet reliefs of the High Classical temple of Athena Nike on the Acropolis in Athens. There a Winged Victory leans over and removes the sandal from her right foot. Her fresh and vibrant body emerges from behind a thin veil of drapery festooned with fine folds. The action of undoing her sandal is perhaps commonplace, yet her graceful and relaxed pose and the stabilizing patterns of the drapery imbue her with a timeless and monumental dignity.

Hellenistic sculptors adopted this very human motif for one of their favorite goddesses, Aphrodite, and turned it into a ritual act which she performs in preparation for her sacred bath. Except for her arm- and ankle-bracelets and her earrings, she has divested herself of all her clothing. Her sandals are the last item to be removed and, as in the relief of the Nike Parapet, she reaches down toward her right foot. Her right arm is completely vertical and follows the direction of the weight leg. All this side of her body seems closed and protected; exposure and openness are reserved for the other side, where her arm rests on a herm and her lifted leg crosses over to the other knee. In terms of cross-axis movement, the balancing of one limb against another, her pose is far more complicated and space-penetrating, but less dignified, than that of her High Classical sister. The apple in her left hand leaves no question as to her identity as Aphrodite.

The herm is surrounded by acanthus foliage and is surmounted by a miniature bust either of Eros or a child-follower of Dionysos. He wears a vine wreath and holds a bunch of fruit. He takes his supporting function seriously, and puts his plump hand under Aphrodite's arm.

The type was very common in Syria and Egypt during the Hellenistic period, and examples in bronze and terra cotta are numerous. This is one of the most exquisite and beautifully made of all. Probably a Roman copy of an original whose semicompact composition would suggest a late third-century date.

Paris, Collection de Clercq. Bronze. H. 0.308 m. From Syria. Right foot missing; ears pierced. Perhaps only base and herm are Roman. In some examples Aphrodite supports herself without the aid of a prop. The original may indeed have been free-standing. For a male "sandalbinder," see 100. A. de Ridder, *Collection de Clercq*, III, *Les Bronzes*, Paris, 1905, no. 89. E. Loewy, *AEM, 7*, 1883, 225-27. A. Minto, *BdA, 6*, 1912, 209-16. For Nike Parapet, R. Carpenter, *Sculpture of the Nike Parapet*, pl. 27.

88 Sleeping Eros

Eros, worn out from work and play, abandons himself, if only briefly, to sound sleep. His limbs lie loose, his mouth is open, and his wings have folded down on his back. His chubby little body is a most agreeable and fetching sight. His glistening skin, and the rock, a fragment of nature which he has just happened upon, it seems, contribute greatly to the sense of immediacy. The hair and the feathers on the wings are finished with great delicacy.

The god of love and the son of Aphrodite, Eros was ubiquitous in the art and poetry of the Hellenistic age. In classical art he appeared as a young boy endowed with a certain amount of dignity. Now he is a child, autonomous, impudent, full of pranks, occasionally exasperating to his mother but not at all easy to dismiss. Kindling amorous fires, he aimed his arrows at all and sundry, and he kept a good supply on hand: here he wears a baldric across his chest to hold the quiver which, though now missing, was under his head. His wings, of course, give him unlimited freedom of movement and hence almost unlimited power over his victims.

Sleeping Eros was a common type of the period. There are also several Roman copies very similar to this example in New York. It is life-size, made of bronze, and is technically of very high quality. Some scholars are of the opinion that it is the original which served as the model for the Roman copies. If true, this would be a most fortunate but very rare situation. In spite of the figure's relaxation, his body and limbs are quite compactly organized. Late third century.

New York, Metropolitan Museum of Art, Acc. no. 43.11.4. Rogers Fund, 1943. H. with mount, 0.433 m. L. 0.781 m. Said to be from Rhodes. Left arm missing. Stone base is modern. Hollow cast. G. M. A. Richter, *AJA, 47*, 1943, 365 f. Cf. Michelangelo's Sleeping Cupid, *AB, 39*, 1957, 251-57.

89 Sleeping Hermaphrodite

One long rhythm, like a gentle river, flows through this peaceful sleeper. Her head, with its damp, waved hair, nestles in her upraised arms. The clear S-curve of her back narrows and then swells into plump and perfectly shaped buttocks. Her long legs, one thrown over the other, continue through the momentary whirlpool of her drapery. Thus Aphrodite, the goddess of love, all female, loses herself in sleep in a pose that later painters and sculptors of the West found endlessly intriguing.

But there is another view that reveals her hermaphroditic form – a view in which harmonies are rather less prominent, in which the left arm and leg counter the rhythm of the torso, and in which the drapery is pulled and stretched as if it were about to be torn. Is the slumber so peaceful after all? The statue is a masterpiece expressing in a unified and ultimately balanced composition the complexity of her nature. The cult of Hermaphrodite, thought to be the divine offspring of Hermes and Aphrodite, had classical antecedents but is highly characteristic of the Hellenistic period, especially at Rhodes and Kos. There was no conflict or tragedy in this concept. On the contrary, Hermaphrodite was a mythical ideal in which the virtue and beauty of both sexes were harmoniously combined.

There are several copies of this statue. If the attribution of the original to Polykles, a second-century artist mentioned by Pliny (*N.H.* XXXIV, 52) is correct, it must have been of bronze. 200-150 B.C.

Rome, Museo Nazionale delle Terme, 1087, Marble. L. 1.47 m. Found in Rome. K. Clark, *The Nude, A Study in Ideal Form*, 391; M. Delcourt, *Hermaphroditea: recherches sur l'être double promoteur de la fertilité dans le monde classique*, Brussels, Latomus, 1966.

90 Capitoline Aphrodite

There are more than one hundred copies of this Aphrodite, a type that enjoyed tremendous popularity in the nineteenth century. The goddess' body, utterly unclothed, is full and fresh; the surfaces undulate warmly and sensuously. She is beauty incarnate. Yet like all Greek renderings of the nude female form, there is nothing carnal or vulgar about her. She is ultimately remote and unapproachable. Her two arms cross over her body, not in any anxious attempt to hide it but out of a sweet modesty and innocence. She turns away from us, uncoyly, self-absorbed. Her hair is piled high at the crown and is knotted behind before it falls down her back. A towel draped over a tall jug, a loutrophoros, is at her side.

There is no agreement as to the time of the original creation: that it was ultimately inspired by an Aphrodite from the school of Praxiteles is, however, granted by almost everyone. We prefer a date near the middle of the third century because the figure's "closed" composition is similar to that of the Crouching Aphrodite by Doidalsas (84).

Rome, Museo Capitolino, inv. 409. Parian marble. H. 1.93 m. Found in Rome. Nose restored. B. M. Felletti Maj (*Arch Cl,3*, 1951, 61) dates the original in the first half of the second century. Similarly W. Helbig, *Führer*, 4th ed. H. Speier, 1963, II, 128, no. 1277. K. Clark, *The Nude, A Study in Ideal Form*, 1956, 84-86. G. M. A. Hanfmann, *Classical Sculpture*, no. 254, 332. P. Friedrich, *The Meaning of Aphrodite*, Chicago, 1978.

91 Apollo Belvedere

"Here is the consummation of the best that nature, art, and the human mind can produce," said J. J. Winckelmann in 1755. From the day it was discovered, sometime late in the fifteenth century, until well into the nineteenth, the Apollo Belvedere evoked the praise of artists, poets, and the learned world, and the admiration of a long succession of ladies and gentlemen who came to Rome on the Grand Tour. The modern tourist is not likely to be so enraptured; yet, because of its history and great influence, the statue remains fascinating and is far from being without merit. It is a Roman copy of Hadrianic date, and this probably accounts for the soapy smoothness of the flesh, the pedantic perfection of the features, and the coiffure which seems all artifice and pomade. The tree trunk used here for support would not have been necessary in the bronze original. A cloak enfolds the neck and left arm. The god, nimble of body and light of foot, seems to float into our purview. He is wonderfully elegant. As he advances in general to the left, his outstretched arm and left leg trail behind, causing a slight counter-movement and implying definite spatial penetration. Because of the quiver on his back we may conclude he carried a bow in his left hand; his right probably held a laurel branch. Apollo's action cannot be connected with any mythological event; opinion prevails that the god of light and prophecy here manifests himself to his worshipers as though in an epiphany, in all his radiance and beauty. Opinion holds also that the original statue was probably made about 320 by Leochares, an Athenian and a sculptor at the court of Alexander the Great. Its "baroque" movement, however, would make an early second-century date quite possible.

Rome, Vatican Museum, Cortile del Belvedere, inv. 1015. Marble. H. 2.24 m. Found between 1484 and 1492, possibly in Anzio. Set up in Belvedere Court by Pope Julius II. J. J. Winckelmann, *Gedanken über die Nachahmung der griechischen Werke in der Malerei und Bildhauerkunst*, Dresden, 1755. Helbig, *Führer*, 4th ed., I, 170-72, no. 226. The literature on the statue is enormous. An excellent survey with bibliography will be found in C. Picard, *Manuel*, IV, 2, 787 ff. Compare the figure of Apollo in the Gigantomachy at Lagina (159). R. Tölle (*JDI*, 81, 1966, 142-72) accepts the attribution to Leochares but shows that the copyist enlarged Apollo's mantle. The head of Apollo in the original may have resembled the "baroque" Steinhauser copy (Fig. 19 in Tölle's article).

92, 93 Dancing Satyr

Satyrs, half-men, half-goats, enamored of wine and every other sensual pleasure, were enthusiastic members of the popular circle of Dionysos. Together with maenads and sileni, they drank and danced themselves into ecstatic states in which their vital and exuberant spirits found a healthy and unabashed release. Such is the condition of this satyr, which was found in a house at Pompeii. His short tail,

pointed ears, and horns are those of a goat; his broad nose is turned up at the end, his bristly hair is wreathed with acorns. Laughing and, we imagine, gurgling happily, he throws himself into the dance, twisting and snapping his fingers. The demonstrative and wanton character of his behavior is expressed by the gyrating turn of his head and torso. His hip and legs follow through on a spiral. One foot is directly behind the other; the arms, like those of a tightrope walker, keep him in balance.

The statuette occupied the center of an open court, a most appropriate location for an objet d'art that is gratifying from every angle. The freedom of the pose and the kinetic energy are inconceivable before the time of Lysippos, but the streaming hair and mobile features are reminiscent of the Pergamon style of the first half of the second century. Probably a Roman copy of an original of c. 200.

Naples, Museo Nazionale, no. 5002. Bronze. Very dark green. H. 0.71 m. The statuette is frequently dated early in the third century: M. Bieber, *Sculpture*, 39. R. Carpenter, *Greek Sculpture*, 184.

94 Flying Eros

This time Eros is not quite the child he was in 88. In fact, were it not for the presence of two holes in his shoulders where wings (now lost) were attached, we would not be certain what the subject was. Myrina terra cotta figurines like this one were made cheaply and quickly by assembling parts from different molds – a leg here, a torso or head there – and the coroplasts were not too particular about adding the appropriate part. This is the reason the limbs here are as long and shapely as those of a full-grown woman, and why the pretty face in exactly the same form can be found in many Flying Victories from the same region.

Nevertheless, the artist in this case was much more skillful than many. Another one of his products may be the superb "Heyl" Aphrodite (97). The graceful body here is very sensitively rendered. The open composition, the slender ankles and small, tense feet reduce his weight and make his flight seem not only plausible but rapid. The two knobs on his forehead represent fruit, and he wears a fillet around

his curly hair. The flying Eros in terra cotta does not appear before the third century. The date of this one is probably about 175 B.C.

Boston, Museum of Fine Arts, 01.7682. H. 0.265 m. From Myrina. D. Burr, *Terracottas from Myrina*, Vienna, 1934, 50, no. 44; E. Pottier and S. Reinach, *La Nécropole de Myrina*, Paris, 1887, S. Mollard-Desques, *Catalogue Raisonné des Figurines et Reliefs*, II, 1963, 35.

95 Satyr Falling Asleep

Some prize examples of Hellenistic art have come from the houses and villas of Pompeii and Herculaneum destroyed in the eruption of Vesuvius in A.D. 79. These residences were sometimes veritable museums with statues, paintings, and mosaics set up in gardens, courts, and rooms, very often for no other purpose than decoration. Whether originals or copies – and the difference cannot always be established – they marked the owner as a man of taste and cultivation.

One of the most lavish villas was the Villa dei Pisoni in the suburbs of Herculaneum. Included among the numerous sculptures found there was the Seated Hermes (85) and this young satyr who is just succumbing – no doubt after a round of wining and dancing – to a sudden fit of drowsiness. He is still half-awake. His eyes close, his lips fall open, he drags one arm to his heavy, sinking head, and his legs begin to sprawl helplessly but gracefully. He is a most sympathetic figure whose weariness is beautifully evoked by the slanting head and the open, radiating composition of his body. Probably a Roman copy of a Greek original of about 200-150 B.C.

Naples, Museo Nazionale, no. 5624. Bronze. Black-brown color. H. 1.15 m. Rock is modern. A. Bulle (*JdI, 16*, 1901, 14 f.) suggested that the figure should be tipped back into a more restful position and the mount accordingly extended. A parallel would be the famous Barberini Faun in Munich (M. Bieber, *Sculpture*, rev. ed., figs. 450-51).

96 Aphrodite from Melos

In the late nineteenth century (1897) the German scholar Furtwängler made a statement that was received with incredulity and even rancor: the

Aphrodite from Melos, one of the most beloved statues in all the world, was not, as had been thought ever since its discovery in 1820, a work of the Classical period but of the Hellenistic period. The shift in date threatened the beautiful maiden with a loss of prestige and admiration, for if she were later than the grand and noble works by Phidias and Praxiteles and was in fact of Hellenistic date, she could only be, by common agreement, inferior. In those days, and only too often even now, the Hellenistic period was regarded as one of decline and dissolution.

Although Furtwängler's proposal was gradually accepted, the statue fully merits our continued approbation: the softness of flesh and the subtle curves of the female body have never been better rendered. Our photograph splendidly reveals the gentle nuances of light and shadow that mold her torso. This is not just a factual account of the female body, however; geometric proportioning governs much of the design. The face, unfortunately, is rather vapid. A work of about 150-100 B.C., based on a late fourth-century type.

Paris, Louvre, nos. 399/400. Parian marble. H. 2.04 m. A. Furtwängler, *Meisterwerke der griechischen Plastik*, Leipzig-Berlin, 1893, 601 f. J. Charbonneaux, *La Vénus de Milo*, Opus nobile 6, 1958. The right arm crossed the body, the left was raised; reconstruction of the pose is still uncertain.

97 "Heyl" Aphrodite (Terra cotta)

This captivating young goddess probably came from Myrina, a small town near the coast of Asia Minor, which manufactured clay figurines by the thousands during the second and first centuries B.C. Fashionably dressed ladies, winged Victories, mischievous Erotes (94), and Aphrodites from this, that, or any angle have been found in the graves of the town's ancient cemetery. Not all are of such high quality as the Aphrodite, or possibly Muse, we illustrate here.

What is especially breathtaking is the complicated sinuous movement of both body and drapery. One thinks of a spiral as her tilted head turns one way, her shoulders the other, and her hips slither around once more only to be countered by her left thigh. Her robe, which is nothing but a thin veil, is very nearly slipping off, but its delicately raised folds travel around her breast, waist, and legs and enhance their shape and movement. How much less provocative that thrust-out hip would be if one or two diagonal folds did not cross against it! She is completely the ideal female: her head is small, her nose narrow, and her small chin round. A slight smile plays on her lips. The same type of face can be seen in the portrait of Arsinoe II, queen of Egypt (7). On her hair, which comes to a bun at the back, she wears a crown, or stephane. Her warm and erotic nature are made evident in the long, fleshy neck, the rounded shoulders, and the ample breasts and hips.

Traces remain of the colorful paint which was once applied over the whole figure. The back is only roughly finished. About 150 B.C.

Berlin, Staatliche Museen, inv. 31272. Formerly Heyl collection. H. 0.37 m. Another possibility is that it came from Pergamon. D. Burr, *Terracottas from Myrina*, 58-59. E. Langlotz, *Kunstsammlungen Baron Heyl*, II, 1930, no. 72, pl. 19. L. Alscher (*Griechische Plastik*, IV, 934) dates it a little earlier. According to F. L. Bastet (*BAntBeschav.*, 37, 1962, 15) it is about 100 B.C.

98 "Borghese" Warrior

Keeping his eye on his opponent, who was perhaps on horseback, the warrior's whole body strains and stretches as he plunges forward protected by a shield (on the left arm, now missing) and sword (in the right hand, missing). The thrust of his body is carried through on a long diagonal, but it is a harsh one and annoyingly straight. His torso and limbs seem well arranged and artificially compressed into a single plane. Yet had the photograph been taken from another angle we would see, with some surprise, that the composition is not as two-dimensional as it appears here. His left arm leaves his body almost at a sharp angle and his right arm pulls his torso back in a strong twist. The surfaces are constantly disrupted by an intricate tracery of muscles and tendons. Unfortunately they are too abundant and too clear; one suspects that beneath them there is little more than straw stuffing.

Agasias of Ephesos, a sculptor not otherwise known, put his signature on the tree trunk that supports this marble figure. Judging by the style of the lettering, Agasias executed the work in the early years of the first century B.C. In the small head and long proportions it is evident that he turned back to the work of Lysippos. His indecision as to whether to revive the planimetric composition of classical sculpture or whether to adopt the tridimensional conceptions of Lysippos and his followers reveals a dilemma also faced by many of his contemporaries.

Paris, Louvre, no. 527. H. 1.99 m. Arms restored. M. Bieber, *Sculpture*, 162. R. Carpenter, *Greek Sculpture*, 219-21. H. V. Hülsen, *Römische Funde*, 1960, 210. J. Marcadé, *Recueil des Signatures de Sculpteurs Grecs*, II, 3, 1957.

99 Singing Negro

As early as the New Kingdom period in Egypt (1570-1085 B.C.) Negroes had been represented in art. In Greece they appear, chiefly in ceramics, from the Archaic age on. In the Hellenistic period, however, they proliferate in the form of small terra cottas and bronzes. Sometimes they are caricatured; at other times they are seriously and sensitively studied, and the effect approximates portraiture. Although figurines of this subject have been found in most of the Mediterranean countries, their major and most natural ambience is thought to be Egypt, especially Alexandria, the multiracial city of the Ptolemies. Regular intercourse, moreover, between Egypt and Ethiopia was first established early in the third century and continued throughout the Hellenistic age. Hellenistic artists maintained a lively interest in all types and races, but they found the Negro, with whom they now experienced increasing contact, particularly fascinating.

The Paris bronze is one of the finest examples of the type. He is a "Black Orpheus" lost in reverie as he sings and plays the musical instrument (now missing – perhaps a harp) which he balances on his right shoulder. His whole body devotes itself to perfecting the sound: the head, neck, and hip, like elastic, lean over, pulling hard against the torso and left shoulder. Characteristic somatic traits such as the thin arms, flat thighs, large heels, and, in the face, the small nose and full lips have been very well observed. The glossy, seemingly-black skin achieved by the gliding planes and polished surface is one more of the many notable features of this little masterpiece. By comparing it with a standing female figure in Athens, which also has an extremely accentuated hip, Alscher rightly proposes a date in the first half of the first century B.C.

Paris, Bibliothèque Nationale, from the Caylus collection. H. 0.20 m. Found at Chalons-sur-Saône in 1764. Beautiful dark green patina. Eyes inlaid with silver. Big and little toes of left foot missing. E. Babelon and J. A. Blanchet, *Catalogue des Bronzes antiques de la Bibliothèque Nationale*, Paris, 1895, 439-40, no. 1009. L. Alscher, *Griechische Plastik*, IV, 132 f. On the Negro in Hellenistic art, see *AM*, 77, 1962, 255 f. (Hausmann), and F. M. Snowden, *Blacks in Antiquity: The Greco-Roman Experience*, Cambridge, Mass., 1969. W. Fuchs (*Greek Art and Architecture*, 514) suggests that the figure may have carried an elephant's tusk.

100 Sandalbinder

In spite of the existence of several complete or partial copies, it is not possible to determine if the stooping young man fingering his sandal is Jason, Hermes, Perseus, or just an athlete. The pose is fairly common in earlier Greek sculpture and painting, but the sharply turned head is an innovation.

Until very recently the Sandalbinder had been accepted as a copy of an original by Lysippos or his immediate circle. However, in a particularly perceptive analysis, B. S. Ridgway has concluded that the prototype was not created at the end of the fourth century but at about the same time as the "Borghese" Warrior (98) – toward the end of the second. The statue indeed has certain Lysippan features: Lysippos' canon of proportion, particularly the small head, has been reintroduced, and the pose is not without spatial implications. But there is a kind of ambiguity in the design. In a general way the profile and isolation of the figure are stressed, and yet the arms are entangled in depth and space, and the contour is interrupted by allowing the head to peep out at us. Is the composition two- or three-dimensional? The observer is left unsure as to the

optimum viewpoint. This sort of "mannerism," along with the detailed description of the anatomy, undoubtedly suggest a late Hellenistic date for the original.

Paris, Louvre, 183. Marble. H. 1.56 m. Much restored; head is antique but does not belong to statue. B. S. Ridgway, *AJA*, 68, 1964, 113 ff. C. Caprino (*BdA*, 59, 1974, 106-14) underlines the Lysippan characteristics of this and other copies.

101 Seated Boxer

The beaten and battered face, the scarred and swollen body, and the gloves – we are left in no doubt as to this man's profession. He leans forward, not altogether comfortably. His massive shoulders, his overdeveloped back, his thick neck seem mountainous compared to the small head. His fingers hang stiffly out of their wrappings. One could continue the survey of his body, his ears, nose, cheeks, and mouth, and catalogue easily the damage they have undergone. The disfigurements that have affected his breathing, his speech, and even his mind are rendered with astonishing realism. But let us hasten to add that the Boxer is not brainless. He lives an inner life of his own, as intense in its way as that revealed earlier in the portrait of the philosopher Poseidonios (32).

Combined with this keen interest in surface and psychological realism there is a reversion to pre-Hellenistic ideals revealed in the composition. Torsion, characteristic of so much Hellenistic art, is no longer present; his shoulders are parallel to his waist, and his hands meet on the central axis. Thus far, the sculptor seems to have been thinking of the quadrifaciality of classical statues in which the frontal and profile views were the most compelling and satisfactory. Yet the head does not fit well with either. We almost suspect that it was screwed on, its final position being arbitrarily arrived at and having no organic connection with either the neck or shoulders. How, then, are we supposed to look at the statue?

Considering the Boxer's coarse features, the hair and beard are surprisingly orderly and delicate. Perhaps in this area, too, the sculptor had a classical model in mind. If so, we are reminded again

of the portrait of Poseidonios in which classicistic elements were present. The Boxer seems to be contemporary with that portrait, that is, about 70-50 B.C.

Rome, Museo Nazionale delle Terme, inv. 1055. Bronze, hollow cast. H. 1.27 m. Found in Rome. Rock modern. For the possible meaning and context of the statue, see comment on 19. Controversy has arisen as to whether there is (or was) an artist's signature on the thong of the boxer's left glove. R. Carpenter so argued in *MAAR*, 6, 1927, 133-36; M. Guarducci (*AS Atene, 37-38*, 1959-60, 361-65), takes a contrary position.

102 "Beautiful Head"

103 Head of Athena

These are obviously not portraits. Both are over-life-size ideal heads representing divinities, and each was originally attached to a full-length body. The goddess in 102 cannot be identified; in 103 we have an Athena who at one time wore a Corinthian helmet. Together they illustrate, in rather extreme form, the two major trends of Hellenistic sculpture in the second century: the emotional, pathetic "baroque" style of the first half of the century, which was most definitively expressed at Pergamon, as opposed to the cold and academic "classicism" of the late second century, which sought to revive the style of the late fifth. The latter trend had its earliest and strongest exponents in Athens.

In the Pergamon work, the axes of the head and neck diverge dynamically, surfaces are delicately modulated, and the flesh seems alive and warm; the features and hair are affected by light and shade, which dissolves edges and prohibits the isolation of any single element. On the other hand the rigid vertical axis through the head and neck of the Athena suggests haughtiness and moral rectitude. When compared to 102, she is seen to be removed from the realm of the living. The heavy jaws and cheeks are smooth and hard; the mouth, though full and open as in 102, seems externally attached, a permanent fixture. The eyes and hair are mapped out carefully, lid by lid and strand by strand. Phidias and his contemporaries were never as compulsive about perfection of shape or clarity of linear design.

A short time ago, H. Luschey proposed that the "Beautiful Head" came from the large frieze of the Pergamon altar (153-156). The head of Athena is probably the work of Euboulides IV, one of a family of sculptors who worked in Athens in the later part of the second century B.C. Pausanias may well have seen this austere goddess on his visit to that city in the second century A.D.

102. Berlin, Staatliche Museen, P90. Parian marble. H. 0.30 m. Found near the Altar of Zeus. The head may have been rubbed down, but not enough to invalidate the analysis. A piece of the thick hair on the right profile was worked separately and attached with metal pins; the holes are still visible. H. Luschey, *Funde zu dem Großen Fries von Pergamon, Winckelmanns-Programm,* 116-17, 1962, 12 f. H. Weber, *Gnomon, 35,* 1963, 503-04.

103. Athens, National Museum, no. 234. Pentelic marble. H. of face, 0.31 m. Found near Kerameikos. G. Becatti, "Attikà-Saggio sulla scultura Attica dell'ellenismo," *Riv. del Ist. Arch., 7,* 1940, 14-16, 52-53. Pausanias, I, 2, 4.

104 Head of a Boy

105 Head of an Old Woman

We take particular pleasure in this contrast between the innocent smile of a young child and the throaty laughter of an old hag. In each case the artist has captured the vital essence of a human being. The boy, in whom everything is potential, is soft and unformed, as pretty as a rosebud and totally alive. The old woman, perhaps inebriated, is all too experienced and cynical; life still pulsates in her, but it has already taken a heavy toll. In art before the Hellenistic age, smiles and unbridled laughter were considered undignified and were only permitted to the masked players in Old Comedy and to the adherents of the cult of Dionysos. In the Hellenistic period, expressions of mirth were still thought inappropriate in representations of gods and heroes. Old crones, however, now entered the charmed circle of Dionysos, which included the half-human satyrs and centaurs. But, as we may learn from the poetry of Theocritus and Callimachus, old age itself elicited the interest and sympathy of the period, and for children, whether they smile or not, a sentimental love is felt for the first time.

The unity of the child's head, its vigorous animation and uncomplicated psychology would seem to place it about 200 B.C. In the case of the old woman, the details of the face dominate the whole, and lines are engraved down the cheeks and around the lips, recalling the portrait head of the priest in Athens (24). We can place her probable date in the first half of the first century.

104. Alexandria, Greco-Roman Museum. Marble, from Alexandria. A. W. Lawrence, *Later Greek Sculpture,* 17.

105. Dresden, Staatliche Skulpturensammlung, inv. 475. Marble. H. 0.22 m. She wears a kerchief and an ivy crown. L. Alscher, *Griechische Plastik,* IV, 133 ff. H. Kenner, *Weinen und Lachen in der griechischen Kunst,* Österreich. Akademie der Wissenschaften, Phil.-Hist. Klasse, *Sitzungsberichte, 234:* 2, 1960. G. M. A. Hanfmann, *DOPapers, 17,* 1963, 85.

106 Palladion from Sperlonga by Hagesandros, Athanadoros and Polydoros

One of the more recent and sensational finds of ancient art occurred in 1957 near Sperlonga, a small town on the west coast of Italy. Thousands of fragments of sculpture, many of colossal proportions, were found in an enormous cave which adjoined the Villa of Tiberius. It was a weird place; the interior of the natural cave had been extended and built up into a watery and fantastic landscape lavishly decorated with four ambitious sculptural ensembles including the blinding of Polyphemus, the fury of Scylla, and Odysseus with the body of Achilles. An inscription written by Faustinus, the court poet of the Roman Emperor Dominitian (A.D.) 81-96), assisted the interpretation. The difficult and sometimes inconclusive task of reconstructing these groups from over seven thousand fragments has been the preoccupation of many scholars from all over the world. The task is especially interesting because so much of the sculpture is of great beauty and the very highest quality.

The fragment illustrated here probably belonged to the fourth group. A large male hand grasps the Palladion, the old and revered image of Pallas Athena, whose presence in Troy guaranteed the city's invincibility. Odysseus and Diomedes contrived to snatch it away, and Troy then fell to the Greeks.

Diomedes holding the prize was represented in this now incomplete group which also included Odysseus.

The Athena of Euboulides (103) was classicistic in style. Here, however, the goddess is archaized; the older, more rigid style is imitated in order to show that in this context Athena is in fact a statue, inanimate and stony, in contrast to the very much alive and even nervous hand that carried her off. The sculptor has successfully reproduced the archaic style in the ruffle across her breast and in her stiff pleats below, and he has even turned up the corners of her mouth in a pseudoarchaic smile. But the fleshy cheeks, the dimple, and the pudgy arms betray the fact that she is, after all, an adorable post-archaic child.

Some uncertainty exists as to the originating period of this Palladion and the related groups. In their pathos and in their pictorial use of light and shade they resemble the Hellenistic sculpture of the Altar of Zeus at Pergamon (153–156). They are even more directly related to the Laocoon (146) because the names of the Rhodian sculptors who made that famous group have been found inscribed in letters of the first century A.D. on the ship from Sperlonga. Thus the sculptures from Sperlonga could have been executed as a special commission for the cave of Tiberius in the early years of the first century A.D. They seem to have been adapted from late Hellenistic painted or sculptured prototypes. The group of which our archaizing child is a part probably goes back to a bronze original of the second half of the second century B.C.

> Sperlonga, Museum. Greek (Rhodian?) marble. G. Iacopi, *L'antro di Tiberio a Sperlonga*, Instituto di Studi Romani, 1963, P. von Blanckenhagen, AA, 1969, 256-75; *AJA*, 77, 1973, 456-460; AJA, 80 1976, 99-104. G. Saeflund, *The Polyphemus and Scylla Groups at Sperlonga*, Stockholm, 1972. B. Conticello and B. Andreae, *Die Skulpturen von Sperlonga, Antike Plastik* XIV, Berlin, 1974.

107 Head of Sarapis

For political reasons, Ptolemy I thought it wise to fuse the religion of his Greek subjects with that of the older religion of the Egyptians. He therefore created the new cult of Sarapis in which, under the aegis of a single god, the functions and attributes of Zeus, Hades, and Asklepios on the one hand and of Osiris-Apis on the other were combined. The new Greco-Egyptian deity thus became at one and the same time the god of heaven and of healing and also of the dead and the underworld. The combination proved powerful. The cult of Sarapis spread rapidly to Greece, Asia Minor, and eventually to Rome where, especially under Hadrian and the Antonines, it became one of the major religions of the empire. Small wonder that heads, busts, and statues, all quite similar, of this formidable and solemn divinity abound in European, African, and Turkish museums. Small wonder, too, that there is no agreement as to whether they are all based on one or two originals, precisely who made them, or when they were made.

We do know that there was a great cult statue of the seated Sarapis at Alexandria and, according to Clement of Alexandria, "the sculptor Bryaxis made it.... He made use of mixed and varied materials for the work. There were filings of gold on it and of silver: also of bronze, iron and lead, and, in addition to that, tin; nor did it lack any of the Egyptian gems – fragments of sapphire, haematite and emerald, and others of topaz. Having ground all these to a powder and mixed them together, he colored the mixture to a dark blue shade. . . ." It must have been a weird but dazzling statue. But whether the Bryaxis referred to lived in the fourth century, or later, and how far his statue was "modernized" in the second century A.D. cannot be determined. This head, now in Cambridge, England, probably bears some relation to the Bryaxis type, although one hesitates to say how much. Characteristic of many versions are the modius with vegetal designs which he wears on his head, the somber expression, and the hair and beard, which, in their abundance, almost obliterate the face. The locks that dangle separately on his brow and the vertical divisions of the beard are also standard elements. Whether the locks belonged to Bryaxis' original is uncertain. Some copies show the hair rising upward from the brow.

> Cambridge, England, Fitzwilliam Museum, Inv.: GR. 15.1850. Marble. H. 0.22. m. Bust and modius restored; a copy of the second century A.D. For a discussion of this head, bibliography, and problems relevant to the Sarapis type,

see L. Budde and R. Nicholls, *A Catalogue of the Greek and Roman Sculpture in the Fitzwilliam Museum*, 1964, 30-33. W. Hornbostel, *Sarapis: Studien zur Überlieferungsgeschichte, den Erscheinungsformen und Wandlungen der Gestalt eines Gottes*, Leiden, Brill, 1973.

108 Head of Anytos by Damophon

We might suppose, from the photograph, that the head was made of some soft material like terra cotta – the beard and hair seem so pliable and pictorial, and the eyelids appear to have been molded around the now-missing eyeballs. The medium, however, is marble, and the painterly style is very characteristic of the sculptor Damophon's art.

Damophon, who came from Messene and was active in the first half of the second century, made several cult statues for sanctuaries in the Peloponnesus. For a temple at Lycosoura in Arcadia he made a colossal group of four figures including the seated Demeter and Despoina ("Mistress"), a standing Artemis carrying a torch and snakes, and the Titan Anytos who, according to local legend, was the foster-father of Despoina. A few fragments of Anytos' cuirassed figure and his very affecting head were discovered in 1889. The short but heavy lower lip, the widely arched and sunken eyes, and the tossed hair and beard lend a certain poignancy and excitement to his expression and alert us to the fact that the Pergamene "baroque" penetrated to the Peloponnesus. On the other hand, there is a touch of blandness and benignity, a calmness of surface and symmetry that are reminiscent of the style of Phidias and Praxiteles. Damophon, who was older than Euboulides, was one of the first sculptors of the Greek mainland to turn back to the austere majesty and more restrained forms of the classical period. One could consider him a forerunner of the Neo-Attic school. New excavations have raised the question of a possible Hadrianic date for Damophon or, more likely, for the repair of his statuary.

Athens, National Museum, 1736. H. 0.79 m. Though of marble, the head was hollow and was composed of several pieces. Pausanias 8.37. 3-5. G. Dickins, *BSA, 13*, 1906-07, 357 ff. W.B. Dinsmoor, *AJA, 45*, 1941, 399 ff. G. J. Despinis (*AA*, 1966, 378-85) has attributed another work to Damophon. E. Lévy, *BCH*, 91, 1967, 518-45; E. Lévy and J. Marcadé, *BCH*, 96, 1972, 967-1004.

109 Sleeping Woman

Perhaps she is one of the Erinyes, or Furies, who pursued and tormented criminals; perhaps she is one of the maenads, the half-insane and frenzied worshipers of Dionysos; or she may be the dying mother "pitiably caressed" by her infant mentioned by Pliny as a work of Epigones, a Pergamene sculptor. Whoever she is, she has only recently capitulated, for her hair is still damp with sweat, and her slumber, which is not deep, has yet to erase her disquiet. Her parted lips, like the snaky strands of her hair, fall limply in the direction in which she lies. The head is in high relief.

Our sleeping beauty is closely related in style to the wife of the Gaul Killing Himself (140) as well as to the heads of several goddesses on the large frieze of the Altar of Zeus at Pergamon. Perhaps from a Roman relief based on the Pergamon Gigantomachy. Original 180–160 B.C.

Rome, Museo Nazionale delle Terme, 8650. Marble. Nose and part of lower lip restored. S. Aurigemma. *Le Terme di Diocleziano e il Museo Nazionale Romano*, Rome, 1958, 80, no. 192. M. Bieber, *Sculpture*, p. 112; G. Kleiner, *Das Nachleben des Pergamenischen Gigantenkampfes, Winck.-Prog.*, Berlin, 105, 1949, 113-15. Later third century: M. Robertson, *A History of Greek Art*, 533.

110 Male Head from Samos

This fine marble head was found many years ago on the island of Samos. In style, it owes a great deal to Pergamon; it may be compared, for instance, to the portrait of Alexander in Istanbul (3) in respect to the open mouth and the divergent axes of head and neck. The divergence, however, is sharper, and the head, which is small, swings loosely on the columnar neck as if the two were only tenuously joined. In this respect, then, the Samos work is closer to the disjointed and inorganic position of the Seated Boxer's head (101) or to that of the "Borghese" Warrior (98). Another late Hellenistic feature is the stylized purity of the oval face (compare Cleopatra in 16). Its lovely shape is stressed but, concomitantly, the bone structure seems weak or nonexistent and the surfaces are rather flaccid. But

while the head may lack physical forcefulness and a powerful organic structure, its expression, chiefly because of the squinting eyes, is direct and intense compared to the vague dreaminess of Alexander and contemporary heads of the first half of the second century.

The Samos head is not a portrait, but we do not know which divinity or mythological figure is represented. He wears a band around his short locks. 100–50 B.C.

Paris, Louvre, no. 2516. Came to Louvre in 1892. H. 0.205 m. Eyes hollowed for inlay. Head unfinished on right side. H. Walter, *AM, 76,* 1961, 149 f. The head is sometimes considered female and has been dated in the second century. See J. Charbonneaux, *La Sculpture Grecque et Romaine au Musée du Louvre,* Paris, 1963, no 2516. R. Horn, *Hellenistische Bildwerke auf Samos,* Bonns, 1972, no. 75, 108.

111-116 Standing Draped Females

Some insight into the still imperfectly understood development of Hellenistic sculpture may be gained by analyzing a series of statues of a type that has survived in some abundance: draped women. Each figure in the group we will discuss is in a standing pose; with one exception they are Greek originals, and as far as possible they are externally dated. The subjects vary. They include a goddess, priestesses, and fashionable ladies. In our analysis we will be especially concerned with the two major elements of body form and drapery and with their interrelationship.

111-112-113 Late fourth century to middle third

In any statue of the classical period the body form, its pose, shape, and movement, predominated. It dictated, always rationally, what the drapery did, how it lay or fell, and where the folds were arranged. That the same relationship prevails in the early Hellenistic period is shown by the three examples, two of marble, one of terra cotta, chosen first for analysis. Although the garments worn lack High Classical transparency and thinness, in each case the shape of the underlying female form is sensed

along nearly all contours and surfaces. Well-covered though these maidens are, the naked flesh lies just beneath. In the arrangement of folds a distinct preference is shown for long parallel diagonals and arcs that cross over the whole figure and model it, narrowing or disappearing over protrusions, widening and deepening in depressions. The arrangement stresses harmony, unity, and the totality of the figure. Even the gathered bundle of Themis' mantle (111) fails to cut her in two. As a design, the surface has, in each case, a definite consistency and calmness. One fold glides gently into or alongside the next. However, unlike a classical statue where the drapery offers no resistance whatever, here there is a slight tension between drapery and body, as if one were reacting in a positive way to the other.

114 Second half of the third century

The drapery accumulates. This young woman, who holds a tray, is wrapped and rolled in a heavy, crinkly gown and a cumbersome shawl. The close rapport between the underlying form and its covering is gone. Her body turns toward the tray, but does this really matter? The garment, the sculptor's prime interest, occupies all our attention. It is busily broken up by bundled folds, triangular pieces, a horizontal belt, and vertical channels. We jump from one autonomous subsection to another. One thick layer covers another; compared to those of her earlier sisters, the contours are far less eloquent, particularly down her left side and over her right hip. Sheer weight has also increased. Although she is taller and higher-waisted than the earlier figures, the lower section is a bulky and ever-widening mass.

115 First half of the second century

This is an exciting period style for which the terms "baroque" and "dynamic" have been used, with every justification. This figure was discovered at Pergamon, the major center if not the originating city of the style. How much longer she is, and what enormous legs! She is a sensuous giantess bearing a load of drapery that exceeds even that illustrated in the previous example. She wears

a thick, long dress covered by a fine linen shawl that reveals the coarser material beneath. But in spite of the ponderous character of her garment, we are not allowed to forget that a living and vital body supports it. The full breasts are so lightly covered they seem bare, her left thigh and calf (though damaged) were similarly exposed, and it is impossible to overlook that hip which pushes out against her robes. There are, however, contrasting elements: her right thigh and leg are positively buried and invisible behind yards of material. It thus seems that the body and drapery, both of them powerful and active, are now in open conflict. A rich interplay of light and shade contributes to the drama. As for the fold arrangement, it is not, on the whole, as indifferent to the body structure as it is in the later third century. Delicately raised ridges model the breasts. The sliding diagonals of her shawl and the slight curve of the roll between her breasts reinforce the volume of her whole figure and yet take cognizance of its subtleties. Fold directions, moreover, are more harmonious and do not arbitrarily subdivide the surface. The resurgence of the body form, the transparency of some of the drapery, and the modeling lines all indicate that this style contains classical elements.

116 Second half of the second century

Cleopatra is the name of the woman represented in this portrait statue from Delos. It is a marvel of carving; few surfaces have been more smoothly finished. Yet, we may ask, where is Cleopatra? Corsets and layers of stiff flannel have submerged her. The woman in 115 thrusts her hip out boldly, but here, though there is a conspicuous curve just below the waist, we are left in no doubt that it is artificial. The body's vigor has been withdrawn; its massive, stony weight stabilizes it, rather than its own organic structure. How subdued, at the same time, the drapery has become. How thin and linear the folds are. There is something mechanical about them, and they substantiate the volume of the figure less than in any of the earlier statues. They are pretty, neat, and mannered, obeying their own decorative rather than either material or structural logic. In contrast to the open and ag-

gressive nature of 115, the Cleopatra binds herself in her arms in the popular "Pudicitia" pose. Her back is an almost undisturbed curved surface; all interest has been concentrated in the front view.

With reference to the physical body, Greek sculptors, of whatever period, were materialists. They regarded it with deep reverence. Although they clothed it, sometimes cleverly, they never went so far as to deny its corporeality completely. We have here summarized some of the changes that occurred in the rendering of drapery in the course of the Hellenistic period. But it is important to remember that not only to Classical but also to Hellenistic artists, a drapery fold was intended to convey physical rather than spiritual reality.

111. Athens, National Museum, no. 231. The goddess Themis. Pentelic marble. H. 2.22 m. From the sanctuary of Nemesis at Rhamnus. By Chairestratos. Dated by inscription to c. 300. E. B. Harrison, *Festschrift für F. Brommer, Mainz*, 1977, 155-61.
112. Berlin, Staatliche Museen. The priestess Nikeso. Marble. H. 1.73 m. From the sanctuary of Demeter at Priene. Dated by inscription to first half of third century.
113. New York, Pomerance Collection. Terra cotta. H. 0.245 m. Find-place unknown. Tanagra-type in "Sophoclean pose."
114. Rome, Museo Nazionale delle Terme, no. 50170. Marble. H. 1.70 m. From Anzio. Probably a copy of a bronze original of a girl assisting at a sacrifice, by Phanis, a pupil of Lysippos. P. Mingazzini (*JDI*, 81, 1966, 173-85) argues the figure represents Phemonoe, an original work sculptured by a Pergamene artist (180-170 B.C.) as an Attalid dedication for the sanctuary of Apollo at Delphi and subsequently transported by Nero to his villa at Anzio. Cf. H. Kenner, *Das Mädchen von Antium*, Vienna, 1971.
115. Berlin, Staatliche Museen, P54. Marble. H. 1.90 m. Comparable to figures on the large frieze of the Altar of Zeus 182-165 B.C. The transparent veil covering a heavier material first appears in the second quarter of the third century.
116. Delos, Museum. Marble. H. 1.67 m. Dated by inscription to 138/7 2.3. J. Marcadé, *Au Musée de Délos*, Paris, 1969, 131-34. R. Horn's study of the standing draped female statue in *RM, Ergänzungsheft* 2, Munich, 1931, and Gerhard Kleiner's study of Tanagra figurines in *JdI, Ergänzungsheft* 15, Berlin, 1942, are invaluable. Hellenistic terra cottas from the Athenian agora have been examined by D. B. Thompson in a series of recent articles (in *Hesperia*). These studies are extremely useful for dating individual drapery motifs. A. Linfert, *Kunstzentren Hellenistischer Zeit; Studien an Weiblichen Gewandfiguren*.

117 Tyche of Antioch

Antioch, the capital of the Seleucid empire, was founded by Seleukos I in 300 B.C. and was named after his father Antiochos. Soon after, the sculptor Eutychides, a pupil of Lysippos, was commissioned to make a statue personifying the new city. The statue, which was made of bronze and was colossal, "was held in great honor by the local people" (Pausanias VI, 2, 6-7) and was reproduced on Syrian coins of the first century B.C. and on several Imperial Roman coinages. Unanimously recognized as the most faithful replica of this famous work is this marble statuette in the Vatican. The city is represented as the goddess Tyche or Fortune – here a sort of mother-figure presiding over the affairs of her people and bringing them good fortune. The belief in a guardian deity was very old among Greek city-states. Personifications were frequent in earlier Greek art too, but they were never as elaborate or meaningful as this. Tyche is seated on a rock that symbolizes Mount Silpius, a prominent feature of the topography of Antioch; she rests one foot on the shoulder of a swimming youth who personifies the river Orontes on which Antioch was situated. Her turreted crown represents the city walls; in her right hand she holds a bunch of wheat, implying fertility and prosperity.

The statuette has the compact, near-pyramidal outline that seems to be characteristic of several third-century sculptures. Compare, for example, the Crouching Aphrodite by Doidalsas (84). In both, the interior of the pyramid is enlivened and its three-dimensional nature exposed by the crossed limbs and, in the case of Tyche, by oblique drapery folds as well. In Tyche, furthermore, the right leg, right arm, and head line up vertically not along a single plane but on three successive ones. The fluid parallel folds and their respect for the pose and structure of body are characteristic of the first half of the third century. Roman copy of a Greek original of 300-290.

Rome, Vatican Museum, Galleria dei Candelabri. H. 0.895 m. Found in 1780 in Rome. Head is alien. Restored: right arm and hand, left hand, parts of drapery; on Orontes, details of head and arms. T. Dohrn, *Die Tyche von Antiochia*, Berlin, 1960; W. Helbig, *Führer*, 4th ed. I, 433-435, no. 548. R. Heidenreich, *Helikon*, 8, 1968, 549-51.

118, 119 Statuette of a Maiden

Is she dancing? The mantle of the marble maiden is ingeniously employed; like a ritual garment, it lends a note of formality and even solemnity. Mantle dancers were a fairly common Hellenistic type, especially among terra cotta figurines, and it is now thought they represent temple dancers, perhaps priestesses, engaged in an act of worship. Such dancers practiced their art in the cults of Dionysos, Cybele, Demeter, and Artemis. On the evidence of the figurines, however, the women who conduct this performance usually spin rapidly and are completely swathed in drapery, drawing their mantles over head and shoulders and, very often, over the lower part of their faces. It may, be, then, that our young bare-shouldered, stooping woman is not dancing in a temple at all but simply taking a few coquettish steps on the village street.

Gracefully and with great elegance she bends her body, in order that her right hand can catch up the folds of her mantle. Her left hand (now missing) holds high the numerous vertical folds that have accumulated after the mantle has crossed over her back. The shawl may be heavy, but it does not obscure her lithesome movement. Her body turns in a slow spiral so that her shoulders are in a plane nearly at right angles to her feet. The drapery lies close over her arm, revealing its form and purpose. The folds subside over this area, just as they do over her right thigh, and then they deepen and crowd together as they converge toward the two hands. The statuette shows particularly well the pressure which both the body and the drapery exert and the roundness of the hips.

The composition, in which all the movement is directed inward and in which the contour remains closed, has frequently been compared to that of the Tyche of Antioch (117). The drapery is handled with the same logic, corporeality, and harmony as in the Themis from Rhamnus (111). First half of third century.

Budapest, Museum of Fine Arts, no. 4759. H. 0.633 m. From Rome. A. Hekler, *Die Sammlung antiker Skulpturen. Die Antiken in Budapest*, I. Abteilung, 1929, 84-85, no. 76. L. Alscher, *Griechische Plastik*, IV, 23 ff. For mantle dancers

see D. B. Thompson, *Troy, Supplementary Monograph*, 3, 102-05. Compare the late third-century bronze dancer discussed by D. B. Thompson in *AJA, 54*, 1950, 371-85, figs 1-3. Also see D. B. Thompson, *Archaeology*, 27, 1974, 70-72.

120 "A Faithful Servant"

When, Master, in hale old age, closing a life without ill
You come down, command your slave's service still.
— From an epigram by Dioscorides, c. 200

Servants are frequently depicted in intimate association with their masters on Greek funereal monuments. Relief scenes on Attic grave stelai of the fourth century may show, for instance, a young slave girl sorrowing beside her mistress, amusing her with trinkets, or tying her sandal. A small boy slave may sink in grief at the feet of his master, or perhaps stand ready with a jug of oil while the master prepares for a bout in the palaestra.

This less-than-life-size young boy, carved out of limestone, was found in the ancient necropolis of Tarentum. His cropped hair and his short, belted chiton (*exomis*) make it almost certain that he is a servant, perhaps brought, as slaves often were in the Hellenistic period, from the peripheral regions of the Hellenic world, for his flat nose, wide, flat head, and protruding lower lip are not fully Greek. We may suppose his short life has been arduous, for his posture rather resembles that of an old man. The statuette was meant to be seen only from the viewpoint shown in the photograph, for the back and left side of the head are incompletely worked. The boy looks to the right with touching seriousness and sadness. Presumably he gazed at his owner; they must have stood together within a small naiskos placed over the grave. The scene in the grave relief from Smyrna (169) offers a rough parallel.

The Tarentines were great art lovers. Terra cotta figurines, locally made, exquisite jewelry and metal work, and other limestone sculptures (149) have been found in many graves. Both Pliny and Strabo mention that Tarentum possessed colossal works in bronze by the sculptor Lysippos. But Tarentum's wealth and her control of the other southern Italian cities diminished after 272, when Rome captured the city and carted off many of its works of art. Our young servant is of pre-conquest date, perhaps about 300 B.C. The soft stone from which he is made does not permit a smooth finish and may account in part for the large, simple fold patterns of his tunic and the expressive force of his features. The traces of paint that adhered to the surfaces when he was found in the latter part of the nineteenth century have since disappeared.

Berlin, Staatliche Museen, no. 502. H. 0.64 m. A. Conze, *SBBerlin*, 1884, 624. P. Wuilleumier, *Tarente, des Origines à la Conquête Romaine*, Paris, 1939; H. Klumbach, *Tarentiner Grabkunst*, Reutlingen, 1937, no. 155, 28, Beilage C. For Tarentum's involvement with King Pyrrhus of Epirus, see 8.

121 Old Pedagogue

It was Plato's opinion that "just as no sheep or other witless creature ought to exist without a herdsman, so children cannot live without a pedagogue." The pedagogue, or tutor, was a family slave who accompanied the boy child to and from school, carried his belongings, made him do his homework, and instructed him in proper behavior. Thus Achilles had been attended by Phoenix, and it was thought that, like Phoenix, the wisest and best pedagogues were older men.

So we may imagine this rather fragile and emaciated old man shuffling along through the city streets and the marketplace with his young charge in tow. In his left hand he carries a bag of knucklebones, a perennially favorite children's game. Bald, bent over, his long beard hanging like melting icicles, he is obviously no aristocrat, but his mien bespeaks kindliness, patience, and wisdom. The deeply etched wrinkles on forehead and cheeks, the squinting eyes and highly arched eyebrows, the sunken and toothless mouth also suggest his loquacity and sense of humor. Every bone sticks out in his bared chest.

The statuette is of terra cotta and is unusual in being handmade instead of molded. The color of the clay, a deep red, indicates that it was probably made in Athens, as does the subject, for pedagogues were characteristic of the Attic educational system.

The type is fairly popular among terra-cotta figurines of the third century, when Athenian intellectual life was in ferment and when major philosophical schools were being founded (see 29, 31). Perhaps third century.

Paris, Louvre, c. 490. H. 0.18 m. Plato, *Laws*, 808. E. Pottier, *MonPiot, 2*, 1895, 169 f. D. B. Thompson (*Hesperia, 26*, 1957, 118, n. 26) says the head is so different from others of the type that it may not belong to the body. The realism and expression of the head suggest that it may be contemporary with the hypothetical portrait of Hesiod (36).

of the original figure was, what position her head and arms were in, and just how much drapery fell down over the rock. There is no doubt, however, that Ariadne's story had a happy ending: Dionysos soon appears, to awaken and marry her.

Rome, Museo dei Gessi, University of Rome. On the copies: W. Müller, *RM, 53*, 1938, 164 ff. and C. Laviosa, *ArchCl, 10*, 1958, 164 f. The cast in relation to the Vatican copy: G. Q. Gigliogi, *ArchCl, 1*, 1949, 74. There is a possibility that the reclining poet in 174 was originally a reclining Ariadne being visited by Dionysos. See T. B. L. Webster, *Hellenistic Poetry and Art*, 297, 308.

122 Sleeping Ariadne

After helping him thread his way out of the Cretan labyrinth, Ariadne was carelessly abandoned by her lover Theseus on the island of Naxos. A statue discovered early in the sixteenth century and now in the Vatican Museum, depicts the forlorn and exhausted maiden retreating into a restless sleep. The pose and the gesture of her arms are extremely expressive. Ariadne reclines on a rocky *chaise longue* (added); her sad face rests on one hand, her right arm is raised and bent down over her head; she crosses her legs just below the knees. Slumber, voluptuousness, and desolation are all evoked by the arrangement of her body. Michelangelo, Titian, and Poussin found it irresistibly eloquent.

The pathos of Ariadne's situation and her sensuality are also brought out by the arrangement of the drapery. One is tempted to describe her veil and shawl and the drooping pieces that expose one breast and a small section of her abdomen as a patchwork of rags. Below her waist, however, the folds and gathers are easier to follow, but they intersect each other and bind her rather mercilessly. This dramatic exploitation of drapery, the occasional thinness of it, and the half-open composition suggest that the original work was made about 200 B.C.

The statue illustrated in the photograph is a plaster cast taken from, but intended to correct, the Vatican copy, in which Ariadne is more erect and leans still more on her left side. Other copies also exist, and when considered together they leave us in doubt as to what the exact inclination

123 Victory of Samothrace

The Winged Victory was found in 1863 in the Sanctuary of the Great Gods at Samothrace (58). Although she is the most familiar and most reproduced of all Greek statues, one never tires of her, nor can one fail to feel uplifted whenever one sees her on her high perch in the Louvre. As long as battles are fought and won, the Victory of Samothrace, like certain beloved songs and symphonies, will remain a symbol of the triumphant spirit.

Originally the goddess appeared in a very romantic and baroque setting. She had alighted on the prow of a ship which stood in a shallow basin of water. She was all sunny white marble (Parian), seen against a blue sky; for the ship a darker gray marble was chosen. The water below sparkled and shimmered, for under it were marble slabs with rippled surfaces. In a second pool which extended in front of and slightly below the first lay enormous boulders; the ship seemed to be coming into harbor. These picturesque effects, Hellenistic in origin, culminated in Roman times in sensational monuments like the cave at Sperlonga (106).

Victory's wings are large and open; she wears a thin, belted chiton with an overlap and a heavy himation which gathers around and between her legs. We can think of no finer illustration, not even from the Periclean age, of the Greek genius for covering the human body and at the same time exposing it. If she were nude we would understand much less. Those short folds, for instance, which start at the circumference of the

breast and then arch over it are highly informative as to shape. How else but by the long rhythmic ridges that flow down from her belt would we know the opulent curves of her waist and hips? Truly marvelous also is the way the drapery enhances the movement. This it does mainly by openly opposing the body. Her right leg strides vigorously forward, but the massive accumulations of her himation blow in precisely the opposite direction. Rippled folds seem to leap ahead of her torso. The sea wind rushes all around her, filling her wings like sails, beating back her cloak and, in a quieter moment, tossing the edges of her overlap.

The marble used for the ship came from the island of Rhodes. We know, moreover, that this island was a center of the "baroque" style during the High Hellenistic period, for some of its sculptors worked on the large frieze of the Altar of Zeus at Pergamon. On all grounds, therefore, it is quite possible that the Victory was created by a Rhodian artist. The monument obviously celebrates a great naval victory, but when the victory took place and whose it was remain uncertain. On stylistic grounds it would seem to have been set up between 180 and 160 B.C.

Paris, Louvre, 2369. H. 2.45 m. Left wing and right breast restored. Her right hand, which held a wreath, was found in 1950. An inscription with the signature of the artist Pythokritos of Rhodes has only a doubtful connection with the statue. The occasion most often cited for the erection of the monument is the Rhodian victory over Antiochos III's associate Hannibal at the battle of Side in 190 B.C. A very perceptive analysis of Victory's "counter torsion" and drapery has been made by R. Carpenter (*Greek Sculpture*, 201 ff.). K. Lehmann, *Guide to Samothrace*, 1966, 75-76. H. Thiersch *Nachrichten der Gesellschaft der Wissenschaften zu Göttingen*, Philologisch-historische Klasse, 1937, 337 ff. The statue was designed to be seen from the angle shown in the photograph. P. and K. Lehmann, *Samothracian Reflections*, Princeton, N.J. 1973, 181-99.

124 Bearded God from Pergamon

Standing along the roof on the west side of the Great Altar of Pergamon and anticipating the deities who battle in the large frieze was a row of gods and goddesses, possibly twelve in all. We illustrate here the best-preserved one, a bearded god as graceful as he is strong. His mantle leaves most of his torso bare, but it clings to his legs and, like a thick hanging, covers his back. Though he does not have the wings of the Victory of Samothrace, the waves of free drapery that billow out behind him almost seem, like a parachute, to equip him for flight. The ribs of a parachute are excellent examples of the motion-lines invented by High Classical sculptors. The god may be Zeus, or he may be Poseidon; in either case his majesty, ease, and beauty are completely appropriate. The soft luxuriance of his hair and beard, the gentleness of his countenance, and the flowing rather than colliding drapery patterns are closer to the style of the small frieze from the altar (166) than to that of the Gigantomachy (153). Furthermore, we see in the long locks, in the swing of his torso, and the unlabored but powerful movement of his whole body a definite kinship with Mausolos (18).

His right arm, which is missing, was raised; the fingers of his left hand are curled around some now-lost object. If he is Zeus, a scepter was probably held in his right hand and a thunderbolt in his left. If he is Poseidon, he would wield a trident in his left hand and perhaps gesture imperiously with the other. The statue, which is less than life-size, is of superb workmanship and should be dated between 180 and 160.

Berlin, Staatliche Museen, P149. Marble. H. 1.33 m. *Altertümer von Pergamon*, VII, 2, 165 f., no. J49. A. Schober, *Kunst von Pergamon*, 104. E. Thiemann (*Hellenistische Vatergottheiten*, Munich, 1959, 66) is convinced it is Poseidon.

125 Athena from Pergamon

Several copies and adaptations of Phidias' colossal cult image of Athena in the Parthenon have come down to us, but only this one, found in the library at Pergamon (77), evokes some idea of the grandeur and nobility of the original. Yet it is far from being an exact replica. Phidias' statue was about forty feet high and was made of gold and ivory; this one is only one-third that size and is made of marble. Phidias' Athena held a Winged Victory in her right hand, which in turn rested on a column; her shield stood by her left side. Her helmet was

surmounted by two griffins and a sphinx, and snakes crawled over her aegis. On the base, the birth of Pandora was represented in relief. The column, the Victory, and the shield were apparently never included in the Pergamon copy, her helmet is plain, and the Pandora scene is abbreviated. The original was highly decorative and enormously rich in symbolic allusion. But although the Pergamon copy has been deprived of some iconographical content, other values, more purely sculptural in nature, have been increased: the corporeality of the figure and its vitality and immediacy. As the full mouth, flaring nostrils, and startlingly near-naked thigh attest, flesh as such was of much more interest to the Hellenistic artist than to Phidias. One detail of the drapery is very symptomatic: the folds above the waist have been pulled toward the center and then pushed down under the belt. High Classical folds and belts are limp in contrast and do not have wills of their own. Set up by Eumenes II between 180 and 160.

Berlin, Staatliche Museen, P24. Pentelic marble. H. 3. 105 m. Found in 1880. Missing arms were attached separately. Back half and tongues of helmet restored. Holes at edge of aegis to hold metal snakes. *Altertümer von Pergamon*, VII, 1, no. 24, 33 f. For a handy list with illustrations of the main copies: G. M. A. Richter, *Sculpture and Sculptors of the Greeks*, 1950, 218-20. For the close relationship between the Attalid monarchs and Athens, see 38, 153. N. Leipen, *Athena Parthenos, A. Reconstruction*, Royal Ontario Museum, 1971.

126 Seated Dionysos

Below the south wall of the Athenian Acropolis and overlooking the theater, a certain Thrasyllos, who had won a choragic victory in 319, erected a monument honoring the god of drama, Dionysos. Nearly fifty years later, in 271, his son Thrasykles, also victorious with his choruses, added at least two commemorative inscriptions. Still further additions were made to the monument centuries later, in Roman times. In the late eighteenth century, Lord Elgin detached this headless seated figure from the monument and took it to the British Museum. It has furnished an archaeological problem ever since. G. Welter proved that the statue was mounted

on a Roman base. There is no doubt in anyone's mind, however, that the statue itself is Hellenistic and not Roman. But does it belong to Thrasyllos' dedication or to his son's or, as Welter believed, to neither? How should it be dated?

The statue represents Dionysos wearing a girdled chiton, a mantle over his lap and legs, and a panther's skin tucked into his belt and over one shoulder. There is a strong possibility that he held a lyre. The figure is truly majestic, relaxed, amply proportioned, heavily and yet simply draped. In both form and spirit it seems to have been inspired by Phidias' sculpture in the pediments of the Parthenon. But Dionysos' drapery is, in comparison, thick and cumbersome, its folds less sharply etched. Despite the numerous breakages, one can see that a dramatic use of contrasts of light and shade has been made throughout. On stylistic grounds, which we are forced to fall back on, the most likely date for the statue would be the first half of the second century. The sculptor was, like Damophon (108), devoted to the style of the late fifth century, yet he did not totally reject the baroque ideals of his contemporaries, especially those in Pergamon. If this dating is correct, the statue cannot have been connected with the choragic memorials of either father or son. The Romans, in their reconstruction, must have taken the figure from a location we cannot know and set it up on the Thrasyllos monument.

London, British Museum, no. 432. Pentelic marble. H. 1.91 m. The generally accepted date is c. 270. G. Welter, *AA*, 1938, 33-68. A. H. Smith, *British Museum Catalogue*, I, no. 432, 257 ff.. R. Carpenter, *Greek Sculpture*, 186. Compare fragment of seated, draped figure in *Altertümer von Pergamon*, VII (plates), pl. XVI. J. Travlos, *Pictorial Dictionary*, 562, Figs. 704-8.

127 Demeter (?) of Knidos

The serene and beautiful goddess is seated on a throne which at one time had a high back and ornate arm-rails. To assure her final comfort, a cushion and footstool were provided. Above a chiton whose fine folds are visible over the ankles and on her right arm, she wears a himation which winds round her body and is drawn up over her

head and long hair to form a veil. Her bent arms (now missing) perhaps leaned on the arm-rails. Contrary to one's first impression, her feet are not crossed, and the right one projects well ahead of the other. Because of the higher finish of the carving on the right side, as well as certain peculiarities in the construction of the throne, B. Ashmole concluded that Demeter was accompanied by her daughter Kore who stood on her left, the two forming a group. Since the statue was found in a sanctuary honoring both Demeter and Kore, his conclusion seems very probable.

So far so good. But the problem of when the group was made still remains. That the Demeter is a Late Classical statue dating somewhere between 350 and 330 is almost universally accepted. In support of this date, analogies have been cited in the reliefs from the Mausoleum of Halicarnassos of the mid-fourth century. Carpenter, however, seems justified in insisting on the Hellenistic origin of the figure. The restless rush of piled folds over Demeter's breast points strongly to the dynamic style of Pergamon art, and it is impossible to find in any work of sculpture prior to the mid-second century drapery that so utterly muffles the body. This is as true for the damaged lower half of the figure as it is for the upper. A comparison between the better-preserved portions of this Demeter and the same areas in the Dionysos (126), dating, we believe, from the first half of the second century, will make our argument clearer. As Carpenter points out, Demeter's strictly frontal pose is an archaizing feature, to which a sentimentalized version of a Praxitelean head has been attached. The result is a mixture of styles – archaic, classical, and baroque—which is characteristic of the late Hellenistic period. Second half of second century B.C.

London, British Museum, no 1300. Parian marble. H. 1.53 m. Head and body made and found separately on Knidos. B. Ashmole, *JHS, 71*, 13 ff. R. Carpenter, *Greek Sculpture*, pp. 213 ff. As D. K. Hill pointed out to me, there is no certainty whatever that the statue represents the goddess Demeter. Her forlorn expression has been the chief reason for the identification. M. Robertson, *A History of Greek Art*, 462.

128, 129 Artemis (?)

Neither the Aphrodite in Berlin (97) nor the one from Melos (96) is as seductive as this figure. Why does her cloak weave its way about so illogically, skirting breast, belly, and buttock, unless to leave them tantalizingly half-exposed? Even those parts of the body that are covered, such as the thighs, are revealed through the luminous drapery which, in imitation of the High Classical style, is close-fitting and transparent. No less seductive is the movement of her body – especially when we view it from the front. The whole figure seems to extend deeply into space, and her torso revolves quite violently so that her right shoulder is thrown way back and one breast ends up directly over her navel. This is a very sophisticated and almost unnatural torsion; we may in fact prefer the quieter view of 129 in which the twist seems to evaporate, and the body flattens out into a single major plane with every part seen in clear and simple profile. Undoubtedly, this is the best angle from which to see the statue. The unexpected contrast between the two views is remarkable, but we have seen that kind of contrast before (98, 100), and it is characteristic of Late Hellenism.

The sensual qualities of the statue led A. Frova in 1954 to suggest that it might represent Aphrodite. But the belt which slides between her breasts and over her shoulder and back is rather hard to explain in an Aphrodite, armed or not. He concluded, therefore, that the figure was a Muse – with a musical instrument laid on her right leg and fastened to the belt – but partaking of Aphrodite's poetic and sensuous nature. A few years later E. Paribeni, citing an analogous statue formerly in the Giustiniani Collection, proposed that the belt was a baldric and that the figure must represent Artemis at the hunt with her quiver full of arrows on her back.

The crux of the matter is in her pose. Both arms came forward and down. But is she at rest like Aphrodite or a Muse, with one foot on a prominence (see 97), or is she running like the hunting Artemis? Her right profile, which we do not illustrate, is no help at all; for on that side the drapery obscures her limbs, and its folds are quite uninfor-

mative, if not misleading. Altogether then, the statue, while very beautiful, seems full of contradictions and ambiguities which still remain unexplained. Probably a Roman copy of a Greek original made in Rhodes in the late second century.

Milan, Museo Archeologico. Parian marble, H. 1.10 m. Found in Milan in 1951. She is attached to a rocky support on her left. A. Frova, *BdA, 39,* 1954, 97-106; E. Paribeni, *BdA, 45,* 1960, 1-6.

130 Polyhymnia (?)

This thoroughly bundled-up young lady is certainly one of the Muses, for she appears with her eight sisters on a relief by Archelaos (170). She may be a creation of Philiskos of Rhodes, whose group of Muses was set up, according to Pliny, near the Porticus of Octavia in Rome. However, a fragment of a draped female figure and a signature, c. 100 B.C., of a "Philiskos, son of Polycharmos, a Rhodian...," which were found in Thasos, raise very difficult questions as to the identity and the style of the artist mentioned by Pliny. Muses comparable to this one have been found at Kos, Miletus, and Halicarnassos, and the Archelaos relief may be of Alexandrian origin. When all the evidence is considered, therefore, we cannot ascertain who made our Muse or exactly where the artist came from. And while she is often identified as Polyhymnia, the Muse of hymns and religious dances, this too is largely conjectural. The figure is of a thoughtful and lovable girl who props an elbow on a tall stump, puts a finger under her chin, and playfully kicks out a heel. Her left arm crosses over her waist; the left hand once held a scroll. The chiton she wears is of extremely heavy material, as is shown by the deep vertical folds and laden arcs in the lower part. In deliberate contrast, a transparent mantle is worn over the chiton. The folds of both garments are quite monotonously parallel and unsympathetic to the volume of the body. Only a profile view is satisfactory. Drapery and pose thus indicate an original of the late second century B.C. of which this is an Antonine copy.

Rome, Museo Nuovo dei Conservatori, Inv. 2135. Parian marble. H. 1.59 m. Found in Rome. W. Helbig, *Führer,* 4th ed. II, 500, no. 1717. Pliny, *N.H.* XXXVI, 34. M. Bie-

ber (*Sculpture,* 127 f.) gives an excellent summary of the many problems and the relevant bibliography. Note that she calls the type "Melpomene." M. Schede, *RM, 35,* 1920, 65 ff. D. Pinkwart, *Antike Plastik,* IV, 1965, 55 ff. See 170.

131 Boy from Tralles

Because of his swollen, spongy ears, this young boy of about twelve or thirteen years is probably an athlete. Wrapped in a heavy woolen cloak over a short-sleeved undergarment, he takes a bit of rest after his boxing exercises and leans against a tall pillar. High-laced sandals cover his socks. Both arms are concealed beneath the cloak, which is fastened on one shoulder and gathered at the neck to form a loose, wide collar. But the position of the arms is clear: his left is bent over his chest, his right hangs down at his side. A few simple folds explain his pose: vertical ones echo the pillar and his weight-bearing leg, and oblique ones follow the direction of his bent arm. The profile views are of no interest, and the back shows the marks of the chisel. The crossed legs and the arrangement of the cloak can be paralleled in sculpture of the late fourth century.

But not the head. It has the proportions, geometric clarity, and roundness of a head by Myron and the close, neat curls of one by Polykleitos. On the other hand, the distinct, sweet smile that plays on his lips and the soft, fleshy cheeks are Hellenistic in their sensuousness and immediacy. The muscles in the legs are realistic to a degree also not found in fifth-century sculpture. The legs, in fact, seem to be turned, rather awkwardly, in a direction different from the body.

The boy charms everyone who sees him – in spite of the "eclectic classicism" he exhibits. Sichtermann quite rightly stresses the creative and unpedantic qualities of the work. Possibly a Greek original of the first half of the first century. Tralles, just east of Magnesia, was a flourishing city in the Hellenistic age.

Istanbul, Archaeological Museum, no. 542. Marble. H. 1.45 m. Found in 1902 in a building that may have been a gymnasium. The statue has often been dated in the third century. H. Sichtermann (*Antike Plastik,* IV, 1965, 71 f.) covers many controversies as to its date and meaning. There may have been an important school of sculpture in

Tralles, for Apollonios and Tauriskos, who made the group of Dirce and the Bull in Naples, came from there (M. Bieber, *Sculpture*, 133-34, fig. 529). B. S. Ridgway argues that it is not Hellenistic but a funerary monument of Roman date: *The Severe Style in Greek Sculpture*, 69.

132 Bronze Jockey

The young jockey gasps in his excitement and breathlessness. With a whip in his right hand and the reins in his left, he strains forward, pushing the horse as hard as he can but still keeping an eye on the field around him. We can see that this is an exacting task for him; tension is felt in every part of his body – in the puckered forehead, the pulsating veins in his neck, and in the rigid, separated toes. In all but his serious and rather old face he seems a mere child, with thin arms and legs which are beautifully formed, even elegant. This statue and the head and limbs of a bronze horse were rescued from the sea off Cape Artemision. The horse, equally breathless and alert, is disproportionately large in scale and yet seems to belong to this group. Greek horsemen used neither saddle nor stirrups.

There is wide disagreement about the date of the statue. Alscher, with whom we agree, places it in the last quarter of the second century, pointing out the two-dimensional aspects of the composition in the parallelism of the arms and legs and the supreme importance of the contour for our understanding of the action. The head, he also argues, is turned abruptly, as is that of the "Borghese" Warrior (98), and the modeling of the negroid face, with its fleshy and almost swollen brows and cheeks, is also similar to that Late Hellenistic work.

Athens, National Museum. H. 0.84 m. Right leg largely restored. L. Alscher, *Griechische Plastik*, IV, 122 f. M. Bieber (*Sculpture*, 151) and many others date it in the third century. H. von Roques de Maumont (*Antike Reiterstandbilder*, Berlin, 1958, 35) prefers the second quarter of the second century. V. G. Kallipolitis, *AAA*, 5, 1972, 419-26.

133 Bronze Statue of a Negro Boy

Every year now the sea yields up one or more of its ancient treasures as underwater archaeology becomes increasingly expert. This hollow-cast bronze statue was recovered in 1963 off the coast of Asia Minor near Bodrum (Halicarnassos). Few sculptures from the Hellenistic period are more charming. It represents a young Negro boy – he is hardly more than a child – wearing a short-sleeved chiton and a belt knotted at the front. His hair consists of a series of small, tight ringlets which are close to the head and increase a little in circumference and plasticity toward the back. His face is full and round, with a high protruding forehead and rather deep, baby-soft indentations at the temples. His full lips are closed; one can imagine dimples breaking into those fat cheeks. Other childlike traits are the smooth unmuscular arms and the little belly which is nicely caught up in the arched folds of the *exomis* and held in place, so to speak, by the belt. One shoulder pops out where the tunic carelessly falls to one side.

The boy is standing on his right leg. His left arm is bent and comes forward; his right also projects a little in front of his body. The fingers of both hands are curved or extended as if he held an object in each. Was he making an offering? Or did reins pass through both hands? Was he then a groom leading the horse of some heroic prince in a large honorific monument? He seems a little young for that job. Because of the cramped posture and distortion of his shoulders we can be certain at least that the main view of the statue was not from the front. From either the left or right angle these peculiarities disappear, and he becomes a perfectly normal child. Late Hellenistic, second to first centuries B.C.

Bodrum, Museum 756. H. 0.47 m. Missing: front just below waist, back above waist, nose, eye inlay. Surface is rough and green-brown. There are two deep indentations in the drapery under the left arm that suggest proximity to another figure. C. Vermeule first suggested to me that the boy could be a groom. Smithsonian Institution, *Art Treasures of Turkey*, Exhibition 1966-68, no. 14. George F. Bass, *Archaeology Under Water*, 1966, 212, pl. 24.

134 Comic Actor

In the comedies written by Menander (33) and other writers of the Hellenistic period, the actors, as in classical times, always wore masks. Because the characters tended to be stock types caught up in standard situations, the masks too were obviously

limited in type. Old men, old women, courtesans, innocent young men and maids were among them, and are easily identified. So too were the masks worn by actors who played the part of slaves. In New Comedy the slaves were clever rascals, incorrigible, talkative, lazy, and complaining. Their masks were often the most grotesque of any on the stage. The standard component, recognizable by everyone in the audience, was a trumpet-shaped mouth which occupied nearly the whole face and must have provoked immediate laughter.

The bronze statuette in Princeton represents a professional "comic" actor wearing a typical slave's mask. He has found refuge from some altercation by sitting on a small rectangular altar.

... Goodbye, I say,
To playing meddler in affairs of other folks.
And if again you catch me putting in my oar
Or chattering I'll give leave and liberty
To cut my — molars out!

— Onesimus, in Menander's *The Arbitrants*

His hands and legs are crossed, and he is dressed in long-sleeved tights under a short chiton and mantle and in a nice pair of soft shoes. A thick ring, with a lost pendant which was perhaps some kind of identification tag, is worn like a collar. The mask is only half human; the great, gaping mouth is a little frightening as well as funny, and it emits, we imagine, loud and devastating witticisms. His wide, flat nose presses against his upper lip, and his eyes are popping and large beneath their widely arching brows. His bald pate is partly covered by rolls of hair and a wreath.

Pollux, a writer of the second century A.D., catalogued the stage sets and masks of New Comedy, basing his account on Hellenistic sources. He lists six masks for slaves, and, as M. Bieber notes, the Princeton statuette may represent the gay, "curly-haired" type who had red skin and receding red hair. Representations of comic actors in almost every medium were plentiful during the Hellenistic period, and they reveal how avidly the ordinary people followed theatrical events. Second to first centuries B.C.

Princeton, The Art Museum, Princeton University, acc. no. 48-68. H. 0.193 m. Said to be from Alexandria. M.

Bieber, *Record of the Art Museum, Princeton University*, IX, no. 2, 1950, 5 f. T. B. L. Webster, "Masks of Greek Comedy," *Bulletin of the John Rylands Library, 32*, 1949, 97-133, and same author, *JdI, 76*, 1961, 100 ff. Compare Plautus' *Mostellaria*, 1094 ff., wherein a wily slave leaps on an altar to avoid the wrath of his master. F. H. Sandbach, *The Comic Theatre of Greece and Rome, London*, 1977.

135 Dancing Dwarf

Among the several bronze sculptures that were found between 1907 and 1913 in a sunken ship near Mahdia, Tunisia, was this statuette of a dancing female dwarf. It is a little masterpiece designed, surely, to lift one's spirits. The figure spins on one foot, raises the other in the air, and throws her head back as if to call attention to her plump and prominent buttocks. She moves so quickly and twists so strenuously that we are not sure that her head, arms, and beads will not scatter in different directions. From her short, lumpy torso sprout two tiny arms, and with each hand she makes as much noise as she can with two rattles. Her features are coarse and sensual, but she is a very good-humored soul utterly possessed by her dancing.

Quite a large number of dwarfs of the same type exist in terra cotta and bronze, and it is now thought that they stemmed directly or indirectly from Alexandria. Their purpose is not known with any certainty. The dances may be purely secular – one more instance of Hellenistic joie de vivre. On the other hand, the riotous and lascivious quality of the figures may mean that they are among the many adherents of the cult of Dionysos. M. Bieber thinks that the dwarfs' dance was religious and performed at banquets.

The wrecked ship, whose cargo consisted entirely of works of art, was on its way from Piraeus to Rome. The most generally accepted view is that its contents were part of the booty Sulla collected after his sack of Athens in 86 B.C. W. Fuchs claims, to the contrary, that the cargo was purely commercial merchandise and that the ship set sail not shortly after 86 B.C. but between 100 and 86 B.C. We agree with him that our vivacious dancer should date in the second half of the second century. "Open form" persisted longer in small bronzes than it did in large-scale marble statues.

Tunis, Musée Alaoui, Le Bardo. H. 0.30 m. A. Merlin, *MonPiot, 18,* 1910, 9 f. M. Bieber, *Sculpture,* p. 97. A. Adriani, *RM, 70,* 1963, 80-92. W. Fuchs, *Die Schiffsfunde von Mahdia,* p. 18, no. 8. W. Binsfeld, *Grylloi,* Cologne, 1956.

136 Thorn-Remover

Late in the third century some unknown sculptor fashioned, probably in bronze, a young boy seated on a rock removing a thorn from the sole of his left foot. The boy was completely nude, very good-looking, perfectly shaped, intelligent, and he performed his task with full but serene attention. A century later another unknown and perspicacious sculptor in Priene took the same subject, familiar now to everyone, and dashed off his own version in terra cotta. The result, in Berlin, is a marvelous parody of the dignified original. The model for this version was not a well-bred ephebe, but an uncouth, prematurely old boy off the streets. Rather misshapen, he has a squat trunk, huge arms and hands, and bony, short legs. A tattered bandagelike mantle is tied around him and he wears a soft cap. But the coroplast had the most fun with the face. What a study in rapt concentration! The face is enlarged, ugly, and puffy; he strains his short-sighted eyes and puckers his lips. Somewhere inside the cheeks his tongue is all rolled up. The operation on his foot is not, we fear, a very neat one, and we can almost feel the pain.

This is one more excellent example of Hellenistic humor. It was found next door to the House 33 on "Theater Street" in Priene (52). About 100 B.C. The famous bronze Spinario is a still later adaptation of the original.

Berlin, Staatliche Museen, Tc8626. H. 0.17 m. W. Fuchs (*Der Dornauszieher,* Opus nobile 8, 1958) discusses and illustrates the various versions.

137 Niobe and Her Youngest Daughter

138 Son and Daughter of Niobe

Niobe, the daughter of Tantalus, was a very proud woman. After marrying the King of Thebes, she gave birth to numerous children: twelve according to Homer, twenty according to Hesiod, and eighteen according to Sappho; but by Hellenistic times the accepted number had become fourteen, seven sons and seven daughters. Niobe was so impressed by her achievement that she deemed herself more worthy of divine honors than Leto, who had borne only two children, Apollo and Artemis. To punish Niobe for her arrogance, Apollo and Artemis took up their bows and arrows and, one by one, slew all fourteen of her children. The frightful massacre was represented in the art of Archaic and Classical times, but the pathos and violence of the event were never more fully understood or more concretely depicted than in the Hellenistic period.

In 1583 a group of agitated marble figures was found in Rome. They were immediately thought to be Roman copies of the "dying children of Niobe" which Pliny said were set up in the Temple of Apollo Sosianus. Whether Skopas or Praxiteles made the originals, as Pliny stated in the first century A.D., no one can say for sure. Today the question is still unsettled, although it no longer seems particularly pertinent for in spite of what Pliny says, the copies, which are now in Florence, do not exhibit in any marked way the style of either Praxiteles or Skopas.

The most heartrending of them all portrays the unfortunate mother clasping her dying youngest daughter. The once-arrogant Niobe is now defeated and pitiful; she looks up helplessly and beseechingly. The two figures are indissolubly linked as Niobe endeavors to shelter her child with her body and mantle. Another group of two was formed by a brother and sister. The sister (known by a copy in the Vatican), already collapsed on the ground, is passionately protected by her older brother (138), who tries to shield her from further arrows by hurling his body and cloak over her. Still more fleeing or expiring sons and daughters and their old, bearded pedagogue appear among the other statues preserved in Florence and in Munich. Perhaps Apollo and Artemis, relentlessly pursuing their victims, were also represented. The entire ensemble must have been quite overwhelming – in sheer size (a minimum of sixteen figures), in the amount and variety of physical activity, and in the range and degree of emotional expression.

But how were these figures and groups combined?

How were they meant to be seen? The individual statues provide the clue. There is not much to be gained by seeing Niobe and her daughter from any other angle than the one shown in the photograph. From a profile view we could not truly appreciate how the child nestles into the cavity of her mother's bent body. Similarly, the vigorous action of the older brother is completely understandable as we see it here: his mantle, in fact, frames his back in such a way that we are virtually compelled to view the whole figure from this angle only. Even though they are carefully finished on all sides, and even though in some details of pose they may incorporate or penetrate space, all the other figures of the group have this same general one-sidedness. They must, therefore, have been lined up in single file in a relieflike composition. In short, the figures have been affected by the three-dimensional innovations of Lysippos' art, but at the same time they adhere, as does the whole ensemble, to the two-dimensional principles of fifth- and fourth-century composition. In addition the sentiment and the drapery may occasionally remind us of Praxiteles or Skopas.

This array of stylistic elements must, of course, be interpreted in order to arrive at the originating period of the Niobe group. Until recently a date near 300 B.C. has been widely favored. From what we know of free-standing groups composed around that time, a single-file design is entirely normal, and the styles of the two great fourth-century masters Praxiteles and Skopas might well have been continued without precluding the newer formal devices initiated by Lysippos. Moreover, a date near 300 gives at least some chronological credibility, which is always desirable, to Pliny's statement. If the eclectic aspects of the style seem rather excessive, perhaps we could attribute them to the Roman copyists.

On the other hand, as H. Weber so deftly argued in 1960, this peculiar combination of a flat and compressed overall design with tridimensional details is characteristic of much late Hellenistic sculpture. We might mention as an example the Sandalbinder in the Louvre which B. S. Ridgway has discussed (100). Weber reminds us, too, that the long schematic diagonals that appear in many of the Niobids are also found in late second- to first-century works.

Compare, for instance, the older brother with the "Borghese" Warrior (98). But it is above all the mixture of styles – a bit of Praxiteles, Skopas, and Lysippos along with the classical, relieflike composition – that smacks of lateness and eclecticism. No wonder, we think, that Pliny could not make up his mind. Weber's conclusion, with which we agree, is that the Niobids as a group were created in the first century B.C.

It is not possible to determine whether the Niobids decorated the gable or the interior of the Temple of Apollo in Rome, or from what part of the Greek world they were brought.

Florence, Galleria degli Uffizi, Niobe and daughter, inv. 294. Pentelic marble. H. 2.28 m. Major restorations include right hand and part of right arm of Niobe; in the daughter the right arm, left leg, and head. Son, inv. 302. Pentelic marble. H. 1.70 m. with restorations. Restored: left arm, right forearm with drapery, right foot, and some of drapery on left thigh. G. A. Mansuelli, *Galleria degli Uffizi, Le Sculture*, Milan, 1958, I, 101-21. Pliny, *N.H.* XXXVI, 28; H. Weber, *JdI, 75*, 1960, 112-32. M. Bieber (*Sculpture*, 74 f., figs. 253-65) discusses and illustrates additional figures of the group, particularly the Chiaramonti Niobid in the Vatican and the whole composition. Copies of eleven out of the fourteen children have been preserved.

139 Menelaos with the Body of Patroklos

While Achilles sulked in his tent, his closest friend Patroklos, who had gone out in pursuit of the Trojans, was slain by Hector. The armor was stripped from his body, and he was left naked on the battlefield. Homer then describes, in Book XVII of the *Iliad*, the fierce, daylong struggle the Greeks and Trojans waged over the lifeless body. At one point a Trojan almost succeeded in dragging it away. Casualties on both sides mounted rapidly. At last Menelaos "went forth like a lion," lifted the corpse, and bore it swiftly out of the fray and back to the Greek camp.

As usual, the most agonizing and dramatic moment of the story has been depicted by the Hellenistic sculptor. Menelaos has just caught up the body of Patroklos. He now pauses anxiously to look for further adversaries. For that brief, unresolved instant, he almost seems to stagger under the weight of the body and the uncertainty of his situation. But

in the next, we know, he will hoist the dead man over his shoulder and start from the battlefield. The heroism of Menelaos' act is all the more impressive because its difficulty is clearly demonstrated, but we also feel it cannot efface the tragedy of Patroklos' death. Sorrow as well as desperation are to be read in Menelaos' bearded countenance, and even while his powerful muscles swell and tense to their task, the long, limp, smooth body of the dead Patroklos is prominently, even oppressively, displayed before us. Contrasts are paramount in this work of art: between the mature and the immature, the living and the dead, the defiant and the helpless, the supporting and the supported.

Long, parallel diagonals provide the main structure of the composition. Patroklos' torso parallels that of Menelaos, though the two also diverge significantly. The two arms on the front plane then cross together in the opposite direction, building a system of triangles which are all enclosed within a final pyramidal outline. That Patroklos' head lolls outside the secure boundaries of the pyramid cannot, of course, be accidental. Menelaos' shield forms a back plane and establishes the main view as the one illustrated in the photograph. The side views are interesting and even essential in understanding the details of the action (how, for instance, does Menelaos actually support Patroklos?), but they tend to obscure the pyramidal design and are of secondary importance. Thus, while the group consisting of Niobe and her daughter (137) is ultimately a one-view sculpture, Menelaos and Patroklos are conceived more in the round. Note, as further proof, the torsion of Menelaos' body compared to the uncomplicated frontality of Niobe.

In the 1930's B. Schweitzer undertook major research on the group. Several copies existed, usually fragmentary, of one or both figures, and restoration (as carried out, for example, on the replica in the Loggia dei Lanzi in Florence) was often profuse and erroneous. Assembling all the evidence, but especially the gems which represent the group, together with the famous "Mastro Pasquino," a torso of Menelaos outside the Palazzo Braschi in Rome, Schweitzer made a correct and complete plaster reconstruction in Leipzig. It is this not-very-attractive reconstruction we show in our illustration.

The date of the original, which was probably of bronze, can only be deduced on the basis of style. The torsion of Menelaos' body and the space-penetrating aspects of the composition point to a date well after the time of Lysippos. The pyramidal design, however, seems to restrict us to the third century. Schweitzer pointed out the analogies between the head of Menelaos and some heads of early Pergamene style. He concluded, reasonably, that the original group was executed about 230 B.C.

B. Schweitzer, "Die Menelaos-Patroklos-Gruppe," *Die Antike, 14,* 1938, 43-72. Schweitzer also attributed the group to Antigonos of Carystos. R. Carpenter (*Greek Sculpture,* 224) dates the work about 190 B.C. The torso of "Mastro Pasquino" greatly impressed both Michelangelo and Bernini. A similar group was found in the cave at Sperlonga (see 106). Because of its restricted tridimensionality E. Künzl (*Frühhellenistische Gruppen,* 184-52) dates it in the second half of the second century B.C.

140-142 Victory Monument of Attalos I

By the middle of the third century B.C. the Gauls had become a grave menace to the newly-founded kingdom of Pergamon. They raided and plundered her territory, and they assisted her enemies at every opportunity. They were formidable, even savage, warriors, and it was often expedient to buy them off rather than do battle with them. In 241, Attalos I became ruler (9). He immediately abandoned the policy of appeasement, refused to pay tribute, and when the Gauls marched in to demand it he defeated them resoundingly near the river Caicus. In subsequent years the Gauls, allied with the Seleucids, gave further trouble until in 228 both were disposed of, at least temporarily, in a battle near Sardis.

These astonishing triumphs shed enormous glory upon Attalos. He promptly adopted the title of king (241 B.C.) and proceeded to erect a series of monuments commemorating his victories. Quite properly he saw himself as the savior of the Hellenes, and he therefore put one of the largest monuments, a circular one, right in the middle of Athena's sanctuary on the citadel. Some base blocks of this are still in situ, not far from the goddess's temple (77). In 1936, M. Schober published a reconstruction of his conception of this monument (141).

On a podium of three steps stood a high base framed above and below by a strong molding. Around the top ran an inscription: "King Attalos having conquered in battle the Tolistoagian Gauls in the neighborhood of the sources of the Caicus river [made this] thank-offering to Athena." But what did the base support? No doubt some statues of bronze that were melted down long ago. Schober looked around for copies of them. He reasoned that because of its cylindrical shape the pedestal must have been occupied by single figures or groups of figures which constantly engaged the spectator as he walked around it. A suitable candidate for the center of the pedestal was the well-known group of a Gaul and his wife (140). The circular plinth underneath them surely reflected their original location, and although some views of the group are more informative than others, the other views also invite our perusal.

The matted, greased hair and the moustache identify the robust male figure as a Gaul. Rather than yield to the enemy, whom he seems to sight over his right shoulder, he first kills his wife and then plunges the dagger into his own breast. It is a grim and tragic scene indeed. The wife sinks slowly to the ground away from the supporting hand of her husband – the only significant point of contact between them, which death will soon nullify. Mouth, head, arms, and drapery – everything about her droops. Though blood gushes from his wound, he, on the contrary, is passionately active. The parallelisms that are so important in the composition of Menelaos and Patroklos (139) are lacking here, nor is there any clear pyramidal configuration of the whole. The two heads face in opposite directions, and the two rotating bodies both diverge and converge. Thus there is no prominent front plane as there is in the Menelaos and Patroklos group. Instead, all forms occupy and interact with space, and the observer is enticed into moving around the whole.

The plinth under another famous statue in the Museo Capitolino (142) prompted Schober to attach it to the periphery of the same monument. The plinth is oval, but its curvature corresponds exactly to the circumference of the pedestal. The figure has the same greasy hair and moustache, and the torque around his neck makes absolute his identification as a Gaul. Fatally wounded, he crawls off alone to die – blood spouting from the rip in his breast. A broken trumpet lies between his thigh and the trembling hand on which he still manages to lean. The Gaul Killing Himself shouts aggressively, we feel, as he administers the final stroke, but the dying Trumpeter is a study in inwardness, despair, and pain. To catch the full force of his expression, he should be seen, as Schober pointed out, from below, where the torsion of his body and its extension into depth are also best perceived.

According to Schober's reconstruction, the Gaul Killing Himself was surrounded by the dying Trumpeter and three other similarly recumbent figures. Altogether this produced a composition harmoniously balanced, interesting from every angle, and yet – with the recumbent figures either back-to-back or feet-to-feet – permitting an unobstructed view of the central group when the spectator entered the precinct from the east gate (75). Death is the theme of this "baroque" monument. In dying the Gauls are made to appear so courageous and noble that Attalos' triumph over them takes on epic proportions.

One major difficulty, unfortunately, mars Schober's reconstruction: the Trumpeter and the Gaul Killing Himself are stylistically dissimilar. The features of the Trumpeter are contracted and tight, his hair short and bristly, his skin leathery, and his bones and veins rendered with sober realism. More rhythm, more movement, and above all more artifice are apparent in the suicidal Gaul's long wavy hair, full round face, and unrealistically exaggerated musculature. The former figure is more at home with, say, the Seated Hermes (85) of the third century, while the latter seems to belong close to the Great Altar of Zeus (153) of the first half of the second century. Pliny wrote that an early Hellenistic sculptor named Epigonos made a statue of a trumpeter. If the statue in the Capitoline is a copy of it, we have another reason for putting the original of the Trumpeter in the third century. On the other hand, the open composition of the suicide group certainly suggests that it is later than the closed pyramid of Menelaos and Patroklos of c. 230 B.C.

We must question, then, whether our two statues stood on the round base after all. If they did, the

monument may have been built over a period of years by at least two sculptors, one of whom was old-fashioned, the other in the vanguard of new development. A compromise date of c. 200 B.C. might then be reasonable. Otherwise the figures under discussion could have come from two of the several other victory monuments constructed by the Attalid kings. Indeed this has been proposed by E. Künzl, who would place them on a long rather than circular base. His solution would compel us to question Schober's very "baroque" reconstruction. R. Wenning would prefer to detach the group of the Gaul killing Himself entirely from the Trumpeter, arguing they cannot belong to the same monument nor can they be by the same artist.

140. Gaul Killing Himself (often called "Ludovisi Gaul"). Rome, Museo Nazionale delle Terme, 8608. Marble. H. 2.11 m. The Gaul's right arm is wrongly restored. The thumb of his right hand should be uppermost. A. Schober, *RM, 51,* 1936, 104-24; Pliny, *N.H.* XXXIV, 88; E. Künzl, *Die Kelten des Epigonos von Pergamon, Beiträge zur Archäologie,* 4, Wurzburg, 1971; R. Wenning, *Die Galateranatheme Attalos I,* Berlin, 1978.
142. Dying Trumpeter (often called "Dying Gladiator"). Rome, Museo Capitolino, Inv. 747. Marble. H. 0.93 m. Restored: tip of nose, left kneecap, toes of both feet. W. Helbig, *Führer,* 4th ed. II, 240-42, no. 1436.

143 Centaur and Eros

The despotic and wayward Eros is up to his pranks again. Astride a venerable centaur, he teases and tortures him by pulling at his hair and perhaps goading him with a whip. The centaur peers back over his shoulder at the meddlesome creature, but he is unable to get rid of him for his hands have been bound behind his back, and his tail, no matter how he swishes it, hardly reaches the chubby body. In short, the centaur is completely vanquished. The Hellenistic age, as we know particularly from Alexandrian poetry, was obsessed by the power of love and sexual passion. But it also had a sense of humor. Except for Chiron, the teacher of Achilles, centaurs – half-horse, half-man – were by long Greek tradition lascivious monsters, especially when under the influence of wine. The ironic twist to the present episode is that the aging monster, once so single-minded and eager in his pursuit of love, now finds the proddings of a mere infant Eros sheer torment. His

suffering is shown by his contorted features, and his predicament is a humiliating one. In classical art, a centaur might well go down in defeat, as he does in some of the metopes of the Parthenon, but only after a fair fight and never with the loss of his dignity. It might be said that in art all the gods, heroes, and monsters lost status during the Hellenistic period. On the other hand, they gained in humanity. As a follower of Dionysos, Eros here wears an ivy wreath.

The statue in the Louvre is a larger replica of one that was found in the Villa of Hadrian and is now in the Museo Capitolino. The latter, and also a second centaur, likewise from Hadrian's Villa and now in the Capitoline, were signed by Aristeas and Papias, sculptors of the second century A.D. from Aphrodisias in Caria. This second centaur is, however, not old but young. Eros is also perched on his back, but the results are different: the centaur is delighted. The two statues are companion pieces showing the different effects of love on the young and on the old. Although the Capitoline statues were commissioned by Hadrian, Aristeas and Papias copied them from Hellenistic originals which were made at either Pergamon or Rhodes about 150 B.C. The fluid features, the wild hair and beard, the torsion and bursting muscles of the centaur's body here have analogies in some of the giants from the large frieze of the Great Altar of Zeus at Pergamon (153) and in the figure of Laocoon (146). The obnoxious support under the centaur's belly was added by the copyist and indicates that the original was of bronze.

Paris, Louvre, 562. Marble. H. 1.475 m. Formerly in the Villa Borghese. Restored: some details of centaur's head, hands, and legs; the plinth and the palm tree except for a few leaves attached to the body of the centaur. For Capitoline statues: H. S. Jones, *A Catalogue of the Ancient Sculptures preserved in the Municipal Collections in Rome, Museo Capitolino,* Oxford, 1912, 274, 277. M. Bieber, *Sculpture,* 141; M. Squarciapino, *La Scuola di Afrodisia,* 32-33, pls. E, VI, VII. A torso of a centaur of High Hellenistic date was found recently at Pergamon and is stylistically analogous (*AA,* 1966, 462, figs. 38a and b).

144 Wrestlers

These two tough Egyptian professionals, so identified by the tuft of hair at the back of their heads, go

to it with all their might. One wrestler has a body hold on the other and has lifted him off the ground. It looks as if he may next throw him to the left. Meanwhile, the elevated athlete struggles to undo the hands that grip him around the waist. A jab at his opponent's left thigh or some other move may be forthcoming. Victorious athletes were always given high honors in ancient Greece, but narrow professionalism and its accompanying ill-effects on the body (101) and on the practice of sport itself were developments of the Hellenistic period.

Wrestling groups were common among small bronzes of the Hellenistic period. Both Alexandria and Pergamon have been suggested as the originating place of the theme. The body hold exhibited here was frequently used, even in classical art, for the representation of Herakles' bout with Antaios. In some bronzes the ostensible subject, for example the mythological struggle between a god and a giant, may have a deeper significance and allude to a very real battle between one Hellenistic king and another or between a king and a barbarian race. Victor and vanquished are, in these cases, more clearly differentiated than they are here.

The figures seem to be solid cast and they were probably built up from partial molds, although no certain sign of joining can be seen. The forms are heavy and thick in this little mass-produced object, and the two figures seem stuck together rather than integrated. Their facial features are roughly indicated, and the hair has been dotted in hastily. Yet energy and movement are very well conveyed. Even though the surfaces are broadly treated, the tilt of the heads and the angle of the arms and legs skillfully capture the strains and stresses of the action.

The dating of the group is a ticklish question. The composition, such as it is, is extremely free and open, and many views of it are lively and interesting. If we rely upon the development of monumental stone sculpture, the wrestlers are not likely to be earlier than 200 B.C., and not later than 100 B.C., when flat, one-view groups came into fashion. On the other hand there is mounting evidence that small centrifugal groups in bronze were being produced within the same period which saw the execution of large one-view compositions in marble. Consequently the only safe dates for this bronze would be second to first century B.C.

Baltimore, Walters Art Gallery, no. 54.742. H. 0.153 m. Surface is shiny green, red, and brown and has been vigorously scraped. Probably from Alexandria. D. K. Hill, *Catalogue of Classical Bronze Sculpture in the Walters Art Gallery*, Baltimore, 1949, 67, no. 141, and the same author in *Hesperia*, 27, 1958, 311-17. J. Charbonneaux, *Mon Piot*, 47, 1953, 114-18.

145 Two Women Gossiping

In the fifteenth Idyll of Theocritus, two young married women of Alexandria, Gorgo and Praxinoa, meet at the latter's house before starting downtown to attend a festival. After they sit down, their first words are gay but snide, as Praxinoa charges Gorgo with arriving late and Gorgo replies that this was to be expected since Praxinoa lives so unfashionably far away. They then amicably discuss clothes, children, servants, and at much greater length, men, particularly their husbands, who come in for some rather sharp criticism, chiefly for stinginess. The deep affection and intimacy that Gorgo and Praxinoa share, their vanity and their worldliness, are all-pervading. We seem to have come upon these two in the midst of their gossip when we observe this group in the British Museum, although it was made well after the time of Theocritus and probably came from Myrina rather than Alexandria.

The two women are seated on a long comfortable couch with elaborate legs, soft mattress, and draped valance. They lean toward each other whispering, their faces almost touching. The one on the left, perhaps the younger, crosses her feet on a footstool. She is stylishly dressed, bejeweled, and wears a fillet around her hair. A fan, now broken, is in her left hand. The other woman is veiled; she wears earrings and holds her left hand over her breast. At salient points or areas of both figures, the body presses through the drapery. The meaning of the scene is not clear. One suggestion is that it represents an older woman giving some advice to a bride. The elegance and charm of the episode were enhanced by paint, which partly remains. The flesh is a delicate pink, the couch is red at one end, and the hangings are blue. The unifaciality of the composition and the

undisguised sentimentality of the scene point to a date in the second half of the second century B.C. A very similar group from Myrina is now in the Louvre.

London, British Museum, c. 529. Terra cotta. H. 0.20 m. From Asia Minor. The back is flat with a hole; hollow underneath. H. B. Walters, *Catalogue of Terracottas*, London, 1903, 244. R. A. Higgins, *Greek Terracotta Figures*, 26. For Louvre parallel: S. Mollard-Besques, *Figurines et Reliefs*, II, Myrina, pl. 137, b.

146 Laocoon

The Laocoon, "a work to be preferred to all that the arts of painting and sculpture have produced" (Pliny, *N.H.* XXXVI, 37), was discovered in 1506 – with Michelangelo standing eagerly by – above the ruins of the Golden House of Nero in Rome. Paraphrases in paint and eulogies in prose and poetry began to be made immediately and continued to be long afterward. In the eighteenth century Winckelmann reiterated Pliny's warm praise, and Lessing felt the group was crucial for establishing the difference between the figurative and poetic arts. Modern taste finds the sculpture of Phidias more palatable, but the Laocoon remains endlessly fascinating as an artistic *tour de force* and as a subject for seemingly unlimited debate.

Laocoon was a legendary priest and prince whose fate was decided just before the fall of Troy. Arktinos (eighth century B.C.) tells the story briefly, but the most elaborate and moving though rather different version is found in Book II of Vergil's *Aeneid*. A great wooden horse, its belly filled with Greek soldiers, had been drawn up before the gates of Troy. The suspicious Trojans vacillated between burning it and dedicating it to Athena. Laocoon, according to Vergil, pleaded with his countrymen not to bring the timber "engine" into the city. Suddenly, two ocean serpents rose from the deep and with their mighty coils strangled the priest and one (according to Arktinos) or both (according to Vergil) of his sons. The horrible denouement is the subject of this marble group which, Pliny states, was made by Hagesandros, Polydoros, and Athanadoros of Rhodes.

Like a sacrificial victim, Laocoon is attacked at his own altar. Heroically nude, massively built, he struggles in vain against the deadly pressure of the serpents' coils. One snake with vicious mouth and evil eye sinks its fangs into Laocoon's side. A long groan, a cry of pain, issues from the tortured, bearded head thrown back in agony. Unseeing and shut off by his own suffering, he is on the point of giving up. At the left, his younger son is even nearer the end. His smooth body has already gone limp; his mouth, too, is open, not in a protesting cry but in a last gasp. With one pathetic hand he can only pat, as it were, the head of the serpent which has embraced him. The stronger, elder son is the most *compos mentis* and still the freest. But his predicament is perhaps the worst of all, for even while he attempts to unravel and escape from the fleshy windings of the snake he must see and hear the anguished moans of his father.

It is possible to see in the present composition, recently reconstructed by Magi, a kind of triangle with the head of Laocoon as the apex. But the design is not planigraphic. Each of the three figures encompasses the third dimension; there are strong projections such as foreshortened legs and forward-moving torsos. The serpents travel back and forth in ominous spirals. The plastic conception of the whole is revealed particularly well in the expanding and contracting as well as turning form of the father. Echoing rhythms and motifs in the torsos and gestures of the three figures and in the entire bodies of Laocoon and his younger son unite them all both compositionally and thematically. Diagonal energies are the most prevalent and emphatic: there is a rush of activity not only toward and away from us, but also to the left and right if we follow, for example, the more obvious paths that the serpents trace. The figures by themselves are sympathetically interrelated, but they are unequivocally interlocked by the coils. Despite its spatial properties, the group as it is shown in the photograph urges the spectator to view it from one angle only. That this may not have been the case originally is one of the points of current dispute. S. Howard suggests that the elder son should be pivoted around on his right foot so that his back is approximately toward Laocoon. The interpretation of the action, especially that of the elder son, in rela-

tion to the literary sources and the date of the group both depend to a large extent upon the resolution of this unsettled problem. If Magi's one-sided design is correct, a late second-century date seems probable. If Howard is correct, a clear pyramidal design emerges, and several viewing positions become possible. Such a composition would indicate that the group originated late in the third or early in the second century B.C.

The stylistic similarities between the Laocoon and the frieze of the Gigantomachy from the Altar of Zeus at Pergamon have long been recognized. The half-serpent giant Alcyoneus (154) is, in pose and anatomical rendering, a close analogy to Laocoon. Both cast their large eyes upward and wail aloud. Pathos and extravagance of mood, baroque intricacy of composition, and the heroization of individual forms are present both in the Laocoon as a group and in the altar frieze. Precisely what this means, however, is controversial. Did one serve as the direct model or stimulus for the other? If so, which one led off? Again the answer depends primarily on what the composition was originally like and thus ultimately on whether the Laocoon group is a work of the early or late second century. If we examine the head of the priest, on the other hand, we find it is undeniably more plastic and more riddled with depressions than any in the Pergamon frieze; in this respect it is similar to the blind Homer (34) and therefore may date 150 to 100 B.C. P. von Blanckenhagen recently suggested that the group is a Roman work of art composed in the first half of the first century A.D. by the sculptors of the Sperlonga groups (106) in accordance with the Vergilian account of the story. He further suggests, however, that a late Hellenistic original which included only one son is reflected in the Roman version.

Rome, Vatican Museum, Cortile del Belvedere, Inv. 1059, 1064, 1067. Marble. H. 1.84 m. A crown of leaves encircles the head of Laocoon. Restorations: several minor details. W. Helbig, *Führer*, 4th ed. I, 162-66, no. 219. F. Magi, *Il ripristino del Laocoonte*, 1960. S. Howard, *AJA*, 63, 1959, 365-69 and *AJA*, 68, 1964, 129-36. P. von Blanckenhagen: *AA*, 1969, 256-75 and *AJA*, 80, 1976, 99-104.

147 Orestes and Elektra (?)

The group is signed by "Menelaos the pupil of Stephanos." Stephanos in turn was the pupil of the famous Pasiteles who was born in South Italy, perhaps Tarentum, and became a Roman citizen in 88 B.C. The three artists, all Greek, produced works for Roman patrons from the time of Pompey and Caesar through at least the Augustan period (c. 60 B.C.- A.D. 14). They are neoclassicists reiterating old formulas and their products are technically facile but emotionally shallow and a little foolish.

The sentimentality of this pair is typical. The massive maiden fondly embraces the youth, who responds with outstretched arms. They gaze – speechlessly and longingly – into each other's eyes. One would think that two figures who display such affection and have such a close relationship could be easily identified. On the contrary, there is no final certainty as to who they are. Because she is taller, the woman is thought to be the elder; if so, she might be the mother or an older sister. Is she perhaps Penelope with her son Telemachos? Or Elektra and her brother Orestes? The latter suggestion has gained the widest acceptance because of the tombstone which functions as a support for the young man. Possibly, then, the group represents the two children of Agamemnon consoling each other at the grave of their father in Mycenae. But the mood is a far cry from the dignified mourning expressed in classical grave reliefs.

The two figures seem almost depressingly familiar – yet they have no known prototypes. The head of Elektra suggests something of the soft sweetness of Praxiteles' style, and the modeling and pose of Orestes seem dependent on the art of Lysippos. Yet Elektra's drapery is, if anything, late Hellenistic, and the nearest parallel for that of Orestes is the cloak which surrounds Augustus in his portrait from Prima Porta (c. A.D. 14?). The composition – it is not unifacial but notably three-dimensional – also seems to be no earlier than the last years of Augustus' reign.

No sculpture by Pasiteles survives, but it is usually supposed that his style is reflected in the work of his pupils Stephanos and Menelaos. We should

not be too ready, however, to dismiss the Pasiteleans as eclectics or inferior copyists, nor should we judge them solely by the kind of example we reproduce here. Pasiteles was not only a sculptor but also a silversmith, and in addition he was a prolific and important writer. He wrote five volumes on art entitled *Famous Works Throughout the World*, which we know had a profound effect on Roman taste and culture. Richter conjectures, too, that he might have been the inventor of the pointing machine for making exact reproductions. As for Menelaos, he must have been one of the most renowned sculptors living in Rome, and as such it is quite possible he was employed to work on the relief sculpture of the Ara Pacis or even to do some imperial portraits.

Pliny made a shocking statement when he said that between the years 295 and 156 B.C. art in Greece came to a halt – "cessavit deinde ars." Not only does he overlook the magnificent portraits that were produced in Athens during the third century, but he ignores the great baroque masterpieces that issued from Pergamon during the first half of the second. Why did he say such a thing? The most probable explanation so far given is that Pliny repeated a statement that was originally made by Pasiteles who, as a classicist, deplored all art of the years between 295 and 156 for being, according to him, nonclassical. "True" art revived only after the middle of the second century when artists such as Euboulides (103) or the Neo-Attics (162) resumed the true Hellenic tradition. Pasiteles and his pupil Menelaos no doubt considered themselves in the mainstream of this grand reawakening. Menelaos' group of Orestes and Elektra, which reflects the style of his teacher, probably dates in the late first century B.C.

Rome, Museo Nazionale delle Terme, no. 8064. Marble. H. 1.92 m. M. Borda, *La Scuola di Pasiteles*, Bari, 1953. G. M. A. Richter, *Ancient Italy*, 112-16. A. W. Lawrence, *Mélange Ch. Picard*, II, *RA*, series VI, 31-32, 1949, 581-85. Pliny, *N.H.* XXXIV, 52.

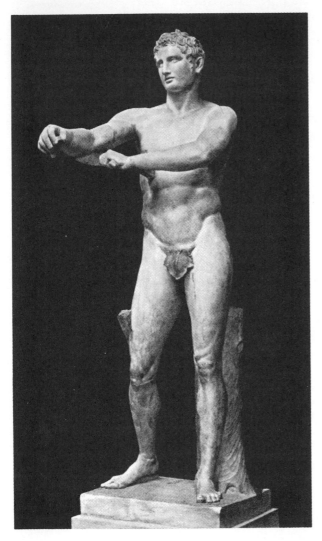

80. Apoxyomenos of Lysippos, Roman
copy. Original c. 320 B.C.
Vatican Museum

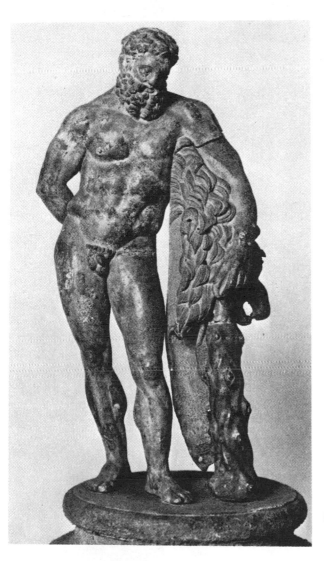

81. Herakles, Farnese type, Roman copy.
Original c. 320 B.C.
Paris, Louvre

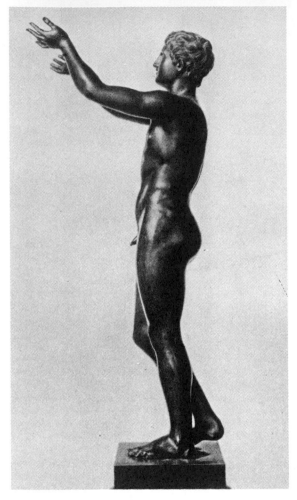

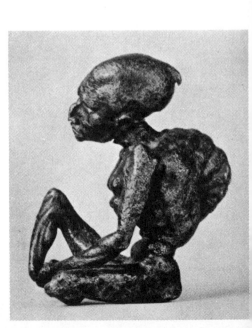

84. Crouching Aphrodite by Doidalsas, (?)
Roman copy. Original 250-240 B.C.
Rome, Museo Nazionale delle Terme

82. Praying Boy. c. 300 B.C.
Berlin, Staatliche Museen

83. Hunchback. c. 250 B.C.
Hamburg, Museen für Kunst und Gewerbe

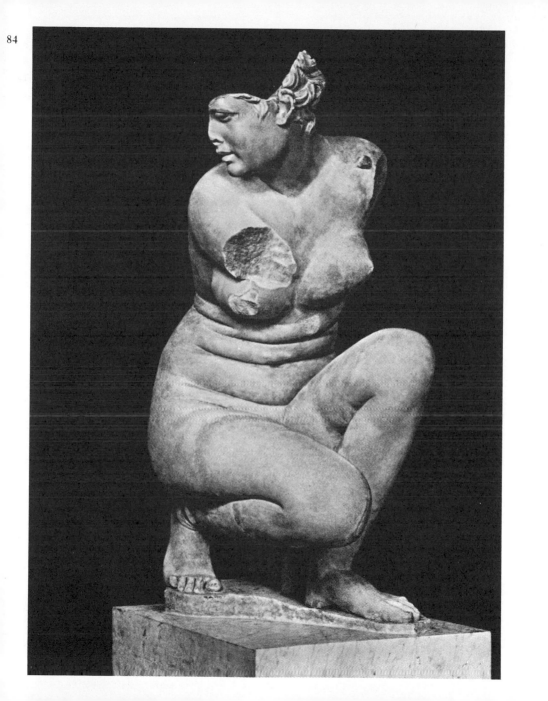

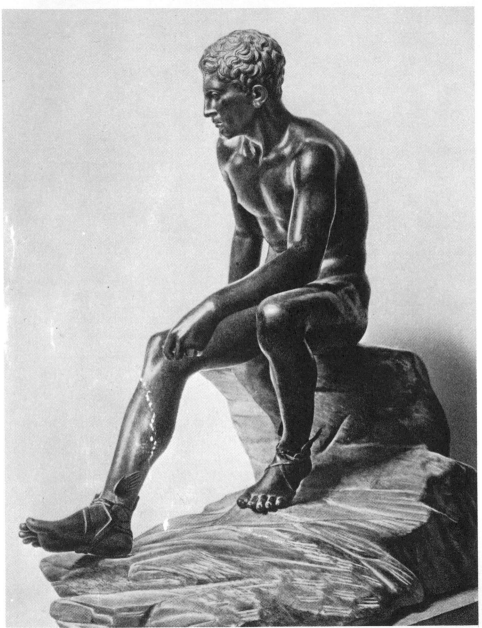

87. Aphrodite Untying Her Sandal.
Third century B.C.
Paris, Collection de Clercq

86. Bronze Maiden.
First half of the third century B.C.
Munich, Museum für Antike Kleinkunst

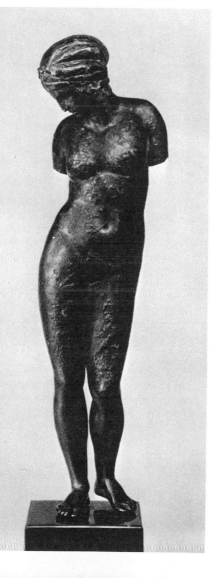

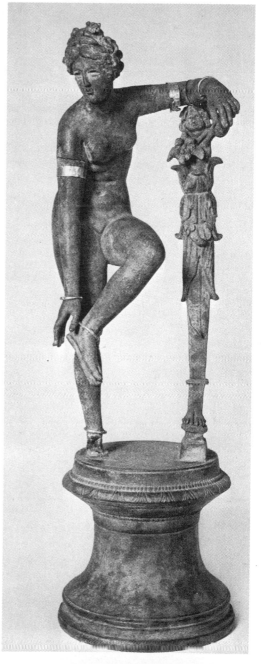

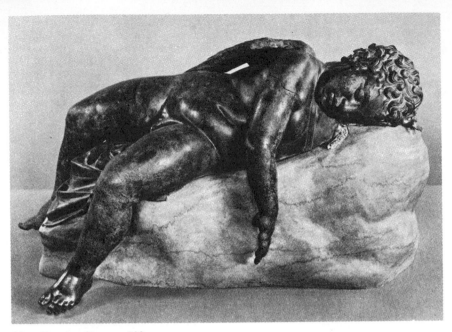

88. Sleeping Eros. c. 200 B.C.
New York, The Metropolitan Museum of Art

89. Sleeping Hermaphrodite, Roman copy.
Original 200-150 B.C.
Rome, Museo Nazionale delle Terme

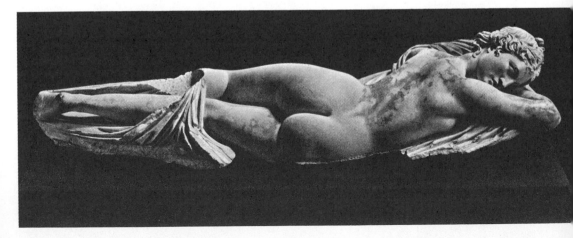

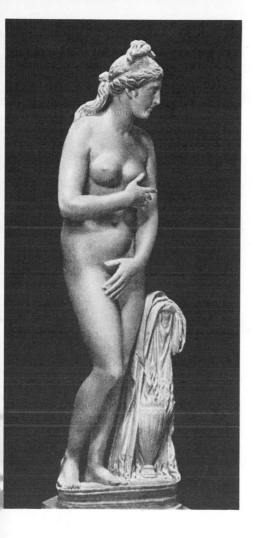

90. Capitoline Aphrodite, Roman copy.
Original c. 250 B.C.
Rome, Museo Capitolino

91. Apollo Belvedere, Roman copy.
Original 200-150 B.C. (?)
Vatican Museum

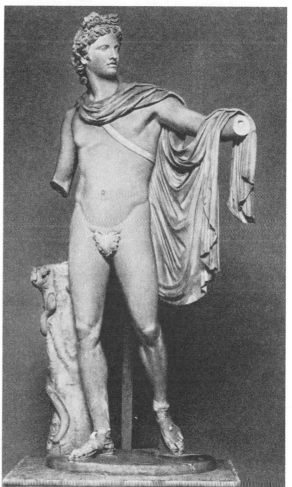

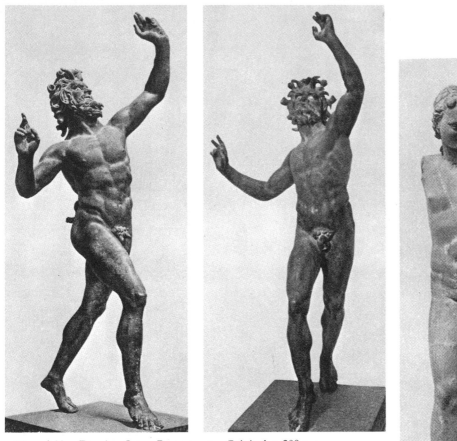

92. and 93. Dancing Satyr, Roman copy. Original c. 200 B.C.
Naples, Museo Nazionale

94. Flying Eros.
c. 175 B.C.
Boston, Museum of
Fine Arts

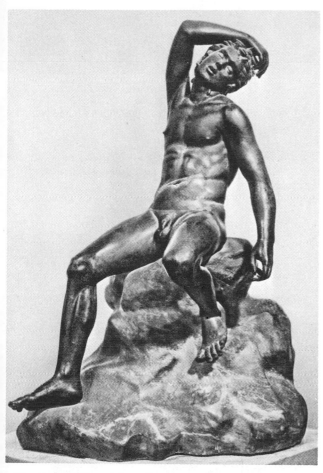

95. Satyr Falling Asleep, Roman copy.
Original c. 200-150 B.C.
Naples, Museo Nazionale

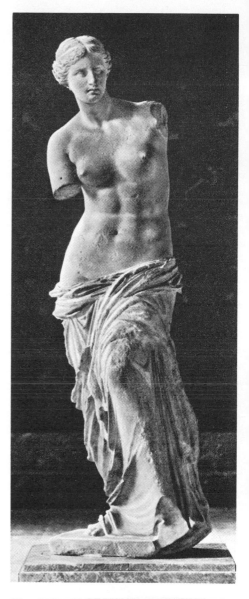

96. Aphrodite from Melos. c. 150-100 B.C.
Paris, Louvre

97

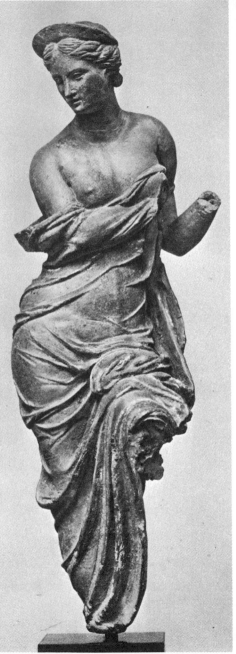

97. "Heyl" Aphrodite. c. 150 B.C.
 Berlin, Staatliche Museen

98. "Borghese" Warrior. Early first century B.C.
 Paris, Louvre

99. Singing Negro. 100-50 B.C.
 Paris, Bibliothèque Nationale

100. Sandalbinder, Roman copy. Original
 c. 100 B.C.
 Paris, Louvre

101. Seated Boxer. 70-50 B.C.
 Rome, Museo Nazionale delle Terme

98

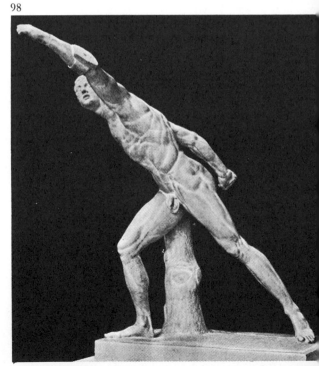

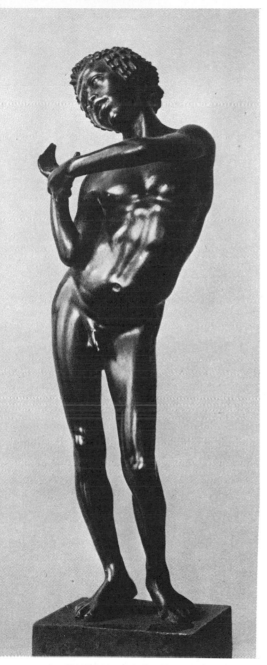

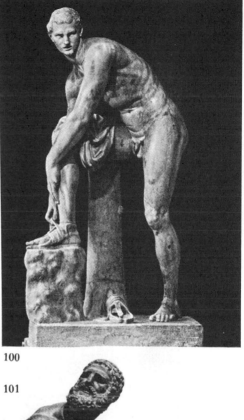

99

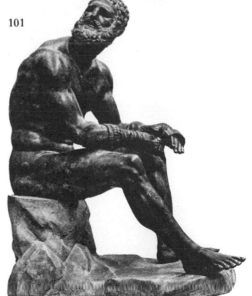

100

101

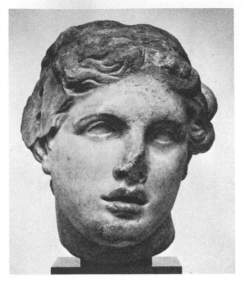

102. "Beautiful Head" from Pergamon.
c. 160 B.C.
Berlin, Staatliche Museen

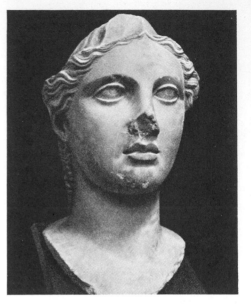

103. Head of Athena by Euboulides.
Second half of second century B.C.
Athens, National Museum

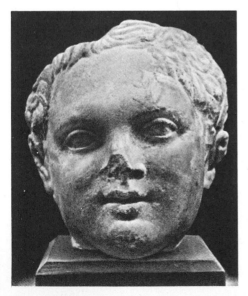

104. Head of a Boy. c. 200 B.C.
Alexandria, Greco-Roman Museum

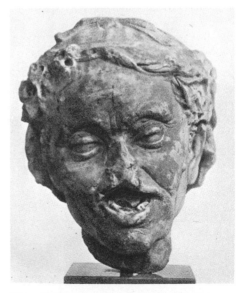

105. Head of an Old Woman. 100-50 B.C.
Dresden, Staatliche Skulpturensammlung

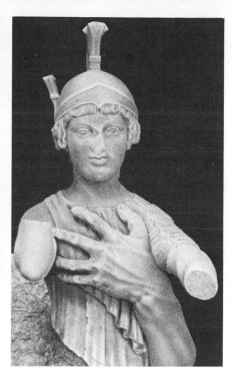

106

107

106. Palladion from Sperlonga by Hage-
 sandros, Athanadoros, and Polydoros.
 175-150 B.C.
 Sperlonga, Museum

107. Head of Sarapis, Roman copy.
 Cambridge, Fitzwilliam Museum

108. Head of Anytos by Damophon.
 First half of second century B.C.
 Athens, National Museum

108

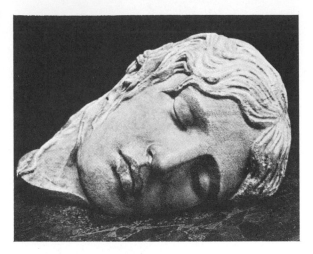

109. Sleeping Woman, Roman copy.
Original 180-160 B.C.
Rome, Museo Nazionale delle Terme

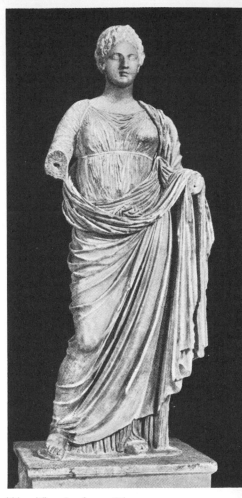

111. Themis from Rhamnus,
by Chairestratos. c. 300 B.C.
Athens, National Museum

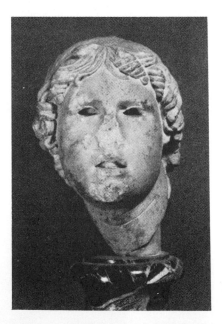

110. Male Head from Samos. 100-50 B.C
Paris, Louvre

112

113

112. Nikeso from Priene.
First half of third century B.C.
Berlin, Staatliche Museen

113. Terra-cotta Draped Woman.
First half of third century B.C.
New York, Pomerance Collection

114. Sacrificing Girl, Roman co-
py. Original second half of
third century B.C.
Rome, Museo Nazionale delle Terme

15 116 117

115. Standing Draped Female from Pergamon. c. 170 B.C.
 Berlin, Staatliche Museen

116. Cleopatra from Delos. 138-137 B.C.
 Delos

117. Tyche of Antioch, Roman copy.
 Original 300-290 B.C.
 Vatican Museum

118. Statuette of a Maiden.
First half of third century B.C.
Budapest, Museum of Fine Arts

119. Statuette of a Maiden (another view).

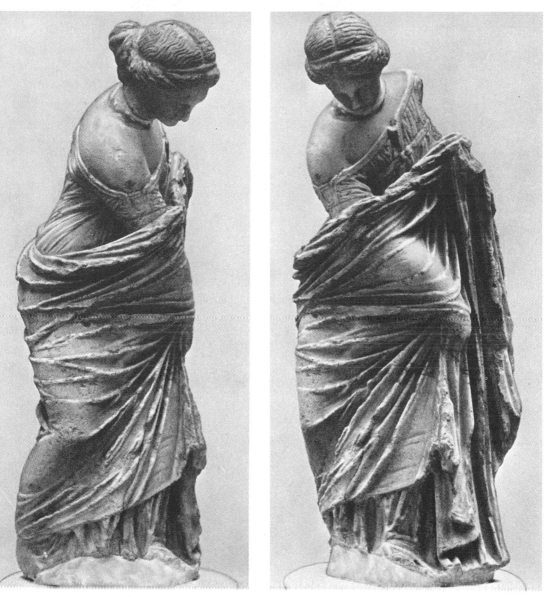

120. "A Faithful Servant" from Tarentum. c. 300 B.C.
Berlin, Staatliche Museen

121. Old Pedagogue. Perhaps third century B.C.
Paris, Louvre

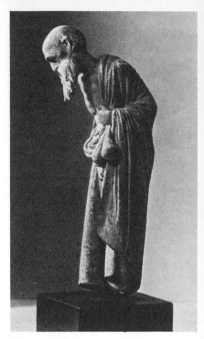

120

121

122. Sleeping Ariadne, cast of a Roman copy. Original c. 200 B.C.
Rome, Museo dei Gessi

123. Victory of Samothrace. 180-160 B.C.
Paris, Louvre

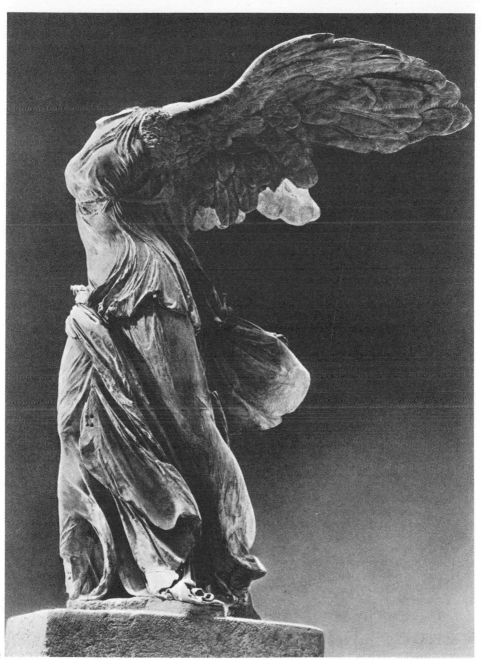

125. Athena from Pergamon. 180-160 B.C.
 Berlin, Staatliche Museen

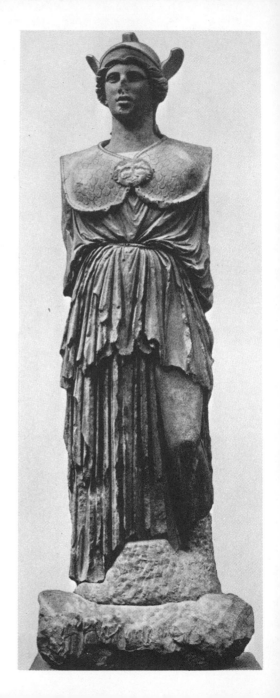

124. Bearded God from Pergamon. 180-160 B.C.
 Berlin, Staatliche Museen

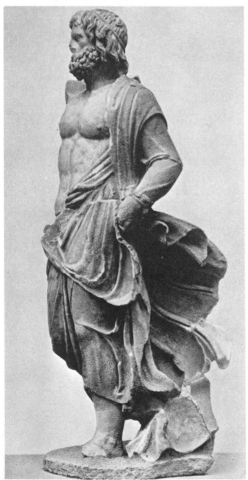

126. Seated Dionysos.
First half of second century B.C.
London, British Museum

127. Demeter (?) from Knidos.
Second half of second century B.C.
London, British Museum

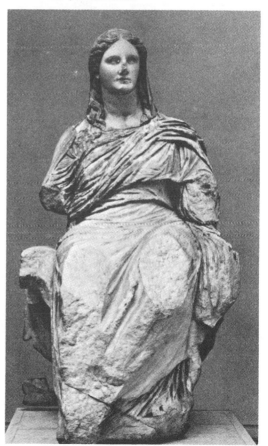

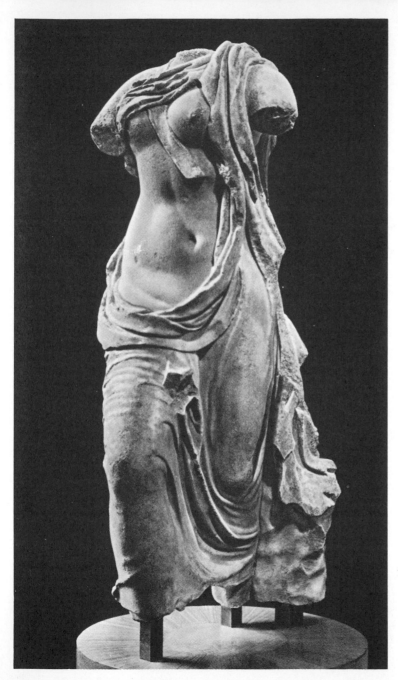

128. Artemis (?), Roman copy.
Original late second cen-
tury B.C.
Milan, Museo Archeologico

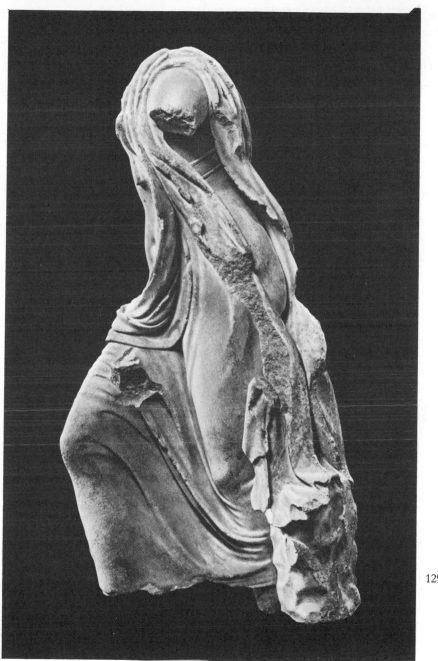

129. Artemis (?),
Roman copy
(another view).

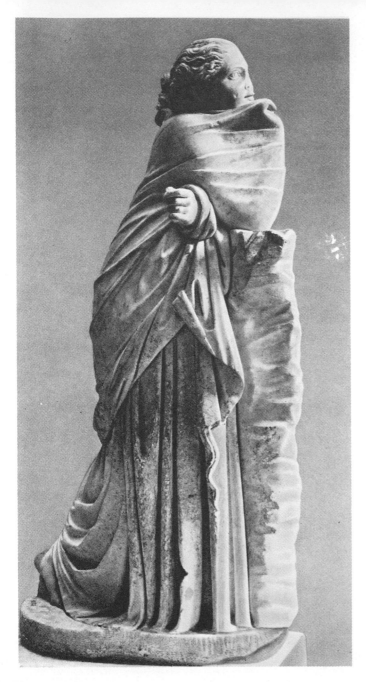

130. Polyhymnia (?) Roman copy.
Original late second century B
Rome, Museo Capitolino

131. Boy from Tralles.
First half of first century B.C.
Istanbul, Archaeological Museum

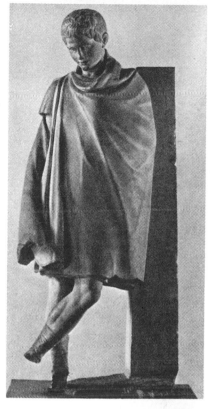

132. Bronze Jockey. 125-100 B.C.
Athens, National Museum

133. Negro Boy from Bodrum.
Second to first century B.C.
Bodrum, Museum

132

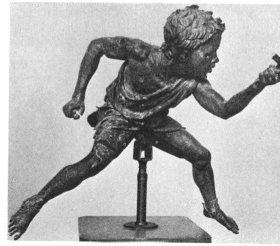

133

134 135

134. Comic Actor. Second to first cen-
 tury B.C.
 Princeton, The Art Museum, Princeton Uni-
 versity

135. Dancing Dwarf. c. 130 B.C.
 Tunis, Musée Alaoui, Le Bardo

136. Thorn-Remover from Priene. c. 100 B.C.
 Berlin, Staatliche Museen

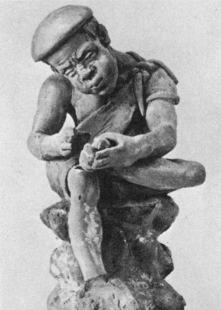

136

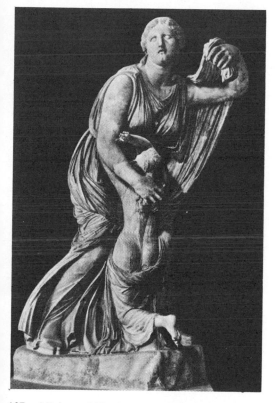

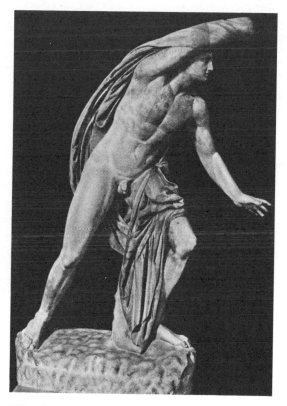

137. Niobe and Her Youngest Daughter, Roman copy. Original early first century B.C.
Florence, Galleria degli Uffizi

138. Son of Niobe, Roman copy. Original early first century B.C.
Florence, Galleria degli Uffizi

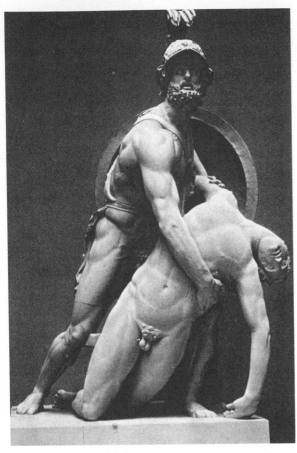

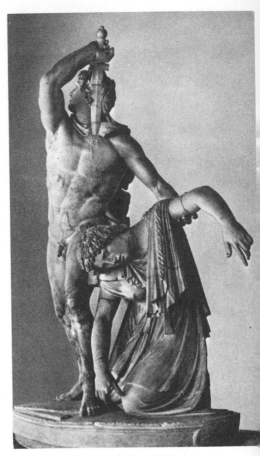

139. Menelaos with the Body of Patroklos. Reconstruction by B. Schweitzer. Original c. 200 B.C. Cast based on a Roman copy in
Florence, Loggia dei Lanzi

140. Gaul Killing Himself, Roman copy (see 141). Original late third century B.C.
Rome, Museo Nazionale delle Terme

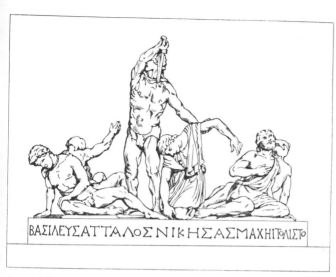

ΒΑΣΙΛΕΥΣΑΤΤΑΛΟΣΝΙΚΗΣΑΣΜΑΧΗΙΓΑΛΑΤ

141. Victory Monument of Attalos.
Late third century B.C.
Reconstruction by A. Schober

143. Centaur and Eros,
Roman copy. Original
c. 150 B.C.
Paris, Louvre

142. Dying Trumpeter,
Roman copy (see 141).
Original late third cen-
tury B.C.
Rome, Museo Capitolino

144. Wrestlers.
Second to first century B.C.
Baltimore, Walters Art Gallery

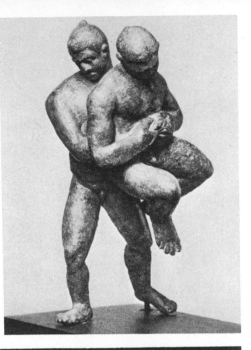

145. Two Women Gossiping.
Second half of second century B.C.
London, British Museum

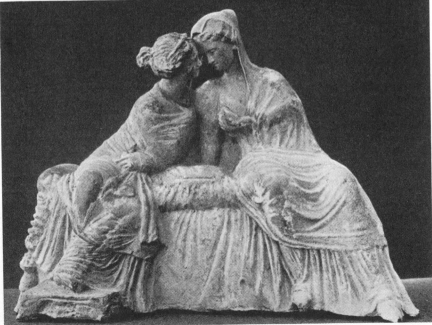

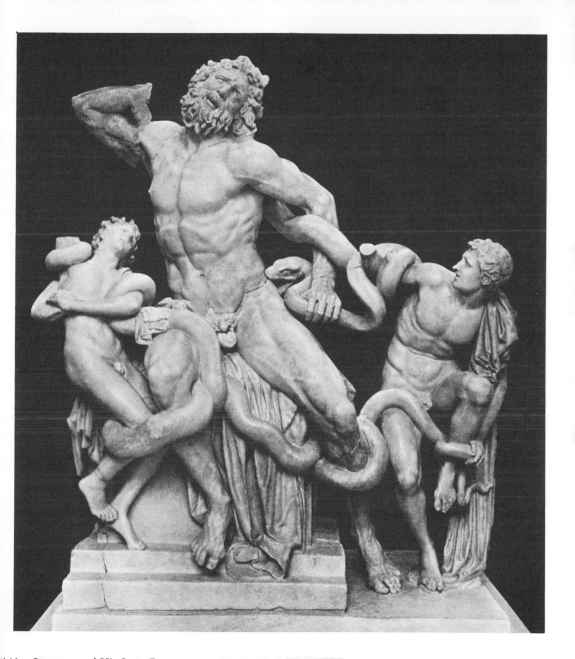

146. Laocoon and His Sons, Roman copy (?). Original 150-100 B.C. Vatican Museum

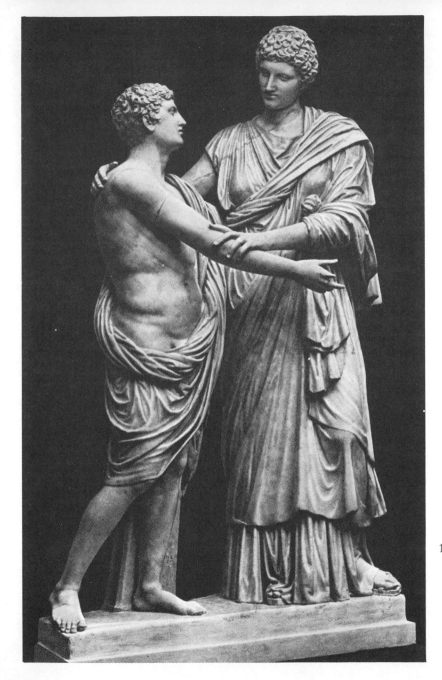

147. Orestes and
Elektra, signed b
Menelaos. First
century B.C.
Rome, Museo Naziona
delle Terme

IV Sculpture in Relief

ARCHITECTURAL FRIEZES
(Illustrations 148-162)

Greek sculptors of the sixth and fifth centuries were committed to the principle that the primary function of the architectural frieze was decorative. Like a long strip of floral or geometric ornament, the figurative friezes of the Ionic order, such as occur on the Siphnian Treasury at Delphi or on the interior of the Parthenon at Athens, were embedded in the wall structure itself and were framed by strong architectural elements. Extending horizontally, in rhythm with columns, architrave, and cornice, the frieze pursued its unbroken course – up to the corners in some cases, right around them in others. The scenes, whether battles, processions, or assemblies, did not disrupt the fabric of the wall or weaken its supporting function. They were conceived as ornamental bands nearly as solid as an egg-and-dart molding or a wall course. Painted in gay colors, chiefly red and blue, their ultimate decorative purpose was entirely fulfilled.

With two interesting exceptions, which we will shortly discuss, the friezes of the Hellenistic period preserve, by and large, Classical traditions. The base for a statue in the Acropolis Museum (148) is our first example (c. 300 B.C.). The subject was a familiar one in earlier Greek art – the athlete, in this case six athletes on one side of the base, each scraping the oil from his body (cf. 80). Despite the turns and stoops which the various naked youths describe, despite foreshortened views of shoulders or hips, and despite, too, the substantial volume of each figure (the modeling is a little higher than the photograph suggests), we could not for a moment delude ourselves that we are looking at fully modeled, three-dimensional forms existing in space. We accept their abstractness, their lack of corporeality, their essential linearity. As such they adhere to the relief ground. The result is a light, lyrical, and entirely suitable surface decoration.

A second frieze, also of about 300 B.C., came from a Tarentine funeral monument. Because so little of it is preserved we cannot be sure of the subject, but it was probably one of the great mythological battles, perhaps the one between the gods and giants which had been depicted over and over again in earlier Greek art. In the preserved fragment (149) two warriors dash along a narrow plinth. They are quite independent of the background – their oblique torsos are casually joined to it but several details are completely detached. Nevertheless these nude heroes are not allowed to behave as though a front and back plane did not exist, and despite the volumetric character of the figures, the two-dimensional or decorative values of the frieze are not actually sacrificed.

The large sarcophagus known as the "Alexander Sarcophagus" (150-152) consists of an architectural form of rectangular shape, with high molded base and bands of delicate designs framing figurative panels on all four sides. The lid is shaped like the gabled roof of a temple, and it is covered with simulated tiles, waterspouts, and akroteria. The reliefs of the long sides are architectural friezes in the usual sense. In one of them a lion hunt is taking place; in the other a battle between the Greeks and the Persians (150-151). One combatant may be Alexander the Great (152). The battle, however, is not one we can put a name to. It is devoid of specific reference and is just as mythological, just as removed from historical actuality, as a battle between the gods and giants. The Greeks and Persians had fought in classical art too – in the frieze on the small temple of Athena Nike on the Athenian Acropolis.

On the sarcophagus the fight is frenzied. Two layers of overlapping figures are often packed between the foreground and background. Whether they are in the first or second row, they are astonishingly round and fully modeled. One or two figures, or parts of figures, move obliquely. Horizontal rhythms and lateral movement, however, dominate the composition, and the protagonists aim their blows to one side or the other and never in a direction that challenges the existence, however invisible, of the front plane.

As far as is known, for the whole of the third century no temple or other monumental building received sculptural decoration in the form of a figurative frieze. But in the second century the frieze reappeared as one consequence of Attic influence in Asia Minor – in the Great Altar of Zeus at Pergamon and in the Ionic temples designed by Hermogenes (see Chapter II) or his followers. After an apparent hiatus of more than a century these second-century examples, then, constitute a virtual renascence of this traditional form of architectural decoration.

The large frieze of the Altar of Zeus at Pergamon again portrayed the battle between the gods and giants. In this case the theme was chosen because it had been twice depicted in the decorations of the Parthenon in Athens, a temple and city much revered by the Pergamene kings. Startling and without any exact precedent, nevertheless, was Eumenes II's idea of lowering the frieze to the base of his Great Altar (79). Nearly eight feet high – very nearly as tall as the columns above – it accosted the spectator to a degree that earlier friezes, whether on temple, tomb, or parapet, had never done. Enormous bulging forms constitute this titanic struggle. The figures are carved almost in the round; they are so fully realized as solid forms that they appear to have no need of a background. Indeed they obliterate it by their aggressive crowding and their histrionic gestures. A few bold giants and divinities, moreover, are about to invade the observer's space. Is this suitable architectural decoration, we ask. Are not classical precepts dangerously threatened – if not discarded – here?

As any visitor to the reconstructed altar can attest, there is no ultimate danger of this. After the manner of the Parthenon frieze, the available field is filled-heads or wings reach the top all the way along. There is no visible background as such, but the bulky figures themselves form a wall which is continuous and substantial enough to function, along with the steps and socle, as a firm base for the colonnades and statuary above. A few forms move towards us, but taken in its entirety the battle proceeds according to classical rules – either to right or left. Although undoubtedly the location, size, and subject of the frieze represent propagandist motives on the part of Eumenes, it remains true that the artistic effect produced is successful: it is a magnificent piece of architectural decoration that confirms rather than denies its role in the structure.

The frieze representing the battle between the Greeks and Amazons, also a subject which had formed part of the sculptural program of the Parthenon, occupied the normal position above the architrave of the temple of Artemis at Magnesia of c. 140 B.C. (158). Hermogenes, the architect and perhaps the designer of the frieze, was, as we saw in Chapter II, a strong admirer of Attic art. In designing the temple, he took pains to reproduce some of the details and refinements of the great buildings on the Athenian Acropolis. We would expect, then, that he would appreciate the decorative function of a frieze. He does not disappoint us. The columns of the temple were extremely tall, and the dentil band above the frieze very heavy. To be visible at all, and to hold their own in this massive context, the figures had to be carved in extremely high relief. Thus the background drops far away and does it quite unevenly. The figures, which are widely spaced, are attached to it only by shapeless appendages, and they are modeled chiefly on the outer surface. Surrounding areas of shadow, caused by the deep undercutting, deprive them of any visual connection with the relief ground. Yet many of the Greeks and Amazons are compressed into profile or frontal views and into parallelisms that reflect the flat but invisible front plane. Despite some foreshortenings and oblique postures, a decorative surface is thus continuously and prominently felt. Hermogenes' frieze may be technically disappointing when viewed close at hand, but at a distance it would have been fully successful as architectural ornamentation.

The friezes so far discussed were classical in more

than form. The subjects represented were traditional and had distinguished histories, sometimes long ones, in pre-Hellenistic architectural decoration. Two other important architectural friezes of the second century, however, represented themes that were new to Greek sculpture. What effect on decorative frieze style did these new subjects have?

In 168-167 B.C. the Roman general Aemilius Paullus erected a tall rectangular pillar at Delphi. Around the top, which supported an equestrian statue of the general, ran a frieze (157) whose episodes were rooted in the historical present rather than in mythology. They depicted the memorable battle between the Romans and the Macedonians at Pydna in 168 in which Aemilius Paullus emerged the victor. But, although the subject was new and topical, the frieze was, in some respects, more old-fashioned, more classical, than those at either Pergamon or Magnesia. Instead of portraying the battle at Pydna as it might have been observed, the sculptor in some passages took over set pieces from earlier monuments. Some of the engagements between cavaliers and foot soldiers, for instance, recall directly those in the late fifth-century frieze on the Temple of Athena Nike on the Acropolis. This, however, was not a novel idea: set pieces of the fifth century had been reused at Magnesia too. But quite apart from the motifs, the reliefs at Delphi were constructed in more direct imitation of the High Classical style. Some forms, such as the shields, are extremely linear, and some figures are pressed flat against the background. The sculptor, perhaps an Athenian, was obviously fully acquainted with the great classical friezes of the fifth century.

But there are also some features of the Aemilius Paullus frieze that have little to do with older prototypes. Many figures, for example, are in relief as high and as deeply undercut as the figures at Magnesia. In addition, forms do not always stay on this side of the background. The decorated shield of the recumbent warrior does not seem to stop at the relief ground. In another passage (not illustrated) a riderless horse in very low relief seems to disappear into the distance – an unheard-of infraction of classical rules and a telling indication that the sculptor did not ultimately think of the relief ground as a solid wall. We even feel that low-relief objects

such as the shields could well be fading into it. The four scenes, moreover, occur in a time sequence: the opening and conclusion as well as the intermediate episodes can be distinguished. One figure can actually be identified because of its portraitlike head. Thus while some classical elements have been revived, the overall effect of this relief is not classical at all.

There are at least four subjects represented in the frieze of the Temple of Hekate at Lagina (c. 100 B.C.). On one side (159) the age-old theme of the battle between the gods and giants is portrayed, and in a manner now familiar to us. As at Magnesia the figures, some of them borrowed directly from the large frieze of the Pergamon altar, are widely spaced and divorced from the background by deep undercutting and high modeling. In these passages overlapping is avoided, and the paratactic succession of forms creates a continuous rhythm along the surface, which is appropriately decorative and free from spatial illusion. The relief ground behind the figures, though again uneven, is neutral and without landscape elements or other indications of place.

But in other sections of the frieze (160) – and these are in the majority – the composition is of a different kind. Two of the subjects had never been represented in architectural friezes before: the birth of Zeus and the Assembly of Carian gods. In the birth scene Zeus' mother Rhea is shown lying on her bed while his father Kronos and other members of the family are nearby. The event is rendered with a certain completeness and attention to detail, as if it were drawn from "real life." That the birth occurred in Caria is made clear by the presence of personifications of Zeus' Carian attributes and of Carian nature gods. In the Assembly scene local interests were also served. For the last frieze the subject was drawn from current history: the alliance between Rome and the cities of Caria. In all these areas the organization is complex. Figures are grouped together rather than isolated; they are arranged in depth, one in front of the other rather than strung out along the surface as in the Gigantomachy, and they do not always reach to the top frame. There are more gradations in the height of the modeling: when figures or objects are close to the spectator they are carved out almost like round statues; when they

are further away, they sink back into lower relief; finally, a few low-relief props – a pillar, a tripod, or a trophy – are embedded in the background. The result is that the relief ground becomes, in effect, penetrable. We seem to be viewing real events occurring in space and time. To the sculptors of these sections of the Lagina frieze, visual reality, rather than a classical style or decorative considerations, was of paramount interest.

NON-ARCHITECTURAL RELIEFS
(Illustrations 163-175)

The style of sculptured reliefs conceived independently from architecture underwent developments during the Hellenistic age that were even more interesting than those of the architecturally integrated reliefs. In the main we deal here with votive and funeral monuments. An exception is the Telephos frieze from the Great Altar at Pergamon which, nevertheless, belongs both in form and content within this category rather than the preceding one. The reliefs of this group involve subjects that are relatively intimate and private. In size they tend to be modest, sometimes quite small. They were intended to be viewed close to rather than from a distance. There was no need for them to be primarily decorative. The artist in these circumstances seems to have been able to exercise greater freedom in stylistic development. He was, after all, not re-required to reiterate the uninterrupted rhythms of the architectural design, and the themes he was called upon to illustrate were less hallowed by tradition.

The votive relief of about 300 B.C. dedicated to the nymphs (163) is one example of the non-architectural relief. Although materially joined to the background, the nymphs and their companions are plastic entities with no compositional dependence on it or on any planimetric scheme. Behind them is the irregular stony wall of a cave, an impenetrable but separated barrier.

Third-century reliefs were apparently handled in the same manner. In an example of about 250 B.C. (164) we search in vain for signs that Homer

and his Muse are posed or modeled in any significant relation to a front or back plane.

During the second century, however, the most significant developments occurred in the non-architectural relief. The frieze narrating the story of Telephos, from the Altar of Zeus at Pergamon (166, 167), was executed around 170 to 160 B.C. It was situated on the inner walls of the altar where the observer could walk up close to it, and although it covered a long surface, one's view was regularly interrupted by piers. The scenes themselves were episodic and ran in a series of separate sculptured reliefs in a continuous frieze. The story they unfold was a myth, but a myth with strong contemporary and dynastic implications. It told of the life of Telephos, the founder of the Pergamene state in ages past. To the king who commissioned it the tale was family history, and he wanted it to unfold logically and continuously. Single incidents from the myth of Telephos had been represented in earlier art, but there was no cycle of scenes, such as was required here, that carried the hero through from birth to death. The sculptor therefore had to strike out on his own, and the results were interesting in many respects. In order to make the narrative more "real" and believable, the background has become a complete landscape, sometimes consisting of rocks, trees, and caves, sometimes of shrines and palaces, sometimes simply of "atmosphere." The figures were set in front of the background as well as within it. They are relatively diminutive and therefore leave air or landscape elements above and behind them. They are carved in high or low relief according to their location in depth. The gradations in the height of the relief are not always consistent, but they are varied enough to convey the impression that some objects are nearer to us than others.

The small votive of a Family Sacrifice (168) in Munich is a more characteristic example of the non-architectural relief of the second century. It looks in many respects like a framed picture. In accordance with normal perspective, figures in graduated relief retreat on a horizontal plane. The field above is expansive and allows adequate room for a landscape setting. The Smyrna gravestone of the same period (169) is conceived in approximately the same

pictorial manner. So too is the lowest tier in the relief representing the Apotheosis of Homer now in the British Museum (170); its date is c. 125. In these three reliefs it is interesting to note that at least part of the scene is rooted in historical actuality: a family gathers about an altar; Homer is feted by the king and queen just as he was at the festivals in Alexandria; and the hero with his horse and groom has the homespun and intimate flavor of genre. The story of Telephos, we recall, also claimed to be historical. There seems to be some correlation, in short, between these "real" events and the desire to depict a real environment.

A closer look at several reliefs bears out this conclusion. One of the conventions of Classical votive reliefs was to represent human worshipers on a smaller scale than the divinities standing beside them. The votive relief to the nymphs in Athens (163), c. 300, perpetuates this distinction. Yet the old man and his youthful assistant on the right occupy more space and, proportionately, a loftier and more comfortable situation than do the nymphs and Hermes, who seem rather crushed between the overhanging ledge and the back of the cave. Thus, in the area set aside for human activity, small as it is, the sculptor has made concessions to visual reality. In the Family Sacrifice (168) now in Munich the contrast between the two parts is still stronger. Recession into depth, grouping, overlapping, gradations of relief, and space itself seem to be relegated to the area inhabited by the family, whereas the two divinities exist in a more ideal, less specified world. Similarly, in a monument of the second century, divine Cybele and Attis (171) look like statues standing in front of a wall, while their human worshipers have come through an open door shown in perspective. When we leave Alexandria and climb the slopes of Parnassos we find that suggestions of space and depth decrease and the Muses line up like mannequins (170). The nymphs in another relief in Athens of around 100 B.C. perform their archaic linear dance while a deep crowd of their admirers hails them from a very palpable distance (172).

There are, then, inconsistencies of style within all these examples. Sometimes the composition is quite spatial; at other times it tends to be flat. By these means a distinction is intentionally drawn between the human and divine realms. In the human realm are space, perspective, and illusion; for the divine, a more decorative style prevails, related to that observed in architectural friezes.

This examination of some examples of Hellenistic sculpture in relief has served to establish a necessary conclusion: we have to distinguish between two modes, or styles, in relief sculpture of the period. The first, which we have called decorative, is associated with the architectural frieze. The second, the "illusionistic" (for want of a better word), is prominent in the independent sculptured panel.

Within the category of architectural friezes, those on the monument of Aemilius Paullus and three of the four on the temple at Lagina prove to be exceptional. In spite of their architectural context they exhibit aspects of the second, illusionistic, mode. We find in both of them effects of depth and space. The subjects of these friezes, however, were unusual. Instead of being remote and purely mythological, derived from fixed traditions in earlier Greek art, the themes were new and in some way relevant to the historical present. It is logical to think that in these cases a style invented for one category of relief sculpture was borrowed for the other.

From the standpoint of the two modes it is also instructive to study the tombstones of the period and consider the contrast between Attic and East Greek. The elaborate gravestone with figures had been discontinued in Attica after the sumptuary law enforced by Demetrius of Phaleron in 317 B.C. When they were resumed, more modestly it is true, in the first century, they maintained in general their classical form. Although from the island of Rheneia, the beautiful tombstone illustrated in 173 is an excellent example of the Attic type. The three tall, statuesque figures of the deceased, all based on earlier prototypes, occupy a shallow, nonspecific space, free of illusionistic elements or props, as if they were gods. In grave reliefs of the same period from Asia Minor, on the other hand, we may find, as the example from Smyrna indicates (169), any number of pictorial additions, coupled, as expected, with more humble content. In short, the Attic type

is essentially an architectural monument – in this case a shrine – filled with figures, whereas the East Greek type is conceived as a picture framed by architectural elements.

As our remarks have indicated, during the third and second centuries the decorative and the illusionistic modes ran along as parallel but separate styles, each one at times adopted exclusively, while at other times, when the content warranted, the two were juxtaposed. There is yet another possibility, one that we believe did not commonly occur before the first century and that is particularly prevalent in Neo-Attic work. Instead of a juxtaposition of the two modes, we find a thorough mixture. That is, a naturalistic environment – whether of landscape or architecture – was added behind a figure or group of figures of divine or semidivine type. This is how we understand the relief of Dionysos' visit to the home of a poet (174) now in the British Museum. Or, conversely, the relief ground was scraped clean and indications of space and locale were all but omitted just where they might be most expected – behind a row of ordinary people (175). Thus the two styles, initially considered appropriate for either mythological or "real" content, became finally the common property of both. Henceforth the two classes of subjects are never as logically distinguished in their treatment, and the artist could, so to speak, confuse the two worlds as he wished.

The distinction between the two modes was an achievement of the Hellenistic age. But the modes did not escape the notice of Rome. Transmitted to Italian soil, undergoing development, manipulation, or combination, they provided the basis for relief representation throughout the history of Roman art.

ARCHITECTURAL FRIEZES

148 Base with Athletes in Relief

Three sides of this rectangular base were decorated with figures of athletes. Our photograph shows one of the short ends on which six nude youths scrape their bodies with strigils, the same action represented in the statue of the Apoxyomenos by Lysippos (80).

They are small-headed, long-bodied, beautiful young men; gracefully and languidly they lean over, tilt, or stand as they draw the scraper along a knee, arm, or chest. The two at the far right seem to be holding a conversation, but there is really no narrative content to the relief. It is a decoration involving six variations on a theme. The sculptor considered this end of his base as a panel quite unrelated to the other sides. The two lateral athletes turn inward, but the composition is friezelike and has neither a center nor symmetry. The tasteful spacing, the rhythmic movements, the flattening of those parts of the figures nearest the spectator all reinforce the surface aspects of the design. The work is delicate, and the forms are in low relief. Nevertheless they appear to have strong volume, for we sometimes see them foreshortened, and the contours imply depth.

The names of the athletes are inscribed just below their feet. The form of the lettering suggests that the base was erected about 300 B.C. It probably supported the statue of a victorious athlete, of the kind that Pausanias said he saw on the Acropolis.

Athens, Acropolis Museum, inv. 3176. W. 0.89 m. H. 0.47 m. Pentelic marble. Restored sections at left and right; the other sides of the base are badly mutilated. Found 1839 on the Acropolis. M. Bieber, *Sculpture*, 2nd. ed., 32.

149 Funerary Relief

The movement of these warriors is almost wild. What a pity we do not know who their enemies were. The relief is only a fragment from a limestone frieze which ornamented an *aedicula* that served as a monument to a dead hero. It was unearthed in Tarentum, a prosperous city in the Hellenistic age whose people, judging from the number of similar reliefs that have been found and from wall paintings, indulged themselves in funeral cults and sumptuous grave monuments. Like an Amazonomachy or Gigantomachy, the battle here is on a heroic plane.

Both figures dart toward the right and are almost entirely free of the background. One wears a broad-brimmed hat, the *petasos*, usually associated with Hermes; a sword in his right hand he looks back anxiously. The other wears a plumed Corinthian

helmet, which has led to his identification as Ares, the god of war. The motion of the figures is accelerated by the drapery: their mantles rise and flutter off their backs and spread out along the background. The plume of the helmet dances up and down. These devices for conveying a sense of motion are High Classical in origin, and they were continued to good effect in heroic battles on another grave monument, the Mausoleum at Halicarnassos of the mid fourth century, which in style furnish the closest parallels to this relief. The figures here are more deeply undercut and seem almost detached from the background. Nevertheless they move along parallel to it, as do those in the Mausoleum frieze. The idea of decorating a tomb monument with heroic battle scenes was to have a deep influence on Etruscan and Roman funereal art.

Tarentum was conquered by Rome in 272 B.C.

Cleveland Museum, No. 27.436. Purchased from H. J. Wade Fund. H. 0.33 m. L. 0.34 m. *Bulletin,* Cleveland Museum of Art, *15*, 1928, 91. H. Klumbach, *Tarentiner Grabkunst,* 1937, 4, no. 15. L. Bernabo Brea, *Riv. del Ist. Arch.,* N.S.I., 1952, 120 f. About 290 B.C.: J. C. Carter, *The Sculpture of Taras,* American Philosophical Society, 1975, no. 188, 68.

150-152 "Alexander Sarcophagus"

In the latter part of the nineteenth century a remarkable discovery was made at Sidon in Syria: Turkish excavators found a Royal Cemetery comprising seven tomb-chambers containing altogether seventeen sarcophagi. The largest as well as the latest of the sarcophagi soon became known as "Alexander's" because his portrait, it was believed, appeared twice in the sculptural decoration. Alexander, of course, was not buried in it; in all probability it originally contained the body of Abdalonymos, the last king of Sidon, who was indebted to Alexander for his throne.

The sarcophagus is lavishly ornamented. A series of exquisite moldings – bead and reel, egg and dart, the meander, and a marvelous crawling vine, to name a few – frame the two panels on the end and the two friezes on the sides. On one long side a lion hunt was depicted, on the other (shown here) the Greeks and Persians engage in battle. Spears, swords,

bows and arrows (usually added in metal) are the instruments of a war which is fought both on horse and on foot. The Persians are distinguished by their long trousers and soft helmets that cover their chins and fold over at the top. The head of the mounted Greek (152) wearing the lion's-head helmet has been compared to the heads of Alexander the Great on coins and has therefore been termed an "idealized portrait." But with the possible exception of the horseman at the far right, all the heads are idealized and similar in features, so there is no proof that this represents Alexander instead of some other Hellenistic prince. Alexander's companion Hephaistion has been identified in the cavalier at the center and Parmenio in the old general at the far right, but these too are only conjectures. Both the lion hunt and the battle presumably celebrate the heroic exploits of the deceased.

Yet there is nothing particularly documentary about either scene, and in view of the generalizing tendency of fourth-century Greek frieze decoration it seems useless to surmise whether the battle depicted was at Issus, Arbela or somewhere else. One Greek, we notice, takes on his enemy in the most unlikely nudity. The composition, moreover, is carefully balanced and symmetrical. There is a central motif, an inconspicuous one it is true, and mounted warriors charge inward to conclude each end. Individual warriors duel with their immediate opponents in episodic fashion, but the friezelike continuity of the composition is maintained by some distant encounters. The kneeling Persian archer, for instance, aims his arrow across several struggling forms to the general at the right end, and another takes a long shot at "Alexander." Pathetic prostrate figures, with arms or heads thrown back and with open mouths, constitute a kind of base line. The relief is very high; the figures are almost in the round and there is a suggestion of depth in the layering of forms. Yet a steady surface rhythm is maintained, and the action remains in general parallel to the background. The composition is not as dense and its boundaries are not as threatened as in the large frieze of the Pergamon Altar, but the available field is crowded enough to convey very effectively the drama of the conflict.

Color – violet, brown, red, yellow, and blue –

remains on many figures. It was applied with more naturalistic intent than is the case in fifth-century sculpture, but it is by no means devoid of decorative value. The background was not painted. The artist is not known, but the style is related to that of the friezes from the Mausoleum of Halicarnassos of the mid fourth century. The sarcophagus is dated about 310 to 300.

Istanbul, Archaeological Museum, no. 68. Pentelic marble. L. 3.18 m. W. 1.67 m. The cemetery was discovered in 1887. Other historic persons have been identified: see J. Charbonneaux, *La Revue des Arts*, 1952, 219 ff. G. Mendel, *Catalogue des Sculptures*, I, 18 ff. F. Winter, *Der Alexandersarkophag von Sidon, Strassburg*, 1912. V. von Graeve (*Der Alexandersarkophag und Seine Werkstaat*, Berlin, 1970) argues for the historical and biographical significance of the reliefs. Cf. K. Schefold, *Der Alexander-Sarkophag*, Berlin, 1968.

153 Altar of Zeus, Pergamon, Large Frieze, Zeus Fighting Giants

The almighty Zeus, king of the gods, towering and terrifying, hurls his thunderbolt at the serpent-legged Porphyrion, the bearded king of the giants. Two other opponents have already received their death blows: to the left a giant sinks back, twice pierced by the lethal rays of a thunderbolt whose flames begin to devour his shield; the second victim, shivering and collapsing from the pain, clutches at the wound on his shoulder. Zeus is the only deity on the enormously long frieze who is called upon to deal simultaneously with more than one enemy. Besides an inexhaustible supply of thunderbolts, he relies upon his indestructible aegis, or shield, held on his left arm, and his monstrous eagle just beyond. The outcome is certain, but victory will not come easily, for Zeus' foes, the sons of the earth, have bodies as powerful and heroic as his and a determination that is if anything even more passionate and self-aware.

The battle of the gods and giants was an old theme in Greek art and literature. In the Pergamon Altar it is raised to unprecedented intensity and fury. The figures are larger than life, their anatomy is knotted and exaggerated, they thrust ahead or retreat and die in diagonal patterns which collide or overlap. All forms are extremely substantial and muscular;

nearly all project in very high relief. They fill up the background and jam themselves between the upper and lower frames. No wonder, then, that the battle is without classical elegance, that we can hear the crackle of flames and screams of agony, and that the figures, scarcely contained by the architectural setting, seem to overpower us. Sometimes the giants are in fully human form, at other times animal features are substituted to stress their bestial natures and their physical strength.

The frieze has more than one level of meaning. Superficially, it is just a good story, told by Hesiod, of a bloody battle that occurred early in the creation of the cosmos. On another level it may imply the victory of order over chaos, or, on still another, of the Greeks over the barbarians. The altar was dedicated by Eumenes II to Zeus and Athena Nikephoros in gratitude for their aid in the Attalid struggles against the Gauls. The frieze may paraphrase this undertaking, and we may even be expected to identify Zeus with the Pergamene monarchs.

Berlin, Staatliche Museen. Frieze is 2.3 m. high and carved on plaques from 0.6 m. to 1.1. m. wide. 182-165 B.C. For the general setting see 75 and 79. In general, the opponents of the giants are: on the east frieze the Olympian gods, on the west land and sea divinities, on the south gods of light, and on the north gods of rivers and springs. This is a section of the east frieze. E. Schmidt, *The Great Altar of Pergamon*, Leipzig, 1962. An apsidal building revealed in the foundations leads K. Stähler to question the purpose and meaning of the altar and its sculpture. Is it rather a heroon to Telephos? (*Festschrift für K. Dörner*, Leiden, 1978, 838-67.)

154 Altar of Zeus, Athena Fighting Giants

Zeus' most prominent ally is his beloved daughter Athena. With wide-sweeping and majestic movements, one toward the left, one toward the right, these two deities were the first to fall within the spectator's line of vision as he entered the altar sanctuary from the propylon. Athena, now unfortunately faceless, wore a Corinthian helmet, an aegis bearing the head of a gorgon on her breast, and a snake belt. Her dress was the Doric peplos, and she carries a shield on her left arm. Assisted by the bites and wrenches of her faithful snake, she endeavors to drain all life from the double-winged giant

Alcyoneus by lifting him off the ground by his hair, which is the source of his strength. His mother, Ge, deeply distraught at the fate of her son, raises arms and head in despair and entreaty. But she is helpless, still buried to above her waist in her own earthly domain whose fruits – grapes, pinecones, apples, and pomegranates – appear above her left hand. Athena's moment of triumph inexorably approaches, for a Winged Nike flies toward her with a crown. In numbers, the opposing forces are about evenly matched over the frieze, yet the gods, usually upright and so often facing the spectator, seem to have moral as well as physical ascendancy over their more contorted and earth-ridden adversaries.

The choice of a Gigantomachy for the major decoration of the Great Altar is most significant. At Athens, the subject filled the east metopes of the Parthenon and, in a painted version, the interior of the shield held by Phidias' figure of Athena Parthenos. In both, the goddess herself plays a more important part than she did in other non-Attic representations of this popular subject. Pergamene devotion to Athens, already mentioned, is thus well attested by the altar. We also know that Attic sculptors came over to work on it. Even the figures of Zeus and Athena were directly inspired by the pedimental sculpture of the Parthenon.

East frieze. The frieze in its entirety was so long and the figures so numerous that labels were originally felt to be necessary. Some have survived and confirm in this case the identifications of Athena and Ge. Artists from Pergamon, Rhodes, and Ephesos also worked on the altar. Some are known through their signatures on the frieze. D. Thiemme (*AJA, 50,* 1946, 345-57) concluded that about forty artists were engaged for the frieze.

155 Altar of Zeus, The Dog of Artemis, Detail of East Frieze

When the frieze is viewed from a distance, the turmoil of battle is conveyed by the overburdened surfaces, the diagonal stresses of the composition, and the vigorous modeling. If we draw near and examine separate passages, the effect is not only reinforced but intensified, and in this case the physical violence truly hits home. The careful description of all details such as skin and bone, body hair, shoes, and shields seems to locate the event in the world of our own experience rather than in a generalized and remote past. This immediacy and concreteness are typical of much of Pergamene art of the second century.

Near the south corner of the east frieze Artemis, the goddess of the hunt, engages in a duel with a fully-human giant carrying a shield. To reach him she places her beautifully sandaled foot on the dead body of another giant and in the meantime sets one of her dogs to attack still another. The hound grabs the poor, bearded semihuman, sinking his teeth into the back of his neck. The giant's left hand is already limp, but with his ebbing strength he raises his right arm and gouges out the dog's eye. The event happens before us, clearly described, excruciatingly real; at any moment the blood will flow. Yet this is "realism" in only a very special sense, for the description is not photographic or objective. The dog's muzzle, for example, is impossibly stretched and curved, but how well it communicates all the sensations of a devilish bite. The giant's hair climbs against gravity and becomes confused with the mane and muzzle of the dog, but how well this suggests the force of the impact and the depth to which the teeth have sunk. Finally, the protagonists are such perfect specimens of their type that it is evident that art, not visual reality, is sovereign.

H. Kähler, *Der grosse Fries von Pergamon.*

156 Altar of Zeus, Eos

During the battle, periods of respite are rare, and the labors of the divinities almost unceasing. Yet here, on the south side, a lovely female creature is wafted along unchallenged on the back of her magnificent stallion. She is Eos, the goddess of dawn and the sister of Helios the sun god, who is nearby. Quite relaxed, she leans toward the horse and puts her right arm behind his neck. Her left arm, brought down into her lap, holds the reins. The fiery, muscular steed jerks back his head and Eos' body twists diagonally. Yet the overall movement, here and within the frieze as a whole, remains parallel to the back plane, as in classical reliefs.

The goddess's drapery is ravishing. It wrinkles and rustles; it both clings to and rushes away from her body; it is heavy in one place and light in another.

Thick folds dash about and cross her torso and legs, sometimes defining their shape, sometimes mercilessly charging into them. The amplitude of her figure exceeds even the lavish charms of some of the female goddesses in the pediments of the Parthenon.

Eos is not often depicted in Greek art. Several other deities of the large frieze are also strangers. Finding a sufficient number of gods to fill such a long decorative field must have taxed the ingenuity of the artists and consulting scholars, as well as the resources of the Pergamon library. Hesiod's *Theogony* may have been the chief literary source, or perhaps a contemporary epic written by some poet with an active and encyclopedic mind provided the information.

On the Hellenistic epic, K. Ziegler, *Das Hellenistische Epos*, 2nd ed. Teubner, 1966. E Simon, *Pergamon und Hesiod*, Mainz, 1975.

157 Monument of Aemilius Paullus

Despite the resounding defeat of his father, Philip V, Perseus, the new king of Macedon, threatened to upset the balance of power Rome had established in Greece. Aemilius Paullus, a great general, was accordingly sent out in 168 B.C. to destroy the meddlesome monarch. At the battle of Pydna the same year he tricked Perseus into taking the initiative at an inopportune moment, and neither for the first nor the last time the Romans emerged victorious over the Greeks. Nonetheless Paullus, like many educated Romans of his day, was a staunch Grecophile. On his way to the scene of battle he stopped to pay his respects to Apollo at the sanctuary at Delphi, and when the battle was over he followed Greek custom by erecting at the sanctuary a monument to celebrate his victory. He actually took over a tall pillar already erected there by Perseus, whom he had just defeated. The monument was situated close to Apollo's great temple and boldly competed with the dedications previously set up by other Hellenistic kings. Aemilius put a statue of himself on horseback on top of the pillar and just underneath it a frieze in which Romans and Macedonians, like the gods and the giants or the Greeks and the Amazons, fought heroically. Fragments of this frieze were discovered in 1838 and in later years.

The reliefs show, more than do even the classicizing friezes of Asia Minor, an awareness of the art of the past. The sharpness of the contours and smoothness of many surfaces, the occasional neat layering of overlapping limbs, bring to mind the sculptural style of the frieze from the Siphnian Treasury at Delphi. On the other hand several mounted and recumbent forms as well as the composition itself recall battle scenes on fifth- and fourth-century friezes. Was the artist an Athenian? This could well be so, for it is known that Paullus particularly admired Attic art and culture. H. Kähler believes the designer was the Athenian Metrodorus. On the other hand, the elongated bodies of the horses can be compared to those in a grave monument from Lecce, so perhaps the sculptor was South Italian.

In spite of its many classicistic elements, an aura of reality pervades some passages of the frieze. The background seems to have been conceived as a void rather than a solid. Shields lose much of their sculptural roundness as they approach it; close and distant objects are in contrasting heights of relief; our eye leaps back as well as ranging horizontally. The sense of space and depth thus achieved is unique in Greek architectural friezes up to that time.

There appears to be close correspondence between the literary record of the battle at Pydna and the scenes rendered in the frieze. Kähler has shown how the episodes on the four sides are arranged in chronological sequence, and in one mounted rider in the second scene he sees the portrait of Paullus himself. Oval shields denote Romans, and circular ones are carried by the Macedonians. The frieze, which is a landmark in the history of both Greek and Roman sculpture, can be dated quite precisely to between June 22, 168, when the battle occurred, and November 27, 167, when Paullus celebrated his triumph in Rome.

Delphi, Museum. Marble. Length of short sides, 1.05 m; of long sides, 2.15 m. A. Reinach (*BCH, 34*, 1910, 433-68) investigated Livy's writings in relation to the reliefs. G. Becatti (*Critica d'Arte* VI, 1, 1941, 70 f.) first suggested that the designer of the reliefs was the Athenian Metrodorus. On Perseus see 11. For the most recent analysis of both the subjects and style of the frieze, and for excellent photographs, see H. Kähler, *Der Fries vom Reiterdenkmal des Aemilius Paullus in Delphi*, Berlin, 1965; J. M. C. Toynbee, *JRS, 57*, 1967, 265.

158 Frieze from Temple of Artemis, Magnesia

There are, as we have seen, several architectural features of Hermogenes' temple at Magnesia that reveal Attic influence (69, 70) The use of a continuous figurative frieze surrounding the exterior also brings to mind some of the classical buildings on the Acropolis. The subject – the battle between the Greeks and the Amazons – was an old favorite; it was represented twice on the Parthenon and again in the frieze of the temple of Apollo at Bassae, a building also designed by the Athenian Ictinus. Indeed, the similarity in both form and content between the Bassae and Magnesia friezes is in some respects so marked that we may speak here of a "classical revival." For example, a nude Greek warrior dragging a terror-stricken Amazon off her horse, a recurrent motif at Magnesia which appears in the photograph, was depicted in almost exactly the same form in the earlier frieze. In addition the sculptors of the Hellenistic frieze have endeavored to revive the strong decorative aspects of the classical frieze style. They succeed by repeating figure types, by leaving wide spaces between the figures, and by avoiding, most of the time, the overlapping characteristic of the large frieze of the Great Altar at Pergamon. They succeeded too well, however, for the composition is sometimes disjointed, the forms isolated, and the connecting rhythms of Bassae and Pergamon are lacking. The figures, moreover, are so highly modeled that they seem actually detached from the background and therefore only partially reaffirm its solidity. There are even occasions, as we see in the passage illustrated, when instead of remaining parallel the figures recede toward the back plane; the plane remains hard and neutral, however, and they do not pass into it. The individual figures, moreover, have the unclassical bulges and muscular development of those on the large frieze of the Pergamon Altar, although here they are either rubbery or wooden. In many sections the movement and emotion seem frozen and artificial, but the finest parts are reminiscent of the true pathos in the Gigantomachy at Pergamon. These inconsistencies and conflicts of style, and the all-too-frequent crudities in the carving, suggest the imminent decline of monumental architectural sculpture in Greece.

The frieze is divided among the museums in Paris, Berlin, and Istanbul. This fragment is in Paris. Total length, about 174.50 m; height, 0.82 m. Executed c. 140 B.C. C. Watzinger, *Magnesia am Maeander, Die Bildwerke*, Berlin, 1904. M. Herkenrath, *Der Fries des Artemisions von Magnesia am Maeander*, Berlin, 1902. G. Mendel, *Catalogue des Sculptures*, Constantinople, 1902, I, 365-419. A. Yaylali, *Der Fries des Artemisions von Mäander*, Tübingen, 1976.

159, 160 Frieze from Temple of Hekate, Lagina

Four separate subjects were represented on the frieze that decorated the Corinthian temple of Hekate of Lagina, a territory of the city of Stratonikeia in Caria. The traditional theme of the battle of the gods and giants (159) ran along the west side and an assembly of Carian gods (160) along the south. Events from the lives of Zeus and Hekate occupied the east. On the north the power of Rome was recognized for the first time in a Greek temple frieze: it depicts the alliance between personifications of Stratonikeia together with her dependent towns and the goddess Roma.

The style of the frieze is varied and as surprising as some of the subject matter. It is both old and new. In the Gigantomachy several figures are borrowed directly from the large frieze of the Pergamon Altar. Artemis, who brandishes a torch and carries her bow and quiver on her back, is almost identical with the Hekate from the east frieze of the altar. The two Apollos from the respective friezes, each with his cloak and quiver, are closely related, and some of the giants from both can be matched too. But how much less ferocious is the later battle at Lagina! The thrusting diagonals of the Pergamon Altar have changed into timid verticals; what was a crowded melee of forms becomes a widely spaced procession of single figures in which each one seems to go through his act of oppression or agony alone. Firm, full bodies and solid muscularity have given way to more slender forms seemingly empty of life and blood, in which bulging tendons or protruding ribs are so much surface pattern.

The assembled divinities of Carian origin shown in 160 cannot be identified individually. The gods, however, are arranged not in a single line along the background as in the Gigantomachy, but in groups in which oblique movements and overlappings create a much greater sense of depth and penetration into the background. To the left of center, for instance, a charming triad is formed by the child, the maiden, and the warrior with the crested helmet, in which each person is conceived as being at a different distance from the spectator. We are reminded here of the Telephos frieze (166). There as well there are differences in the height of the relief between foreground and background. The inconsistencies of style are reminiscent of the frieze from Magnesia, but are here even more startling.

The temple may have been begun after 133 B.C., when Rome made Stratonikeia a free city in the province of Asia, or, alternatively, after 81, when the Senate heaped rewards on the city for its stiff resistance against Mithridates VI (14).

Istanbul, Archaeological Museum. Marble. H. 0.93 m. Found in 1891. A. Schober, who has done the major work on it, favors the earlier date: see *Istanbuler Forschungen, 2,* 1933, 12 f. A. Laumonier, *Les Cultes Indigènes en Carie,* Paris, 1958, ch. VI.

161 Relief of Aphrodite

Divine Aphrodite leans lazily and with abandon upon a rectangular pillar. Her head tilts, her body curves, and her thigh projects as her weight falls on her right leg. With her right hand she draws aside a thick, long cloak which passes over her head and winds around her legs. She thus voluptuously exposes her soft face and her thinly covered torso.

This is one section of an architectural frieze containing four figures. Eros, with graceful wings, turns toward his mother, who stands on his right; Demeter and Kore stand at either end. All four figures recall famous earlier originals. Aphrodite's pose and the general arrangement of her drapery are taken from a Phidian statue of the second half of the fifth century. Her dreamy expression and the gentle play of light and shade on her face and hair suggest the art of Praxiteles, who worked in the fourth century. However, the extreme contrast between the transparent drapery over Aphrodite's upper body and the massive burden of folds which weighs on her thighs and accumulates over her legs constitutes a style-characteristic that cannot be paralleled before the second century. The four figures project in high relief, in front of a neutral surface. They face out and stand on projecting plinths. Their essential independence from the background, their mutual isolation, and the eclecticism evident particularly in the figure of Aphrodite, indicate a date somewhere in the late second or early first century B.C.

Cyrene, Museum, no. 15004. Pentelic marble. Whole relief measures H. 0.92 m. W. 2.30 m. Found in the ancient agora in Cyrene in 1917. G. Traversari (*L'Altorilievo di Afrodite a Cirene,* Rome, 1959) believes it was made about 300 B.C. The back of the relief was reworked in Roman times.

162 Tripod Base, Aigeus

The base, of marble, is triangular with concave sides and was used to support a bronze tripod. A single figure decorated each side: Theseus, his father Aigeus, and Medea. Each figure stands alone and at rest. Aigeus, draped in a long flimsy garment, holds a scepter before him and leans his wrist on his hip. In relief 165, of about 200 B.C., archaistic drapery details enliven forms which are fully Hellenistic in conception. This relief (162) of about 100 B.C., by a Neo-Attic sculptor, illustrates the archaistic style in its second, and academic, phase in which the archaic is imitated more industriously. The profile view of the human body preferred in early Greek relief is adopted for each figure on this base, and an effort has been made to suppress volume and to increase the linear effects of the drapery. Aigeus' straight, central fold anchors him to the backgroud, and his zigzag train is ironed flat. Some of the hieratic quality of archaic art may here be revived, yet the total effect seems rather artificial and devoid of meaning.

Athens, Agora Museum, S7327. Marble. H. 1.09 m. Found in the Athenian agora. C. M. Havelock, *AJA, 68,* 1964, 43 ff. E. Harrison, *The Athenian Agora, XI, Archaic and Archaistic Sculpture.* Princeton, 1965, no. 128, 79-81.

163 Votive Relief to the Nymphs

A few years ago quarrymen working on Mount Pentelikon accidentally came upon a cave. Several reliefs found inside certified that in ancient times it had been a rustic sanctuary devoted to the worship of the nymphs, those lovely semidivine maidens who were thought to inhabit the springs, rivers, grottoes, trees, and mountains of Greece. In the late fourth century a certain Agathemeros, who may have been a shepherd, honored the local nymphs of Pentelikon with this relief found in the cave.

The relief itself is in the shape of a cave. Rocklike projections frame the peaceful and idyllic scene. Three radiant nymphs appear at the left; beside them is Hermes, their frequent companion and the favorite god of herdsmen. He wears only a cloak and holds his staff, or *kerykeion*, in his left hand. Seated cross-legged and looking very much like a goat is Pan, the great deity of flocks and shepherds, who is about to make music on his syrinx. At the far right is the dedicator Agathemeros. A bunch of grapes is cupped in his left hand and his wine jug, or *kantharos*, is being filled by a nude youth. So, it seems, the old man already benefits from his act of devotion. In this votive relief, as in many others found in Greece, the deities come right into the presence of their humble worshipers.

There is no foreground or background plane and no systematic gradation in the height of the modeling. The figures are casually grouped and exist in a real space which is slightly deeper at the right where men, rather than gods, are situated. The ledge at the top hangs over all the roundly modeled forms so they do indeed seem to be three-dimensional objects contained in a shallow cave.

Athens, National Museum, no. 4466. Marble. H. 0.71 m. W. 1.07 m. W. Fuchs (*AM, 77*, 1962, 242 f.) dates it close to 300 B.C. U. Hausmann, *Griechische Weihreliefs*, 61 f.

164 Homer and a Muse

In this small relief a bearded old man, leaning on a tree trunk, is studied intensely by a draped young woman. His eyes appear to be closed, and around his head is a poet's wreath. Probably he is the blind Homer standing beside the Muse of epic poetry, Kalliope. Across his forehead is a wide band of hair, and his expression is serene. The head, therefore, is drawn from an earlier type of Homer portrait than that depicted in 34. The treatment of drapery, which in both figures stays relatively close to the body and is spare in the number of its folds, would indicate a date in the first half of the third century for the execution of the relief. The tender but unspoken communication between the two figures recalls certain Attic grave reliefs of the same period, in which man and wife or father and son gaze upon each other with affection and puzzlement.

Homer seems wrapped in his own thoughts, only half aware of the Muse. She, on the other hand, seems to await his utterances eagerly and to marvel at him. She appears to worship rather than inspire him. The subject, the poet with his Muse, was fairly popular during the Hellenistic age, and the rendering here throws light on the unprecedented esteem enjoyed by celebrated poets at this time and the near awe in which the creative process was held. About 250 B.C.

Rome, Museo Nuovo dei Conservatori, inv. 1409. Pentelic marble. H. 0.40 m. K. Schefold (*Bildnisse*, no. 130) dates the relief about 250 B.C. and thinks the poet could be either Homer or Epimenides. D. Mustilli (*Il Museo Mussolini*, Rome, 1939, 86, no. 7) believes it to be fourth century.

165 Dionysos and the Seasons

One member of the company is missing. It is Winter, who originally followed along, thoroughly bundled up, to bring up the rear of this gay dance. Leading off is the god Dionysos, carrying his thyrsus and wearing high boots and a cloak which

flies back as he sails ahead. Spring steps lightly behind him with flowers caught up in her apron; a very dainty Summer, dressed in a diaphanous garment, holds a sheaf of wheat in one hand and reaches back to Autumn with the other. Autumn carries a bunch of grapes and pivots around to look at Winter. Thus the Seasons dance by, rhythmically, inevitably, always in the same order – and happily, for each one brings her special gifts and charms. This is the first known representation of the Four Seasons who, symbolizing a formal and rational division of the year into quarters, became generally accepted only in the Hellenistic period.

The charms of all are increased by the trains, ruffles, and zigzags of their garments which, in contrast to the three-dimensional movement of their bodies, are rendered in the tight, linear manner of the Archaic style. The sculptor has taken considerable pleasure in thus combining the old with the new. He has deliberately looked back at earlier art in order to intensify the decorative and piquant quality of the scene, and to awaken nostalgic emotions in the observer. An archaistic style proper, of which this relief is an example, first arose in coinages of the early Hellenistic period, but it is hardly apparent in other art forms before the second century. The relief is a poor Roman copy, probably of a painted rather than a sculptured Greek original of about 200 B.C. It does not, therefore, really exhibit either the decorative or the illusionistic modes as defined in our discussion of Hellenistic sculpture in relief. We know through literary sources that the dance of the Seasons was enacted at festivals in Alexandria during the reign of Ptolemy II (305-284 B.C.) and in many other capitals as well. It is possible that the painter saw one of these. This may account for what seems like a "reality" element: the penetration of the background by Summer.

Paris, Louvre. Marble. H. 0.32 m. W. 0.44 m. W. Fröhner, *Notice de la sculpture antique du Louvre,* Paris, 1869, no. 205. For the full composition and on the Seasons in general, see G. M. A. Hanfmann, *The Season Sarcophagus in Dumbarton Oaks,* Cambridge, Mass., 1951, I, 111 ff.; II, fig. 80. T. Krauss (*Hekate,* Heidelberg, 1960, 133) favors a date of c. 160 for the original. C. M. Havelock, *AJA, 68,* 1964, 43 ff. and *AJA,* 69, 1965, 331 f. B. S. Ridgway, *The Archaic Style in Greek Sculpture,* Ch. 11.

166, 167 Altar of Zeus, Telephos Frieze

When standing in the precinct of the Altar of Zeus at Pergamon one could look up and see the temple of Athena Polias on the next terrace (74). The two sanctuaries, though distinct, were thus interrelated. The two gods, Zeus and Athena, were honored, we have seen, in the large frieze of the altar. They were addressed once again in the small frieze that adorned the upper part of the inner wall of the colonnade. Represented there, for a length of nearly 300 feet, was the life story of Telephos, the grandson of Zeus and the son of Auge, who was alleged to have brought the cult of Athena to Pergamon. As for Telephos himself, he was acclaimed as the mythical ancestor of the Pergamene kings. As in the large frieze, then, the gods and the Attalid dynasty were both extolled at once.

Compared to the bombast and rhetoric of the Gigantomachy, the Telephos relief is quiescent and intimate, and to share in this intimacy and follow the hero from birth to death the observer must stand close at hand. Telephos' life is illustrated in a way that is without precedent in Greek sculpture. The battle of the gods and giants of the large frieze, the Panathenaic procession on the Parthenon, and all other classical friezes assume a unity of time and place. Here both are constantly changing. Telephos appears and then reappears in a series of episodes which occur sometimes in Arcadia, sometimes in Mysia, in an open-air landscape or within a palace or shrine. Indications of locality appear many times along the background and, where necessary, divide one episode from the next. This is, all in all, a pictorial history.

Auge, after being seduced by Herakles, gave birth to Telephos, but was then disowned by her father, who decided to set her adrift in a small boat. In 166 the scene is set in Arcadia, and the boat is being constructed by four industrious workmen who are supervised, at the far left, by Auge's father. The unhappy Auge, her head and body covered by drapery, sits above with her handmaidens. At the right a mountain nymph is seated on a rock, and below her a young girl starts a fire under a kettle containing the pitch to caulk the

boat. The infant Telephos, forcibly abandoned by his mother, is next suckled by a lioness in a rocky cave, where he is discovered by his father, Herakles (167). Not all of the frieze is preserved, but the succeeding scenes completed the narrative wherein first Auge and then eventually Telephos make their way to Mysia and the latter becomes king.

In spite of its deep modeling, the Gigantomachy (153, 154) remained effective as pure decoration; its many writhing forms created a very rich and continuous surface pattern. In the Telephos relief, on the contrary, the figures are small in relation to the available field, and they are frequently arranged in vertical tiers in front of landscape or architecture. There are numerous gradations of relief: the kneeling workman is sculptured more in the round than the maidens who accompany Auge. The cliff to their left is in still lower relief. Herakles' body boldly projects from the background; the plane tree and cove on either side lie closer to it. We see all these forms in relation to each other and in varying degrees of light and shade. We inevitably understand them as existing within different spatial depths, rather than simply against a flat surface. Although the environment and the action are depicted with only relative accuracy, we have no difficulty whatever in believing in their complete reality. The battle of the gods and giants, recently viewed in totality but not in detail, now seems to be but a fantasy. The continuous narrative of the Telephos frieze never reappeared in monumental Greek sculpture. It was, however, of crucial importance in the development of Roman historical relief.

H. 1.58 m. H. Kähler (*Der grosse Fries von Pergamon*), believes the large frieze was executed between 182 and 165, and the Telephos frieze between 164 and 158. About half of the latter frieze survives and is now in the Staatliche Museen in Berlin. H. Schrader (*JdI, 15*, 1900, 97-135) attempted to establish the sequence of the remaining slabs, but since no inscriptions have been found, uncertainty persists. Compare the scene in Color Plate XVI.

168 Family Sacrifice

A huge plane tree spreads its gnarled branches and spiky leaves. Tied to one bough a great curtain loops and hangs like a screen. A short distance away two tiny statues prance on a tall pillar. Thus all the props are set up in this scene depicting an open-air sanctuary in which gods and men gather together in the holy act of sacrifice. The ritual is performed by a family of four, the parents and two children. On the left, the relatives in still smaller scale observe the event or look toward us with pleasant smiles. In much larger scale and with infinitely more dignity, two deities, a bearded male sitting on a lion-griffin throne, and a young goddess leaning on a pillar, preside in front of the curtain. All this is surrounded by an architectural frame. We look beyond it, as through a window, to objects seen in perspective, to groups of figures arranged in depth, to a tree and draped curtain that exist in light and air and partially blot out the sky. This illusion is created by the overlapping forms, by gradations in the height of the modeling, and by reservation of a large part of the background for scenic elements instead of for figures. In the rendering of visual reality in relief sculpture, the Greeks never achieved more than this. But, it should be added, the reality seems to pervade the human arena at the left more thoroughly than the divine scene at the right.

The date of the relief has been much debated. Its classicistic and eclectic qualities make it quite certain that it was made in the late second century, probably in Athens. Both the deities are close adaptations of Phidian originals, and the two statues on the pillar are in an imitation archaic style. The members of the family and the observers, on the other hand, wear gowns of Hellenistic type and are grouped according to post-Classical principles. The pictorial aspects of the whole, moreover, are understandable only if they postdate the Telephos frieze (166).

The seated male god may be a combination of Zeus and Osiris. The goddess is probably Isis. The cult of these Egyptian gods spread far and wide during the Hellenistic period.

Munich, Glyptothek, no. 206. Pentelic marble. H. 0.61 m. W. 0.79 m. K. Schefold (*AM, 71*, 1956, 219) and others believe it is later third century. Richter (*Portraits*, III, p. 278) submits that the sacrificing father may be a portrait of Euthydemos I of Bactria (230-200). Rhodian rather than Attic origin is favored by Bieber (*Sculpture*, 127).

H. G. Beyen, "Das Münchner Weihrelief," *B Ant. Bes-chav.*, 27, 1952, 1-12. H. Thiemann, *Hellenistische Vatergott-heiten*, 93 ff. H. von Steuben, *AA* 1967, 428 f.

169 Grave Relief

Framed by pilasters, or architecture with three fasciae and cornice, a slender young man accompanied by his horse and groom walks leisurely toward the spectator. Since he is nude, he enjoys the status of a hero. The space provided is shallow but quite real, and the figures seem to wish to move into it and away from the background as much as possible. The tree makes it clear that the scene occurs outdoors. A fat snake, a symbol of death, coils around its branches. In the corner a child plays with two dogs, which from the Archaic period on appear frequently in Greek gravestones.

The relief came from Smyrna. In its architectural setting, high modeling, and the figure's independence from the relief ground, it continues the tradition of late fourth-century grave stelai from Attica. The tree, whose leaves lie low along the surface, and the rocks near the child place the relief after the Telephos frieze (166) and nearer the votive relief in Munich (168). Second half of second century.

Berlin, Staatliche Museen, no. 809. E. Rohde, *Griechische und Römische Kunst in den Staatlichen Museen zu Berlin*, Berlin, 1968, 107, Fig. 80. E. Pfuhl and H. Möbius, *Die Ostgriechischen Grabreliefs* II, no. 1439, 341, Pl. 210.)

170 Apotheosis of Homer

The great Homer must be acknowledged and crowned. The first poetic genius, the source of inspiration to all, he was wise, virtuous – indeed a veritable god. Sacrifice must be offered to him. Zeus, Apollo, and each of the Muses shall be called upon to bear witness.

This relief in the British Museum is surely one of the most interesting from the entire Hellenistic period. It is shaped like a tall mountain whose summit, slopes, and base are peopled with elegant maidens and dignified divinities arranged within four shallow stages. Zeus with his eagle and scepter majestically occupies the peak of the mountain, whose name—Helikon, Parnassos, or Olympos – cannot be ascertained. Below are the Muses, nine of them, but since they are not named, their identities are in some cases a matter of debate. Their mother, Mnemosyne (Memory), stands close to Zeus. Inside a cave Apollo, their leader, holds his cithara. On the bottom tier the enthroned poet receives the acclaim of an array of personifications whose identities, fortunately, are indicated on the base. Beginning at the left, World and Time place a wreath on Homer's head. The bard's two masterpieces, the *Iliad* and the *Odyssey*, kneel beside his throne, and Myth and History conduct the sacrifice: Poetry holds aloft two torches, and Tragedy and Comedy, wearing masks, raise their arms in greeting. On the far right, the attention of four adoring women, Excellence, Memory, Trustworthiness, and Wisdom, is sought by a little boy, Genius.

Not participating in these festivities and elevated as a statue on a pedestal near the right edge of the second tier is a male figure carrying a scroll. He is another poet and a victorious one, too, for the prize tripod stands behind him. Now faceless, he cannot be identified, but it was probably he who dedicated the relief, in honor of his choragic victory.

Although the sculptor Archelaos, who signed his name under Zeus, was from Priene, the relief apparently contains several references to the Alexandrian school of poetry. Ptolemy IV (ruled 221-205) and his wife Arsinoe III, whose portraits have been recognized in World and Time, founded the sanctuary of Homer at Alexandria and endowed it with a noted statue of the bard which may well be reproduced in the relief. The allegorical nature of the events and the erudite cataloguing it reveals could have come right out of the museum. Accordingly the poet represented as a statue might well be Callimachos. But then why would he choose an artist from Priene rather than one from Alexandria? Another puzzle is the fact that some of the Muses, considered as types, seem to be of Rhodian origin (130). With this in mind it has been suggested that the victorious poet could be Apollonios. Finally, we should probably not exclude Smyrna – which according to Strabo (XIV, c. 646) also had a Homereion – in considering the significance and originating place of this relief.

The style of the Archelaos relief is as interesting as its iconography. Like the Telephos frieze (166) the figures are seen in relation to a landscape setting. The lowest tier, however, is distinguished from and unrelated to those above it. The Muses parade in single file as if they were statues, and the mountain behind them rises like a wall leaving them little room to move. In the coronation scene, on the other hand, groups are formed, figures overlap in depth, and are in different heights of relief. The scene takes place presumably in an interior described by the long curtain which is tacked to the column capitals. The curtain forms a perfectly flat plane, yet it hangs from top to bottom in front of a space, not a wall.

On the basis of the lettering in Archelaos' inscription, his work can be dated to about 125 B.C.

London, British Museum, 2191. Parian marble. H. 1.18 m. W. 0.80 m. A few details are restored. Found near Bovillae, Italy, about the middle of the seventeenth century. C. Watzinger, *Das Relief des Archelaos von Priene*, Berlin, 1903. M. Bieber, *Sculpture*, 2nd ed., 127 ff. G. Kleiner (*Die Inspiration des Dichters*, Berlin, 1949, 18 ff.) identified the poet as Callimachos; U. Hausmann (*Griechische Weihreliefs*, 102) proposes Apollonios Rhodios. D. Pinkwart, "Das Relief des Archelaos von Priene." *Antike Plastik*, IV, 1965, 55 ff. D. Pinkwart, *Das Relief des Archelaos von Priene und die "Musen des Philiskos*," Kallmünz, 1965, D. B. Thompson, *AJA*, 73, 1969, 384-85.

171 Cybele and Attis

The illusion of space existing behind the figures and the seeming penetrability of the relief ground are evident in the right portion of this votive tablet. We are thus led to believe that it can be no earlier than the Telephos frieze (166) or even the Family Sacrifice now in Munich (168). The enormous door extends for the whole height of the relief. One of its leaves, shown in perspective, is thrown back revealing exterior space; the other lies flush with what can only be construed as a solid wall. A woman has already come through the door into the interior, the servant behind has just crossed the threshold. In this portion of the relief the continuity and logical interrelation between foreground figures, background architectural elements,

and the open space beyond are very striking and sophisticated. They will become even more developed in the Roman pictorial relief style. The barrier behind the two divinities, on the other hand, seems to place them in a more ideal and less spacious location.

The interior is perhaps one room of a shrine or temple, for the two women have come in bearing before them gifts for the gods. Cybele, the goddess of life and fertility, wears a tall crown and carries a scepter and symbol. The lion, sacred to her, crouches at her feet. Attis, her young lover who perpetually deserts her but perpetually returns, stands in his Phrygian outfit with a mournful expression and holds a club. The couple (are they meant to be statues?) were worshiped enthusiastically in Asia Minor during the Hellenistic period, but became even more popular under the Romans when the cult became increasingly orgiastic. The relief probably came from Magnesia, Smyrna, or Sipylos, all major centers of the cult.

The mechanical neatness of the zigzag and vertical folds of Cybele's gown and the mixture of drapery styles are further indications that the relief probably dates about 100 B.C.

Venice, Museo Archeologico del Palazzo Reale, no. 17. Marble. H. 0.57 m. L. 0.80 m. B. F. Tamaro, *Il Museo archeologico del Palazzo Reale*, Rome, 1953, 21. H. Kähler (*Der grosse Fries von Pergamon*, 75 f., n. 30) dates it in the second half of the third century. L. R. Farnell, *Cults of the Greek States*, III, ch. VI. A. Linfert, *AA* 1966, 496 f. M. J. Vermaseren (*Cybele and Attis, The Myth and Cult*, London, 1977, 74) identifies the two women as mother and daughter.

172 Dance of the Nymphs

The dance of the nymphs was a very old and popular theme in Greek art, especially in Attica. In this relief, found near the Athenian Acropolis, three nymphs whose dress and hair are all alike join hands beside a low, round altar. Their usual associates, Pan with the syrinx, Apollo with his lyre, and Hermes with his *kerykeion*, are there to provide dance music and tone. Over at the right six ordinary human beings gaze in wonder at the spectacle.

The major figures, all in low relief, are lined up

along the surface within a frame consisting of pilasters and epistyle. The nymphs perform sedately, hardly moving a muscle; shown frontally, they are pressed against the background; their drapery is full of pleats and symmetrical dips which recall the archaic style. The gods at the left belong to another world – the relaxed one of Praxiteles and Lysippos of the fourth century. The worshipers, crowded and grouped in depth, are on the other hand fully Hellenistic. This artificial and abrupt juxtaposition of various period styles and the flatness and strong linearity of the relief indicate that it was made by an artist of the so-called Neo-Attic school. It could profitably be contrasted to the much earlier relief of the nymphs illustrated in 163. About 100 B.C.

Athens, National Museum, no. 1966. H. 0.39 m. L. 0.73 m. Marble. E. Schmidt, *Archaistische Kunst, 37.* S. Papaspyridi-Karusu, *Guide du Musée National,* Athens, 1928, 278, no. 1966. C. M. Havelock, *AJA, 68,* 1964, 46-47.

173 Grave Relief

A section of Rheneia, a small island west of Delos, was reserved for many centuries in antiquity as a burial site for residents of Delos. The cemetery has yielded a number of beautiful tombstones, most of which originated between 168 and 88 B.C., from the time Delos was put under the jurisdiction of Athens until its sack by Mithridates of Pontus. The present example was found in the late nineteenth century.

Although smaller and more ornately framed, in general form this tombstone is a revival of the Attic type of the fourth century. Five figures are depicted within a shrine, or naiskos, consisting of two half-fluted columns with Corinthian capitals, a Doric frieze above an architrave, a row of Ionic dentils, and a low gable with akroteria. At the left a seated woman draws her veil aside and joins hands with a standing, beardless youth – a tender scene which is observed by an older man at the right. All three figures are derived from fourth-century prototypes. There is no attempt at portraiture. The handshake is also a familiar motif in classical tombstones and probably signifies the enduring bond of affection which was thought to

exist between the living and the dead members of a family. Compared to the gravestone of the first century B.C. now in Berlin (175), this one still shows some psychological communication between the figures. A girl slave at the far left holds a box, and a boy servant, standing cross-legged, looks on from the opposite corner. The attendants who frequently appeared on fourth-century tombstones were never as diminutive as these, and they were more inclined than these to share in the sorrow of the occasion.

Below each of the large figures is an inscription occupying a vertical column. The two men, probably relatives, are called Apollonios and come from Alexandria. The woman, presumably the wife of the center figure, is Mysta, daughter of Mnaseos from Laodicea. Each figure is addressed as "worthy," and the final word in each column says "farewell." The inscriptions seem to have been added at slightly different times; the one at the right is the poorest and therefore probably the latest. 130-88 B.C.

Athens, National Museum, Inv. 1194. Athens, National Museum, Inv. 1194. H. .122 cm. M-T. Couilloud, *Les Monuments Funéraires de Rhénée,* Exploration Archeologique de Delos, Paris, 1974, **XXX,** no. 107.

174 Dionysos Visits a Dramatic Poet

Dionysos, the god of wine, of drama, of fertility, of joy – and of much else – was the most celebrated or at least most popular of the Olympic deities during the Hellenistic age. In this relief he pays a visit to the house of a dramatic poet whose occupation is clarified by the assortment of masks under the couch. Bearded and corpulent, the intoxicated Dionysos is propped up by a young satyr while another removes his shoes so that he can recline for the banquet. Behind him are his *thiasos,* or followers, dancing, drunken, and noisy: first a satyr, reeling under Dionysos' long thyrsos; then an old, potbellied silenus playing the double pipe; then another reveler; and finally a maenad (only the lower part of her body remains) who is overcome by the wine and keels over into the arms of a bearded satyr. The poet is of course hospitable: he turns and hails them. All this occurs in front of curtains,

walls, buildings, and trees. The mood is festive; garlands have been strung up for the occasion, and everyone wears a wreath. Are we perhaps watching a stage drama or a mystery play? The scene is essentially religious, Dionysos' drunkenness and that of all those who join his train being considered a kind of divine madness.

The relief as we see it was probably made in Italy in the first century A.D. The figure-types are, however, all earlier and all Greek. Dionysos stems from a fourth-century statue, and the others seem to be second century. They were probably combined in this composition early in the first century B.C. by a Neo-Attic artist. Perhaps the curtain and a wall were also part of this composition, but the elaborate buildings above were not added until the first century A.D.

London, British Museum, no. 2190. Marble. H. 0.90 m. L. 1.51 m. Some details have been restored. Several other versions of the scene exist (see M. Bieber, *Sculpture*, 2nd ed., 153). C. Picard (*AJA, 38,* 1934, 137-52) believes the original composition dated between 250 and 200 and was made in Alexandria. Cf. A. Adriani (*Una Coppa Paesistica*, Rome, 1959, 33 f.). The reclining figure was earlier identified as Icarius the Athenian, who entertained Dionysos when he visited Athens.

175 Funerary Relief

The quadrangular frame enclosing a Y in the background is baffling. Is it a window or a picture or a letter of the Greek alphabet? Its meaning must be related to the foreground scene, which, unfortunately, is equally baffling. Bieber long ago suggested that the relief, which was found in an olive grove, represented a family reunion following the tradition of Attic grave stelai of the fourth century in which the deceased was prominently seated on the only chair. The object in the background, the argument continues, signifies an olive press seen through a window. In that case the dead man was an oil merchant. Perhaps, according to another theory, he was a carpenter, the symbol on the wall being a carpenter's instrument. Picard's proposal is the most ingenious: the scene is inside a philosopher's school, and its leading sage is shown surrounded by his star pupils. Hanging on the wall, according to him, is a Pythagorean symbol which indicates that the deceased was a member of the Neo-Pythagorean school, which enjoyed a good deal of favor in the late Hellenistic and early Roman periods. So far, however, the meaning of the relief is uncertain.

Several aspects of the style point to a late Hellenistic date. As in many late gravestones from both Attica and Asia Minor, the figures are isolated from each other and turn to peer out at the spectator. There is a certain flatness and fastidious neatness in the modeling and emphasis on line that recall the work of Neo-Attic artists. Most late Hellenistic Attic gravestones imitate those of the classical period and place the figures against a completely neutral background within an architectural niche. The horizontal format of this one and the presence of a symbol on the wall are unusual. The clinching arguments as to date are the heads, which are close to Roman portraits of the late Republican period. 50 30 B.C.

Berlin, Staatliche Museen, no. 1462. Pentelic marble. H. 0.55 m. L. 0.75 m. M. Bieber, *RM, 32,* 1917, 130 f. C. Picard, *RA, 23,* 1945, 154 f. G. Hafner, *Späthellenistische Bildnisplastik,* p. 59. P. Mingazzini (*Festschrift B. Schweitzer,* Stuttgart, 1954, 286-90) denies the relief is a gravestone; according to him it honors a Stoic philosopher and the three-armed symbol stands for the Stoic tripartite division of knowledge into physics, ethics, and logic.

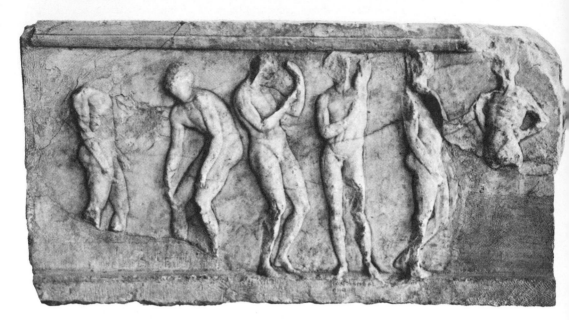

148. Base with Athletes in Relief.
c. 300 B.C.
Athens, Acropolis Museum

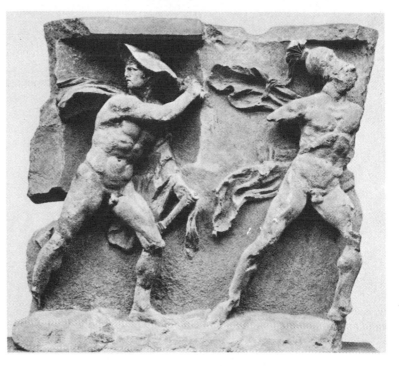

149. Funerary Relief from
Tarentum. c. 300 B.C.
Cleveland Museum of Art

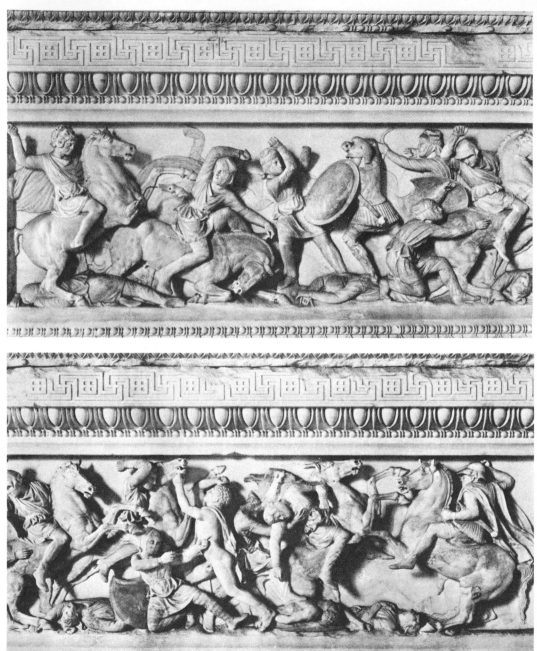

150.–152. "Alexander Sarcophagus" (Battle between Greeks and Persians and detail). 310-300 B.C.
Istanbul, Archaeological Museum

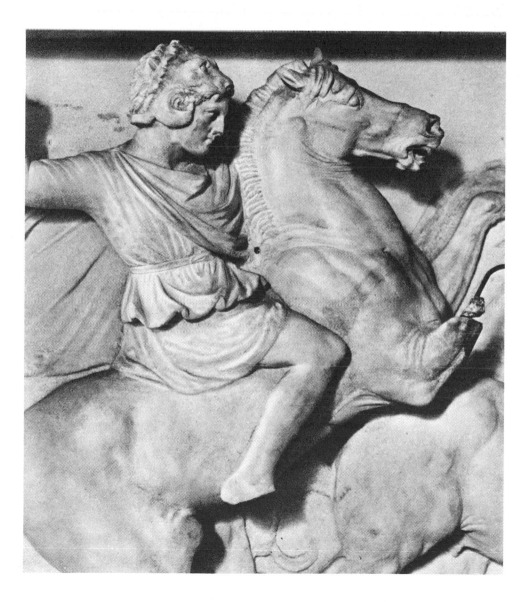

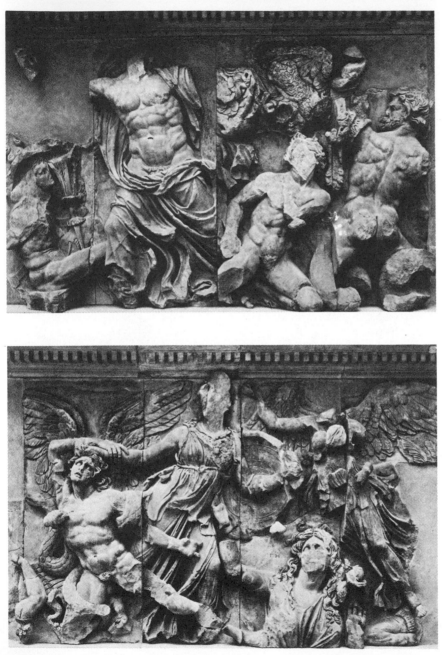

153. Large frieze,
Altar of Zeus,
Pergamon : Zeus
fighting giants.
182-165 B.C.
Berlin, Staatliche
Museen

154. Large frieze,
Altar of Zeus,
Pergamon :
Athena fighting
giants.
Berlin, Staatliche
Museen

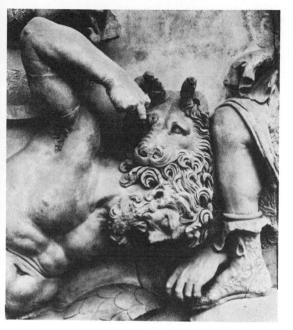

155. Large frieze, Altar of Zeus, Pergamon:
The dog of Artemis.
Berlin, Staatliche Museen

156. Large frieze, Altar of Zeus, Pergamon: Eos.
Berlin, Staatliche Museen

157. Frieze from
 Monument of
 Aemilius
 Paullus.
 167 B.C.
 Delphi, Museum

159. Frieze from Temple of Hekate, Lagina. c. 100 B.C.
 Istanbul, Archaeological Museum

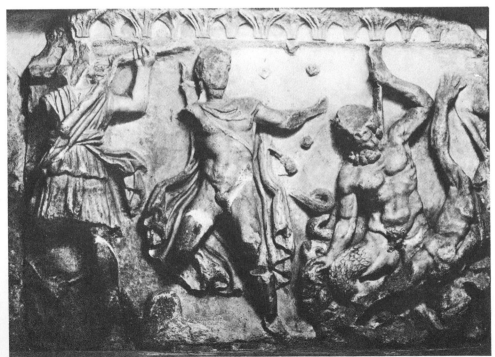

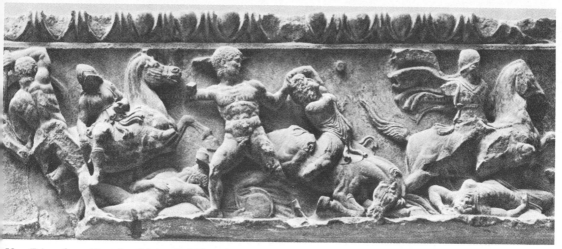

158. Frieze from Temple of Artemis, Magnesia. c. 140 B.C.
 Paris, Louvre

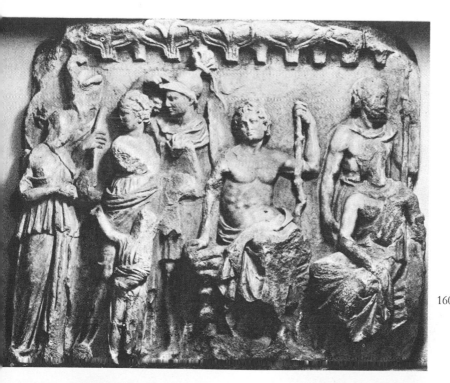

160. Frieze from
 Temple of
 Hekate, Lagina.
 c. 100 B.C.
 Istanbul, Archaeo-
 logical Museum

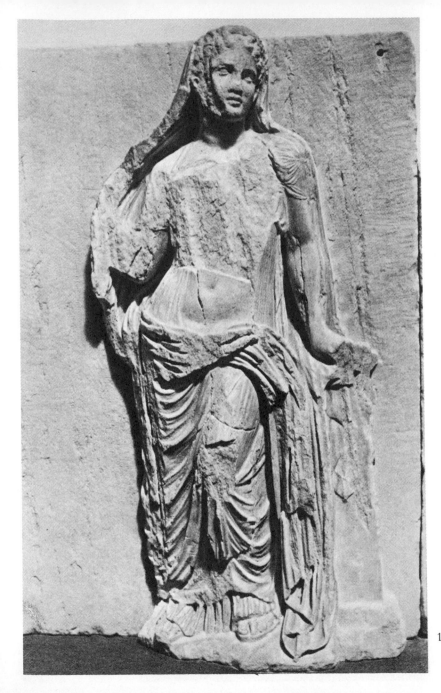

161. Relief of Aphrodite
c. 100 B.C.
Cyrene, Museum

162. Tripod base, Aigeus. c. 100 B.C.
Athens, Agora Museum

163. Votive relief to the Nymphs. c. 300 B.C.
Athens, National Museum

164. Relief of Homer and a Muse, c. 250 B.C.
Rome, Museo Nuovo dei Conservatori

165. Dance of Dionysos and the Seasons,
Roman copy. Original c. 200 B.C.
Paris, Louvre

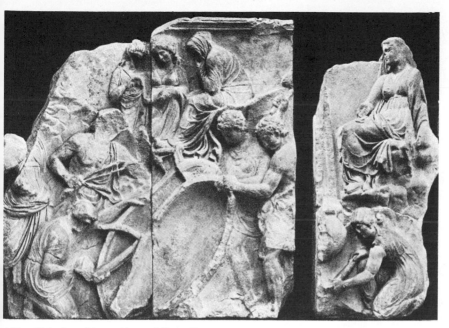

166. Telephos frieze, Altar of Zeus, Pergamon.
Building of Auge's boat. 170-160 B.C.
Berlin, Staatliche Museen

167. Telephos frieze, Altar of Zeus: Herakles.
Berlin, Staatliche Museen

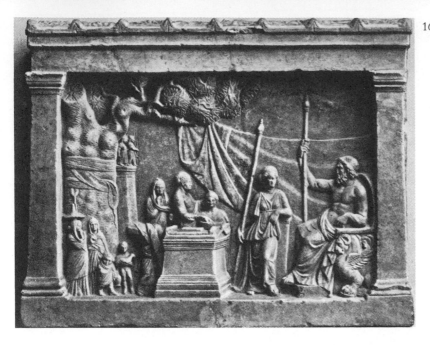

168. Relief of Family Sacrifice. Late second century B.C.
Munich, Glyptothek

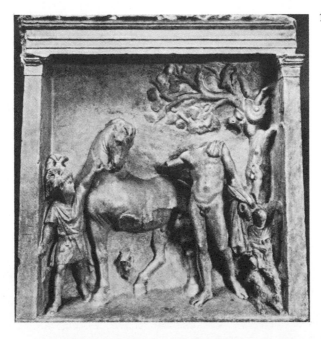

169. Grave Relief from Smyrna. Second half of second century B.C.
Berlin, Staatliche Museen

170. Relief of the Apotheosis of Homer. c. 125 B.C.
London, British Museum

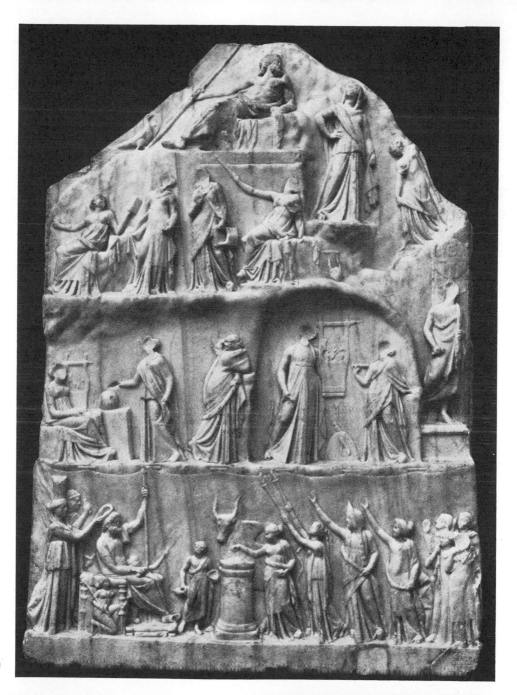

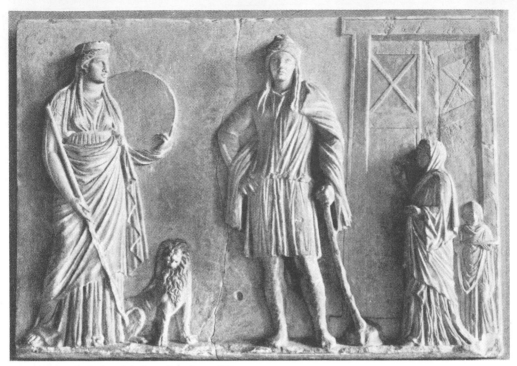

171. Votive Relief to Cybele and Attis. c. 100 B.C.
Venice, Museo Archeologico del Palazzo Reale

172. Relief of the Dance of the Nymphs. c. 100 B.C.
Athens, National Museum

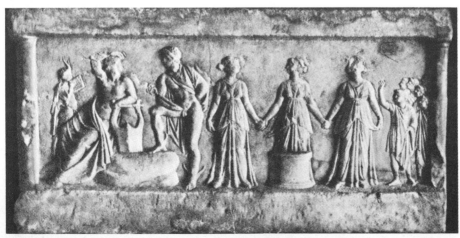

173. Grave Relief. Early first century B.C.
Athens, National Museum

174. Dionysos Visits a Dramatic Poet, Roman
copy. Original early first century B.C.
London, British Museum

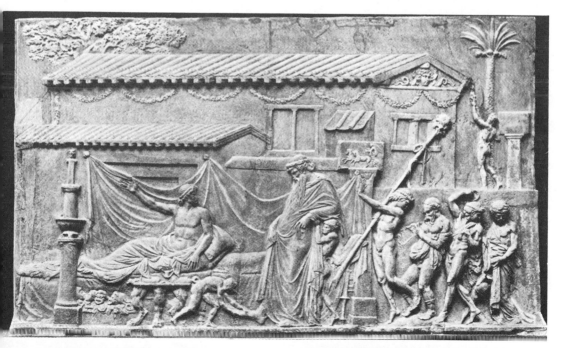

V Painting and Mosaics

Any study of painting during the Hellenistic age must acknowledge at the outset one unfortunate but inescapable fact: too little of it survives. We know through ancient literary sources that Greek painters were held in high esteem and that the walls of public buildings were decorated with murals. The writers, however, devoted the greater part of their attention to the painting of the fifth and fourth centuries. In writings about the Hellenistic period, the masters tend to be mere names and their masterpieces little more than titles. As for Vitruvius, who wrote at greater length, it will always be debatable how far his observations were based on Roman rather than on Hellenistic painting. The sources are even less helpful concerning the related art of mosaics. In this field, however, there is a more substantial amount of original material, and more is accumulating rapidly even as we write. It is thus from mosaics that we propose to draw our initial conclusions about the nature and development of the pictorial arts during the period in question. A few of the rare examples of painting may shed still further light. Finally, we shall turn to the literary sources in the hope that they will confirm our findings.

A comparison of the Lion Hunt from Pella in Macedonia (Pl. VI) and the Head of a Tiger from a house in Delos (Pl. VIII) allows us to see the overall difference between a Classical and a Hellenistic mosaic. In the Pella example, a two-color scheme predominates. The hunters and lion are essentially lively, pale silhouettes that stand out against the dark blue background. Lines, whether on the contour or interior, are clear and firm, and modeling is reduced to a minimum and is, in fact, primarily linear in effect. In short, the design is two-dimensional and is highly appropriate as floor decoration.

The Lion Hunt was made, around the year 300 B.C., of natural pebbles. Within a few decades, a new technique was introduced: the mosaicists began to cut their own stones, or tesserae. Although the older method was not entirely supplanted, it is worth asking what this change signified. If we consider the history of art as a whole, it is evident that a new medium or technique is adopted whenever an older one proves inadequate as a means of expression. In the early fifteenth century, for example, the Van Eycks found that the atmospheric values they sought could not be rendered in tempera, so they "invented" oil paint. In the seventeenth century, Rembrandt discovered that the etching rather than the engraving process produced the jagged line and misty shading that he desired. Pebbles gathered from the riverbed or seashore were rounded and irregular; when laid in a pavement they never completely lost their individuality. Mosaics composed of them were granular in effect and their color areas broad and flat. Tesserae, on the contrary, were rectangular and uniform in both size and shape. They could be more closely packed, and inch by inch they constructed a surface that was almost as smooth and dense as a painted canvas. They enriched the range of color of the work, and their small size made possible subtle gradations in tone. With this new technique the artist could now create the illusion of opening a window into a world of volume, space, and light. How marvelous this world could be is illustrated in the Head of the Tiger from Delos (Pl. VIII) of about 100 B.C. The change in technique was thus of great significance. It was, indeed, as revolutionary as the rejection of quadrifaciality by Lysippos (see page 114) which was a nearly contemporary occurrence.

Another feature of the mosaic may be cited in

support of our broad thesis that Hellenistic artists were aiming at three-dimensional and pictorial effects. In the fourth century a major scene or figurative motif surrounded by a decorative border was often inserted into the center of the floor mosaic. But the decorative border and central panel constituted one continuous, flat pattern. In the Hellenistic period the major scene, or emblema, began to take on the characteristics of a framed picture. The forms projected as strong volumes, and at the same time the background developed definite spatial qualities. The emblema, in short, detached itself from the border and became something to look at rather than to walk on. We can imagine even from the detail how reluctant we would be to step on the Tiger of Color Plate VIII or on the Dove mosaic (Pl. XIV). We also have one fairly good example of the intentional contrast between the frame and the interior panels in the House of the Masks at Delos (53, and Pl. XVIII). If we entered that particular room we would instinctively stop and admire the "picture" of Dionysos Riding a Panther. Would it not be more appropriate for these emblemata to be on walls?

In our survey of Hellenistic sculpture in Chapter III we observed that as the period drew to a close there was a tendency to deny plastic values and to return to the more conceptual forms of the Classical period. The emphasis on linear definition in certain late portraits (16, 24, 32) was an analogous development (see pages 22-23). We could anticipate, then, that the art of mosaic would evolve in the same direction. Indeed, this is the only conclusion we can reach if we compare the "baroque" Head of the Tiger with the later scene of Dionysos Riding a Panther, which, in spite of its illusionistic layout, is remarkably linear in detail.

The mosaic of the Lion Hunt from Pella and others from the same site have frequently been compared to red-figure vase painting of the fourth century. There, too, the color scheme was two-toned and very decorative, with bright figures silhouetted against a solid dark background. But just as pebbles were eventually superseded by tesserae for the composition of a mosaic, the red-figure technique also proved too limiting. In the course of the fourth century, Attic, South Italian, and Sicilian potters departed more and more from its strict red and black contrasts. White, yellow, gold, or blue were increasingly applied to flesh or drapery, and the figures became ever more independent of the vase surface. Then, in the early Hellenistic period, nearly all attempts at purely linear ornamentation were abandoned; the decoration became polychromatic, and the forms became fully modeled volumes. The outcome of this development is illustrated in the large crater from Centuripe in Sicily (Pl. V). But we sense that the monumental figures depicted there would also be more appropriate on a wall. Before long, apparently, the potters in Sicily as well as in other centers recognized this themselves, and they stopped producing this pretentious form of vase decoration. Both occurrences – the substitution of tesserae for pebbles and the rejection of figurative decoration for painted vases – are, we suggest, indicative of the increased interest Hellenistic artists felt in plastic form and in visual reality. We need hardly remind the reader how our study of sculpture of the Hellenistic period, as opposed to that of the Classical period, led to the same conclusion.

It was not uncommon in red-figure vase painting of the fourth century for artists to depict a small colonnaded building surrounding one or more figures. Shown frontally, the buildings were extremely shallow, and the figures were placed side by side in a single plane. The black background did not retire, but rather pushed itself forward between the columns and the figures. Thus the architecture functioned as a decorative frame rather than an enclosing space. But it is probable that this form of setting would not suffice for third-century painters. Such a deduction is supported by the evidence of a notable painted gravestone of a woman called Hediste from Pagasae (Volo) in Thessaly[1] in which the scene portrayed also occurred in the interior of a building – presumably an ordinary house. But the figures were set in successive planes and the architectural elements of the house – pillars, walls, and open door – overlapped and receded to suggest three different spatial areas. This is the kind of first-hand evidence that is needed to justify our belief that paintings such as Achilles on Skyros (Pl. IX) or Thetis in the Workshop of Hephaistos (Pl. X), both

of which are Roman copies, reflect third-century Greek originals more or less accurately. In both instances the architectural setting and the arrangement of the actors are comparable to those in the stele from Pagasae. For the same reason the comedy scene in the mosaic by Dioskourides of Samos (Pl. XIII) can claim to be a fairly reliable replica of an early Hellenistic painting.

Even though the original material is scanty, we have seen that it can provide some understanding of the major characteristics as well as the development of the pictorial arts during the Hellenistic period. Literary sources confirm and even amplify our findings.

Ancient writers, particularly Pliny the Elder (first century A.D.), were aware that the art of painting had reached a culminating point by the early Hellenistic period. Pliny praised the skillful use of line, the nuances of light and shade, the foreshortening, and the precise mixing of colors that artists such as Zeuxis, Parrhasios, and Apelles had achieved by the end of the fourth century. He marveled at their advances in view of what he considered the gropings and limitations of earlier ages. We are led to believe, then, that all the essential devices of the pictorial arts had been mastered and were at the ready command of subsequent Hellenistic artists. How else are we to interpret Pliny's enraptured comments over the illusionism of the work of Apelles? Apelles, who practiced into the early years of the third century, sought to prove that he could "compete with nature itself." He therefore made a painting of a horse, and when actual horses were led in to see it, Pliny reports, they neighed!

On one technique Pliny makes a very interesting comment[2]. He confesses, first, that he does not know who invented encaustic painting, but then adds that he is perfectly convinced that Pausias of Sicyon, who worked in the latter part of the fourth century, was the "first well-known master in this style." Now in encaustic painting, tempera is mixed with heated wax and applied to marble or wooden panels. The method roughly corresponds to oil painting, and it has something of the same capacity for impressionistic and translucent effects. It therefore seems no coincidence that it began to be used widely only at this time. Actually the gravestone from Pagasae mentioned above was painted by this technique.

Recent studies have argued that the writings of Euclid (c. 300 B.C.) and Vitruvius contain the idea that a true vanishing-point perspective was probably developed as a theory during the Hellenistic period and that it may have been employed by Hellenistic painters.[3] If this is true we have one more piece of evidence that the post-Classical period in Greece was vitally concerned with the representation of pictorial space. For this reason it seems legitimate to include among our examples one panel of the controversial Odyssey Landscapes, where rocks, mountains, and pools extend into a vast distance (Pl. XVII).

Literary sources also reveal that the kings of the Hellenistic periods were eager collectors of paintings. Alexander the Great would allow only Apelles to make his portrait; the two men were good friends and conversed on artistic matters.[4] We may gather that on his visits to Athens Alexander visited the studios of prominent painters and, if it struck his fancy, would buy one of their works and take it with him to Pella. Ptolemy III had his own art dealer, Aratos, a man of refined taste, who bought works which he considered of high merit and then shipped them to the king of Egypt.[5] It is recorded that Attalos II of Pergamon paid exorbitant prices for the masterpieces he bought. A description in a mime by Herodas of two chattering women who lose themselves in admiration of the murals in the temple of Asklepios at Kos (72) testifies to the general popularity of pictorial art during this period.

That the subject matter of Hellenistic paintings and mosaics covered a wide range can also be learned from ancient writings. Representations of gods and heroes and mythological battles were continued as before. Animal scenes, still lifes, caricatures, portraits, comic episodes (Pl. XIII), "barbershops, cobblers' stables, asses, eatables" and all manner of "odds and ends"[6] became common and were evidently greatly relished. Another innovation was the illustrated biography in which in a sequence of pictures the life of a hero, like Achilles (Pl. IX, X), was unfolded episode after episode. As we recall from the small frieze with the story of Telephos on the Altar of Zeus at Pergamon (166), this kind of

continuous narrative had its counterpart in sculpture in relief. The painted wanderings of Odysseus (Pl. XVII) may be a related phenomenon.

Finally, the sources provide us with ample evidence that the paintings and mosaics which were discovered on Italian soil and which we illustrate in this book can be regarded as based in one way or another on Greek originals. The copying of famous paintings was regularly undertaken during the Hellenistic period. Attalos II had his own crew of painters who were sent to Greece specifically for this purpose. We are told how Aemilius Paullus brought back Greek paintings as well as sculptures to Rome after his defeat of Perseus of Macedon in 168 B.C., and how Sulla sent home an original painting but left a copy of it behind in Athens.[7] Pliny himself saw many examples in Rome of the works he describes. At Pompeii it is obvious that painters found both Greek originals and copies readily available; presumably they owned pattern-books in which celebrated compositions were inscribed. Nevertheless, we can have no assurance as to the accuracy of any of these copies. We must view them with caution, and remember that they are more likely to be variations than exact replicas. [8]

This warning having been issued, we may nevertheless enjoy these paintings as reflections of the creative spirit of the Hellenistic age. They are imbued with monumentality and grandeur; the forms have an intense physical reality and a vivid plasticity – qualities with which the original sculpture of the period is also endowed.

See Plates Identified by Roman Numerals with Commentaries V—XX.

[1] G. M. A. Richter, *Handbook of Greek Art*, fig. 385. A few original Greek paintings which survive in provincial tombs are also of interest, although they are often inferior in quality. Notable examples are from Kazanlak in Bulgarian Thrace (V. Micoff, *Le tombeau antique près de Kazanlak*, Sofia, 1954) and Alexandria (B. Brown, *Ptolemaic Paintings and Mosaics and the Alexandrian Style*). For additional gravestones from Pagasae: A. S. Arvanitopoulos, *Graptai stelai Demetriados Pagason*, Athens, 1928. For more recently discovered and sometimes astonishingly beautiful murals: from near Lefkadia: *AAA*, 6, 1973, 87-92 and from Vergina: *AAA*, 10, 1977, 46-50.

[2] Pliny, *N.H.* XXXV, 122-23.

[3] See John White, *Perspective in Ancient Drawing and Painting*, ch. II.

[4] Pliny, *N.H.* XXXV, 79-97.

[5] Plutarch, *Life of Aratos*, 12-13.

[6] Pliny, *N.H.* XXXV, 112.

[7] On painters of Attalos II: *BCH, 5*, 1881, 388 ff., and Pauly-Wissowa, *R.E.*, *4*, 1901, cols. 2575 f.; on A. Paullus: Plutarch, *Life*, 32; on Sulla: Lucian, *Zeuxis and Antiochos*, 3.

[8] Some of the complications are discussed by P. von Blanckenhagen in *RM* 75, 1968, 106-43.

VI Decorative Arts

"My magic wheel, draw home to me the man I love!"

Thus, by incantation, prayers to the Moon, the burning of laurel, and the pouring of libations, the forsaken maiden in the second Idyll of Theocritus attempts to win back her lover. All the while she twirls her wheel, Aphrodite's gift to the lovelorn, which if fortune should favor will cast a spell over the loved one. Besides the prayers and potions, however, the maiden has another resource – a charm as powerful and, we might add, equally religious in character: her jewelry. At least one piece of her ensemble, perhaps her earrings (Pl. I), expresses her erotic desires and her expectation of divine assistance. While she twirls the magic wheel, Eros dangles from her ears and joins in the pursuit. But all her jewelry, of course, she wore as an adornment of her body, and because it increased her personal attractiveness it became an invitation to love. We cannot help but think that, given the superior beauty of each piece she wore, the Hellenistic maiden had a decided advantage over her modern counterpart.

The jewelry of the Hellenistic age is exceptionally mobile and dainty. Pendants were extremely popular, although they were not, it is true, an innovation of the time. They fell from necklaces, earrings, and clothing ornaments in a fashion that had begun as early as 700 B.C. but seldom with the same profusion and buoyancy and rarely with that delight in intricacy and interwoven registers that we see in some of the examples illustrated here. Tiny objects of varying sizes, always naturalistically modeled – dolls, Erotes, pyramids, or amphorae – dance on thin chains of ever-different lengths. Frequently the chains form a V, and within this small area another tiny motif will be suspended. How perfectly the intervals are calculated and the spaces filled, how lavish and ingenious, and yet how delicate and truly

free each motif remains! Every one can swing independently of the next. Imagine the rotation of the dolls and the flight of Erotes when a woman, wearing the earring we illustrate, turned her head! The mobility of this style of jewelry is also revealed in the serpentine windings of the diadem and bracelet. Gold strips or wires turned or twisted over and over, forming continuous rhythms and alternations of lighted and shadowed elements. The "knot of Herakles" at the center of the diadem is composed of two unending loops whose curvilinear journeys cause the eye to move in ceaseless fascination.

We should speak, too, of the three-dimensional aspects of Hellenistic jewelry, which, as we have seen, were also present in the architecture and sculpture of the period. Flatness and low-relief ornamentation were characteristic of earlier Greek jewelry. But now a great deal of the decoration – particularly of the pendants – takes the form of miniature sculptures in the round. The freedom with which they are allowed to dangle on their chains is additional proof that they were intended to be appreciated as tridimensional objects. Many of them are space-penetrating as well. In the earrings this can be noted in the pointed ends of the amphorae, the inverted pyramid, and the Erotes' spread wings; in the bracelet, in the bulls' heads that shoot out of the top. Even the winding ribbons of the diadem would touch the hair lightly and only, as it were, periodically. Again, the rosettes in the disk of the earring refuse to lie back but instead project, one above the other, in high relief. Moreover, the roundness and depth of many of the motifs have been made all the more prominent by being contrasted occasionally with a flat strap (necklace) or by the compact arrangement of low-relief designs on a nearby surface

(diadem). Perpetually turned and twisted, and shaped into tiny volumes, the gold glistens and sparkles; light reflects from numerous protrusions, and shadows gather in the crevices between the petals of a rosette. And so these half-animate decorative objects become even more enlivened.

In addition to the vivacious and virtuoso working of the pure gold, Hellenistic jewelers, for the first time in Greek history, embellished their products with colored stones and enamels. Tastefully fused with filigree and granulation were garnets, emeralds, carnelians, agates, sardonyx, and glass enamels, usually in blues and greens. The results, of course, were polychromatic and marvelously rich, yet the goldwork in the early Hellenistic period always provided the predominant color and the framework of the composition. Large as is the garnet of our diadem, it is only an embellishment. Bountiful as are the scales of blue and green on either side, their paleness serves chiefly as a foil for the deep and brilliant yellow of the ribbons. It was not until the late Hellenistic period that multicolored stones were added in quantity, and the goldwork, as a consequence, became incidental to the general design. It also declined in quality.

As the examples discussed in this chapter attest, the people of the Hellenistic age relished luxury and splendor in their private lives. Beautiful and expensive objects – the shinier the better – accumulated in the palace and entered the domestic house to a degree they never had before. Alexander the Great, the hero of the period and of this book, was largely responsible, in an indirect sense, for this transformation in daily living and taste. His conquests in the East, above all the capture of the Persian treasuries of Darius and the mines that were taken over by his successors, made gold and silver available in vast, until then unheard-of amounts. Gold jewelry proliferated among the upper classes. Kings and queens surrounded themselves with dishes, bowls, goblets, trinket boxes, and furniture wrought from or ornamented with precious metals. Athenaeus (c. A.D. 200), himself a native of Naucratis in Egypt, describes a fabulous festival held in the reign of Ptolemy II Philadelphos (285-246 B.C.) in which "young men... wearing gold crowns, marched in line" and "statues of all beings . . . were borne along, some gilded, others draped in garments of gold thread. One could only guess how great was the number of gold and silver vessels . . . one thousand slaves marched in the procession carrying silver vessels. Then came six hundred royal slaves with gold vessels. After them nearly two hundred women sprinkled scented oil from gold pitchers . . . The management of these matters was undertaken by the king himself," and Athenaeus describes "these matters" for pages on end. The guests, we can well believe, were full of wonder. The gods, too, as the temple inventories from several cities certify, received, in the form of dedications, their share of gold and silver plate and jewelry of all kinds.

Repoussé designs on the exterior of metal vases, in which the ornament and figures project in high rather than low relief, are more frequent in the Hellenistic age than in any earlier Greek period. This is only one more indication that the artists of the time, regardless of medium, were deeply interested in three-dimensional representation. Dionysos and Ariadne (Pl. III) are depicted as a group extending into depth. Their obliquely placed and intertwined limbs allow us to measure and appreciate the degree of spatial penetration. The maenads gyrate in utter freedom on either side. But the craftsman perhaps betrays what he is most inclined to do by modeling four figures completely in the round and setting them on the shoulder of the vase. Color contrasts appealed to him, furthermore, as much as they did to the jeweler. Silver vines thread their way among the gold or, in another example, a ruby is implanted in the eye of a gilded monster (177).

Metalworkers and jewelers found gainful employment at all the princely courts and in all the prosperous cities of the Hellenistic world. So far, however, the evidence of their work has come mainly from South Italy (Tarentum), South Russia, Northern Greece (Thessaly and Macedonia), and in Asia Minor from Cyme and Sardis. Since the craftsmen moved from one center to another, it is almost impossible to distinguish regional styles. Our examples illustrate the incredible beauty of their work and the wide geographical range of their activities.

The Tazza Farnese, the enormous cameo in the museum in Naples (Pl. IV) epitomizes many aspects of the decorative and other arts of the Hellenistic

period. There is, first of all, its sumptuous beauty, which bears witness to the ostentatious habits and wealth of Hellenistic kings. The polychrome stone, sardonyx, is another legacy of Alexander's conquests in the East. The involved iconography allegorizing the achievements of the Ptolemies accords with and perhaps surpasses the self-glorifying visual state ments made by other Hellenistic monarchs (153, 154). Cameos as such are an innovation of the period. Carved in relief rather than engraved, the layers of the stone have been exploited for their coloristic value as well as used to detach the figures from the background. Supremely decorative though it may be, the scene, which also includes landscape elements, occurs in a real environment through which the wind may blow and into which light may enter.

animals – horses or ducks – or even busts of gods and goddesses were used to decorate the sumptuous bronze or wooden couches of both Hellenistic and Roman private homes. The idea, according to Pliny, originated in Delos. It is often difficult to distinguish Hellenistic from Roman examples. The spirited lightness and unschematic modeling of our mule suggest that it was made in Hellenistic times; because of the slim neck and sharp turn of the head, it is probably of a rather late date within that period. Second to first century B.C.

New York, Metropolitan Museum of Art, acc. no. 13.227.9. Rogers Fund, 1913. One of a pair from Asia Minor. H. 0.089 m. G. M. A. Richter, *Bronzes*, 91, no. 133. Same author, *Furniture*, 52-58, 105-09. C. Ransom, *Couches and Beds*, Chicago, 1905. A. Greifenhagen, *RM, 45*, 1930, 137-46. K. A. Neugebauer, *AM, 57*, 1932, 29 f. Pliny, *N.H.* XXXIV, 9.

176 Mule Ornament

We see here the bronze head and neck of a mule which served as part of the end decoration of a *fulcrum* – the head- or foot-rest of a banquet couch. The narrow, even elegant head, modeled in the round, projects from an abnormally long and slender neck rendered in relief. The base of the neck terminates in a curved rim which was attached to the arched end of the *fulcrum*'s frame.

The steep rise of the mule's neck, its elongation, and the sharp angle then taken by the head impart a strong impression of animation and movement. The flattish surface of the neck, which is without any indication of underlying structure, contrasts with the round and volumetric forms of the narrow nose, flaring nostrils, the protruding eyes and cheeks, and the soft, drooping muzzle. The long daggerlike ears point in a direction independent of both head and neck and seem to increase the lively effect of the whole. The short tufts of the mane are clustered in nervous bunches and rise in irregular waves. The eyes were inlaid with silver, and the irises, now missing, were inserted in another material. Ivy leaves trail from the wreath that surrounds the head, and the trapping around the neck is decorated with the skin of an animal, probably a panther, whose jaws and eyes are only roughly sketched in.

Ornaments such as this mule or the heads of other

177 Nereid Riding a Sea Monster

This sea nymph, or nereid, is taking a voyage on the back of a fabulous monster. She rides sidesaddle, her feet dangling in the volute-shaped waves below. An arm is affectionately thrown around the creature's neck; with her left hand she nonchalantly fans herself. Her carefully arranged "melon" coiffure terminates in a small bun. Her mantle has slipped down and encircles her thighs, leaving her back and buttocks, composed of sinuous curves, completely bare. Her arm bracelets, her nudity, and the artful way in which she exposes herself to the viewer reveal the erotic implications of the theme. A joy ride, and not an abduction, it truly is. The motif of nereids mounted on fantastic sea animals is as old as the fifth century, but the nymphs were then fully clothed and less cooperative.

The monster, half-land and half-sea in type, paddles along with his two leafy fins. The jaws of his doglike head are open, his ruby-beaded eye glitters, and he has a spiked mane. Soft, wavy hairs turn abruptly into hard scales, and his long, coiling serpent's body tapers and finally spreads into an erect acanthus tail.

This scene, rendered in repoussé relief, is depicted on the silver lid of a round pyxis, or jewelry box. It was found at Canosa near Tarentum in South Italy in a tomb which contained other valuable objects

including a gold diadem, necklace, and earrings. The colorful richness of the lid is increased by the application of gold over the whole of the monster, over the hair, drapery, and bracelets of the nereid, and on some of the waves. The schematic neatness of the volutes, the compressed, two-dimensional disposition of the nymph's torso, and the rather frozen movement of the serpent suggest that the pyxis was made after the ebbing of the baroque style of the first half of the second century. It may have been fashioned by an artist in Tarentum, which continued to be a flourishing center for the toreutic arts even after it had been subdued by Rome in 272 and 209.

The nereid's voyage may allude to the journey of the deceased to the other world. The contents of the tomb indicate that this person was a woman of considerable wealth. Late second century B.C.

Taranto, Museo Archeologico, no. 22429. Dia. 0.103 m. Found in 1928 at Canosa di Puglia. G. Becatti, *Oreficerie*, no. 447. L. von Matt, *Magna Graecia*, New York, 1962, 187 ff. E. Langlotz, *Kunst der Westgriechen*, pl. XX, 97 f. The sea monster is a "Ketos"; see K. Shepard, *The Fish-Tailed Monster*, New York, 1940, chs. IV-IX. D. E. Strong, *Greek and Roman Silver Plate*, Ithaca, N. Y. 1966.

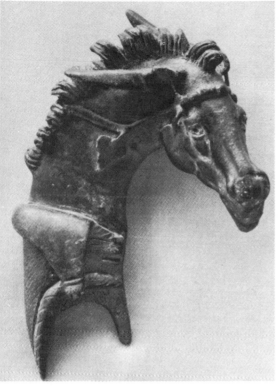

176. Mule ornament

Late second to first century B.C.
New York, The Metropolitan Museum of Art

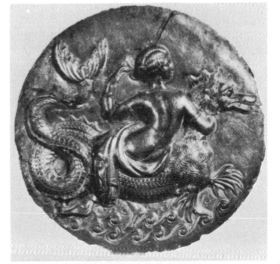

177. Gold and silver Lid with Nereid on sea animal

Late second century B.C. *Taranto, Museo*

PLATES WITH ROMAN NUMERALS

for Chapters V and VI

PLATE I Jewelry

Each item may be ranked among the supreme masterpieces of the goldsmith's art. With incredible ingenuity and craftsmanship, the gold has been hammered, chased, twisted, rolled, or stretched to form an amazing variety of designs in which delicacy, motion, and complexity are the hallmarks. The most minute motif is finished to perfection; there is never a "dead" area; joins are never crudely exposed. The glittering properties of the metal have been exploited to the full, and precious stones and enamels, always in the most discreet quantities, enhance the coloristic effects. Since gold never grows old, this jewelry is as sparkling as if it had been made yesterday. Most of it was found in tombs, for the dead liked to be buried with their most luxurious possessions.

The middle of the diadem (center), meant to be worn over an upswept hairdo, is marked by one of the favorite motifs of Hellenistic jewelry: the so-called Knot of Herakles, which was believed to have apotropaic power. Composed of two interlocking loops with no visible ends, it seems to ask yet also refuse to become untied. The loops are decorated with gold wire and rosettes, and they enclose a large round garnet. The knot is held in parenthesis by two flattened gold cylinders covered with filigree scales whose shallow cavities are filled with pale green and dark blue enamel. Three fine, parallel ribbons turn rapidly over and over to form the band. Tiny rosettes nestle in the central strand. The open effect of these ribbons, coiling in apparent freedom, touching and then immediately parting, is in deliberate contrast to the density of the enameled scales and the tight interlacing of the "Herakles Knot." From Melos, third to second century B.C.

The necklace (lower left) also achieves a delicate balance between static and free elements. Two registers of pendants dangle from a somewhat flat strap consisting of four plaits. The pendants, hung from fantastically fragile chains, take the form of painted amphorae in three sizes, the largest in the lowest register. Wherever the chains join strap or amphora, a minute rosette, an enameled disc or leaf, masks the juncture. The accumulation of very small ornaments is, however, never excessive, and the necklace does not resemble the heavy Egyptian collar. A woman would display it best by pinning it from one shoulder to the other of her garment, where it would rest lightly. Perhaps from Melos, 330-200.

The earring, one of a pair from Cyme in Aeolis, is amazingly intricate. A disc with a raised border of beaded wire is decorated with filigree spirals and rosettes surrounding a design in high relief of three superimposed rosettes. At the center is a small but very distinct globule. Suspended from the disc are no fewer than five pendants, each one a miniature work of sculpture. The largest, in the shape of an inverted pyramid ornamented with globules, spirally-wound wire, and rosettes, is attached to an intermediate figure of a half-seated draped female. Swinging out on either side of the pyramid is a solid-gold winged Eros holding a cord through which is strung the magic wheel. Tiny female figures, which are cut off at the knees and represent dolls, hang from just below the disc. The joins as usual are concealed by rosettes. Late fourth century.

Six smooth gold wires were entwined around a core to form the bracelet. Around and around the wires go, and it is therefore no wonder that they end up in animate finials: the heads of bulls with inlaid blue eyes. Amulets and leaves frame the dark red garnet collar. This type of bracelet, of Persian origin, was adored by Hellenistic women, who usually wore two at once. The heads of rams and lions were also highly favored. The bulls, here identical, were perhaps worked by pressing sheet gold over a wooden model. From Cyme, late fourth century.

A fashionable woman might have worn all these pieces at once, though she probably preferred to have matching necklace and earrings. Such sets have been found.

London, British Museum. Diadem no. 1607, L. 27.9 cm.; necklace no. 1947, L. 33.6 cm.; earring no. 1670, H. 6.1 cm.; bracelet, no. 1989, Dia. 8 cm. F. H. Marshall, *Catalogue of the Jewellery*. R. A. Higgins, *Greek and Roman Jewellery*, 159-73. H. Hoffmann and P. F. Davidson, *Greek Gold*, 4-6, 95-98, 115, 121-23.

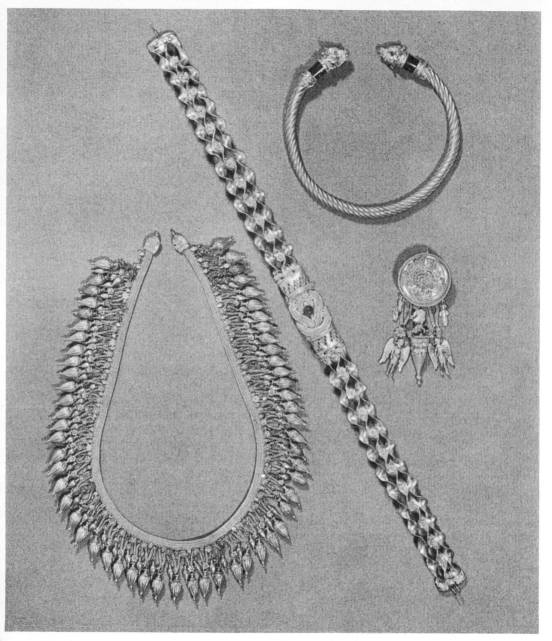

Hellenistic jewelry

Late fourth to second century B.C. London, British Museum

PLATE **II** Gold Medallion

The bust of Artemis, a long-necked and long-haired beauty, dominates this gorgeously framed medallion. Her head projects, a fully rounded volume, from the dotted background. Her right shoulder and pointed breasts are strongly modeled and plastic. The goddess, who carries a quiver on her back and wears an animal skin above her light chiton, seems almost an independent sculptural entity in which the forms, on the whole, are broad and bold. The border designs, on the other hand, reveal the intricate and patient work of the jeweler. The frame consists of three concentric zones which rise toward the center like a dome and from which the bust dramatically and finally obtrudes. On the inner zone eggs and darts alternate between two rows of triangles. In the middle and widest zone gold threads wave from one side to the other and are interspersed with palmettes and rosettes, in either granulation or filigree, and velvety-red garnets. A wreath of leaves periodically encircled by ribbons surrounds the exterior. Throughout, high and low relief are juxtaposed and contrasted: the eggs nearly burst their shells, the bulging wreath must be fastened down by ribbons, and yet many rosettes and triangles are of lacy delicacy. Sixteen rings are soldered to the periphery, and hanging from them is a net of chains studded at the intersections with garnets, tiny medallions, and flowers. Dazzling though the medallion is, it was originally even more colorful and elaborate, for several of the filigree ornaments were filled with bright enamel paint.

The medallion is breathtakingly beautiful, but it is also baffling. What was its use? A few others are known, and they were first thought to be lids for round pyxides (cf. 177). The chains would thus fall down the sides of the vessel and the projecting emblem could be grasped, like a handle, for lifting. Parallels in terra cotta can be cited. Recently, however, a more acceptable suggestion has been made: it is an ornament for the hair. The medallion might have been fitted over a chignon and secured by a string drawn through the outer rings of the chain. So far, unfortunately, no Greek woman of the period represented in painting or sculpture has been discovered wearing such a headdress.

Other medallions, some of which may have been breast ornaments, have been discovered in South Italy, Egypt, Syria, and South Russia. Ours seems to have come from Thessaly and may have been made in a Macedonian atelier in the third century.

Athens, National Museum, Collection of Mrs. Hélène Stathatos. From the Carpenisi (?) lot. Dia. of medallion, 11.5 cm., with chains, 21 cm. The eggs of the inner zone are soldered on. The disc containing the repoussé bust was separately worked and stapled to the frame. R. H. Higgins (*Greek and Roman Jewellery*, 157, 218) dates the medallion in the second century. P. Amandry, *Collection Hélène Stathatos, Les Bijoux Antiques*, no. 233, 97-105, pls. 36-37. H. Hoffmann and P. F. Davidson, *Greek Gold*, 223-31, 266-70.

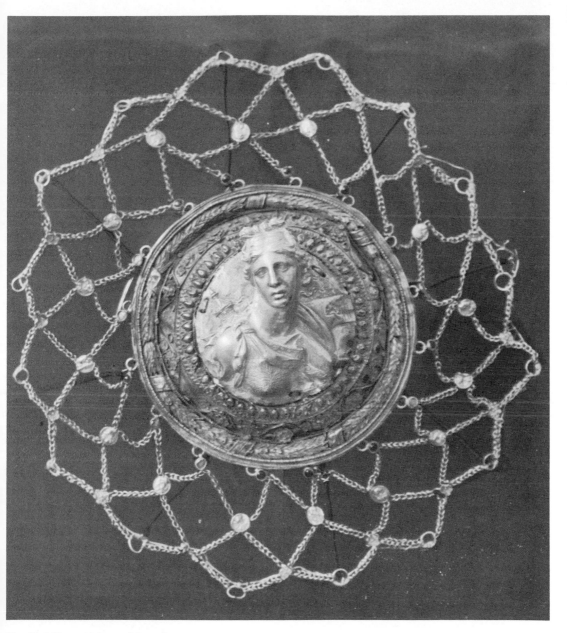

II. Medallion with bust of Artemis

Third century B.C. *Athens, National Museum, Collection of Mrs. Helene Stathatos*

PLATE III Bronze Crater from Dherveni

The creative vitality and expert craftsmanship of Hellenistic metalworkers are nowhere better revealed than in this gilded bronze wine-bowl, or crater. Found in 1962 in a grave at Dherveni in Macedonia, it held ashes and was once covered with a shroud. An inscription on the mouth refers to the owner of the vase rather than to the deceased. Parts of the vase were discovered scattered around the tomb, but when it had been reassembled it took on a quite incredible splendor and richness. The tall, narrow body is surmounted by high vertical handles which turn over into volutes framing bearded masks of Herakles, Acheloos, Poseidon, and Hades. Palmettes emerge from the handle columns and cross elegantly to join the lip and neck. From there on, what an array of figurative and foliate decoration! Wild beasts in appliqué designs parade in the upper zone of the neck. Below them is a lilting garland of ivy. Seated luxuriously on the shoulders and reclining against the curving neck are four solid bronze, fully-rounded figures representing two maenads, Dionysos, and a satyr holding a wineskin. Beneath another graceful wreath of ivy a continuous frieze, rendered in repoussé technique, surrounds the body. With his panther nearby, Dionysos, the god of wine, rests so to speak in the lap of his beloved bride Ariadne. Languidly he leans back, one arm over his head (cf. 122) and one long leg lying across Ariadne's thigh. Lifting her veil, she looks at him and waits. Her veil and gown, her body, and even her expression are soft and yielding. The other figures are as active as these are quiescent. Caught up in ecstatic and intoxicated dances, the maenads, so lightly clad they are nearly naked, twirl and toss their heads and arms. Another maenad, out of viewing range in the photograph, responds to the lascivious gestures of a satyr as if hypnotized. Rippling linear waves of drapery, thrown aside in the frenzy, travel along from one to the next, subsuming all in one rhythmic whole.

But death, in spite of the gaiety, is more than likely the underlying theme. The apparently happy company, or *thiasos*, of Dionysos may hope to achieve, because of total identification with the god, an everlasting life. The figures who repose on the shoulders of the vase are either listless or agonized. They are grieved by the death of the man whose ashes they enclose. They are traditional tomb mourners, so frequently depicted in earlier Greek art, yet here a better parallel seems to be Michelangelo's sorrowful figures on the Medici Tomb.

A gold coin depicting Philip II (359–336 B.C.) was found in the vase. A papyrus text dated around 300 B.C. that was discovered in an adjacent tomb is also an important reason for assigning the contents of the tomb to about the same period. Fourth-century painted clay vases from Tarentum have comparable shape and decorative detail. The High Classical traits, so evident in the body and drapery of Ariadne, may have been retained into the late fourth century, and the elongated proportions of Dionysos' figure recall the style of Lysippos. The *thiasos* scene – particularly some of the individual maenads – is reminiscent of and indeed may have furnished the model for the classicistic Neo-Attic renderings of the same subject on marble craters.

Salonika, Archeological Museum. H. 70 cm. Silver incrustations. Name of owner: Asteiounios of Larisa, son of Anaxagoras. G. Daux, *BCH, 87,* 1963, 802, pls. XV-XX T. B. L. Webster, *Age of Hellenism,* 20 f. From Tarentum according to G. Bakalis, *AA,* 1966, 532-34. Two craters in the Louvre illustrated by M. Bieber (*Sculpture,* figs. 791 and 795) are comparable. J. Bousquet, *BCH,* 90, 1966, 281-82. M. Andronikos, The Greek Museums, *Thessalonike, Archaeological Museum,* Athens, 1975, 11-12.

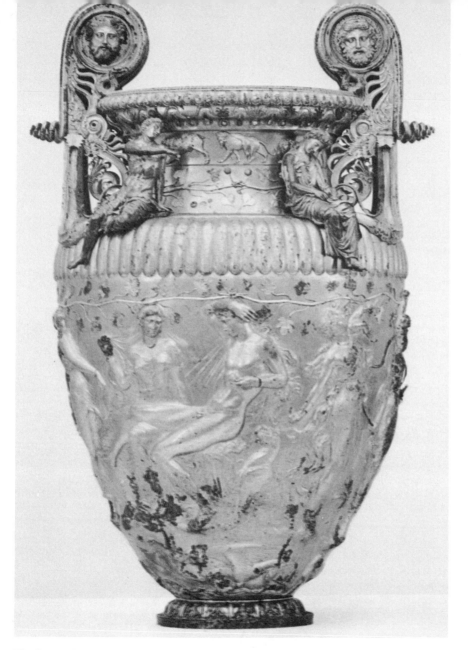

III. Bronze Crater from Dherveni

Late fourth century B.C. *Salonika, Archeological Museum*

PLATE **IV** Tazza Farnese

Pearly-gray figures are set against the brown darkness of the background. Tawny streams meander and disappear along the border. Delicate and fluctuating tones and colors characterize this magnificent sardonyx cameo, one of the largest known. Shaped like a flat cup and presumably made in Alexandria, it is decorated on both sides: on the back, by the startled face of a Gorgon with flowing hair, and on the inside, shown here, by an idyllic scene of amazing beauty and magnificence.

At the left, as benign as a philosopher yet as majestic as Olympian Zeus, the seated river god Nile leans against a knotty tree and holds a large horn of plenty. His wife Euthenia ("Well-Being" or "Abundance"), dressed in the garb of Isis and with ears of corn in her right hand, reposes at his feet and rests one arm on the head of a sphinx. Just in back of her, a handsome, almost naked youth, identified as Isis' son Horus and also as the Eleusinian Triptolemus, strides along with vigor and purpose carrying a seed bag and a knife and, in his right hand, the shaft of a plough. Two radiant, partially nude females recline at the far right. They are thought to represent the Seasons, or Horae. One, in a pose particularly favored by later Hellenistic artists (177), reveals her bare back and buttocks and prepares to sip from a wide cup. The other, who leans against a sheaf of wheat, holds, like Nile, a horn of plenty. In the upper zone two wind gods fly across the sky, the scarf of the first billowing in the breezes blown by the second through a shell. The whole scene, as Furtwängler long ago recognized, is an allegory of the bounty of the Nile. The great river, assisted by the seasons and the winds, overflows its banks with perfect regularity and the land around, thus fertilized, yields manifold and abundant harvests.

The scene perhaps portrays even more than this. Nile, the sphinx, Euthenia-Isis, and Triptolemus-Horus can all be considered members of one divine Greco-Egyptian family. Concurrently, the same gods may symbolize the ruling family of Egypt, the Ptolemies. But of what generation? Charbonneaux proposed that Cleopatra I is portrayed in Euthenia-Isis and that her son Triptolemus-Horus is Ptolemy VI.

If his interpretation is correct, the cameo was made between 181-173, the period when mother and son were co-regents. Bastet, on the other hand, identifies the two figures as Cleopatra III and Ptolemy XI, which would move the date to c. 100 B.C. The third and even first century B.C. have also been proposed, on different grounds, by other scholars.

The classicizing aspects of the style have frequently been noted and, indeed, contribute to the dating problem. Nile is based upon a bearded god of fourth-century type. The clinging, transparent drapery of Euthenia-Isis can be matched in High Classical reliefs of the fifth century. Charbonneaux pointed out the rigid Egyptianizing pose of her torso. The other figures are Hellenistic in type. Bronze satyrs in the round and in relief provide parallels for Triptolemus-Horus, and terra cottas from Myrina for the Horae and Winds. The composition has the axial arrangement and circular rhythms of fourth-century mirror designs, but diagonal movements, especially in the wind gods, and indications of depth and space in the disposition of all the figures point to the sophisticated handling of the third dimension which was introduced in the first half of the second century. A certain flatness in the modeling, however, a schematism and inorganic joining between heads and bodies, are undeniable. These features, along with the mixed styles of the figure types, are characteristic of the classicistic current of the late rather than the early second century. The complicated and possibly specific nature of the allegory has, at least in the visual arts, no earlier analogy. In spirit the scene closely approximates the Tellus panel of the Ara Pacis. Indeed a late first-century date has been proposed by D. B. Thompson.

Naples, Museo Nazionale, 27611. Dia. 20 cm. In 1471 it was in the possession of Lorenzo de' Medici. A. Furtwängler, *Antike Gemmen*, I, II, 235 f. J. Charbonneaux, *MonPiot, 50*, 1958, 85-103; F. L. Bastet, *BAntBeschav. 37*, 1962, 1-24. C. Picard is in favor of a third-century date (*ArchCl, 20*, 1951, 362 f.) Gorgon head on reverse is dated in the first century B.C. by E. Buschor, *Medusa Rondanini*, Stuttgart, 1958, 20. D. B. Thompson, in *Das Ptolemäische Ägypten*, Mainz, 1978, 113-22.

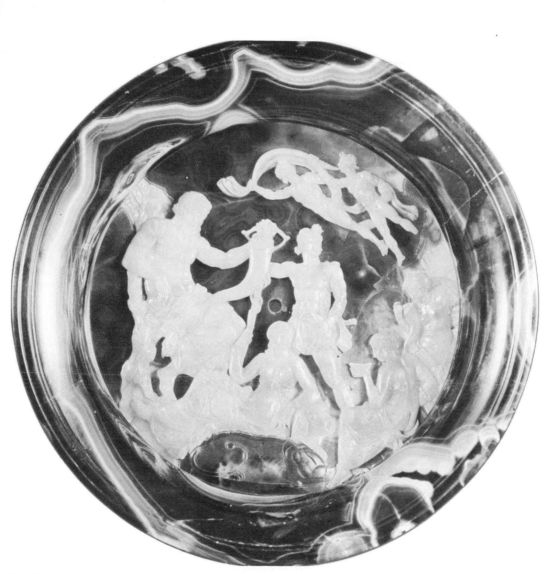

IV. Tazza Farnese

Late second century B.C. (?) *Naples, Museo Nazionale*

PLATE **V** Vase from Centuripe

The vase, made of clay, is large and in form not exactly elegant. It is a bell-shaped crater with a domed lid surmounted by a tubular finial. Two handles, which seem unnecessarily sturdy, are fastened to the body just below the mouth. Originally the vase was probably set on a separately-worked high foot.

The contour may be rather lifeless, the handles clumsy and obtrusive, and the lid with the tube an oppressive kind of roof. But surface, not shape, is what interested this Hellenistic potter; all his energies have been expended on the painted and relief additions. A wide, gilded band surrounds the finial; white dolphins and a sea panther leap around the dome. The top of the body proper has been handled as if it were a building – with a cornice composed of painted palmettes and disks and lion's heads alternating in relief. Below this, rectangles of blue and red run along like a Doric frieze above a relief design of eggs and darts. The main scene, framed by white volutes, is charming; in the center a woman is seated on a stool with turned legs. A parasol is held over her by a young girl wearing a wreath of leaves and, at the left, another maiden with her back toward us offers a fan. The paint, which is in tempera, is soft and unglossy; a rosy pink is spread over the whole background. Blue, yellow, and white are applied broadly and are shadowed or highlighted to suggest the solidity of the forms. Occasionally a dark line delineates a detail. At the base, plastic, regularly spaced acanthus leaves make still another decorative zone. All the relief ornamentation was at one time gilded. Was the potter indeed hoping to make his vase resemble the one shown in Plate III?

This is certainly no ordinary pot. Intended to be used at funerals rather than in the home, it is one of the best preserved of several polychrome vases which have been found exclusively in or near the cemeteries at Centuripe in Sicily. These vases are usually quite bizarre in shape, and the figurative scenes, restricted to one side, sometimes have Dionysiac or mystery-cult significance. The scene here, on the other hand, probably represents the dead person attended and honored by her closest kin or servants in a manner reminiscent of fourth-century tombstones from Attica. The paint was applied after the vase was fired, so that in some examples it has almost entirely flaked off. The pink background and the plastic ornament are characteristic of the whole class.

Both in shape and decoration, the vases from Centuripe appear to be related to certain late fourth-century vases from Sicily and the Lipari Islands. For this reason they are thought to have been manufactured, as a remarkably homogeneous group, during the third century. Although Centuripe was at this time (after 263 B.C.) in Roman hands, it was a prosperous town, and its painters were in touch with the artistic movements in the Greek part of the world.

Catania, University, Institute of Classical Archaeology. H. 56 m. Rim of lid has bead and reel molding. G. Libertini. *Atti e Memorie della Società Magna Grecia*, 1932, 187–212; for vases from Centuripe in the Metropolitan Museum of Art, New York, G. M. A. Richter, *MM Studies* 2, 1930, 187-205; 4, 1932, 45-54; and A. D. Trendall, *BMMA*, 13, 5, 1955, 161-166. U. Wintermeyer, "Die Polychrome Reliefkeramik aus Centuripe," *JdI*, 90, 1975, no. 52.

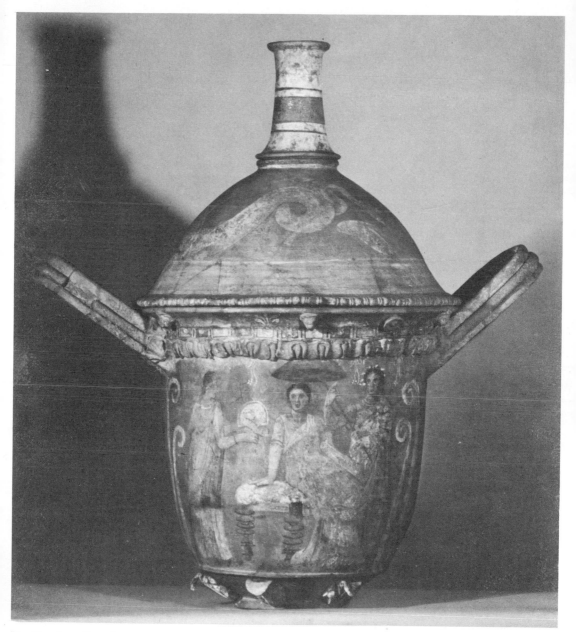

V, Vase from Centuripe

Third century B.C. *Catania, University, Institute of Classical Archeology*

PLATE **VI** Lion-Hunt Mosaic

Lysippos the sculptor, Pyrgoteles the gem cutter, Zeuxis and Apelles the painters, and Aristotle the philosopher: could one assemble a more distinguished list of artists and intellectuals? These men, each foremost in his profession, agreed to serve the royal court at Pella during the fourth century. This is proof, if more be needed, of the wealth and power of Macedonian rulers at that time. But — and this is equally important — it also confirms that their capital, Pella, was one of the most civilized and magnificent cities in the contemporary world and was regarded as such. According to literary sources, its palaces were sumptuously decorated, its theater large, and its public buildings numerous.

Only recently has something of the material splendor of this ancient city come to light. Dwellings – apparently public or official in function – have been unearthed in which a colonnaded court formed the center. Reception and living rooms surrounded the court and on the floors of several of them were discovered pebble mosaics of astonishing beauty and workmanship. The main scenes are sometimes surrounded with elaborate floral borders. Some of the subjects were drawn from mythology: Dionysos riding a panther, the battle of the Amazons, or the abduction of Helen by Theseus. Other scenes equally large, lively, and interesting are devoted to the hunt. We illustrate here one of these: a lion hunt, which was found in 1957 in Room C, perhaps used for dining, of Building I. The probable date is about 300 B.C.

Two youths close in upon a snarling and desperate lion. The one at the left, wearing a chlamys and soft hat, aims his spear at the animal's throat. The other, also nearly naked, brandishes a sword in the direction of the beast's rump. The action is at its peak; the lion is still a formidable opponent. His tail slashes the air angrily and his mane bristles with tension. In general the three forms are conceived as white silhouettes against a dark blue background. Some of the contours are sharpened by thin clay strips. A suitable decorative, two-dimensional emphasis is thus achieved. However, the third dimension is not overlooked: a few gray or brick-red bands, never very wide, suggest that shadows have gathered in depressions, whether of the anatomical forms or the folds of drapery. The blue background, moreover, is differentiated from and thus seems to fall slightly behind the uneven ground upon which the figures stand. Figurative floor mosaics had become fairly popular in Greece by the late fifth and early fourth centuries.

Who these young men were (if indeed they represented specific persons) is a matter for speculation: the lion hunt, an Oriental subject, was portrayed in early Greek art, but not during the Classical periods. Alexander was very fond of the sport as a diversion during his military campaigns in the east, and on one occasion he was assisted by his good friend Krateros. Is this episode depicted here? We know that it was rendered in a bronze group at Delphi. On one side of the "Alexander Sarcophagus" (150, 151) a lion hunt is also represented. It is quite possible that this old theme was now revived because of Alexander's eagerness for the chase. As we know, the travels and triumphs of the Great King affected every aspect of Hellenistic art and life.

Pella. H. 1.63 m. L. 3.36 m. Apparently precious stones were once set into the eyes. Ch. J. Makaronas (*Scientific American*, Dec. 1966, 104) argues that the headdress of the figure on the left identifies him as a Macedonian prince and therefore, in all likelihood, as Alexander. Ph. Petsas, "Mosaics from Pella," *Colloques Internationaux sur La Mosaique Greco-Romaine*, Paris, 1965, 41-56, figs. 1-21.

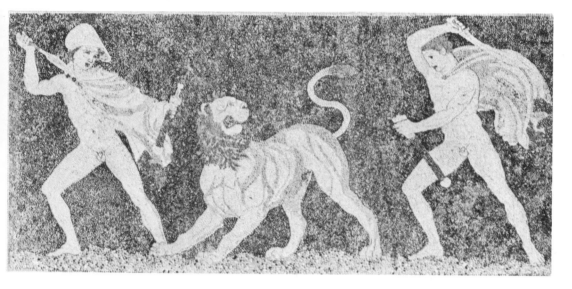

VI. Lion Hunt Mosaic

 c. 300 B.C. *Pella*

PLATE **VII** Lion-Hunt Mosaic, Detail

The pebbles for the Pella mosaics were probably gathered from the shores of the nearby river Lydias, smoothed and rounded by the incessant abrasive effects of the water. They were laid on the floor in a foundation of plaster. Only now, in this detail, can we see how variegated and subtle are their colors and how complex is their arrangement. The blues are deep and solid in the background and pale in the inner markings of the head. White changes to gray or tan, and brown to red or yellow. No two pebbles are precisely the same shape, and they are packed tightly, often in an irregular fashion. A red or a blue unaccountably turns up in the midst of an assembly of browns. The clear outlines and broad patterns suggesting light and shade are consequently devoid of monotony or harshness. Terra-cotta strips, inlaid with considerable attention to volume, define each pointed tuft of the lion's mane and the contour of its face and eyes. They are omitted, however, at the top of the mouth and along the back, areas which therefore seem to recede. The way in which the stones are graded according to color to model the forms suggest that the artist was inspired by mural rather than vase painting. He will soon, as we have seen, abandon his search for the proper pebble and instead cut his own stones.

On Greek pebble mosaics, see C. M. Robertson, *JHS, 85,* 1965, 72-89, and ibid., *87,* 1967, 135; P. W. Lehmann, *Essays in Honor of Karl Lehmann,* 1964, 190-97.

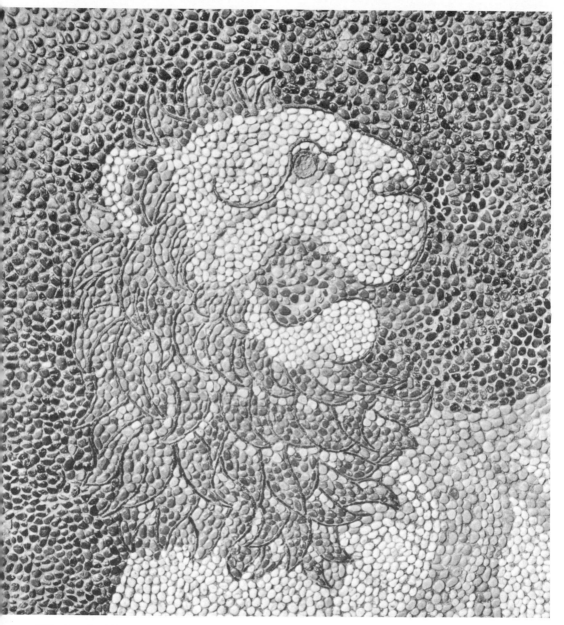

VII. Detail of Plate VI

PLATE **VIII** Mosaic, Head of a Tiger

This mosaic is composed of small cut stones, or tesserae, rather than natural pebbles. The new technique was introduced during the first half of the third century and remained in vogue for the rest of the Hellenistic period. In addition to the colored limestones out of which the majority of tesserae were made, marble and onyx as well as enamel and clay cubes were set into the cement to form, all together, a richly textured, seemingly soft carpet. The head of the tiger, partly destroyed, is only a detail from a large mosaic found in a house on Delos. The full scene represented a winged Dionysos serenely mounted on the back of this glorious beast.

The background is black and the main color of the tiger golden yellow. Nearly every cube has not only one predominant tone but also the tint of another in it. Pink stones delineate the muzzle; deep reds define the fleshy parts of the mouth and the interior of the ear. The animal's eyelashes and whiskers are thin streaks of solid white; actually the eyelashes narrow into needle-thin strips made of fine cement in which stones are absent. The tiger wears around his neck a wreath of vine leaves and grapes. How succulent the grapes are in their translucent rose and bluish skins! The heavy leaves fold over, their reddish veins running through the green.

The fierceness of the lion in the preceding plate is evoked almost entirely by linear, indeed by non-mosaic, methods. Were it not for the clay strips that sweep boldly along the contours of his snout and jaw, plunge over his brow, and surround the tufts of his mane, the pebbles would subside into bland, rather loose although attractive color patterns. The head of the tiger, on the other hand, is described only by tesserae – regularly shaped, very densely packed, and infinitely varied in tone. The effect is as of a painting. The ferocity of the animal's expression and his sheer physical power come into being because all the cubes hold together and form a solid volume that is built of detailed modeling in strong and contrasting colors. Late second century B.C.

Delos, from the peristyle of the House of Dionysos. The technical name for this kind of mosaic is *opus vermiculatum*. M. Bulard, "Peintures murales et mosaïques de Délos, *Mon-Piot, 14*, 1908, 199-205. J. Chamonard, *Délos* VIII, 1 (1922) 127-34. For a discussion of masaic techniques : K. M. D. Dunbabin, *AJA*, 83, 1979, 265-77.

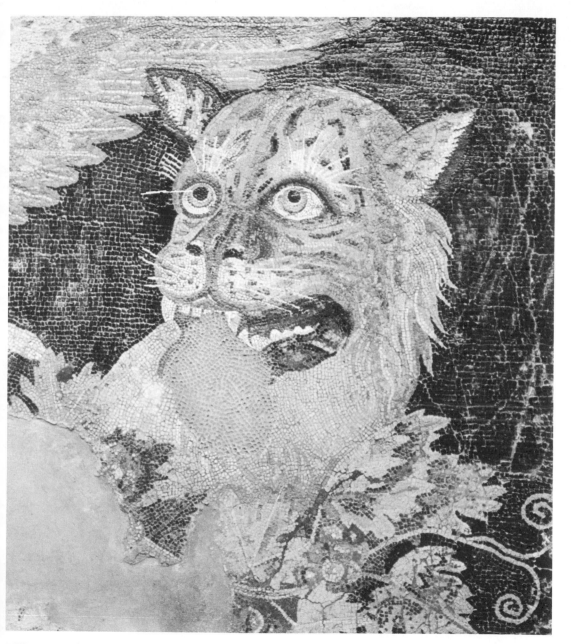

VIII. Detail of Mosaic, Head of Tiger

Late second century B.C. *Delos*

PLATE **IX** Achilles in Skyros

Odysseus can hardly believe his eyes. He appears in the right foreground, wearing a conical cap. He is astonished to discover that the maiden before him, so prettily dressed, is none other than Achilles, the most manly of all Greek warriors. Odysseus grasps him and so does Diomedes: Achilles will have to repair to the battlefield after all. Thetis, his mother, so the legend goes, sought to prevent the death foretold for her son on Trojan soil by hiding him among the daughters of Lykomedes, the king of Skyros. One day, however, Odysseus and Diomedes, disguised as merchants, enter the palace and begin displaying their wares. At the sight of the gleaming armor and the sound of a trumpet, Achilles' militant nature is instantly aroused. He seizes the shield and sword and is about to rush into battle. Deidamia, whom he has already seduced, waves her arms in distress while her father Lykomedes, directly behind Achilles, seems unable to understand the meaning of it all. A helmeted guard with a shield stands in front of a row of columns. Another is scarcely visible at the left rear.

Achilles establishes with Odysseus a large pyramidal design that dominates the entire painting. The remaining figures form a semicircle behind them; the portico and "air" beyond are the final delimiting plane. Brown and brown-red, pierced by streaks of white suggesting reflected light and projecting surfaces, are the strongest colors in the painting. Pink, lilac, green, as well as white are used to sketch out the billowing draperies. A rather amusing feature is the contrast between the ruddy skin tone of Odysseus and Diomedes and the pale, soft tints of Achilles' flesh. In this sense Achilles is Deidamia's authentic sister.

Homer, as Pausanias goes out of his way to point out, never hints at Achilles' sojourn among the daughters of Lykomedes. The myth, however, may have been current by the early fifth century. Polygnotos, an artist of the fifth century, and Athenion in the fourth, are both alleged to have painted it. But in art the legend is not at all common until the Hellenistic period when, as this painting reveals, the transvestite theme was throughly exploited and enjoyed.

The fresco may copy an early Hellenistic original by Theon of Samos, who is recorded to have painted a whole series of scenes illustrating Homer's *Iliad*.

Naples, Museo Nazionale, Inv. no. 9110. H. 1.30 m. L. 0.84 m. Strip along left edge destroyed; surface considerably damaged. From *Tablinum* of the House of the Dioscuri, Pompeii. Attributed to the "Achilles Painter" by L. Richardson, *MAAR, 23,* 1955, 135. Pausanias, I, 22, 6, K. Schefold, *Zeugnisse Griechischer Malerei*, Munich, 1958, 30-35. A second copy probably preserves more of the original composition: see L. Curtius, *Die Wandmalerei Pompejis, 206-13*, pl. II.

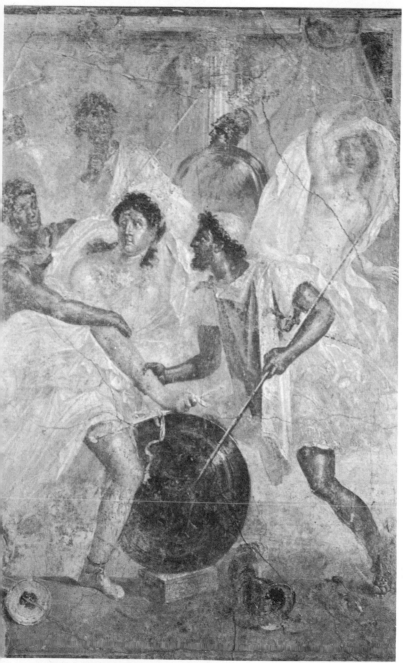

IX. Achilles in Skyros

Copy. Original third century B.C.
Naples, Museo Nazionale

PLATE **X** Thetis in the Workshop of Hephaistos

The story of Achilles as told by Homer in the Iliad was ever after a source of inspiration for Greek artists. It was the painters of the Hellenistic period, however, who constructed the most elaborate visualizations. One of these, the sojourn of the hero on Skyros, is illustrated in the preceding color plate. In this one, probably also derived from the cycle illustrated by Theon of Samos, Achilles is not present, but the event portrayed is a crucial one in his biography. Patroklos had worn Achilles' armor into battle, and after his death the Trojans had stripped it from his body. Achilles wept passionately at the news, but he was now unarmed and could not wreak the vengeance he so desired until his mother Thetis rose from the foamy sea to console him. She promised to return in the morning with bright armor made by Hephaistos, the god of fire and patron deity of human smiths.

The painting, from a house in Pompeii, shows Thetis seated in the workshop of Hephaistos' palace. Corselet and greaves lie in the foreground; a workman puts the finishing touches on the helmet. Hephaistos, assisted by another workman, balances on his knee his pride and joy: a magnificent bronze shield. In Homer this shield was described as being embossed with numerous scenes and gilded. Here instead the center is filled with the reflected image of Thetis. Other replicas of the scene omit this diverting detail, which converts the shield into a mirror. The second female figure (a Nereid?) seems to be attending Thetis as she inspects the wares she has ordered, rather than serving as the Charis of the Homeric version who dwells in the house of Hephaistos. Rather than being merely illustrated, a heroic theme has here been transmuted into a very Hellenistic context. Since a reflected image also appears in the contemporary Alexander Mosaic (Pl. XI) it may have been included in Theon's original. The painter's keen interest in light is also revealed in the metallic glints that animate the helmet and corselet, in the shimmering draperies of Thetis, and in the perspiring face of Hephaistos. The palette is a limited one. The composition, in which large figures occupy a deep space in front of an architectural background, is similar to that in the painting of Achilles in Skyros. We suspect, however, that the copyist has indulged his fancy by suspending draperies from the ceiling. From an early-third-century original.

Naples, Museo Nazionale, no. 9529, from Regio IX, insula 1, house 7. H. 1 m. L. 0.81 m. Considerably damaged. For other copies: L. Curtius, *Die Wandmalerei Pompejis*, 220-29, and G. Lippold, *Antike Gemäldekopien*, 130-34, pls. 20, 108.

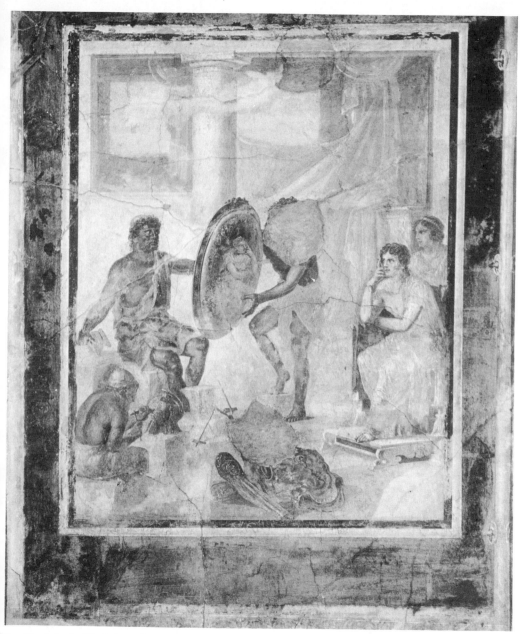

X. Thetis in the Workshop of Hephaistos

Copy. Original third century B.C. *Naples, Museo Nazionale*

PLATE **XI** The Alexander Mosaic

It takes a little time to sort out the contestants in this scene. No work of art has better captured the frenzy and fury of battle. Our first impression is of hysteria and panic; we can almost hear the cries and the clash of metal. The narrow stage is packed with colliding horses, men, shields, and spears; in the foreground abandoned weapons add to the untidy and tragic impression of the whole. The event described is probably the second of Alexander the Great's historic battles against Darius, the king of Persia, which took place at Issus in 333 B.C. A mosaic composed of minute stone and glass tesserae, it is the largest and most ambitious pictorial composition that has come down to us from antiquity.

The mosaic underwent repair even before it was submerged under the lava of Mount Vesuvius. When it was found in the Casa dei Fauno in Pompeii in 1831, much of the left side had been obliterated. Nevertheless the two main protagonists can be detected. Darius, wearing a yellow Persian tiara, dominates the right portion, if not the whole composition. Raised high in his chariot, he is a man in acute distress. At the left, a youthful and bareheaded Alexander is mounted on his beloved steed Bucephalos. He is in a calmer but by no means confident frame of mind. The major thrust of the movement is directed toward the right. Here, around Darius, the confusion is the most intense as he and his chosen bodyguard retreat before the advancing Greeks. Even as he is being driven away, Darius reaches out compassionately to the companion who has been nailed by Alexander's lance. Another, whose dying face is reflected in his shield, has fallen beneath the huge wheel of the chariot. There are several masterfully foreshortened forms, but the riderless horse seen from the rear is the most effective of these

in impeding the general direction of the action and in establishing the density of the combat. A lonely, seared tree trunk rises in the airless background. Only four colors – black, white, red, and yellow – have been used, and it is amazing how they have been graded and arranged to create both decorative and plastic effects.

"Philoxenos of Eretria painted a picture for Kassander (King of Macedon, c. 319-297 B.C.) which must be considered second to none; it contained the Battle of Alexander against Darius." Perhaps, as is generally believed, the mosaic reflects this famous lost original mentioned by Pliny (N.H. XXXV, 110). But its discovery in the Casa dei Fauno indicates that the replica was made in the second century B.C., and the copyist has undoubtedly made changes in his model. Certainly the head of Alexander, with its streaming hair and soulful expression, is closer to the second-century portrait in Istanbul (3) than to either of the late-fourth-century renderings (1, 152).

Naples, Museo Nazionale, no. 10020. H. 2.17 m. L. 5.12 m. Technique is *opus vermiculatum*. The original painting has also been attributed to Aristides of Thebes and Helena of Alexandria. For the attribution to Philoxenos, cf. H. Fuhrmann, *Philoxenos von Eretria*, Göttingen, 1931. L. Curtius (*Die Wandmalerei Pompejis*, 323) believed that the final battle between Alexander and Darius, at Gaugamela in 331, is represented. B. Andreae (*Das Alexandermosaik*, Opus nobile 14, 1959) argues that all three of Alexander's major confrontations with Darius (Granicus, Issus, and Gaugamela) have been incorporated into the one composition, and this may be true. M. Robertson, *A History of Greek Art*, 498-503; Four-color palette: V. Bruno, *Form and Color in Greek Painting*, Ch. 5. For excellent color detail plates: B. Andreae, *Das Alexandermosaik aus Pompeji*, Recklinghausen, 1977.

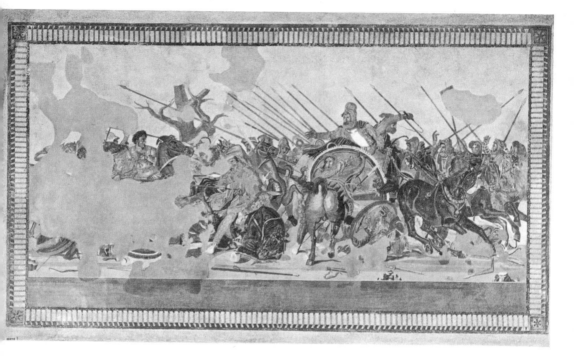

XI. Alexander Mosaic

Copy. Original c. 300 B.C. *Naples, Museo Nazionale*

XII Herakles and Omphale

Almost all the senses are assaulted in this scene. It represents Herakles succumbing to the pleasures of life at the court of Omphale, the queen of Lydia. The god of wine has already received his tribute: the hero is inebriated – a large drinking cup drained of its contents rolls over at his feet – and he has donned the god's wreath of vine leaves and carries his thyrsos. Like Dionysos himself (see 174) Herakles requires support, so he throws his arm around the wily Priapos, a daemon of fertility. The noise is terrific: a maenad clashes cymbals in Herakles' right ear, and Eros, perched on his shoulder, blows pipes into the other. Two more Erotes gambol in the foreground next to the quiver which has been cast aside. The very lightly clad queen relishes the proceedings, and her attendants gaze at the hero not in disgust but in awe. They are, after all, witnessing a religious event, almost a miracle, in which the hero has become possessed and rendered helpless by divine power. The deep physical bond, if not the "sacred marriage," between Herakles and Omphale is pointed up by the exchange of garments. The queen wears Herakles' standard uniform, the lion's skin, over her head and shoulders and rests her soft hand on his club. Presumably her flimsy robes trail around his arms and thighs. The nudity or near-nudity of both, the amplitude of their bodies, and their presence so large and close to the picture plane all lend a sensual immediacy

to the scene which, with every justification, has often been compared to the Dionysiac subjects painted by Rubens. The genial mood of all the participants is reflected in the sunny coloring: the background is a light greenish blue; this is picked up again in some draperies, but bright yellow, warm flesh tones, and glowing reds and browns radiate from the majority of forms. Judging by the Asiatic locale of the subject and the heroic proportions of both Herakles and Omphale, the painter may have lived in Asia Minor, perhaps at Pergamon.

Herakles is not yet the degraded fool Roman comic poets will make him out to be. The "baroque" exuberance and the good-humored mingling of the religious and the sensuous are characteristically Hellenistic. Copy of an original, possibly of the early second century B.C.

Naples, Museo Nazionale, Inv. no. 8992. H. 1.92 m. W. 1.51 m. From the *Triclinium* of the House of M. Lucrezio, Pompeii. The inherently religious nature of the painting is underlined by the fact that it was in the same room with two other paintings that celebrate Dionysos. All three paintings may be derived from one Hellenistic cycle illustrating the life of the wine god. M. Borda, *La pittura romana*, 237-39. E. Suhr, "Herakles and Omphale," *AJA, 57*, 1953, 251-63. K. Schefold, *Pompejanische Malerei*, 132 ff. L. Richardson, (*MAAR, 23*, 1955, 139) attributes the panel to the "Achilles Painter." G. M. A. Hanfmann, *DOPapers, 17*, 1963, 90, fig. 30. For a different interpretation of the action see J. Beazley and B. Ashmole, *Greek Sculpture and Painting*, 2nd ed., 1966, 58.

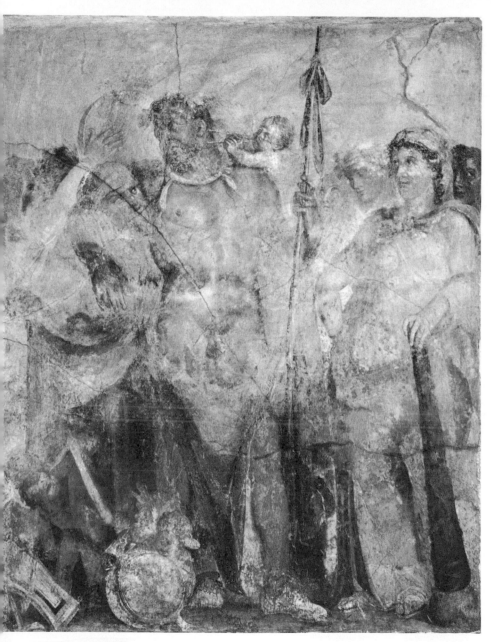

XII. Herakles and Omphale

Copy. Original early second century B.C. *Naples, Museo Nazionale*

PLATE **XIII** Mosaic of Musicians

Dioskourides of Samos made this mosaic – as the small neat inscription at the top left informs us. He also signed another one, similar in size and subject, and the two served as floor decoration in the Villa of Cicero at Pompeii. Both scenes appear to be drawn from the world of the theater: the grinning or grotesque masks worn by nearly all characters and the merrymaking situations suggest that we are observing some aspect of New Comedy performance. The narrow stagelike space occupied by the four figures, as well as the door on one side, shown in this mosaic, also recall a theatrical setting.

The merrymakers here make music. The loudest sounds come from the two masked(?), wreathed, and beribboned men. One bangs a large tambourine, the other, watching his fellow trouper intently, beats time with his cymbals. Their bodies are incapable of resisting the rhythmic tones, and so they dance, none too gracefully, along the stage. Close by, a woman wearing a white mask pierces the air with double pipes, and next to her a diminutive male – a dwarf? a child with aged face? – listens and observes in silence. This is not, obviously, a dramatic episode. Perhaps, then, these "lowlife" creatures represent a company of itinerant musicians who were hired to entertain the audience between acts.

Although the mosaic has been considerably restored (especially the door, the platform, and the woman's gown), enough of the original remains for us to marvel at the minuteness of the tesserae and the regularity with which they have been set into the plaster. The colors on the whole are subdued but the deeper hues – blue, yellow, white, pink, and brown – reside in the figures, which consequently stand out from the paler background. Rendered as three-dimensional forms, parts of which appear in strong light, the figures cast shadows like sculptured objects in the sun. Each of the two men, in fact, has a twin among terra-cotta figurines of the period.

Except for one minor variation, exactly the same scene was represented in a painting at Stabiae. Presumably both were derived from a lost painted original. The date of the original probably falls within the third century.

It has been argued, furthermore, that the subject of the companion mosaic depicts an episode from one of Menander's plays. The lettering of the inscription in our mosaic indicates that Dioskourides, who must have migrated from Samos to Italy, made his copy about 100 B.C.

Naples, Museo Nazionale, no. 9985. H. 0.437 m. For the terra-cotta figurines: M. Bieber, *History of Greek and Roman Theater*, figs. 341, 342. On the possible relationship to New Comedy: T. B. L. Webster, *Hellenistic Poetry and Art*, 185. E. Pernice, *Pavimenti und figürliche Mosaiken, Die hellenistische Kunst in Pompeji*, VI, 169-71.

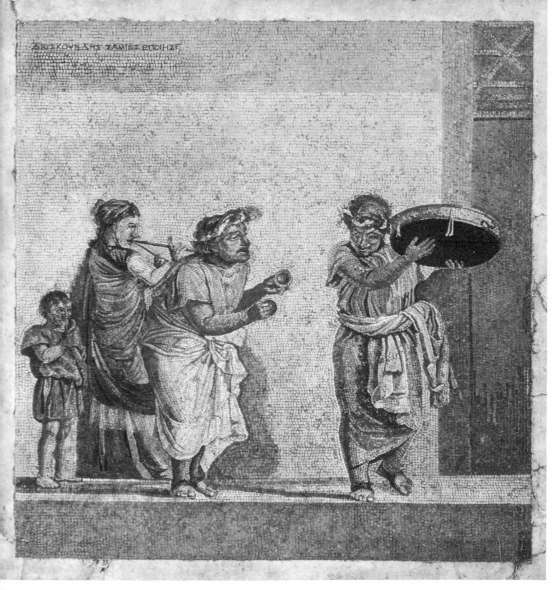

III. Mosaic of Musicians, by Dioskourides of Samos

Copy. Original third century B.C. *Naples, Museo Nazionale*

PLATE **XIV** Dove Mosaic

It was Pliny's view that the most famous exponent of the mosaic art in Greece was Sosus of Pergamon. In one example Sosus showed "a dove who is drinking and casts the shadow of its head on the water, while others are sunning and preening themselves on the brim of a large drinking vessel" (*N.H.* XXXVI, 184). Such a scene is preserved in several mosaics of the Roman period, but this copy is usually considered to be the best reproduction of Sosus' original. It was discovered in a room of Hadrian's Villa at Tivoli in 1737.

Within a colorful frame decorated with a bead and reel design, a large gold bowl rests on a slab of marble. Its feet are spool-like, and its handles are broad loops attached to a rim with an egg and dart molding. A strange winged male figure is embossed under the handle; he stretches from the base to the rim like a caryatid. Two white doves and one brown one perch above the water exactly as Pliny describes. However, the cool clear liquid, though filled with its own lights, does not throw any reflection of the drinking dove's head. The mottled forms of the birds create saucy silhouettes against the dark and empty background. And again, their asymmetrical arrangement contributes to our appreciation of the bowl as a three-dimensional object. The modeling effects of light and shadow also achieve this. The hard metallic surface of the vase as opposed to the downy softness of the doves is also skillfully handled.

Sosus had a sense of humor. One of his mosaic pavements (of which this dove panel may have formed the center) represented an unswept floor after the dinner guests had departed. The debris from the table and other sweepings were strewn about at random. Copies of this mosaic also exist.

This important artist probably worked in Pergamon in the first half of the second century.

Rome, Museo Capitolino. H. 085 m. E. Pernice, *Pavimenti und figürliche Mosaiken*, VI, 164-67; E. Pfuhl, *Malerei und Zeichnung*, II, 8946, 948. K. Parlasca (*JdI, 78*, 1963, 256-93) connects Sosus' rendering of the doves and vessel with Nestor's cup (Homer, *Iliad*, 11, 632-37) and with funerary symbolism. The connection, if true, would constitute another example of the transfer of a heroic motif to a non-heroic context (see Pl. X).

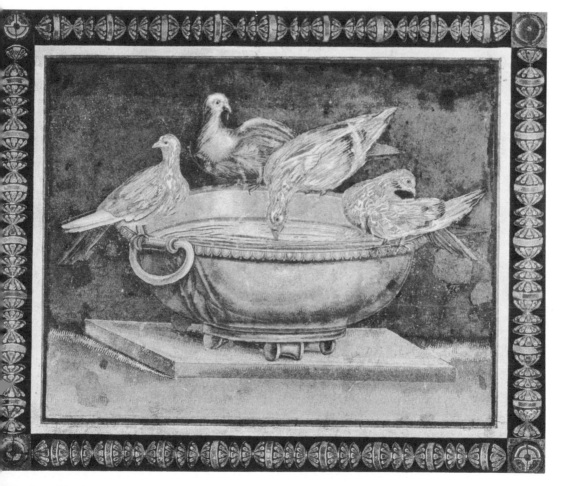

IV. Dove Mosaic

Copy. Original first half of second century B.C. *Rome, Museo Capitolino*

PLATE **XV** Citharist and Attendant

In 1900 a villa which belonged to P. Fannius Synistor was uncovered at Boscoreale near Pompeii. Several rooms were decorated with murals, which all together constitute one of the most interesting and yet most problematic series of paintings to have come down to us from antiquity. On the walls of an exceedingly spacious room, a veritable hall opening off the peristyle, were nine panels separated by painted Corinthian columns. We illustrate here one of the three panels from the east side of the hall which were acquired by the Metropolitan Museum of Art in New York in 1903.

The panels themselves are large – so too are the figures. This is the most striking thing about the seated woman shown here; she is monumental, sculptural, and unconfined. In these respects, she resembles "Arcadia" (Pl. XVI) or the seated Dionysos in the British Museum (126). Her orange throne seems to have been made for a queen; it appears to be all the more ample because we see it in perspective. The stage is fairly deep, and the red wall is far enough back to provide plenty of room for the stocky young female attendant.

The seated woman plays a cithara of gold. Her tapering fingers lie lightly on the strings. She wears a bracelet, ring, earrings, and diadem. The young girl is also well equipped with jewelry. The two of them look out with large eyes, in slightly different directions.

Whether or not all of the panels in the hall are related in meaning is one of the major points of contention. Even those scholars who accept a single comprehensive theme cannot agree on its nature. Is it mythological or historical – or are the scenes taken from daily life? If mythological, as P. W. Lehmann proposes, our citharist is a bard at the festival of Adonis; if historical, she would be a courtesan at the court the Macedonian king Antigonos Gonatas (so argues F. Studniczka). In M. Robertson's opinion she is a musician at the wedding of Alexander and Roxane, or perhaps even the city goddess of Susa. Bieber claims she is a member of the family who owned the villa. It seems that these two disturbingly quiet figures and their several companions will never betray their secret. On one issue, however, the majority agree: the paintings are copies made about 40 B.C. after lost Hellenistic originals executed in the late third or second century B.C.

New York, Metropolitan Museum of Art, no. 03.14.5. H. 1.88 m. W. 1.87 m. E. Simon (*Die Fürstenbilder von Boscoreale, Deutsche Beiträge zur Altertumswissenschaft*, 7, 1958) summarizes the proposed identifications (with bibliography). P. W. Lehmann's description of the New York paintings is indispensable: *Roman Wall Paintings from Boscoreale in the Metropolitan Museum of Art.* M. Robertson, *A. History of Greek Art*, 571-75.

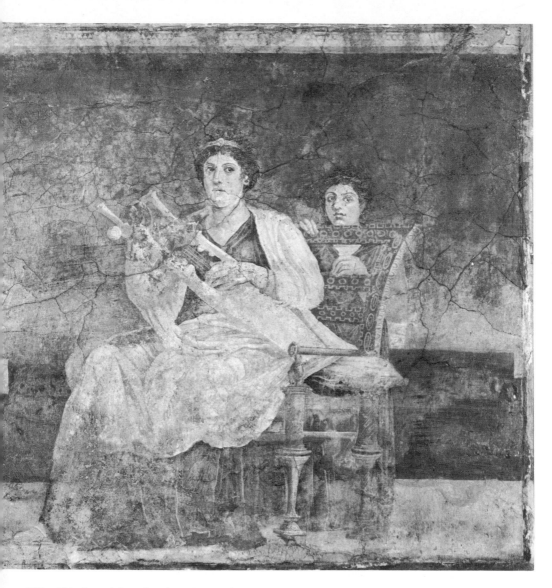

XV. Citharist and Attendant from Boscoreale

Copy. Original late third to second century B.C. *New York, Metropolitan Museum of Art*

PLATE **XVI** Herakles and Telephos

This is a memorable painting – one of the most impressive to have survived from antiquity. The mood is idyllic; the setting is rustic. The figures maintain an Olympian calm and dignity. The ivory-skinned seated female is as timeless and statuesque as a figure by Poussin. The monumental forms are close to the spectator and they occupy, without crowding, nearly the whole panel. Heroes, or at least heroic persons, and noble beasts have foregathered on what seems to be a mountaintop.

We already know the story and, indeed, have seen it, in part, in sculptured form (167): Herakles discovers his son Telephos safe and well after all. The child, which had been exposed by its mother, providentially escaped death by being suckled by a hind. This is the tender episode in the foreground which Herakles, his back toward us, observes and which he seems to have no inclination to disturb. A large eagle stands by protectively. A lovely winged maiden, who points toward Telephos, has guided Herakles to this place. She has been identified as Parthenos, the nymph of the mountain where the child was born. But by far the most majestic figure is Arcadia, who is seated on a rocky ledge holding a staff and gazing into the distance. Her hair is wreathed with flowers; a basket containing grapes and pomegranates lies at her side. Her gifts to the land which she personifies are bounteous; her stillness suggests that they are unending. It is a joyful land; perched still higher, perhaps on a cloud, a satyr or Pan happily plays his pipes and holds a shepherd's crook.

The painting is usually thought to be a copy of an original executed in Pergamon. Both subject and style seem to support this view. Telephos, as we know, was the mythical founder of the Attalid dynasty, and the Pergamene kings carried their ancestry back, accordingly, to Herakles and to his father Zeus, symbolized here by the eagle. The shaggy lion at the lower right may denote the power and might of this famous Hellenistic city. In addition, the presence of grapes and a satyr-Pan may allude to Dionysos, a god highly honored at Pergamon. The diagonal penetrations, the layering of figures, and the liberal inclusion of landscape elements are strongly reminiscent of the boat scene from the Telephos frieze of the Altar of Zeus (166). On the other hand Herakles' pose almost exactly reproduces that of the "Farnese Herakles" by Lysippos (81), and Arcadia might have stepped out of a fourth-century Attic grave stele. These classicizing features, accompanied as they are by an elaborate program of dynastic propaganda, call to mind the Tazza Farnese (Pl. IV). The original painting, therefore, probably dates between 150 and 133 B.C., after which Pergamon became Roman territory.

In its present condition the painting is almost monochrome. The overall tonality is a deep rose, becoming red-brown for the darker forms of Herakles and the two animals. Pale blues and greens tint the background, the rocks, the fruits, and the flowers.

Naples, Museo Nazionale, no. 9008. H. 2.02 m. Surface slightly concave. From the Basilica at Herculaneum. Telephos is suckled by a lioness, not a hind, in the Telephos frieze. Also compare Herakles with the Hellenistic Ruler (19). E. Simon, *JdI, 76*, 1961, 138-47. For other interpretations: M. Gabriel, *Masters of Campanian Painting*, 27-29, and R. Hamann, *Abh. Deut. Akad., Klasse für Sprache, Literatur und Kunst*, 9, 1952.

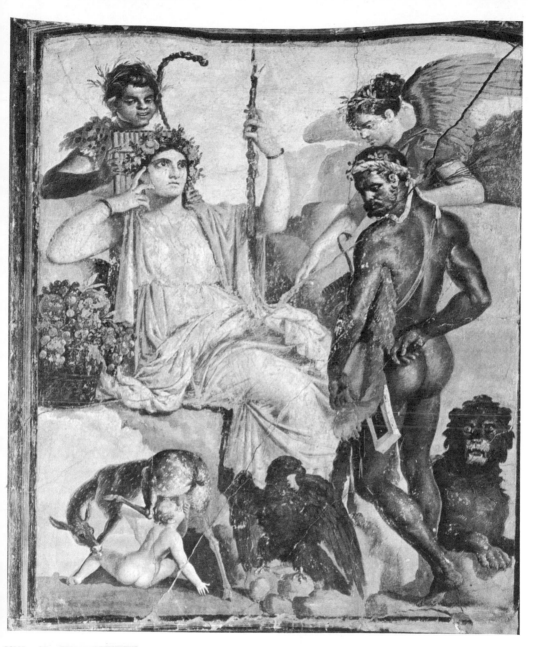

XVI. Herakles and Telephos

Copy. Original second half of second century B.C. *Naples, Museo Nazionale*

PLATE **XVII** The Attack of the Laestrygonians

This is the third of eleven sections of a long frieze illustrating episodes from Books X-XII of Homer's *Iliad*. The frieze was found in a house in Rome in the 1840s, and it is one of the wonders of ancient art. In recounting the adventures he and his men experience on their journey homeward from the Trojan War, Odysseus tells of the visit to the land of the Laestrygonians. It was a most unfortunate one. After bringing their ships into a calm harbor, they made their way toward the town and were suddenly set upon by the giantlike, man-eating Laestrygonians. Odysseus hoisted his sails forthwith and escaped, but he lost all but one of his ships, and a "pitiful destruction" descended upon his men. This is the tale that occupies several sections of the frieze, including the one shown here. Odysseus' sojourn in the home of Circe and in the underworld were also represented in the sequence.

In his oral account, Odysseus mentions only briefly the steep cliffs, jutting headlands, and craggy hills of the Laestrygonian country. The painter of the frieze, however, has made this landscape his romantic hero. The episodes should be read from left to right. In the panel preceding this one, the ships lie in the bay, and then a lovely pastoral scene opens out and continues into our section. In the foreground, to the left, while a nymph and a shepherd watch, sheep lie asleep or drink at a pale blue pool. Behind them a herdsman tends his goats, which graze in a meadow. In the background we see the walls of the town projecting from the mountaintops and a small building containing a statue. This peaceful scene abruptly changes as we move again to the foreground: the Laestrygonians attack. One

brawny giant tries to pull down a tree; another rushes forward with spears, and a third bends over to gather rocks. Further to the right one of them is already making off with his midday meal – a corpse – on his back, and another poor Greek is being captured in the water. On the shore the Laestrygonian king Antiphates (his name is written in Greek above) raises the war cry while still more of his men scramble up the cliffs in order to cast boulders upon the Greeks. The projecting rock in the foreground, the spaces between the pools, and the trees and soaring mountains in the distance dwarf the figures and send our eyes exploring the awesome beauty of the landscape.

Peter H. von Blanckenhagen has demonstrated that the Odyssey landscapes are copies rather than originals. Odysseus' adventures unfold against a continuous landscape background reminiscent of the way in which Telephos' life is described in the small frieze of the Pergamon Altar (c. 160 B.C.) (166). Perhaps, then, these painted landscapes originated about 150 B.C.

Rome, Vatican Museum, Library. H. 1.50 m. Found in 1840 and 1849 in a house in Rome on Via Graziosa. There is considerable restoration and damage. The colors are generally more pastel than in our reproduction. The wall on which the frieze was found was in *opus reticulatum*, which may be dated to between 50-30 B.C. The subdivision of the frieze into eleven sections by painted pilasters was presumably the work of the copyist. Not all sections are preserved. The frieze is very controversial. Some scholars deny that it is Greek at all. Blanckenhagen (*RM, 70*, 1963, 100-46) and G. M. A. Hanfmann (*Roman Art*, comment on Color Plate XXVII) summarize the major problems and theories. See also A. Gallina, *Le Pitture con Paesaggi dell' Odessea dall'Esquilino*, Studi Miscellanei, 6, 1964.

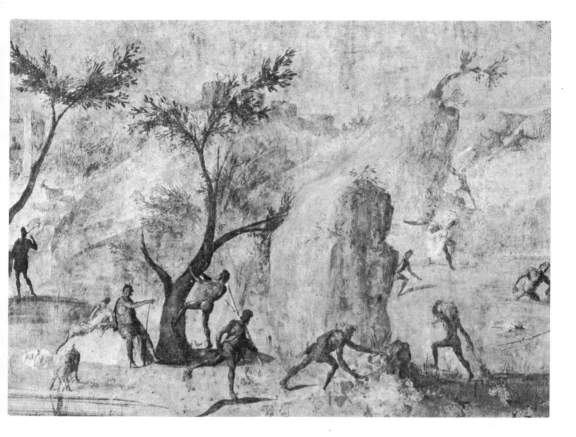

XVII. The Attack of the Laestrygonians

Copy. Original c. 150 B.C. *Vatican Museum*

PLATE **XVIII** "Dionysos Riding a Panther"

The ground plan of the House of the Masks (53), one of the most sumptuous houses at Delos, shows the location of the various mosaic pavements. The floor of Room C, to the right of the peristyle court, was decorated with a long rectangle surrounded by a wide ornamental border. In the center, within its own simple and almost square frame, lay the main feature of the design, the emblema, which we illustrate here. It depicts a richly robed figure seated cross-legged on the back of a panther. What is the identity of this person? Is it, for instance, a male or a female, or perhaps a mixture of both? If a kantharos were carried, or if vine instead of ivy leaves encircled the neck of the panther, there would be no question that the figure represented Dionysos, the habitual animal-rider of the Greek gods.

J. Chamonard suggested that the person is indeed Dionysos, but in rather unusual guise. He appears here less as the god of wine than as the patron of dramatic festivals. The gravity of his expression, his long-sleeved costume, red shoes, and elaborate headdress can all be connected with the performance of tragedy. He holds in his left hand a tympanum to suggest, very likely, the musical aspects of the festivals.

It is interesting to contrast this mosaic with the detail of an earlier one – also from Delos and similar in subject – illustrated in Color Plate VIII. The forms have become drastically simplified and hard. In the earlier example, the tesserae, exquisitely graded and variegated in tone, construct a very dense volume and a terrifyingly believable animal.

Bulges and protuberances in the brows and snout of this panther, on the other hand, have been severely outlined and pressed into a two-dimensional framework. The beast is unpleasant, it is true, but he is petrified. His mottled body is surprisingly flat despite some residual modeling, and the folds of the rider's yellow cloak are extremely linear and stylized. The god, moreover, is in danger of falling off his mount.

Yet for all that, this emblema from the House of the Masks is a colorful piece of decoration, and it could be argued that strong pictorial effects are in any case unsuitable in floor mosaics. The background is solid black, and a dark gray strip suggests the ground. Then vivid yellow and vermilion, and bright pink and white, are juxtaposed or shaded with brown or gray. Technically, also, the mosaic is very fine. The tesserae vary in size, the smaller ones being reserved for the details of the face, the larger for the background and border.

The house was erected apparently before 150 B.C., but the schematized forms of the mosaic indicate that it was installed at least fifty years later.

Delos, House of the Masks. H. 1.08 m. J. Chamonard, *Les Mosaïques de la Maison des Masques* ("Exploration archéologique de Délos," XIV; Paris, École française d'Athènes, 1933), 11-22. I have accepted the dating of B. R. Brown (*Ptolemaic Paintings and Mosaics and the Alexandrian Style*, 76); T. B. L. Webster, *The Age of Hellenism*, 152-53, proposes some very interesting extensions of Chamonard's interpretation. P. Bruneau, *Mosaïque de Délos*, Paris, 1973, no. 13.

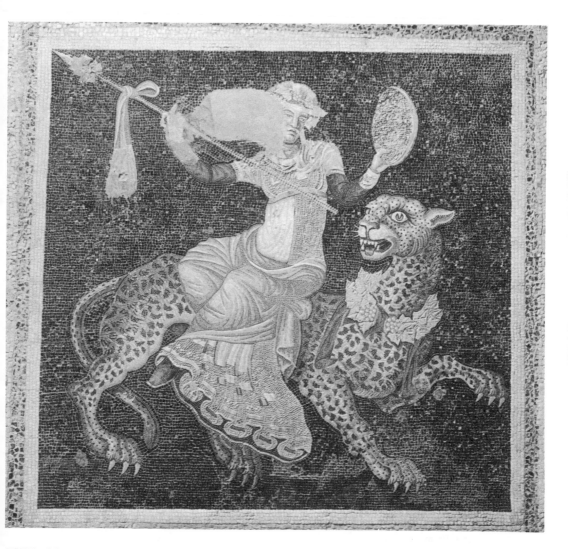

XVIII. Mosaic of Dionysos Riding a Panther

c. 100 B.C. *Delos, House of the Masks*

PLATE **XIX** The Three Graces

The Three Graces were the daughters of Zeus and, at least according to Hesiod, of Eurynome. More inseparable than their sisters the nine Muses, they were represented as a group in Greek art from the Archaic period on. In early renderings they are fully clothed and normally face the spectator. Hellenistic artists, however, preferred them nude and in the intertwined arrangement that we see here.

Their duties were manifold, but they spent most of their time in the company of Aphrodite, whom they so much resembled in youth, beauty, and purity. They helped her bathe and they anointed her. Their influence was without exception beneficent. When represented in art they almost always touch each other – in archaic reliefs they hold hands – as a manifestation of their kind and loving natures. Very frequently also they dance, an indication of the joy and harmony their presence arouses. Fruits and flowers or water-filled vases – associating them with the fertility of nature – are their customary attributes.

Modesty and virgin beauty are the outstanding qualities of the figures as they are represented here in this small painting discovered at Pompeii. They dance quietly in a rocky glade sprinkled with plants and flowers. Their heads tend to be lowered, as do their eyes. From their "eyes as they glanced flowed love that unnerves the limbs; and beautiful is their glance beneath their brows" (Hesiod, *Theogony*, 907-909). The design is symmetrical and balanced, but subtly so. The poses are repetitious, but variation is achieved by changing the distribution of weight. The central Grace stands with her back facing us – that favorite Hellenistic motif! (Pl. IV) – and rhythmic interlacings are provided by the gracefully extended arms. The Graces' freshness and youth are particularly evident in the pink blushes of their flesh. Each wears a flowered wreath, gold anklets, bracelets, and earrings. They are all brunettes.

The same composition exists in mosaics, gems, coins, and in sculpture in relief and in the round of the Roman period. These, along with this example, are thought to be derived from one Greek original. Whether it was painted or sculptured has been debated for a number of years. The opinion currently favored is that the group was first executed in round sculpture. The most famous example is now in Siena. The rather elongated proportions and the one-view principle on which the composition is based make it fairly certain that the Three Graces were first sculptured in the late Hellenistic period. The name of the sculptor is not known, but he may have been a member of the school of Pasiteles (147) of the first century B.C.

Naples, Museo Nazionale, no. 9236. H. 0.50 m. For the statuary group: M. Borda, *La Scuola di Pasiteles*, Bari, 1953, 79 ff.; R. Lullies, *Mitt d. Inst.* I, 1948, 45-52 (with earlier bibliography). For the considerable influence of the group during the Renaissance: A. von Salis, *Antike und Renaissance*, Erlenbach-Zurich, 1947, 153-64.

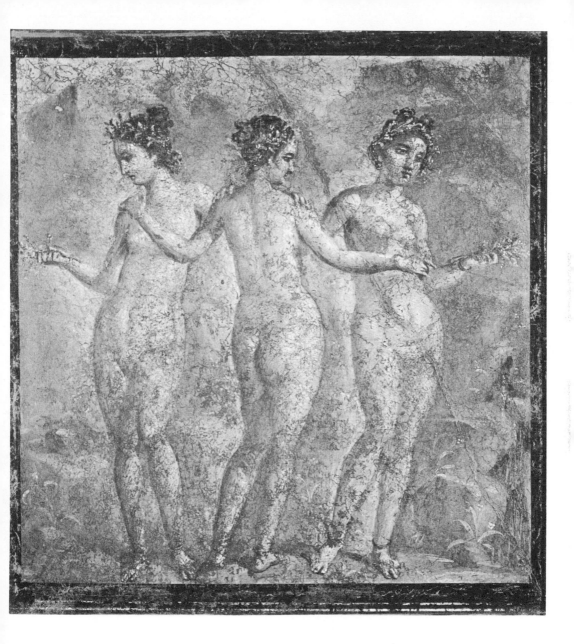

XIX. Three Graces

Copy of Hellenistic sculpture of first century B.C. *Naples, Museo Nazionale*

PLATE XX Medea

Toward the end of Euripides' play *Medea*, the heroine, in an unforgettable speech, deliberates upon the fatal act she is about to commit: the murder of her two children. This she feels driven to do in order to punish her husband Jason, who has deserted her. "Why," she asks, "should I hurt their father by hurting them? – No, I cannot do it. – O, what is wrong with me? – I shall follow this thing to the end. How weak I am! My poor heart – do not do this thing!" And yet a few moments later she does it.

Medea's pride and passion and her inner turmoil are all captured in this fragmentary painting from Herculaneum. There are no histrionics. We could read her mind even if she were faceless – by her lowered head, by the rigidity of her arms (they hug her body as if she were restraining herself), by the intertwined and working fingers. She stands still, but one foot restlessly stirs. Her pose sums up her dilemma and the whole point of the drama: she is a dignified and thinking person on the verge of a base and desperate act. In her hands is the sword she will soon use. Her gown is depicted in delicate lilac and rose tones. Another complete rendering of the scene shows that her half-vacant stare is directed at her two sons, who innocently play nearby. The steps and door behind locate the scene in front of her Corinthian house.

The dignity and statuesque quality of Medea's figure and the position of her arms and hands recall the full-length portrait in Copenhagen of Demosthenes of the early third century (25). The heavily wrapped drapery around her waist and hips, however, resembles that in the Sacrificing Girl in Rome of the late third century (114). Still, the folds of the lower part of her gown are arranged according to High Classical conventions (cf. 125). The figure thus seems to be eclectic in style, and it may therefore be copied from a late Hellenistic original, perhaps by Timomachos of Byzantium (mid first century B.C.). Medea moved audiences all through the Hellenistic period, for Euripides' famous play was revived many times.

Naples, Museo Nazionale, no. 8976. H. 1.37 m. For the complete scene (with a slightly different version of Medea): L. Curtius, *Die Wandmalerei*, pl. VII. G. Lippold (*Antike Gemäldekopien*, 62-63) dates the original in the fourth century.

XX. Medea

Copy. Original first century B.C.
Naples, Museo Nazionale

Bibliography

General

E. Akurgal, *Ancient Civilization and Ruins of Turkey*, Istanbul, 1970.

E. Badian, *Studies in Greek and Roman History*, Oxford, 1964.

G. E. Bean, *Aegean Turkey, An Archaeological Guide*, New York, 1966.

J. D. Beazley and B. Ashmole, *Greek Sculpture and Painting*, Cambridge, England, 1966.

E. R. Bevan, *A History of Egypt under the Ptolemaic Dynasty*, London, 1927.

J. Boardman, J. Dörig, W. Fuchs, *Greek Art and Architecture*, New York, 1967.

A. Burford, *Craftsmen in Greek and Roman Society*, Ithaca, N. Y., 1972.

Cambridge Ancient History, Cambridge, England, 1923-39, VI-IX.

R. Carpenter, *The Esthetic Basis of Greek Art*, 2nd ed. Bloomington, Ind., 1959.

————, "Observations on Familiar Statuary in Rome," *MAAR, 18*, 1941.

J. Charbonneaux, R. Martin, F. Villard, *Hellenistic Art*, New York, 1973.

K. Clark, *The Nude: A Study in Ideal Form*, Bollingen Series 35.2, New York, 1956.

L. R. Farnell, *The Cults of the Greek States*, 5 vols. Oxford, 1896-1909.

W. S. Ferguson, *Hellenistic Athens*, London, 1911.

M. Hadas, *Hellenistic Culture*, New York, 1959.

G. Hagner, *Geschichte der griechischen Kunst*, Zürich, 1961.

G. M. A. Hanfmann, "Hellenistic Art," *DOPapers, 17*, 1963, 79-94.

————, *Classical Sculpture*, Greenwich, Conn., 1967.

E. V. Hansen, *The Attalids of Pergamon*, Ithaca, N.Y., 1947.

H. A. Harris, *Greek Athletes and Athletics*, Bloomington, Ind., and London, 1966.

W. Helbig, *Führer durch die öffentlichen Sammlungen klassischer Altertümer in Rom*, 4th ed., H. Speier, vol. I, 1963: vol. II, 1966.

A. Körte, *Hellenistic Poetry*, trans. Hammer and Hadas, New York, 1929.

D. C. Kurtz and J. Boardman, *Greek Burial Customs*, Ithaca, N. Y., 1971.

E. Langlotz, *Die Kunst der Westgriechen in Sizilien und Unteritalien*, Munich, 1963.

G. E. R. Lloyd, *Greek Science after Aristotle*, London, 1973.

A. A. Long, *Hellenistic Philosophy; Stoics, Epicureans, Sceptics*, London, 1974.

G. H. Macurdy, *Hellenistic Queens*, Baltimore, 1932.

M. P. Nilsson, *A History of Greek Religion*, trans. F. J. Fielden, 2nd ed. Oxford, 1949.

I. Noshy, *The Arts in Ptolemaic Egypt*, London, 1937.

J. J. Pollitt, *The Art of Greece, 1400-31 B.C.: Sources and Documents*, Englewood Cliffs, N.J., 1965.

————, *Art and Experience in Classical Greece*, Cambridge, England, 1972.

G. M. A. Richter, *Ancient Italy*, Ann Arbor, 1955.

————, *Three Critical Periods in Greek Sculpture*, Oxford, 1951.

————, *A Handbook of Greek Art*, 4th ed., New York, 1965.

M. Robertson, *A History of Greek Art*, London, 1975.

M. I. Rostovtsev, *The Social and Economic History of the Hellenistic World*, 3 vols. Oxford, 1941.

G. Sarton, *A History of Science*, vol. 2, Cambridge, Mass., 1959.

D. Schlumberger, *L'Orient Hellenisé, L' Art Grec et ses Héritiers Dans l'Asie non Mediteraneéne*, Paris, 1970.

Portraits

J. Babelon, *Le portrait dans l'antiquité d'après les monnaies*, Paris, 2nd ed. 1950.

J. J. Bernoulli, *Die erhaltenen Darstellungen Alexanders des Grossen*, Munich, 1905.

M. Bieber, *Alexander the Great in Greek and Roman Art*, Chicago, 1964.

E. Buschor, *Das hellenistische Bildnis*, Munich, 1949.

N. Davis, C. M. Kraay, *The Hellenistic Kingdoms, Portrait Coins and History*, London, 1973.

R. Delbrück, *Antike Porträts*, Bonn, 1912.

B.M. Felletti Maj, *I ritratti, Catalogo del Museo nazionale romano*, Rome, 1953.

G. Hafner, *Späthellenistische Bildnisplastik*, Berlin, 1954.

A. Hekler, *Bildnisse berühmter Griechen*, Berlin, 1962.

R. P. Hinks, *Greek and Roman Portrait-Sculpture*, London, 1935.

C. M. Kraay and M. Hirmer, *Greek Coins*, New York, 1966.

L. Laurenzi, *Ritratti greci*, Florence, 1941.

G. Lippold, *Griechische Porträtstatuen*, Munich, 1912.

E. T. Newell, *Royal Greek Portrait Coins*, New York, 1937.

H. P. L'Orange, *Apotheosis in Ancient Portraiture*, Oslo, 1947.

E. Pfuhl, "Ikonographische Beiträge zur Stilgeschichte der Hellenistischen Kunst," *JdI, 45*, 1930, 1-61.

————, *Die Anfänge der Griechischen Bildniskunst*, Munich, 1927.

V. Poulsen, *Les portraits grecs*, Copenhagen, 1954.

G. M. A. Richter, *The Portraits of the Greeks*, 3 vols. London, 1965.

K. Schefold, *Die Bildnisse der antiken Dichter, Redner und Denker*, Basel, 1954.

B. Schweitzer, *Die Bildniskunst der Römischen Republik*, Leipzig, 1948.

E. G. Suhr, *Sculptured Portraits of Greek Statesmen*, London and Baltimore, 1931.

O. Vessberg, *Studien zur Kunstgeschichte der römischen Republik*, Lund, 1941.

Architecture

H. Berve and G. Gruben, *Greek Temples, Theatres and Shrines*, New York, 1963.

M. Bieber, *The History of the Greek and Roman Theater*, 2nd ed. Princeton, 1961.

A. Boëthius, *Roman and Greek Town Architecture*, Göteborg, 1948.

T. D. Boyd, *The Arch and Vault in Greek Architecture*, Diss. Indiana, 1976, Xerox University Microfilms, Ann Arbor, Michigan.

J. J. Coulton, *The Architectural Development of the Greek Stoa*, Oxford, 1976.

————, *Greek Architects at Work*, London, 1977.

W. B. Dinsmoor, *The Architecture of Ancient Greece*, London and New York, 1950.

A. H. M. Jones, *The Greek City from Alexander to Justinian*, Oxford, 1966.

A. W. Lawrence, *Greek Architecture*, Baltimore, 1957.

P. W. Lehmann, "The Setting of Hellenistic Temples," *JSAH, 13*, 1954, 15-20.

M. Lyttelton, *Baroque Architecture in Classical Antiquity*, London, 1974.

W. A. McDonald, *The Political Meeting Places of the Greeks*, Baltimore, 1943.

R. Martin, *Recherches sur l'agora grecque; études d'histoire et d'architecture urbaines*, Paris, 1951.

————, *L'urbanisme dans la Grèce antique*, Paris, 1956; 2 ed., 1974.

D. M. Robinson and J. W. Graham, *The Hellenic House, Excavations at Olynthus*, VIII, Baltimore and London, 1938.

R. L. Scranton, *Greek Architecture*, New York, 1962.

————, "Group Design in Greek Architecture," *AB, 31*, 1949, 247-68.

V. Scully, *The Earth, the Temple and the Gods: Greek Sacred Architecture*, New Haven and London, 1962.

H. A. Thompson, R. E. Wycherley, *The Athenian Agora 14. The Agora of Athens: The history, shape and uses of an ancient city center*, Princeton, 1972.

R. A. Tomlinson, *Greek Sanctuaries*, New York, 1976.

J. Travlos, *A Pictorial Dictionary of Ancient Athens*, London, 1970.

J. B. Ward-Perkins, *Cities of Ancient Greece and Italy: Planning in Classical Antiquity*, New York, 1974.

R. E. Wycherley, *How the Greeks Built Cities*, London, 1962.

————, *The Stones of Athens*, Princeton, 1978.

Sculpture

A. Adriani, *Testimonianze e momenti di scultura alessandrina* (Documenti e ricerche d'arte alessandrina), Rome, 1948.

L. Alscher, *Griechische Plastik*, 3 vols. Berlin, 1954-57.

M. Bieber, *The Sculpture of the Hellenistic Age*, rev. ed. New York, 1961.

P. Bienkowski, *Die Darstellungen der Gallier in der Hellenistischen Kunst*, Vienna, 1908.

R. Carpenter, *Greek Sculpture, A Critical Review*, Chicago, 1960.

J. Charbonneaux, *Greek Bronzes*, trans. K. Watson, New York, 1962.

P. Demangel, *La Frise Ionique*, Paris, 1932.

G. Dickins, *Hellenistic Sculpture*, Oxford, 1920.

H. Diepolder, *Die attischen Grabreliefs des 5. und 4. Jahrhunderts v. Chr.*, Berlin, 1931.

G. M. A. Hanfmann, "Etruscan Reliefs of the Hellenistic Period," *JHS, 65*, 1947, 45 ff.

U. Hausmann, *Griechische Weihreliefs*, Berlin, 1960.

R. Horn, Stehende weibliche Gewandstatuen in der hellenistischen Plastik, *RM, Ergänzungsheft II*, 1931.

F. P. Johnson, *Lysippos*, Durham, N.C., 1927.

H. Kähler, *Der grosse Fries von Pergamon*, Berlin, 1948.

G. Kleiner, Tanagrafiguren, Untersuchungen zur hellenistischen Kunst und Geschichte, *JdI, Ergänzungsheft, 15*, 1942.

K. Kluge and K. Lehmann-Hartleben, *Die antiken Grossbronzen*, 3 vols. Berlin, 1927.

G. Krahmer, "Die einansichtige Gruppe und die späthellenistische Kunst," *Nachrichten der Gesellschaft der Wissenschaften zu Göttingen*, Phil.-Hist. Klasse, 1927, 53-91.

————, "Stilphasen der hellenistischen Plastik," *RM, 38-39*, 1923-24, 138-89.

E. Künzl, *Frühhellenistische Gruppen*, Cologne, 1968.

A. W. Lawrence, *Later Greek Sculpture and Its Influence on East and West*, New York, 1927.

A. Linfert, *Kunstzentren Hellenistischer Zeit, Studien An Weiblichen Gewandfiguren*, Wiesbaden, 1976.

G. Lippold, *Die Griechische Plastik*, Handbuch der Archaologie, Part 6, vol. III, 1, Munich, 1951.

R. Lullies and M. Hirmer *Greek Sculpture*, rev. ed., New York, 1960.

F. Magi, *Il Ripristino del Laocoonte*, Rome, 1960.

G. S. Merker, *The Hellenistic Sculpture of Rhodes*, Göteborg, 1973.

H. Mobius and E. Pfuhl, *Die Ostgriechischen Grabreliefs*, Mainz, 1977.

S. Mollard-Besques, *Catalogue Raisonné des Figurines et Reliefs en terre-cuite Grecs, Etrusques et Romains*, Paris, 1954.

V. Müller, "Chronology of Greek Sculpture," *AB, 20*, 1938, 359 ff.

C. Picard, *Manuel d'archéologie grecque, La sculpture*, Vol. IV : 1-2, Paris, 1963.

G. M. A. Richter, *The Sculpture and Sculptors of the Greeks*, new rev. ed., New Haven, 1950.

B. S. Ridgway, "Notes on the Development of the Greek Frieze," *Hesperia, 35*, 1966, 188-204.

————, *The Severe Style in Greek Sculpture*, Princeton, 1970.

————, *The Archaic Style in Greek Sculpture*, Princeton, 1977.

E. Sjöqvist, *Lysippus*, Lectures in Memory of Louise Taft Semple, University of Cincinnati, 1966.

Decorative Arts

A. Adriani, *Divagazioni intorno ad una coppa paesistica del Museo di Alessandria* (Documenti e ricerche d'arte Alessandrina III-IV), Rome, 1959.

P. Amandry, *Collection Hélène Stathatos, III. Objets antiques et byzantins*, Strasbourg, 1963.

G. Becatti, *Oreficerie antiche dalle minoiche alle barbariche*, Rome, 1955.

E. Coche de la Ferté, *Les bijoux antiques*, Paris, 1956.

R. A. Higgins, *Greek and Roman Jewellery*, London, 1961.

H. Hoffman and P. F. Davidson, *Greek Gold : Jewelry from the Age of Alexander*, Museum of Fine Arts, Boston : The Brooklyn Museum, New York ; Virginia Museum of Fine Arts, Richmond, 1965-66.

F. H. Marshall, *Catalogue of the Jewellery... in the British Museum*, London, 1911.

G. M. A. Richter, *The Furniture of the Greeks*, London, 1966.

B. Segall, *Museum Benaki. Katalog der Goldschmiedede Arbeiten*, Athens, 1938.

D. E. Strong, *Greek and Roman Gold and Silver Plate*, London, 1966.

Painting and Mosaics

M. Borda, *La pittura romana*, Milan, 1958.

B. R. Brown, *Ptolemaic Paintings and Mosaics and the Alexandrian Style*, Cambridge, Mass., 1957.

V. J. Bruno, *Form and Color in Greek Painting*, London, 1977.

L. Curtius, *Die Wandmalerei Pompejis*, Leipzig, 1929.

C. M. Dawson, "Romano-Campanian Mythological Landscape Painting," *YCS, 9*, 1944.

R. P. Hinks, *Catalogue of the Greek, Etruscan and Roman Paintings and Mosaics in the British Museum*, London, 1933.

H. Kenner, *Das Theater und der Realismus in der griechischen Kunst*, Vienna, 1954.

P. W. Lehmann, *Roman Wall Paintings from Boscoreale in the Metropolitan Museum of Art*, Cambridge, 1953.

G. Lippold, *Antike Gemäldekopien*, Munich, 1951.

La Mosaique Greco-Romaine (Colloques internationaux du centre national de la recherche scientifique), Paris, 1965.

E. A. Pernice, *Pavimente und figürliche Mosaiken* (Die Hellenistische Kunst in Pompeji, VI), Berlin, 1938.

P. Petsas, *O taphos ton Lefkadia*, Athens, 1966.

E. Pfuhl, *Malerei und Zeichnung der Griechen*, 3 vols. Munich, 1923.

————, *Masterpieces of Greek Drawing and Painting*, trans. J. D. Beazley, New York, 1955.

M. Robertson, *Greek Painting*, Geneva, 1959.

A. Rumpf, *Malerei und Zeichnung*, Handbuch der Archäologie, Part 6, vol. IV, 1, Munich, 1953.

K. Schefold, *Pompejanische Malerei, Sinn und Ideengeschichte*, Basel, 1952.

M. H. Swindler, *Ancient Painting*, New Haven and London, 1929.

A. Vassiliev, *The Ancient Tomb at Kazanlak*, Sophia, 1960.

J. White, *Perspective in Ancient Drawing and Painting*, London, 1956.

Abbreviations of periodical titles appearing in footnotes and bibliography.

AAA: Athens Annals of Archaeology.
AA: Archäologischer Anzeiger.
AB: Art Bulletin.
Abh. Deut. Akad: Abhandlungen der Deutschen Akademie der Wissenschaften zu Berlin, Klasse für Sprachen, Literatur und Kunst.
AEM: Archäologisch-epigraphische Mitteilungen aus Oesterreich (-Ungarn).
AJA: American Journal of Archaeology.
AM: Mitteilungen des Deutschen Archäologischen Instituts, Athenische Abteilung.
ArchCl: Archeologia Classica.
AS Atene: Annuario della R. Scuola Archeologica di Atene.
B *AntBeschav*: Bulletin van de Vereeniging tot Bevordering der Kennis van de Antieke Beschaving (Leiden).
BASOR: Bulletin of the American Schools of Oriental Research.
BCH: Bulletin de correspondance hellénique.
BdA: Bollettino d'Arte.
BMMA: Bulletin of the Metropolitan Museum of Art.
BSA: British School at Athens, Annual.
BSR: British School at Rome: Papers.
CAH: Cambridge Ancient History.
DOPapers: Dumbarton Oaks Papers.
GöttNachr: Nachrichten von der Gesellschaft der Wissenschaften zu Göttingen.
HSCP: Harvard Studies in Classical Philology.
Ist. Mitt.: Mitteilungen des deutschen archäologischen Instituts. Abteilung Instanbul.

Jdl: Jahrbuch des k. deutschen archäologischen Instituts
JHS: Journal of Hellenic Studies.
JNautArch: International Journal of Nautical Archaeology and Underwater Exploration.
JOAI: Jahreshefte des oesterreichischen archäologischen Instituts.
JRS: Journal of Roman Studies.
JSAH: Journal of the American Society of Architectural Historians.
MAAR: Memoirs of the American Academy in Rome.
Mitt d. Inst: Mitteilungen des Deutschen Archäologischen Instituts, Berlin.
MJb: Münchener Jahrbuch der bildenden Kunst.
MMS: Metropolitan Museum Studies.
MonPiot: Monuments et mémoires publ. par l'Académie des inscriptions et belles lettres, Fondation Piot.
MusHelv: Museum Helveticum.
ProcBritAc: Proceedings of the British Academy.
RA: Revue archéologique.
RE: Pauly-Wissowa, Real-Enzyclopädie der klassischen Altertumwissenschaft.
REG: Revue des études grecques.
Riv. del Ist. Arch: Rivista del R. Istituto d'Archeologia e Storia dell'Arte.
RM: Mitteilungen des deutschen archäologischen Instituts, Römische Abteilung.
SBBerlin: Sitzungsberichte der Deutschen Akademie der Wissenschaften zu Berlin.

INDEX Numbers in bold type refer to the illustrations

Vergil, poet 149; **33**, 20, 44–6
Verroia, Macedonia **86**, 114, 122
Victory (Nike), 19, 122, 125, 126, 193
Victory of Samothrace: *see* Samothrace
Victory Monument of Attalos **140–2**, 145–7
Villa: Borghese **143**, 147; dei Pisoni 44; **85**, 122; **95**, 125; of Cicero **XIII**, 256; of P. Fannius Synistor **XV**, 260
Vitruvius, architect 68, 79, 84, 221, 223
votive relief 100. to Cybele and Attis **171**, 201; to the Nymphs **163**, 188–9, 202

Walls **43**, 73; **51**, 76, 77, 77*n*, 78, 78*n*, 86*n*, 185; **65**, 82 (*see also* friezes, architectural; painting, mural)
warrior: *see* "Borghese" ———
washroom **50 (D)**, 76
waterclock 79

Weber, H. 144
Welter, G. 138
Williams, P. 36
Winckelmann, J. J. 124
Winds: *see* Athens; Tower of the ———
Winged Victory: *see* Victory; Samothrace
Woman, Sleeping **109**, 131
Women: *see* Draped Females; Two ——— Gossiping
Wrestlers **144**, 147–8

Zeno, philosopher 43
Zephyrus, west wind 79
Zeus, god 19, 20, 26, 79, 83, 83*n*, 130; **160**, 187; **XVI**, 262 (*see also* Altar of ———; Bearded God)
Zeuxis, painter 223, 242

MUSEUM INDEX Numbers refer to the illustrations